CONTEMPORARY ART
FROM CRESCENT MOON PUBLISHING

The Art of Andy Goldsworthy: Complete Works: Special Edition
by William Malpas

The Art of Andy Goldsworthy
by William Malpas

Andy Goldsworthy: Touching Nature
by William Malpas

Richard Long: The Art of Walking
by William Malpas

The Art of Richard Long: Complete Works
by William Malpas

Constantin Brancusi: Sculpting the Essence of Things
by James Pearson

Alison Wilding: The Embrace of Sculpture
by Susan Quinnell

Eric Gill: Nuptials of God
by Anthony Hoyland

The Erotic Object: Sexuality in Sculpture From Prehistory to the Present Day
by Susan Quinnell

Minimal Art and Artists in the 1960s and After
by Laura Garrard

Land Art, Earthworks, Installations, Environments, Sculpture
by William Malpas

Land Art: A Complete Guide to Landscape, Environmental, Earthworks, Nature, Sculpture and Installation Art
by William Malpas

Andy Goldsworthy In Close-Up
by William Malpas

Richard Long In Close-Up
by William Malpas

Land Art In Close-Up
by William Malpas

Colourfield Painting: Minimal, Cool, Hard Edge, Serial and Post-Painterly Abstract Art From the Sixties to the Present
by Stuart Morris

Mark Rothko: The Art of Transcendence
by Julia Davis

Jasper Johns: Painting By Numbers
by L.M. Poole

Brice Marden
by Laura Garrard

Frank Stella: American Abstract Artist: Special Edition
by James Pearson

Maurice Sendak and the Art of Children's Book Illustration
by L.M. Poole

The Erotic Object In Close-Up: Sexuality in Sculpture From Prehistory to the Present Day
By Susan Quinnell

Sacred Gardens: The Garden in Myth, Religion and Art
by Jeremy Robinson

Sex in Art: Pornography and Pleasure in Painting and Sculpture
by Cassidy Hughes

Postwar Art
by George Knighton

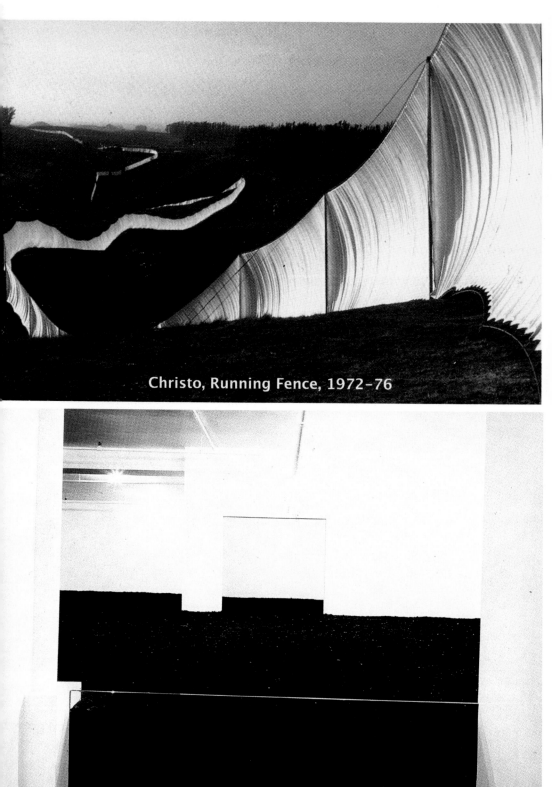

Christo, Running Fence, 1972–76

Walter de Maria, Earth Room, 1977

Land Art

A Complete Guide to Landscape,
Environmental, Earthworks, Nature,
Sculpture and Installation Art

Land Art

A Complete Guide
to
Landscape
Environmental
Earthworks
Nature
Sculpture
and
Installation Art

William Malpas

Crescent Moon Publishing

CRESCENT MOON PUBLISHING
P.O. Box 393,
Maidstone,
Kent, ME14 5XU,
United Kingdom

First published 2004. First edition.
© William Malpas 2004.

Printed and bound by Antony Rowe Ltd, Eastbourne.
Set in Book Antiqua 10 on 14pt.
Designed by Radiance Graphics.

The right of William Malpas to be identified as the author of *Land Art: A Complete Guide* has been asserted generally in accordance with sections 77 and 78 of the Copyright, Designs and Patents Act 1988.

British Library Cataloguing in Publication data

Malpas, William
Land Art: A Complete Guide to Landscape, Environmental,
Earthworks, Nature, Sculpture and Installation Art. – (Sculptors Series)
1. Sculpture – Criticism and interpretation
2. Sculpture, Modern – 20th century
I. Title

730. 9′2

ISBN 1-86171-062-3

Contents

Acknowledgements

Thanks to Richard Long; Peter Redgrove; Andy Goldsworthy; Viking Press, London; Penguin, London; Thames & Hudson, London; Anthony d'Offay Gallery, London; Henry Moore Centre for Sculpture, Leeds.

Illustrations © the artists.
Thanks to the authors quoted and their publishers.

BILLOWING CLOUDS OF FERROUS OXIDE

SETTING APART A CORNER ON THE

BOTTOM OF THE SEA

Lawrence Weiner, Billowing Clouds..., 1986 (Anthony d'Offay Gallery, London)

A FIVE DAY WALK

FIRST DAY TEN MILES
SECOND DAY TWENTY MILES
THIRD DAY THIRTY MILES
FOURTH DAY FORTY MILES
FIFTH DAY FIFTY MILES

TOTNES TO BRISTOL BY ROADS AND LANES
ENGLAND 1980

Richard Long, A Five Day Walk, 1980

1

Introduction

Most land artists have their favourite motifs, practices, materials and styles, instantly recognizable: Robert Smithson with his giant spiral earthworks; Michael Heizer carving up the Nevada desert; Dennis Oppenheim's Conceptual borderlands and concentric circles; Walter de Maria's lightning fields; Nancy Holt's celestial observatories; Christo's vast wrapped structures; the Roden Crater and 'skyspaces' of James Turrell; Hans Haacke's steam, fog and ice ephemeralities; Alice Aycock's underground labyrinths of night-mares and childhood memories; Richard Long's stone circles and rows; David Nash's wooden figurative sculptures; Andy Golds-worthy's serpents, arches, walls, snowballs, body prints, splashes, cairns and holes; and Chris Drury's shelters, medicine wheels and baskets.

The term 'land art' is used here as a shorthand to refer to many kinds of art, including landscape art, earth art, earthworks, nature art, green or ecological art, and installations. Land art was part of modernism and, in particular, 1960s art, the time of late Henry Moore, Robert Morris, Yves Klein, Anthony Caro, William Tucker, Tony Smith and Phillip King. It was the 1960-70s era of what Rosalind Krauss called 'expanded field' sculpture), the High Renaissance of land art.[1] Krauss's 'expanded field' sculptors in-

cluded Robert Irwin, Michael Heizer, Richard Serra, Walter de Maria, Sol LeWitt, Bruce Nauman, Alice Aycock, Mary Miss, Dennis Oppenheim, Nancy Holt, George Trakis, Richard Long, Hamish Fulton, Christo and Joel Shapiro.

I have concentrated on some of the more well-known land artists, such as Robert Smithson, Christo, Walter de Maria, Michael Heizer, Richard Long, Robert Morris, David Nash, Hamish Fulton, Hans Haacke, Nancy Holt, Alice Aycock, Mary Miss, Carl Andre, Dennis Oppenheim, and James Turrell. There are, of course, many more artists working with place, site, landscape and the environment. They include Robert Adzema, Vijali, Ana Mandieta, Jan Norman, Jane Balsgaard, Jussi Heikkilä, Tom Van Sant, Sherry Wiggins, Charles Jencks, Roger Ackling, Gordon Matta-Clark, Kazuo Shiraga, Bonnie Sherk, Charles Simonds, Isamu Noguchi, Richard Serra, Tony Smith, Daniel Buren, Gutzon Borglum, Jørn Rønnau, Helge Røed, Lars Vilks, Andy Lipkis, Nils Udo, Giuliano Mauri, Bror Westman, Debbie Duffin, Gloria Carlos, Phyllidia Barlow, Richard Fleischner, Michelangelo Pistoletto, Hiroshi Teshigahara, Vong Phaephanit, Alighiero Boetti, Herman de Vries, Joseph Beuys, Betty Beaumont, Betsy Damon, Andy Lipkins, Keith Arnatt, Herbert Bayer, Ant Farm, Newton Harrison, Helen Myer Harrison, Charles Ross, Peter Erskine, Juan Geuer, Jody Pinto, John Baldessari, Donna Henes, Phyllis Yampolsky, William Furlong, Art & Language, Peter Fend, Christian Philip Müller, Cildo Meireles, Harriet Feigenbaum, Ian Hamilton Finlay, Meg Webster, Jan Dibbets, Toshikatsu Endo, Mark Dion, Guo-Qiang Cai, Peter Hutchinson, Lothar Baumgarten, Maya Lin, Douglas Huebler, Bruce McLean, Avital Geva, Barry Flanagan, Mierle Laderman Ukeles, Viet Ngo, Mel Chin, Agnes Denes, William Jackson Maxwell, Constance DeJong, Doris Bloom, Reiko Goto, Michelle Oka Doner, Buster Simpson, Martha Schwartz, Peter Richards, Douglas Hollis, Patrick Zentz, Othello Anderson, Fern Shaffer, Lynne Hull, Patricia Johanson, Karen McCoy, Dominique Mazeaud and Alan Sonfist. What is written here about the more well-known land artists also applies to the other artists cited

above, plus many others.

Performance art, live art, body art and action art has many links with land, environmental, nature and installation art. In performance art, the field is vast. There isn't space in this study to consider them all (there are plenty of other studies). There are artists who talk to dead hares in their arms (Joseph Beuys), artists who carry out weird post-Catholic rituals or cut up sheep carcasses (Hermann Nitsch), artists who perform nude with film, video and installations (Carolee Schneemann), artists who draw on their bodies (while naked, of course), artists who sat in rooms and menstruated (Catherine Elwes), sculptors who stood and sang in suits (Gilbert & George), artists who replayed the physical martyrdom of saints (Ron Athey), groups who threw paint and food over each other while singing vaudeville songs (the Kipper Kids), artists who painted gallery floors with their long hair (Janine Antoni), artists who examined their genitals and masturbated before an audience (Annie Sprinkle), artists who had themselves bound and gagged in a gallery, holding a pig's heart (Tania Bruguera), artists who (while naked, of course) masturbate with cuddly toys (Mike Kelly), artists who meditate, chant, sing and play music (Caryle Reedy), groups who burn US flags and protest against war while naked on Brooklyn Bridge (Yayoi Kusama), artists who re-enact car crashes at a happening (Jim Dine and Judy Tersch), artists who douse themselves in water (Nam June Paik), artists who shoot guns at paint-filled balloons (Niki de Sant Phalle), artists who burn books (John Latham), groups who stage a protest 'blood bath' in a New York street (Guerrilla Art Action Group), artists who sat on horses in galleries (Jannis Kounellis), performers who locked themselves in rooms for six days while covered in paint (Stuart Brisley), artists who hung themselves upside-down in galleries (Jill Orr), creative couples who walk and bump into each other for an hour (while naked, of course), artists who scrubbed cow bones (Marina Abramovic), artists who stand against trees (nude, of course), covered in mud and plants (Ana Mandieta), artists who set themselves on fire (Tomas Ruller), or ignite gunpowder charges

(Roman Signer), groups who sit naked in healing baths (Cai Guo Qiang), performers who have their clothes cut off by the audience (Yoko Ono), artists who signed semi-nude women as 'living sculptures' (Piero Manzoni), artists who hid under wooden ramps in galleries and masturbated while speaking to visitors (Vito Acconci), artists who hung between bridges (Dennis Oppenheim), and artists who crucified themselves on the roof of a Volkeswagen (Chris Burden),

Land artists are sometimes termed 'Romantic' sculptors, and part of this book relates their art to (British) Romanticism, as found in William Wordsworth, J.M.W. Turner, Percy Bysshe Shelley, John Keats and others. The British novelist John Cowper Powys (1875-1963) and the British poet Peter Redgrove (1932-2003) are used as examples of a poetic equivalent of land and environmental art and nature mysticism. Powys's and Redgrove's works evoke a sensitivity which is close to land art.

Some of the key writers on land art include Rosalind Krauss, Lucy Lippard, Michael Fried, Kenneth Baker, John Beardsley, Lawrence Alloway, John Coplans, Diane Waldman, Harold Rosenberg, Stephanie Ross, Robert Hobbs, David Bourdon, Mel Gooding, Germano Celant, Alan Sonfist, Baile Oakes, Jeffrey Kastner, Andrew Causey, and Gilles Tiberghien.

Key land art shows include *Earth Art* (Andrew Dickson White Museum of Art, Cornell University, 1969), which showed Dibbets, Long, Smithson, Oppenheim and Morris, *Land Art* (Hanover, 1970), *Earthworks* (Dwan Gallery, 1968), *The New Sculpture, 1965-75* (Whitney, 1990), *Qu'est-ce que la sculpture moderne?* (Paris, 1986), *Virginia Dwan, Art Minimal, Art Conceptuel, Earthworks* (Paris, 1991), *Earthworks* (Seattle, 1979), *Conceptual Art, Arte Povera, Land Art* (Turin, 1971), and many of the Documenta exhibitions at Kassel. At *Earth, Air, Fire, Water* (Boston, 1971), Haacke, Christo, Smithson, Oppenheim, Long, Sonfist, Huebler, Hutchinson, Warhol and Heizer showed works.

Some of the best places to see land art *in situ* is in sculpture parks and gardens. In the US, these include Grounds For

Sculpture in New Jersey, Rockerfeller Estate, New York, the Storm King Art Center, New York, Empire State Plaza Art Collection, Albany, New York, Abington Art Center Sculpture Garden, Pennsylvania, Hirshhorn Museum and Sculpture Garden, Washington, DC, Des Moines Art Center, Iowa, Walker Art Center, Minneapolis, Laumeier Sculpture Park, St Louis, Sheldon Sculpture Garden, University of Nebraska, Lincoln, Florida International University, Miami, Chinati Foundation, Marfa, Texas, Oakland Museum, California, Franklin D. Murphy Sculpture Garden, UCLA, L.A., Los Angeles County Museum of Art and the Museum of Outdoor Arts, Colorado. Any visit to land and environmental art displays in the United States would take in many of the above sites, with Donald Judd's transformation of the army base at Marfa being near the top of the list. Further essential sites include Michael Heizer's *Double Negative* in the Nevada desert, Waltetr de Maria's *Lightning Field* in Quemado, New Mexico, James Turrell's volcano transformation, *Roden Crater,* near Flagstaff, Arizona, Robert Smithson's *Spiral Jetty* in the Great Salt Lakes and Nancy Holt's *Sun Tunnels* in Lucin, Utah.

For some critics, the worst kind of land art is that which avoids political or 'important' or problematic issues, such as AIDS, poverty, 'Third World' debt, globalization, colonialism, war, terrorism, and so on. It romanticizies the natural world. It's conservative. It's nostalgic (for a vanished agricultural, working class past that never existed in the first place). It's escapist. It's self-indulgent. It's élitist. It's repetitive and lacks imagination. It lacks formal experimentation. It over-simplifies its subjects. For the nay-sayers, land art is a romantic retreat into escapist, nostalgic fantasies about nature, with nothing to say about the anxieties, problems and challenges of living in the contemporary, 21st century world. It's hippy, tree hugger art which panders to the middle class's nostalgia for nature, seen from the perspective of neurotic city dwellers who hanker for the peace and quiet of the countryside. It's an art that flatters and assuages the bourgeoisie's

liberal guilt over wrecking the natural world with its ceaseless, massive consumption and pollution. It doesn't seem to say much about the late capitalist world, the technological, post-industrial, consumer society.

Americans may be more receptive to land art than Britons, Andy Goldsworthy remarked. He said that when he was working outside sometimes it was difficult to explain to the general public what he was doing there. Occasionally, he had 'to deal with the anger and bitterness that is sometimes shown towards contemp-orary art' (*Arch*, 74). There is a suspicion and distrust of contemp-orary among parts of the population of the UK (*viz.*, the hostile reactions to 'Young British Art' or the Turner Prize). Americans, Goldsworthy remarked, were more sympathetic and welcoming (*Wall*, 12). In Digne (France) in 2002 Goldsworthy encountered some resistance to his *Refuges d'Art* sculptures (the cairns and monuments) – 'the usual dislike of contemporary art' – with some talk of locals sabotaging them. Like other land art, Goldsworthy's sculptures have occasionally been vandalized: for instance, the snowballs (which some folk can't resist kicking over), and the Gateshead *Cone* – the top part was stolen.

2

The Alchemy of Matter:
Land Art Aesthetics

SPIRIT OF PLACE: LAND ART, NATURE POETRY AND
NATURE MYSTICISM

For the land and site artist, the whole planet can be an artist's
studio. The land artist ranges over the whole globe. A desert, a
beach, a field, a hill, a valley, a forest becomes a studio, a place of
creative activity. The landscape itself is crucial in land art. That's
obvious. Or is it? This means the very texture and colour and
shape and dampness and springiness and strength and size of
moss, for instance. Or a stone. Or a crevice in a rock wall. The way
the light falls on a clump of grass, the little bits of dead, yellowish
grass on top of the newer, green grass. Pine cones, closed-up.
Flowers turning sunward in the late afternoon. As Henry Moore
wrote in the Thirties:

> I have always paid great attention to natural forms, such as bones,
> shells, and pebbles, etc. Sometimes for several years running I have
> been to the same part of the seashore – but each year a new shape of
> pebble has caught my eye, which the year before, though it was there
> in hundreds, I never saw. Out of the millions of pebbles passed in
> walking along the shore, I choose out to see with excitement only those
> which fit in with my existing form-interest at the time.[1]

17

These are the things land artists deal with in making art. These are the actualities that artists employ when they create artworks. To fully appreciate land art, then, one has to look really closely, to grasp the details, as well as the overall conception and the grand design. This is true of small sculptures, as well as the larger American earthworks. Then there are the many layers of human history to consider, the social uses of the land, ranging from industrial and agricultural usage to the private, intimate experiences of individuals.

For David Nash, land art is 'close-up', not distanced:

> The term "landscape" is like "portrait". It is an expression of a distancing: here I am and there it is. But what has been happening in the last twenty years or so is that artists have been getting right in there. Saying no, it is not out there. It is here. We want to make our images with what is here – here. That is why it is called land art rather than landscape art, "scape" denoting distancing.[2]

For David Nash, land art is about getting as close as possible to nature: the land artist does not paint nature like the painter, at a distance, with a paintbrush or watercolour block in front of her or him. The sketchpad or easel is a wall, a veil, a barrier between artist and world. The land artist, rather, dives in, 'gets right in there', as Nash says. The land artist does not use oil or pastel or ink to 'represent' nature. Rather, she or he works directly with nature, getting her or his fingers dirty with mud, snow, animal waste, stone, ferns and wood.

It is exactly the same with poetry. Poets have long written of nature in close-up, of the tiny details that go to make up an accurate description of the natural world (a 'truthful' rather than 'realistic' portrayal). Land art can be seen as the sculptural equivalent, in one sense, of nature poetry, so that land artists such as Michael Heizer, Richard Long, Hamish Fulton, Nancy Holt and Alice Aycock are the inheritors of the work of poets such as William Wordsworth, Matsuo Basho, Francesco Petrarch, Robert Frost, William Shakespeare, Emily Dickinson, Pablo Neruda, Rainer

Maria Rilke and Aleksandr Pushkin. The nature poem itself is a piece of land art, a work evoking or representing or describing or situated in particular places. The poem can be regarded as an object in its own right, as well as communication or language. A poem as a magic circle, a sacred or special place where the poet works. Something like an alchemist's crucible or laboratory. ('The sculpture that I do,' said David Nash, 'is appropriate to a particular place and it stays in that place. It is made from and for that place').[3]

The attention to the minute, detailed qualities of nature that much of land art rejoices in is mirrored in Romantic and nature poetry. John Cowper Powys, for instance, could get excited by nothing more 'spectacular' than a patch of moss on a wall. Land art has the same delight in the small, seemingly unimportant aspects of the natural world. In his *Autobiography*, written in the early 1930s, John Cowper Powys remarked: 'I am looking at a patch of moss on a greenish marbly rock and I am aware of a deep sensual pleasure' (41). And in Cambridge, on one of his many walks around the outskirts of the city (Powys always liked the edges of towns), Powys remarked that 'certain patches of grass and green moss transported me into a sort of Seventh Heaven' (199).

In his (much-neglected) fiction John Cowper Powys described the ecstasies that artists (not only land artists) have in when interacting with the natural world. Powys' characters are, like those in William Wordsworth, Goethe, George Seferis, Maria Tsvetayeva or Victor Hugo, nature mystics, just as land artists such as Nash, Holt, Drury, Mandieta and Smithson are nature mystics. Sam, in Powys's massive nature mysticism novel *A Glastonbury Romance*, experiences the *participation mystique* with the Earth: '[w]hat he felt was a strange and singular reciprocity between his soul and every little fragment of masonry, of stony ground, of mossy ground...'[4] And Dud No-Man in the last of the Wessex quartet books, *Maiden Castle*, when he comes 'on a patch of green moss on a grey wall' gets 'a sensation that's more important than what you call 'love', or anything else, nearer the secret of things too!'[5]

Land artists, like nature poets and nature mystics, are inspired by particular places. Nature poets, like religious mystics or land artists (like all artists) can be described as 'following their bliss' (Joseph Campbell's term). When one follows one's bliss 'you come to bliss'.[6] Campbell uses the model or metaphor of following the 'pollen path' of the Navaho Indians. As Campbell defined it:

> The Navaho have that wonderful image of what they call the pollen path. Pollen is the life source. The pollen path is the path to the centre. The Navaho say, "Oh, beauty before me, beauty behind me, beauty to the right of me, beauty to the left of me, beauty above me, beauty below me, I'm on the pollen path". (ib., 230)

This is one way of imagining the creative journey – towards the centre, the life source. Paradise, the Golden Age, Eden, was not back there then, but it is now. 'Eden is... this is it, this is Eden' (ib.). The journey, whether physical or imaginary, is along the *feng shui,* the 'dragon lines', or along the 'songlines' or 'dream tracks' of the Australian aborigines, or the 'pollen paths' of the Navaho Indians.[7]

Maybe the whole world was a work of art – a piece of land art – in that now vanished Golden Age. Eden, Arcadia, Paradise... maybe those terms point towards a time and a place that of total art, presided over by a deity known in some guises as God, the Creator, with the world God created as the ultimate work of art (also known as the Creation). This ties in with Mircea Eliade's view that all artworks replay the first creative act, which was the creation of the world. For Eliade, all art refers to and reworks the Creation (which, by extension, makes artists equivalent to the creator, to God).

Like Chris Drury, Hamish Fulton and Richard Long, British author Bruce Chatwin spoke lovingly of walking, of wandering, of nomads and wildernesses. In *The Songlines,* Chatwin made notes on Australian dreamtime and 'songlines', the lines that crisscross the landscape and are sung by the aborigines. Britain has its own version of this *feng shui* or earth magic: ley lines ('discovered' in

the modern era by Alfred Watkins). Richard Long's maps often look like those of a New Age ley line hunter, crisscrossed with ink lines. Goldsworthy, Fulton and Long produce their own versions of 'songlines', whether in powdered snow, drips of water, lines of maple leaves, or words. As in the work of Bruce Chatwin, Paul Theroux, Jonathan Raban, Patrick Leigh Fermour and other travel writers, there is a deep sense of motion and travelling in Fulton's and Long's art. Theirs is an art born out of travels, even if the journeys are nothing more than morning walks out from the studio. These journeys don't have to be weeks long, crossing the Sahara on foot or over the Poles by sled; they can be made on an afternoon stroll. Ecstasy can be found anywhere.

Where people live is both local and universal, both particular to them and particular to everyone. The path snaking around the hill outside that town in Peru, North Dakota or India, where one walked in childhood, is both a very particular place, with particular kinds of shadows and plants, and also a universal path, like all other paths. Mircea Eliade, who is another Jungian, like Campbell, writes of regaining what he calls the 'mythic centre', which is the spiritual core of one's life. For Mircea Eliade, the regaining of this mythic centre is spatial. That is, it pivots around particular places: in *Ordeal By Labyrinth*, Mircea Eliade wrote:

> Wherever one is, there is a *center of the world*. As long as you are in that center, you are at home, you are truly in the real *self* and at the center of the cosmos. Exile helps you to understand that the world is never foreign to you once you have a central stance in it... (1984, 100)

For Eliade, sacred acts create a 'mythic centre'. As art is a sacred act, the creation of an artwork can be seen as the creation of a sacred place or mythic centre. Some pieces of land art (the boulder, hole, pillar, shelter, stone circle) are obvious forms of a mythic centre. Making (land) art can be seen as a sacramental experience – essentially one of a sacralization of life and living things. It is like the Australian Bushmen's *alchuringa* experience, mythic dreamtime and mystical participation with the earth and

21

with life. In the *alchuringa* of the Australian aborigines the world is sung into existence (a notion also found in Western occultism, in the 'music of the spheres' of hermetic philosophy).[8] As the poet Rainer Maria Rilke put it, 'song is existence' ('Gesang ist Dasein') where art is life itself, and making art is not a commentary 'about' life, but is life itself.

This notion of art equals life is the foundation of much of land art. As James Turrell said, in 1987, the goal was not to turn an experience into art, but 'to set up a situation to which I take you and let you see. It becomes your experience... not taking from nature as much as placing you in contact with it'.[9]

The 'sacred' or 'mythic' does not have to be extraordinary. Ordinary things can be the sources of sacrality, the mythical and ecstatic. Things such as moss on a wall, or the feel of wood, or the colour of a particular patch of sky. Artists such as Leonardo da Vinci show the viewer that the 'ordinary' is really extraordinary (think of Leonardo's fabulous drawings of a sprig of oak, a lily, a rain storm). The poet Peter Redgrove said:

> ...this 'strangeness' is 'strange' because reality is so fucking extra-ordinary, and strange too because most of us try to live without strangeness, and construct something called the 'ordinary' which never existed. Actually, the strangeness is so ordinary as to be quite natural. The strangeness is wonder and what is wondered at is so wonderful that it is strange we do not wonder more.[10]

What happens is that these tiny sensations and feelings are pushed to one side, displaced, buried, forgotten, suppressed and ignored by society, by the media. by general discourse. Hardly anyone (except perhaps children) speaks of such minute feelings, because they seem to be 'unimportant'. Poets such as Marina Tsvetayeva, Louise Labé, Novalis, John Skelton and Bernard de Ventadour show that these sensualities are important. They don't seem to add up to much, as John Cowper Powys says in his *Auto-biography,* yet they are crucial to poetic living.

Marcel Proust knew that a ray of sunshine could lift the spirits,

and for John Cowper Powys, simply by seeing the sun on a wall one could have a 'Beatific Vision'.[11] Nature poetry (and similarly land art) veers between the sensualism of the pastoral view of life, as created in the bucolic poetry of Theocritus and Virgil, and a more intense pantheism as found in mystics such as Meister Eckhart, Jacob Boehme and Henry Vaughan. The Elizabethan and Renaissance poets (Edmund Spenser, William Shakespeare, Mich-- ael Drayton, Samuel Daniel and others) were particularly fervent about nature. Sir Philip Sidney wrote: 'O sweet woods, the delight of solitariness!'[12] Unlike the world of rustic verse, land art is not populated with images of satyrs, sylphs, Pan-figures, shep-herds and shepherdesses and magicians.

DEUS LOCI IN MODERN LITERATURE

Of the many writers who have explored the 'spirit of place', two of the most interesting were Lawrence Durrell and D.H. Lawrence. Lawrence Durrell's notion of landscape or 'spirit of place' was defined thus: 'I firmly believe in the theory that landscape shapes people and behaviour patterns'.[1] For Durrell, landscape is one of guiding principles or forces that humans must respond to.[2] For Durrell, 'man is only an extension of the spirit of place'.[3] In Durrell's most famous work, *The Alexandria Quartet*, the events are controlled by the city, so that the narrator says '[w]e are the child-ren of our landscape; it dictates our behaviour and even thought' (ib., 36).

Durrell developed D.H. Lawrence's 'spirit of place',[4] mixing it with Freud and Spengler, folklore, and an amateur anthropology. Lawrence employed landscape as a setting and a symbol: he did not choose landscapes simply for their 'beauty'. The settings of Lawrence's fictions add much to their meanings. The snowy countryside of the short story *Wintry Peacock* is central to its theme; the environs of Eastwood, lovingly evoked in *Sons and Lovers* and

The Rainbow, form so much of the impact of the novels. As with *Wuthering Heights, Tom Sawyer* or *War and Peace*, one couldn't take away the settings without altering much of the meaning.

> As a poet of historic consciousness I suppose I am bound to see landscape as a field dominated by the human wish – tortured into farms and hamlets, ploughed into cities [wrote Lawrence Durrell]. A landscape scribbled with the signatures of men and epochs. Now, however, I am beginning to believe that the wish is inherited from the site; that man depends for the furniture of the will upon his location in place, tenant of fruitful acres or a perverted wood. (*Justine*, 100)

Land art gains much of its power (its meaning, its value, its presence) from particular places. Many land artists, for instance, work away from urban areas. Some, like Michael Heizer and Walter de Maria, work in what are regarded as 'exotic' locations – deserts and mountains. The 'glamour' of the locations aids the sculptures. Some land art is overpowered by the Romantic settings. Some of Richard Long's stone circles, for instance, look feeble in their desert or snowscape locations.

Lawrence Durrell's fiction is set in and is an expression of what is now called the 'post-colonial' world. It's an epoch in which 'ethnic', 'national' and racial 'boundaries' are dissolving, producing uncertainty and anxiety. The upside of this post-colonial world is the ease with which land artists such as Fulton, Christo, Heizer and others jet around the world. Land art is very much the product of the privileged, relatively wealthy First World, a world in which the Northern hemisphere is superior to the Southern; American, Eurocentric ethics are dominant; bourgeois/ 'imperialist' politics predominate; and the racial 'colour' of the art is not black, brown, red or yellow, but definitely white. Though 'post-colonial', land art is distinctly not 'politically correct' when it comes to issues of ethnicity or economy (although there is a strain of land art that engages with political, financial and ecological issues).

In a key text, the essay "Landscape and Character", Lawrence

Durrell speaks of being a 'residence writer', that is, someone who lives in a place not as a tourist or visitor.[5] This is the opposite of Richard Long's and Hamish Fulton's desire, which is to pass through the world 'invisibly'. Any number of (travel) writers (Bruce Chatwin, Julia Kristeva, V.S. Naipaul, Colin Thubron) have explored the dislocation of a postwar, post-colonial world. The narrators of their fictions, like land artists themselves, are exiles, ex-pats, colonials, 'castaways', 'displaced persons', 'migrants'. While land art is about 'centring' oneself in a particular place, in postwar fiction the sense of displacement is paramount.

THE LAND ART SUBLIME: LAND ART AND ROMANTICISM

There is no habitation between our road and the Schroon river four miles cross country. I enjoy the phenomenon of nature, the sounds, the Northern lights, stars, animal calls, as I did the harbor lights, tugboat whistles, buoy clanks, the yelling of men on barges around the T.I.W. in Brooklyn. I sit up there and dream of the city as I used to dream of the mountains when I sat on the dock in Brooklyn. I like my solitude, black coffee, and daydreams. I like the changes of nature; no two days or nights are the same.

David Smith (1951)[1]

Nature poetry is an ancient form of poetry – from Greek bucolic verse onwards poets have written of nature. Land art and land artists seem to have most in common with Romantic art and Romantic artists. The marks of late 18th / early 19th century European Romanticism include: exalting nature; going to extremes; the cult of solitude; the pre-dominance of subjectivity; rebellion; the artist as outsider; infinity; the sublime, and so on. Postwar artists (such as Mark Rothko, Robert Smithson, David Inshaw, Anish Kapoor, James Turrell and Thérèse Oulton) express some of the marks of Romanticism cited above. The cult of solitude, for instance, as found in writers such as Emerson, Goethe, Thoreau,

25

Rousseau, Wordsworth, and others – is a part of postwar art. Post-war art exalts the subjectivity and sovereignty of the artist creating on her/ his own. R.W. Emerson wrote of the ecstasy of being alone in nature:

> The lover of nature is he whose inward and outward senses are still truly adjusted to each other... His intercourse with heaven and earth becomes part of his daily food. In the presence of nature a wild delight runs through the man in spite of real sorrows.[2]

Land art in its grander moments echoes the gestures of High Romanticism – the Blakean, Wordsworthian, Goethean, Turnerian gestures – which have become so familiar in Western art. 'The Romantics' awe in the face of nature is hard to revive in a culture as estranged from nature as ours' remarked Robert Hughes, 'but, enfolded in distance and immensity, such works of land-art [by Heizer and de Maria] are saturated in nostalgia for it'.[3]

One of the apotheoses of High Romanticism is Johann Wolf-gang von Goethe's novel *The Sorrows of Young Werther*, where the soul alone actualizes the myriad things of nature. In this passage from Goethe one can see similarities with the more opulent (sublime) moments in Robert Smithson and Walter de Maria:

> Ah, to view this vast landscape from there! Oh, distance is like the future: before our souls lies an entire and dusky vastness which overwhelms our feelings as it overwhelms our eyes, and ah! we long to surrender the whole of our being, and be filled with all the joy of one single, immense, magnificent emotion.[4]

The 'Land Art Sublime' (*pace* Robert Rosenblum's coining of the term 'Abstract Sublime' to describe Barnett Newman's and Mark Rothko's paintings) might include the snow and stone circles made in the wildernesses of Scotland, Nepal and Peru of Richard Long; Christo's islands surrounded with pink polypropylene; the stone circles of Nancy Holt; and of course Smithson's *Spiral Jetty*.

There are links between land art and the theory of the sublime in the history of art. These are useful to consider. Art critic

Christopher Hussey defined (in 1927) seven aspects of the sublime, derived from the philosopher Edmund Burke's *Philosophical Enquiry Into the Origin of Our Ideas of the Sublime and Beautiful* (1757): (1) obscurity (physical and intellectual); (2) power; (3) privations (such as darkness, solitude, silence); (4) vastness (vertical or horizontal); (5) infinity; (6) succession; (7) uniformity (the last two suggest limitless progression).[5] These tenets can be applied to land art, especially that of Turrell, Pierce, Irwin, Smithson *et al*.

The nature poet uses the same emotional/ cultural stuff as the land artist: the human relationship with nature. Whatever the poet writes about or the land artist sculpts, it is the *feeling* for nature that is important, the relation between self and nature, that is employed by both poet and land artist. As Clement Greenberg, the foremost critic of postwar art in America, wrote: '[a]rt is a matter strictly of experience, not of principles', a statement which chimes with the views of land artists, for whom experience is primary.[6]

Poets regard poems themselves as physical things that affect people, just as land art is a physical thing (a stone, soil, leaves) that affects people. When Walter de Maria filled a gallery with soil, the sensual aspects of work (smell/ taste/ touch/ sight/ sound) were crucial. Similarly, when John Keats, Sylvia Plath, Walt Whitman or Anna Akhmatova describe a place (or even its soil), they employ synæsthetic means, in order to make the poem itself a physiological experience. As Ted Hughes wrote:

> The value of [some] poems is that they are better, in some ways, than actual landscapes. The feelings that come over us confusedly and fleetingly when we are actually in the places, are concentrated and purified and intensified in these poems. (80)

The sheer *scale* of some of the works of land artists is of itself visceral and erotic (de Maria's *Lightning Field*, Christo's *Running Fence*, Viet Ngo's *Lemna System*).[7] Among novelists, it is British author John Cowper Powys (d. 1963) who has captured most accurately the synæsthetic experiences of life, where so many tiny

and seemingly ordinary and inconsequential sensations fuse into illumination. Powys writes about landscape in a way wholly in tune with land artists such as Nash, Fulton, Long, de Maria and Aycock. One extract from Powys' *Autobiography*, which is one long record of ecstasies and sensations, serves to introduce his highly charged, eidetic, pellucid way of seeing. The author has been out walking and is returning to Cambridge with his walking stick:

> What I am revealing to you now is the deepest and most essential secret of my life. My thoughts were lost in my sensations; and my sensations were of a kind so difficult to describe that I could write a volume upon them and still not really have put them down. But the field-dung upon my boots, the ditch-mud plastered thick, with little bits of dead grass in it, against the turned-up ends of my trousers, the feel of my oak-stick "Sacred" whose every indentation and corrugation and curve I knew as well as those on my hand, the salty taste of half-dried sweat upon my lips, the delicious swollenness of my fingers, the sullen sweet weariness of my legs, the indescribable happiness of my calm, dazed, lulled, wind-drugged, air-drunk spirit, were all, after their kind, a sort of thinking, though of *exactly what*, it would be very hard for me to explain.[8]

Brancusi, Long, Woodrow, Houshiary and many sculptors have spoken of the importance of materials in their work, how they learn from their materials, and 'follow' their materials. Tony Cragg speaks of 'works in which I learnt from the materials'.[9] A stone is not merely a stone for land artists: it has its own essence, its own form and presence.

> Nothing could convince Brancusi that a rock was only a fragment of inert matter; like his Carpathian ancestors, like all neolithic men, he sensed a presence in the rock, a power, an "intention" that one can only call "sacred."[10]

The land artist has a special, fetishistic relation with her/ his materials: they are not simply bits of matter to be wielded in a particular way. They are treated with respect. Wolfgang Laib dusts the Earth with pollen, to form an enormous square layer of brilliant yellow. The delicacy – and potency – of the sculpture is

immediately apparent. This is the sort of sculpture that exerts a synæsthetic power over the gallery goer: the pollen affects not only the visual sense with its incandescent hues, but also affects smell, taste and touch. Another of Laib's installations was *The Passageway* (1988-93), made up of huge panels of beeswax. 'I believe that the impossible, the invisible and visions can become reality if one really wants to make the effort' said Laib.[11] Anya Gallaccio made large installations using flowers: thousands of red roses in *Red On Green* (1992), 101 sunflowers in *Preserve Sunflower* (1991) and 1,600 zinnias in *Untitled* (1992). Gallaccio's flowerpieces emphasized beauty and decay, sensuality and death. Goldsworthy, Laib and Drury collect leaves, berries, pollen, honey and other natural elements and weave sensuous artifacts that are ephemeral and intricate. Dennis Oppenheim worked with snow and circles in his *Annual Rings*, a series of concentric circles that straddled the Canadian/ American border, and with burning circles onto grass in his *Branded Mountain*. In fact, Oppenheim was the first land artist to work with snow on a grand scale.

LAND ART AND GARDENS

'Land art' is a term that includes a wide variety of artistic forms, like the term 'garden'. Gardens are not a single form with a single set of characteristics. Gardens can be so various that some critics have suggested that the word 'garden' is as broad and vague as words such as 'art'.[1] It's a term so general it's practically useless.

Gardens can be very small or very big; they can be flat or terraced; they can be circular, square, or narrow; they can be organized around a 'natural' plan or a strict geometric plan; they can be 'wild' or 'tamed'; they can be enclosed or open; they can contain lakes, ponds, streams, fountains, statues, trees, statues, lawns, shrubs, rocks, walls, fences, benches, flowers, stones, follies, ruins, grottoes, temples, paths and many kinds of environ-

mental art.

A traditional Japanese (Zen Buddhist) garden, with its stones and sand raked into patterns, is quite different from, say, an English kitchen garden in Chelmsford, or a suburban yard in Iowa. Gardens can be vast displays of state and regal power, such as the garden at Versailles or Hadrian's Villa, or modest attempts at cultivating food in a yard. Gardens have been made for many reasons: in the pursuit of decoration, finance, medicine, religion, contemplation, play, sport and food. Sculptor Isamu Noguchi thought of gardens as 'sculpturing of space: a beginning, and a groping to another level of sculptural experience and use: a total sculpture space experience beyond individual sculptures. A man may enter such a space: it is in scale with him; it is real' (1968). For some critics, the most interesting aspect of land art is its connection with gardening and landscape design.[2] But for the chief land artist – Robert Smithson – art degenerates as it approaches gardening.[3]

If there can be 'found art', can there be 'found gardens'? Perhaps an artist, working in the Conceptual and environmental art mode, could simply claim any piece of land as their 'found garden', just as artists such as Marcel Duchamp, Kurt Schwitters and Robert Rauschenberg took found objects and exhibited them as art (and Gordon Matta-Clark bought tiny pieces of land and it became an artwork). When does a garden start becoming a garden? How many objects are required to make a garden? Is a single blade of grass a garden? Are two plants on a window ledge a garden? Or five plants, or ten plants, clustered together in pots? Is an overgrown path a garden? Or an allotment dedicated to growing tomatoes and potatoes? Is a couple of yards of grass behind an abandoned gas station a garden? Is a municipal park, consisting only of children's swings and slides on grass, a garden? Is a farmer's field a garden? Or a farm?

And when does a garden stop being a garden? Is a garden of a hundred years ago that can barely be seen amidst piles of refuse still a garden? How much of the human touch is required to make

a piece of land a garden? If sand raked into a pattern can be a garden for the Japanese Zen Buddhist, is any piece of raked sand a garden? Are the patterns made in the sand by the receding tide a garden? Is the sea making gardens with every tide? Or the wind, or erosion, or earthquakes or other natural forces? Does a garden have to have the 'human' touch to make it a true garden?

Environmental or land or garden art can include American earthworks (such as those by James Turrell and Mel Chin); ephemeral interventions in the environment (such as those by Andy Goldsworthy, Hans Haacke and Michael Singer); architectural installations (such as those by Alice Aycock, Mary Miss and Nancy Holt); land art as performance art (Richard Long, Hamish Fulton, Christo), even if the artist is the only audience; land art that involves landscaping and garden art (such as Alan Sonfist, Patricia Johanson, Robert Irwin and Ian Hamilton Finlay); and sculpture or art parks. There are 'video gardens', too, such as Matthew McCaslin's *Bloomer* installation: 12 TV monitors played tapes of flowers blooming in time-lapse. The TV sets were arranged in groups like plants, with the cables tangled on the floor (St Louis Art Museum).

In the historical Japanese Zen garden, colours are carefully orchestrated, so that a single leaf can set off a vast acreage of predominantly green or ochre. In the Oriental garden, notions of *feng shui* and *yin* and *yang* control how a landscape is shaped by humans. In the system of *feng shui*, the elements of a garden or a building must be in harmony with natural forces of air, water and earth. Get it wrong and one messes up the creation. The Zen or Taoist harmonizing approach is very much that of much land art. In the manner of the ecologically-friendly follower, Andy Goldsworthy speaks of wanting to be in harmony with nature. Goldsworthy, like other artists, can be seen as an ecological artist, artists committed to ecological issues. Robert Rosenblum wrote:

> There's a German artist Wolfgang Laib who does something of this sort too. He spends a lot of time in the woods gathering such things as pollen and collecting it and forming minimal geometric patterns out

of gossamer and natural materials such as honey or dust of various kinds. It is some kind of ecological last gasp of communion with some pure beautiful stuff of nature. I guess this attitude is expiring even though it may, as in the case of Richard Long, still produce some marvellous artists.⁴

Chinese gardens were designed by balancing the principles of *yin* (feminine) and *yang* (masculine), water and mountain. Goldsworthy's art, like other land art, can be seen as a kind of modern *feng shui*, a Westerner's way of harmonizing the *yin* and *yang* elements. Land artists re-organize the landscape, building mountains, digging holes, creating pools, as in *feng shui*.

Oriental gardens were asymmetrical – in that single non-formal element they differ greatly from Western formal gardens with their patterns, squares, crosses, parallel paths, and mathematically exact *parterres*. Oriental gardens were founded on stone, sand, water, flowers, moss and trees. If sand was used, it could evoke water by being raked into wave-like shapes. Stones could be mountains, but also, via abstraction, other natural forms. In the 'dry garden' of Zen Buddhism (the *karesanui*), stone could be water, or cascades. Stones were valued highly for gardens, and were bought and sold. Many kinds of stone were used in Oriental gardens, including schist, volcanic rock, granite, limestone, slate and jasper.

Perhaps the most famous of the Japanese Zen gardens is at Ryoanji, Kyoto (made in the 1480s). It is 30 by 70 feet with white gravel raked parallel to the longer side. There are 15 rocks placed in it, and a verandah surrounds it. The Ryoanji garden is garden design reduced to its simplest elements, an ultimate in reduction and purification. There are no trees, flowers or plants in the garden. In Goldsworthy's art there is a similar emphasis on asymmetry, on keeping forms as they appear in nature, on contemplation, on valuing objects such as stones as sacred in their own right, with nothing needing to be added to them.

Contemplation was clearly a key purpose of the Oriental garden. 'Contemplation gardens' were meant to be consumed

from one viewpoint (from the noble's house, for example). The 'contemplation garden' was often a 'dry garden', with various islands in its midst having particular meanings. Some of Andy Goldsworthy's sculptures recall the 'islands' in Oriental gardens; like contemplation gardens, Goldsworthy's works are usually designed to be viewed from one point (Goldsworthy endorses the single-viewpoint in his work in his use of photography, with its monoscopic vision). Goldsworthy can thus be seen as as creating Western versions of Oriental and Zen gardens, in which contemplation is the primary activity for the art consumer.

'TRUE CAPITALIST ART'?: THE COST OF LAND ART

Not all but much of land art is very expensive. That is, it is costly moving tons of earth around. Taking a motorbike out into the desert and drawing lines with it is one thing (as Michael Heizer had done in *Circular Surface Displacement* [1968], North of Las Vegas), but making a 40 mile 18 foot high fence (Christo) is another. Much of land art requires patrons, sponsors, co-ordination with galleries, lawyers, public administrators, helpers and industry. The costliness of land art may explain why much of it is American.[1] Land art requires investment with no immediate return. Patrons are crucial to land art. In American earthworks the key patrons were the Dia Art Foundation, Robert C. Scull and Virginia Dwan, director of the Dwan Gallery between 1966 and 1971.

Richard Long perhaps speaks for many British sculptors when he writes of his aversion to American earthwork art:

> In the sixties there was a feeling that art need not be a production line of more objects to fill the world. My interest was in a more thoughtful view of art and nature, making art both visible and invisible, using ideas, walking, stones, tracks, water, time, etc, in a flexible way... It was the antithesis of so-called American "Land Art," where an artist needed money to be an artist, to buy real estate to claim possession of

the land, and to wield machinery. True capitalist art.[2]

Although Long (and others) may despise the amounts of money spent by the American earthwork artists, isn't he also part of '[t]rue capitalist art'? Doesn't he also live off his art? Doesn't he just wander around the planet on his sacred 'walks', putting a few stones into a pile, and taking a photo of his (slight) efforts? Isn't Richard Long (and Andy Goldsworthy, David Nash, Shirazeh Houshiary, Rachel Whiteread, Richard Wentworth, Bill Woodrow, Helen Chadwick, Alison Wilding, Hamish Fulton and Richard Deacon) also a part of the 'capitalist' art world?[3] Don't Long's art-works sell for lots of money, a lot more money than the materials cost? Isn't Long being hypocritical when he criticizes the bombastic aspects of American land art when he himself benefits from the hugely over-priced art gallery system, where even mundane art it seems (such as artists' prints) are sold for 'silly prices'?

It's easy to view the Christos' wrapped buildings or Walter de Maria's $500,000 *Vertical Earth Kilometer* as expensive, pointless art. This sort of land art may be '[t]rue capitalist art', an art of excessive cost and excessive waste, but then, art has been full of idiot amounts of money for ages. What about Christo's wrappings? They cost a bomb, for sure, but, as Christo says, he pays for it himself, with money made from selling smaller works. Christo's *Running Fence* cost $2.5 million; *The Umbrellas* in Japan and California, cost $26,000,000. Christo says his art 'has to do with things that are very simple'.[4] This definition can also apply to other land artists; they, too, transform ordinary things.

When these transformations of the ordinary cost so much, and require 200 rock climbers, as Christo's covering of the Reichstag in Berlin needed, then commentators wonder about the 'importance' of such artistic productions. There is something right and homely about Andy Goldsworthy and his couple of stonewallers building a wall in the Northern wildernesses of Britain. They toil away in true grimy, stalwart, Eric Gill-like craftsman style. But there's something cynical and obscene, perhaps, about Michael Heizer or

Walter de Maria carving great gashes in the American desert, or Christo making artworks that cost 26 million dollars yet only last for two weeks. Surely that money would be better spent on a hospital? Or on feeding needy groups or countries? Surely artworks that cost millions of dollars but only 'benefit' a (relatively) tiny amount of people are wasteful? Isn't famine relief a better alternative? Perhaps one could make famine relief/ earthquake relief/ medical supply/ housing, and other 'charity' and 'aid' projects, an art event? Perhaps if Christo spent $26 million on providing food for the needy instead of wrapping a building in Berlin in a bit of plastic, people would not be so angry? When artists spend such vast amounts of money on art, it's no wonder people find this obscene. But then, if spending millions of dollars on art were outlawed, we'd have no Hollywood, no movie industry, no television. These are the hypocrisies and ambiguities that surround art. How can one 'justify' a $26,000,000 Christo wrapping? Or a typical Hollywood feature film (cost: $45 million, with a typical advertizing budget of $5-15 million)?

If Christo's artworks cost a lot, this is chickenfeed to scientific and military experiments, which cost billions of dollars. The Large Hadron Collider, for instance, will cost $1.5 billion. Just one nuclear submarine costs the same amount. In the mid-1980s 1,000,000 dollars per minute were spent on the arms industry (1982 figures). That's $16,500 per second.

Although it may appear that land artists tour the whole globe making art, they actually stick to a small number of countries (tending towards the Northern hemisphere, and the Western world). For instance, there are few major land artists who have made significant work in Africa, or large parts of South America, or mainland China, or Russia. There are few Western land artworks in Egypt, for instance (perhaps because the competition is pretty fierce there from some of the most wonderful structures humans have ever made – the tombs, temples, cities and pyramids of ancient Egyptians. Of course, there are also social, political, cultural and ideological reasons for the lack of major land

35

art in Islamic and Middle Eastern territories).

Europe's a favourite location, but not Eastern Europe. Favourite places tend to be America and Europe, obviously, and Japan, and occasionally Australia. Occasionally also India (if it's India, it's usually the scenic parts to the North, in Nepal or the Himalayas). But even in America, birthplace and chief centre of land art, artworks tend to be clustered around the East (New York, Washington, DC, Chicago), the South-West (New Mexico, Arizona), the Mid-West (Colorado), or California.

LAND ART AND PHOTOGRAPHY

In land art photography, the viewer is not offered a *range* of viewpoints of a work, although land artists clearly take more than one shot of each work they make. No artist takes just *one* photo out of a 36 exposure 35mm film, or one frame out of a twelve shot 120mm format film, or one image out of 100s available on a digital camera. No, an artist, like an photographer, takes a range of shots, at different, bracketed exposures, from different viewpoints (much as the trendy advertizing film director of today shoots twelve hours of footage for just one thirty second advert).[1]

Each land artist, then, must select this or that viewpoint, behind this bush or next to that tree. The land artist is therefore also a photographer, selecting views, reframing their works, making choices about lighting, angles, lenses, film stock, etc. Land artists will make decisions about exactly *when* to photograph their work. Some works are ephemeral, and last only moments, so the photograph must be taken immediately (but even when a work lasts only a few seconds or minutes, there are still choices about which moment to select). Other works, such as Robert Smithson's *Amarillo Ramp* or Nancy Holt's *Star-Crossed* (1981), last longer. The land artist as photographer can therefore wait for a certain combination of sunlight and clouds. This is particularly crucial in

cloudy places like Britain, where lighting can vary so dramatically over a few minutes. As anyone who has been in Dartmoor or the Peak District will know, the sunlight can burst through the clouds at one moment, then a moment later there'll be dark, sombre clouds, looking as if it's going to rain. A moment later, it *will* rain, and afterwards, facing away from the sun, one might see a rainbow. Much of the world's weather is this changeable, so every land art photograph is a highly selective and subjective view of a particular place.

Another critical aspect of photographing land art is not only deciding what to *include*, but choosing what to *exclude* from the composition. Visiting a land artwork in the flesh, one can see it from all sorts of angles, with all sorts of backgrounds, in all sorts of conditions. Knowing a land artwork only from a photograph, one knows only *that* particular viewpoint, and no others. The land artist will take great care in framing the images, to show the artwork from the best vantage points. Many aspects of the surroundings might be elided from the final published photographs – an apartment block, a row of cars, trash, people, power lines, and so on.

Land artists must also oversee the journey of the films they've shot from development through printing to framing. As anyone who has taken a photo will know, all manner of details can affect how one reads a photograph: how it is printed, light, dark, soft, hard, cropped, full frame, more red, more blue, burnt in, dodged, touched up, glossy or matt paper, and so on. The size of the photo affects it very much, as does the frame. Go into any framer's shop and one'll see a plethora of different types of frame. All these things the viewer might take in at one glance in a gallery, but the artist has to make decisions all the time about all these matters, and many more. Land artists/ sculptors, then, must be accomplished photographers. Their work must be high standard, for it is exhibited in 'high art' locations, such as the city gallery, or glossy coffee table art books.

In land art, the commentary, the written records, the obsessive

documentation, is just as important as the artwork itself. Often, it *is* the artwork. The land artist's life becomes part of the artwork. The American sculptor David Smith spoke of this consuming aspect of sculpture, where the artist lives and breathes art. In a series of questions to students, Smith described the committed artist's stance:

> Do you make art your life, that which always comes first and occupies every moment, the last problem before sleep and the first awaking vision? ...How do you spend your time? More talking about art than making it? How do you spend your money? On art materials first – or do you start to pinch here? ...How much of the work day or the work week do you devote to your profession – that which will be your identity for life?[2]

Andy Goldsworthy said '[m]y art will always be a reflection of my way of life.'[3] Brilliant late 1960s sculptor Eva Hesse spoke in Romantic, emotional terms of her art, employing words such as 'essence' and 'soul'. She spoke of wanting to emphasize 'soul or presence or whatever you want to call it.' Although Richard Long is not as openly emotional in his descriptions of his art, these words of Hesse's could apply, with some minor revisions, to Long's (and other land artist's) art: 'I think art is a total thing. A total person giving a contribution. It is an essence, a soul... In my soul art and life are inseparable.'[4]

Jan Dibbets said that documenting the work wasn't important: 'I've done lots of works without taking photographs'.[5] Bust most land artists record their activities (e.g.: 'walk this morning; made a snow sculpture; it wasn't successful; back home for lunch'). Ultimately, *any* activity can be land art. Going to the shops can be a piece of art. One might drop a stone on the path as one goes, or perhaps not. Either way, you've just made a work of art. Is, then, walking to Gilmor's corner store for a pint of milk and a pack of cigarettes a fully accomplished and thoroughly authentic work of art? Where does authenticity end and artifice begin? Or, rather, where does life end and art begin? Clearly, they are a continuum

in land art.

Richard Long says that '[n]ot all walking is art'. That is, a walk becomes art when it is conceived as art. The conception of the walk, made before the walk, is crucial, even if there is no 'reason' at all for the walk. 'A walk, and place, can be chosen for any reason'.[6] Long also says, though, that '[a]nything an artist makes, is art', but adds '[n]ot everyone is an artist.'[7]

The relation between outdoor and indoor works, between stone cairns in some remote zone and a stone cairn in a Western gallery, is resolved simply in land art by being regarded by the artist as a continuum. One can see how for the land artist both indoor and outdoor works are one, i.e., part of the same thing. But the viewer might see them as separate, because the viewer (usually) can't see many land art outdoor pieces (Richard Long likes to keep his locations secret and anonymous).[8] The viewer only knows land art outdoor pieces from photos. So it's always an odd relationship with land artworks for the viewer. For the artist, it's great, because the big photos and writings relate to her/ his own experiences, of working outdoors. S/he knows the work inside out: *s/he lived it*. The viewer, though, gets a different experience: s/he sees odd phrases, titles, dates, measurements. Odd snippets of info. Or photos. So people love land art not because they love the photographs, or the writing. They love it, perhaps, because of *what it suggests*. Land art persuades people to look outwards, away from cities, towards the landscape, towards stones and water and all the rest of it. Perhaps that's why people love land art, and nature poetry, and all things to do with nature, from gardening to walking the dog to vacations in wildernesses. As Hamish Fulton put it, 'I walk on the land to be woven into nature' (1995).

The outdoor work itself isn't present in land art's text pieces or photos. The work isn't 'in' the gallery. No, the work is *elsewhere*, and it is to that *elsewhere place* that people want to go. Land art creates *desire* in people, as the work of J.M.W. Turner or Aleksandr Blok creates desire – for travel, for other places. Richard Long spoke in the Santa Fe interview of feeling refreshed and

renewed after a good walk: that's the experience, perhaps, that viewers wish to gain from land art, from all art.

Land art, then, whether by Aycock, Shiraga, Drury or Christo, is part of a postmodern trend in self-reflexivity, the *mise-en-âbyme* commentary so familiar now. Art about (the artist's) life. It's found not only in the postmodern literature of the 1960s and 1970s, but also in the fiction of, say, André Gide. Gide's novel *The Counterfeiters* (1925) is a key text in this respect: the main character is, of course, a novelist. But Edouard is more interested not in the novel he's trying to write, but in his book about the writing of his novel. Thus, the diary/journal of the work becomes more important than the work itself; and the act of *writing about* the art becomes more important than *making* the artwork itself. Indeed, so crucial was the 'making of' the book *The Counterfeiters* to Gide that he published a book after *The Counterfeiters*, called precisely that, *The Journal of The Counterfeiters* (although he swore he'd never do that, despising artists 'explaining' their works). Land artists, like Conceptual and Process artists, steer clear of 'explaining' their works.

Much of André Gide's concerns are also those of the land artists. For, as he lived his life, Gide was conscious of *how he would write it up later*. When something extraordinary occurred, Gide would be thinking about it as an account in his journal. After living, for Gide, comes making art. Like the readymades of Marcel Duchamp, Gide's *The Counterfeiters* destroys the diegetic effect of fiction, its naturalism and suspension of disbelief. Like Jean-Luc Godard's movies and Jasper Johns's paintings, Gide's art is self-reflexive art, a Pop Art æsthetic forty years before Pop Art.

When Marcel Duchamp and Kurt Schwitters put 'real' objects into the gallery, they did so because it seemed a natural thing to do. It's the same with land artists: why not, they say, have an art made out of found objects, stones found on a remote path, or leaves, or household bricks. The use of ordinary objects in (land) art ushers in a new sense of the object in sculpture, a new way of looking at art. The 'real' objects and readymades of Duchamp and

Schwitters were developed by Robert Rauschenberg and Jasper Johns, among others. As with Rauschenberg, the stuck-on objects set alight Jasper Johns' paintings. Johns explains why he used 'real objects' stuck onto his paintings:

> My thinking is perhaps dependent on a realization of a thing as being the real thing… I like what I see to be real, or to be my idea of what is real. And I think I have a kind of resentment against illusion when I can recognize it. Also, a large part of my work has been involved with the painting as object, as real thing in itself. And in the face of that 'tragedy,' so far, my general development… has moved in the direction of using real things as painting. That is to say I find it more interesting to use a real fork as painting than it is to use painting as a real fork.[9]

Easy to see how Johns' thinking applies directly to land art: Nash, Smithson and Morris also like what they see to be real, to be the object in and of itself (the 'thing-in-itself' of Existentialism, or Rainer Maria Rilke's *Kunstdïng*, 'thing of art'). They too dislike illusionism. For land artists, their sculpture doesn't symbolize or represent nature, it *is* nature, a part of nature. As Jasper Johns remarked: 'I find it more interesting to use a real fork as painting than it is to use painting as a real fork.' Similarly, one can see how, for Turrell, Johanson, Pierce, Michelle Stuart and other land artists, it's much more interesting to use a stone as a stone rather than as a representation of something else. Robert Smithson's definition of an earthwork is pertinent here: 'instead of putting a work of art on some land, some land is put into a work of art'.[10]

INSIDE — OUTSIDE

Sometimes it's odd to see land art in a gallery, because the mound of soil, the cairn of stones, the slate circle, demands the viewer to look outwards, to nature, to the wildernesses from whence this art comes. Richard Long's stone circles are familiar now, having been

seen in art galleries and museums, but one is always aware of the place of their origin, and how odd they look.[1] Those sticks and stones are tiny parts of nature, bits extracted, chopped up, re-arranged, as all art is nature chopped up and reformed according to the artist's æsthetics. Land art creates an ambiguous continuity with the world of nature that exists outside the gallery. Sometimes this ambiguity works against the art on show in the gallery space.

Land art sites, in the first wave of land (late 1960s/ early 1970s – land art's 'golden age'), tended to be wildernesses, deserts, post-industrial spaces, waste grounds, quarries and dumps. One of the reasons for going far from the gallery, the city and the pretty countryside spots was because land artists wanted to avoid the 'pastoral' and the 'picturesque' at all costs.[2] Land artists, asserted Dennis Oppenheim, wished to go beyond the picturesque (while British land artists, such as Richard Long, had some relationship with the picturesque [ibid.]).

David Nash discussed this indoor/ outdoor problem in a 1978 interview:

> An object made indoors diminishes in scale and stature when placed outside. The reverse happens when an object made outside is brought inside, it seems to grow in stature and presence. It brings the outside in with it. The object outside has to contend with unlimited space, uneven ground and the weather. The sculpture I show inside is meant to be seen inside, it relates to the limited space, the peculiar scale, and the still air.[3]

The indoor-outdoor dialectic much concerned Robert Smithson, who said 'I don't think you're freer artistically in the desert than you are inside a room'.[4] In fact, Smithson said he 'liked the artific-ial limits that the gallery presents'.[5] One of the problems land art must address is the age-old relation between the 'real world' and art, between objects as they are in the everyday world, and objects as they are represented in art. Land art makes the viewer look again at the natural world: not just at the beauty of it, but at the multitudinous variety of forms in nature. Land art/ sculpture is a

poetry of natural forms, in which notions of 'representation' are sidestepped, because it uses things 'as themselves' (the use of photography, though, sees a swift return of confusions over the politics of representation). An object such as the snowball in Andy Goldsworthy's *Snowballs in Summer* (1989 and 2000) is not plastic masquerading as a snowball, but a real snowball. Similarly, the twigs and stalks and needles and pebbles folded into the snowballs are real. What's amazing is the actuality of nature: the variety of forms; the way the branches twist, for instance. Land artists would have the viewer look closely at nature again. By using 'real' objects, land artists aim to demolish notions of representation and mediation. Instead of a picture of snow, one has snow itself; rather than paint pebbles, or sculpt them in bronze, land artists use real pebbles.

Of course, there are problems with using objects as objects – Marcel Duchamp with his readymades confronted this problem. The problem is partly one of context: for, placed in a museum, so obviously as items to be studied, the natural forms become art. The objects may not be on pedestals, but they are perceived as art objects. If you're looking at land art in a book or a gallery, one is already anchored in a gallery/ art/ æsthetic mode of viewing.

Ephemeral, land art aims for an eternity in one place: the soul. As Lawrence Weiner, the Conceptual/ Process artist who exhibited 'statements' (text on a wall), said: '[o]nce you know about a work of mine, you own it. There's no way I can climb into somebody's head and remove it.'[6] Thus, much of land art exists in that socio-cultural space which is actually inside people's heads. Thus, anyone can 'own' land art: simply by thinking about it. Once thought about, land art, Conceptual art or Process art is 'possessed' by the viewer, in Weiner's system. Indeed, some Conceptual art requires the existence of the viewer to make the work work at all. The viewer brings the work alive.

Working inside was problematic for Goldsworthy, he confessed, because he was disconnected from the natural world outside, with its changes, its seasons, animals, people, history. The

outside world was alive, while the gallery or public space could all too easily begin to feel dead after a while. 'I am not not sustained by working indoors. I have too much control inside, and after a while I am drained of reasons for being there'.7

CHANGES, CYCLES, SEASONS

Critical in land art is the concept and reality of change, for these works in wood, snow, ice, leaves, water, slate, grass and so on, do not stay. They are not 'permanent', in the way that, say, bronze, marble, steel or stone can be. The soil in Walter de Maria's *Earth Room* dries out and alters; Robert Morris's steam works and Hans Haacke's balloons are blown away by the wind; Christo's plastic wraps stay on for two weeks. Joseph Beuys emphasized process, evolution, change: his sculpture, he said, was not 'fixed and finished. Processes continue in most of them: chemical reactions, fermentations, colour changes, decay, drying up. Everything is in a *state of change*'.[1] The notion of decay and entropy was an important element in Robert Smithson's earth art.[2] It's the same for Richard Long: 'my work is partly about change or disappearance, invisibility... all these strange states of matter'.[3]

Some land artists enjoy the impermanence of (their) art, and exploit it. As politicians know, words such as 'permanent' are difficult to define, and even more difficult to maintain. Artists with a large vision of life know that nothing on Earth will be truly 'permanent'. After all, 'civilized' humanity is only 10,000 years old, or three million (depending on how one measures 'civilized'). And the planet itself will not last forever: millions more years, perhaps, but not forever.

Andy Goldsworthy said he is not against long-term art: '[t]hat art should be permanent or impermanent is not the issue. Transience in my work reflects what I find in nature and should not be confused with an attitude towards art generally. I have never been

44

against the well-made or long-lasting.' *Domination* and *penetration*. These are familiar terms describing patriarchal actions or constructions or ideologies used by feminists. Is Goldsworthy, seemingly so delicate in his touches, dominating nature?

Yet, clearly, land artists (and not just the American 'earthworks' artists – Heizer, de Maria, Smithson, Simonds, Christo, Aycock) do dominate nature. James Turrell's *Roden Crater* or Michael Heizer's gigantic *Double Negative* will clearly be around for a long time, unless someone or something destroys them. Andy Goldsworthy's stone pieces, too, may stay around for a while. There is a sense of gloating when Goldsworthy says '[f]ourteen years ago I made a line of stones in Morecambe Bay. It is still there, buried under the sand, unseen. All my work still exists, in some form.' Daring not to change or affect nature, land artists do just that, all the time. They 'interact' with nature, but their 'interactions', however small scale, can't help changing nature. 'I like the idea of using the land without possessing it' said Richard Long, ever the idealist.[4] Goldsworthy's aim is to 'touch' something in nature, the essence of nature itself, to understand it, and the identification of himself within nature.[5] Thus, about the 'lake pieces', the stick and stalk sculptures he was commissioned to do in the Lake District in 1988, he remarked: 'I felt I really got through in the lake pieces. I had touched it, and understood it'.[6]

Some environmental/ action/ Conceptual artworks had a built-in impermanence, such as Allan Kaprow's *Fluids* (1967, Pasadena, California), large structures made from blocks of ice, which were left to melt. Barry Flanagan's *Hole in the Sea* (1969) was a cylinder embedded in a beach: Flanagan filmed the water covering the hole as the tide came in. Hans Haacke produced impermanent works, such as ice freezing around an element.[7] He wrote of an artwork which would be as majestic and as transient as birds gathering in the sky: 'I would like to lure 1000 seagulls to a certain spot (in the air) by some delicious food so as to construct an air sculpture from this combined mass.' In "Natural Phenomena as Public Monuments" (1968), land artist Alan Sonfist suggested

45

building 'museums of air' in cities, which would 'recapture the smells of earth, trees and vegetation different seasons and at different historical times, so that people would be able to experience what has been lost' (1978). Sonfist also suggested monumentalizing the natural world with sounds: '[c]ontinuous loops of natural sounds at the natural level of volume can be placed on historic sites' (ibid.).

There are bronze and marble sculptures still looking remarkable from the Græco-Roman period, and stone figurines from the Palæolithic period. Michael Heizer's scars in remote deserts will endure, but not Morris's steam works or Hans Haacke's *Grass Grows* (1969). Indeed, ephemerality, transiency and change are key components in land art. The bulk of some land artists' work is ephemeral. As Barry Flanagan writes:

> Truly sculpture is always going on. With proper physical circumstances and the visual invitation, one simply joins in and makes the work... there is a never-ending stream of materials and configurations to be seen, both natural and man-made, that have visual strength but not object or function apart from this. It is as if they existed for just this physical, visual purpose – to be seen.

LIVING PLANTS

Many land artists have used living plants at some time or other. Some artists have installed trees upside-down (Vito Acconci) and plants upside-down in galleries (Michael Blazy, Henrik Håkansson, Sam Kunce). Some artists have trained plants to grow at odd angles (Hans Haacke, Cartsen Höller). Some artists have forced plants into vacu-formed moulds (Laura Stein) and rubber foam (Ingo Vetter, Annette Weisser). Some artists have lined rooms with cages of bay leaves to produce an aromatic environment (Guiseppe Penone). Some artists have planted seeds on their naked bodies (Teresa Murak). Some artists have planted clover fields in

galleries (Nikolaj Recke) and made couches from grass (Daniel Spoerri). Some artists have built parks running up the sides of buildings (Vito Acconci); some have made enclosed indoor gardens (Knut Åsdam). Other artists have made portable orchards (the Harrisons); portable indoor vegetable gardens (N55); and crammed hothouses (Lothar Baumgarten). And some have let roses run riot over cars (Silvie Fleury). Herman de Vries is a close competitor with Andy Goldsworthy for the artist who's created the most works with living plants

Plenty of land artists and sculptors have used real flowers: Anya Gallaccio used roses (1992), sunflowers (1991) and zinnias (1992); Herman de Vries (who spread thousands of lavender flowers on a gallery floor in 1998); Wolfgang Laib with his pollen floor spreads; Richard Long, who pressed flowers flat in a field in *Brough of Birsay Circle* (1994); Jenny Holzer's *Black Garden*, a war memorial garden of very dark plants and flowers (1994); Gary Rieveschl, who planted *Heart Wave*, a line of 12,000 red tulips, in 1980; Daniel Buren also made a row of tulips, *11,000 Tulips* (1987, Holland); Peter Hutchinson, who planted 'thrown ropes' of flowers (1996); Annette Wehrmann; Shelagh Wakely; Mark Dion; Meg Webster; Carsten Höller; Paula Hayes; Peter Fischl; David Weiss; Tobias Rehberger; Lothar Baumgarten; Brigitte Raabe; and Olaf Nicolai.

One of the most famous of contemporary sculptures using living flowers was Jeff Koons' giant dog (*Puppy*, 1992), constructed in Arolsen with 17,000 flowers, and standing 11.5 metres tall. 'I decided I wanted to make an image that communicated warmth and love to people. A very spiritual piece. It just came to me to make the *Puppy* out of live flowers'.[1] Although Koons' art was known for its postmodern, camp, trashy chic, Koons likened the interior of the *Puppy* to a church: 'I wanted the piece to deal with the human condition, and this condition in relation to God. I wanted it to be a contemporary Sacred Heart of Jesus' (ibid.).

TREES IN LAND ART

Many sculptors and land artists have worked with trees: David
Nash, Guiseppi Penone, William Jackson Maxwell, Robert Irwin,
Jackie Winsor, Daniel Buren, Alan Sonfist, Harvey Fite, Peter
Walker, Giuliano Mauri, Nils Udo, Luc Wolff, Maria Nordman,
Sjoerd Buisman, Cosima von Bonin, Stefan Banz, Vito Acconci,
Jørn Rønnau, Buster Simpson, Jan Dibbets, Helge Røed, Lars
Vilks, Andy Lipkis, Herman de Vries and Mel Chin. Using trees
means working within a long and celebrated religious and cult-
ural tradition.[1] For example, trees have since time immemorial
been associated with spirits and religions. The Greeks believed
that trees had spirits; there were the apples of immortality and
trees of eternal life; Daphne turned into a tree when pursued by
Zeus; Actaeon was turned into a stag in the forest when he spied
Diana bathing nude; deities such as Athena, Artemis, Dionysus,
Apollo, Orpheus and Cybele are associated with trees and woods.

The Celts worshipped trees, and the Germanic tribes had
mystical relations with trees. The Druids revered the oak, the
royal tree of ancient England, and had rituals that involved oaks
and mistletoe. The oak was sacred to Jupiter, Hercules, the Dagda,
Thor, Jehovah, Allah and other gods in their 'thunder-god' mode.
Trees were associated with secret languages and religious
symbolism. Fire festivals are in particular linked with trees –
burning wood is central to many land artworks: there were the
bonfires at the Celtic fire festivals (such as Samhain, or Hall-
owe'en, a fire festival inaugurating the beginning of the Celtic
year which transferred in the UK to Bonfire Night); on Mid-
summer Day fires are lit, traditionally with oakwood; Midsummer
was also the time of the sacrifice of the oak-king of Nemi. The
willow is deeply associated with witchcraft (the words 'witch' and
'wicked' are derived from the same ancient word for 'willow'); the
laurel is linked with poetry – the reward for great poetic endeav-
our was the laurel ('Daphne', in Greek, is associated with Apollo's
pursuit of the Goddess Daphne); laurel was also an intoxicant – the

leaves were chewed to induce a frenzy – and the poet Francesco Petrarch revered the laurel tree, linking it with his beloved Laura and the longed-for notion of poetic immortality which the laurel symbolized.

Particular trees have been mythologized: there was the 'holy thorn' that, as legend has it, sprang from Joseph of Arithamea's staff as he planted it in the sacred ground of Glastonbury; the wood of the Sacred Tree of Creevna, at Killura, had healing properties; naked children were passed through gaps in pollard ashes before dawn as a cure for rupture; Yygdrasill was the sacred ash tree of the god Woden – he used it as his steed; in secular times trees still play a mythic role: there are the trees that hid figures such as Robin Hood and Charles I from their foes.

In fairy tales, forests are places of enchantment, initiation and trial, where strange beasts are encountered, spells are undertaken. The 'dark forest' or *selva oscura* occurs at the opening of the great poem of European culture, Dante's *Divine Comedy*, where the first thing the poet-pilgrim does is enter the 'dark forest'. When the land artists pick up a bit of wood, then, or use a branch in their work, they are activating a mass of associations in the fields of symbolism, legend, myth, magic and religion. Every tree and type of wood has its symbolic associations: oak, beech, laurel, willow, sycamore, ash, larch, hawthorn, holly, vine, hazel, ivy, elder, rowan, alder and birch.

One of the most ancient religious functions of the tree was the World Tree of shamanism, the oldest of all religions. The World Tree was the mythic centre of the world of the community, it was the *axis mundi*, the pivot of time and space. The archaic shaman had many tasks: one of them was to travel to the Other World, to bring back news of what happened there, and to guide the souls of the departed to the Land of the Dead. The shaman did this by climbing up the Cosmic Tree: the shaman's magical flight to the Other World was linked with climbing the World Tree. What has all this to do with 20th century land art? A lot.

Constantin Brancusi, more influential on land art than Picasso,

Arp, Giacometti, Rodin, Matisse or Maillol, worked notions of shamanic flight into his *Birds in Space* sculptures, and most especially in his *Endless Column*, which is cited by many key sculptors (Judd, Andre, Morris) as an important inspiration. Brancusi's *Birds in Space* aimed to express the essence of flight, the moment when a quivering verticality is released from the chains of gravity and flies upward. One only has to look at David Nash's *Tripods*, Chris Drury's cairns of rocks, Barnett Newman's *Broken Obelisk*, or Donald Judd's ladders, to see how important Brancusi's sculptures were, with their shamanic, World Tree associations.

Planting trees has become a favourite with land and environmental artists: Alan Sonfist created various solid circles and rings of trees (*Circles of Life*, 1986, *Circles of Time*, 1987); Mel Chin planted trees and plants on a landfill site in St Paul, MN (*Revival Field*); Joseph Beuys led the planting of oak trees a Documenta 7 in Kassel in 1982; Andy Lipkis planted trees in urban areas (such as L.A.), and organized fund-raising marathon runs for trees (1979); Andy Goldsworthy has planted dwarf oak saplings in the Holocaust memorial in New York; Guiseppe Penone placed a long white crystal in tree trunks (*Light Traps*, 1994); Vito Acconci constructed a tower of trees (1996), one above the other, all of them upside-down; Robert Irwin installed nine plum trees in Seattle, WA (1983), separated by blue screens; Buster Simpson planted willow trees in drinking fountains (1993).

Daniel Buren constructed one of the most compelling of all treeworks: an olive tree standing atop a huge cube of soil in a gallery (*Untitled*, 1999), a truly spectacular (and enigmatic) work, with the tree and earth in proportion, quietly dominating the ornate room at Castello di Rivoli.

HOLES

Many land artists have dug holes, cracks, caverns, tunnels and underground labyrinths in the Earth. Maybe there's more to this than just the æsthetic dimension of creating new spaces. Andy Goldsworthy, for instance, has an anxious, ambivalent attitude towards holes in the ground which recall the views of (usually male) philosophers on the negativity of holes and voids, which are associated with the sexual identity of women. These fears and ambiguities are found in much of Western culture: in Freud's castration myth; in the belligerent misogynist theology of St Augustine, Tertullian, St Paul and Origen. In this view, women are vampires and loathed witches, sucking up masculine desire and energy. Another religious view sees women as Mother Goddesses, identified with nature, the seasons, vegetation and the powers of the Earth. One deity which some feminists and British poets (such as Robert Graves and Peter Redgrove) have worshipped (though they would not use that term) is the 'Black Goddess', a divinity of darkness, night, the unknown and the supernatural.

French psychologist Jacques Lacan's notion of the 'lack', which subsequent feminists (such as Hélène Cixous, Julia Kristeva and Luce Irigaray) have criticised, is another obvious reference. What women lack (for Lacan) is the phallus, the 'transcendent signifier' as cultural theorists call it. The art object is thus (in Julia Kristeva's interpretation) a fetish, a stand-in for the imaginary maternal phallus. Nietzsche had similar views of the 'feminine': it was not menstruation or lactation that scandalized Nietzsche about the 'feminine' so much as the lack or absence of a visible (sexual) organ. 'What Mother Nature needs so urgently to hide from view is not so much what she has as what she lacks. Nietzsche suspects a void at the center of the body of nature.'[1] In Luce Irigaray's reading of Lacan what women lack is the ability to speak from/ with the phallus: the genital lack suggests an ideo-logical or æsthetic lack, the absence which becomes cultural silence.

51

STONE CIRCLES: LAND ART AND PREHISTORIC ART

The circle motif, one of the primæval symbols of eternity, cycles, time, rebirth, and so on, is employed throughout much of land art. Circles in land art are made from slate, timber, snow or by walking in a circle; they seem to be gentler, more eco-friendly kinds of 'sculpture'. The circle shape itself speaks of organic forms, and, in some religions, evokes the 'feminine' and the Goddess. Not a few sculptors and land artists have made the circle crucial to their works: Alison Wilding, Richard Deacon, Stephen Cox, Mary Miss, Anish Kapoor, Peter Randall-Page, Robert Morris and Dennis Oppenheim.

Land art based on circles includes Vijali's *World Wheel* (1987), Alan Sonfist's *Circles of Life* (1987) and *Pool of Virgin Earth* (1975), Adam Purple's *The Garden of Eden* (1975), Charles Jencks' *Snail Mound* (1992-94), Michael Heizer's *Circular Surface Planar Displacement Drawing* (1970), Stan Herd's *The Circle* (1992), and Mel Chin's *Revival Field* (1993). Many of Nancy Holt's works are circular: *Annual Ring* (1981), *30 Below* (1980), and *Sun Tunnels* (1976).

Donald Judd produced two circular steel bands, 180 inches in diameter, as well as a concrete circular 'wall'. Robert Morris made gigantic circular works, such as his *Observatory* (1971), which was a huge earthwork recalling the megalithic structures of ancient times, such as Avebury stone circle. His *Labyrinth* (1974) was a maze-size sculpture, the kind of maze one finds in theme parks and country houses, except that Morris' *Labyrinth* used the ancient pattern of the Cretan labyrinth, itself a motif some see as distinctly feminine, speaking of Goddess mysteries. Herbert Bayer's *Mill Creek Canyon Earthworks* (1979-82) was a series of earthworks recalling ancient monuments. Robert Smithson's *Closed Mirror Square* was like an Aztec ziggurat, while his *Amarillo Ramp* recalled the massive embankments found at Neolithic earthworks in the British Isles such as Maiden Castle, or Iron Age hill forts such as British Camp on the Malvern Hills.[1]

Some artists have produced stone circles which look very

much like Stonehenge, such as Nancy Holt's monumental *Stone Enclosure: Rock Rings* or Alan Wood's *Ranchenge* (1983), a wooden Mid-West American version of Stonehenge. Vida Freeman's *Installation* (1981) in an L.A. gallery comprised white porcelain and stoneware stones with white pillars emerging from them. Michelle Stuart constructed cairns and circles in *Stone Alignments/ Solstice Cairns* (1979). Margaret Hicks fashioned three concentric circles from oak and sandstone in Texas (*Hicks Mandala*, 1975), intended for a 'Ritual of Giving'. David Harding cast his *Henge* (1972) from nine foot tall slabs of concrete, while Donna Myars' *Dream Stones* (1979) were cast and carved from cement. Michael McCafferty built his *Stone Circles* (1977) on a beach in Oregon, where they were flooded at high tide. Marlene Creates' interventions on prehistoric earthworks included laying rows of paper over them (*Paper Over the Turlough Hill Cairn*, 1981).

The spiral and snake employed by so many land artists down the ages (in ancient Peru, or on the doors of Neolithic tombs, or in the Mid-West of America) is associated with Goddess cults and with the energies of life. The circles and spirals of Nash, Oppenheim and Smithson are also those of the Goddess, the ancient Earth Mother. In the eco-neo-pseudo-pagan view, the land artists, then, make marks upon Mother Earth, upon the surface or skin of the Goddess. Andy Goldsworthy inadvertently evoked phallic penetration when he said: 'I want to get under the surface... At its most successful, my 'touch' looks into the heart of nature' (WH). Land artists, then, penetrate or cut into nature, into the Goddess. The Earth, which is regarded as female in this particular religious/ pagan worldview, is penetrated – by Michael Heizer gouging vast chunks out of the American desert, by Walter de Maria thrusting a kilometre-long brass rod into the Earth (this must be art's biggest phalus, surely?), and Goldsworthy, seemingly so gentle, has cut trenches into the earth, or smashed slabs of slate or pebbles or leaves, to make lines of broken, shattered material on the earth. He has torn leaves apart to form a line, and has smashed pebbles, making a line, like a fault line in continental

structures (*Leaves Torn in Two*, 1986, *Broken Pebbles*, 1987). These are violent gestures, destroying the organic make-up of the natural forms he so adores. All land artists – all artists – must break up and reform materials, but these cracks and holes can look to the eco-friendly follower like scars on the body of Mother Earth.

Land artists often use circular forms, which hide the violence of their gestures. The spiral or circle is a 'kind', organic, even gentle shape, seemingly in tune with 'earth energies'. Circular structures (igloos, huts, stone circles, tombs, earthworks, pools) seem to be in harmony with nature, echoing the circle shapes of the planet itself, or suns, eyes, blood cells, orifices, orbits. The circular structures suggest primitive, archaic, more 'authentic' ethics, the 'back to nature' syndrome. There is, then, not only a mystical side to land art, to Nash, Smithson, Oppenheim, de Vries and Bayer, but also a nostalgic element (nostalgia is a key element in any religion). Looking *back* to the land, land artists also look *back* to a former, even ancient era which was, patently, better (to a golden age which is and was imaginary, which never existed). This is the hidden subtext in the writings of the land artists, this nostalgia for the better times of archaic cultures, when people lived 'in harmony' with the earth. This is, of course, a widespread nostalgia, not backed up by the evidence, which is that for ancient and prehistoric peoples life was as hard, if not harder, than it is now.

Many land artists have made mounds which recall prehistoric burial mounds (apart from the ones cited above) including Charles Jencks (*Snail Mound*, 1992-94), Judy Varga's *Geometry of Echoes Converge* (1980), Maya Lin's *Wave Field* (1995), Peter Walker's *Turf Mountain* (1993) and James Pierce (*Burial Mound*). These (Minimal) sculptures are ambivalently related to ancient monuments, however, as Samuel Wagstaff remarked of Tony Smith's works: '[t]hey are related to early cultures intentionally or through sympathy – menhirs, earth mounds, cairns... [and] to this culture with equal sympathy – smokestacks, gas tanks, dump trucks, poured concrete ramps.'[2]

Land artists, then, consciously or slyly invoke ancient,

prehistoric monuments. Heizer, Smithson, Gormley, Morris and Holt make references to ancient earthworks. Anthony Gormley likened the *Angel of the North* site to a burial mound. (What separated Haacke's earth mound from gardening? By *intent*, Haacke replied.) The famous *Serpent Mound* in Adams County, Ohio, dating from the 10th century AD, is an obvious ancestor of Goldsworthy's *Lambton Earthwork* and landscaped art by Heizer, Bayer, Morris and others.

Some land artists work in megalith-rich landscapes (such as Richard Long in the South-West of Britain). There are over nine hundred stone circles in the British Isles. Long too makes connections with prehistoric art in terms of manufacture: the cave paintings at Lascaux, Long said, were made by people's hands on the rock. Long has made references to some of the key sacred/ religious/ prehistoric sites of Britain: to Silbury Hill, the largest humanmade mound in Europe, so the textbooks say; to the ithyphallic Cerne Giant in Dorset; to Glastonbury Tor, mecca for hippies, occultists and 'New Age' travellers; to Windmill Hill, and so on. Long even put a picture of himself with a rucksack in Africa right next to one of the famous ancient hill figures of England, the so-called 'Long Man of Wilmington', 231 foot tall, in Sussex. This is one of those prehistoric sites that some see as being an alien, or St Paul, or a Roman emperor, or King Harold. Richard Long ironically compared himself with another 'Long' Man.[3]

Locations such as Silbury Hill and Glastonbury have long been revered by people as holy sites, 'places of power' as they are called. Land artists capitalize on the mystery of such places. One of Richard Long's works is a walk between two prime magical centres of Britain, Stonehenge and Glastonbury, both deeply associated with prehistoric astronomy, ancient priesthoods, Arthurian legend, Merlin the Magician, the Age of Aquarius, ley lines, Druids, geomancy, and so on:

ON MIDSUMMER'S DAY
A WESTWARD WALK

55

FROM STONEHENGE AT SUNRISE
TO GLASTONBURY BY SUNSET
FORTY FIVE MILES FOLLOWING THE DAY

The photograph that goes with this text is the sort of picture postcard view one finds in newsagents and heritage centres around the UK: Glastonbury Tor at sunset. Like St Paul's, the Tower of London, Big Ben, Buckingham Palace, Beefeaters, the changing of the guard, red buses and telephone boxes, this is one of the archetypal images of Britain. And, typically, it is Glastonbury Tor that Long chooses to photograph, not the shops nearby, the electric pylons, the junk yard behind the highways, the rows of garages, the housing estates.

Some artworks seem so clear and 'obvious' (Leonardo da Vinci's drawings, Rembrandt's self-portraits, Bach's *B Minor Mass*) it's amazing that they weren't made centuries earlier. Even 'ancient' stone circles, built *c.* 1000-500 BC, seem so 'obvious'. People were making flint knives and axes *two million years* ago, so why weren't they also making stone circles? The stone circle seems such an obvious structure, marking off and enclosing a sacred space Andy Goldsworthy's globes, whether made out of stacked rocks (1980), or snow (1980), or from redwood sticks (1995), seem so 'obvious' to the viewer. They look simultaneously 'out of place' and quite at home in their settings. Or maybe it's just that the viewer is so used to seeing the extraordinary structures humans make (New York City, a passenger jet, a television set) that seeing a snowball hanging in some trees or a globe made from stacked ice ain't that amazing.

Land artists' stone circles often recall prehistoric stone circles. While they may deny it verbally, Nancy Holt's *Stone Enclosure*, Robert Morris's *Observatory* and Richard Long's circle sculptures evoke the great circles of Britain: the Rollright Stones in Oxfordshire, Boscawen-Ûn and the Merry Maidens in West Penwith, Cornwall, Castlerigg in Cumberland, Stanton Drew in Somerset (a huge and little-known set of circles, and the nearest large circle to

Richard Long's home in Bristol), and of course the mother of all stone circles, Avebury.

Some land artists, such as Richard Long, maintain that their stone rings are subjective, private, individual works, quite different from the public, social art of the prehistoric stones circles. The ancient stone rings were made by a group of people, a society, constructed, perhaps, according to the plans of a priestly élite. Land art circles are (usually) the work of one person, but a major postwar artist is no less a member of the cultural, æsthetic élite. Prehistoric stone circles may have been made for religious rituals, perhaps connected with the position of certain astronomical bodies or celestial alignments. The circles in stone, snow, dandelions, trees and concrete of land art are made for private consumption, for the artist alone, or for an onlooker who wanders into a gallery or a space then out again, back into the chaos of the city. Yet the ancient sacred sites and land art/ Postminimal earthworks have much in common, because art and religion join at so many points.

Land artists benefit from the allusions to ancient monuments, because the atmosphere and magic of prehistoric stones rubs off on their own work. In stressing the importance of megaliths, the land artists not-so-subtly imply a continuity between themselves and these prehistoric relics. The æsthetic continuity that's emphasized also implies religious affinities. Thus, the land artist is the postwar equivalent of the priests and hieratic sects who created Stonehenge, the lines in Peru, the Pyramids, and Australian aborigine 'songlines'. A spirituality is affirmed in land art, which only a few land artists actually speak about. But this religious feeling is definitely there, definitely a part of the discourse of Heizer, Turrell, Smithson, Fulton, Morris and Holt.

MAZES

Mazes and labyrinths are favourite land art forms. Robert Smithson, Richard Fleischner and Alice Aycock created large earthwork mazes in the late 1960s/ early 1970s. Andy Goldsworthy designed a maze (at Burham in 1988), and an earthwork which was a curving ramp, exactly like Smithson's *Armarillo Ramp*, though on a much smaller scale. Richard Fleischner created a *Sod Maze* in 1974, in the turf at Newport, Rhode Island, an enormous *Zig Zag* (1972) in grass (370 feet long) and a *Chain-Link Maze* (1978), 61 feet square. Michelangelo Pistoletto built an interior maze from large pieces of corrugated cardboard laid out across the whole gallery (*Labyrinth,* 1991). In *Monumental Ikebana* (1990) Hiroshi Teshigahara made a giant arched path from bamboo in a gallery space. For Vong Phaephanit's bamboo installation (*What Falls to the Ground Cannot Be Eaten*, 1991), a forest of bamboo sticks was hung from the ceiling of the London gallery, approached through a monumental black doorway.

The mazes of land artists can be seen as a part of the resurgence of interest in mazes which occurred in the 1980s (aligned, as ever, with green/ ecological/ occult/ New Age trends). Mazes were commissioned for country houses, zoos and theme parks. A maze became seen as one more feature for visitors to enjoy: apart from the country mansion or palace or museum interior and formal gardens, the public could visit a maze, and perhaps an adventure playground. Some mazes were set beside children's playgrounds, emphasizing the sense of play, rather than ritual. At country houses in the United Kingdom, such as Ragley Hall in Staffordshire, the maze was part of the adventure playground, and was conceived as something of a gym or assault course: there were walkways and bridges over some of the passages in the brick maze, which were climbed via ropes and ladders. Probably the most famous maze in Britain is at Hampton Court.

1991 was 'The Year of the Maze' in Britain (largely orchestrated by maze designer Adrian Fisher of Minotaur Designs).

Some modern mazes were conceived as part of civic architecture, such as the Bristol Water Maze, which took its design from a roof boss in nearby St Mary Redcliffe church. Some pavement mazes were made as part of new parks or new shopping centres (such as at Worksop). An underground maze was constructed at Leeds Castle in Kent. Old turf and hedge mazes were re-cut and restored (Fisher, 1991). At Symonds Yat in Herefordshire the Jubilee Maze was made in 1977 by the brothers Lindsay and Edward Heyes. The way out of the maze lead to a small Maze Museum, where the history of mazes was told via simple displays. The Symonds Yat Jubilee maze made a leisure outing of the maze: the maze is the centrepiece of the visit. This is unusual: mazes are more often add-ons to the theme park or country house.

The maze is a very satisfying motif or design: it is self-contained, like other geometric patterns; it can use almost any perimeter shape, from circles and squares to 'organic' shapes; it offers opportunities for games and play; it can be a visual device, for decorating floors or walls, or one of the main features of a garden; and it carries a sizable slice of symbolism, religion, paganism and history. The symbolism and history of the labyrinth can be happily ignored in favour of simply enjoying solving a maze. Unlike sacred sites such as churches and stone circles, which are loaded with religious significance, and generally demand some religious or intellectual response from the visitor, the maze can be consumed simply as an interesting structure. One doesn't need to know about mythology (such as Theseus and the Minotaur in the Greek myth) or religion (such as the ritual aspect in Christianity of walking a maze) to appreciate a maze.

LAND ART AND CONSTANTIN BRANCUSI

It was Constantin Brancusi's project to strip away the detritus that had accumulated around sculpture, Henry Moore said, and to offer the pure, simple shape. What Brancusi did was 'to concentrate on very simple shapes, to keep his sculpture, as it were, one-cylindered, to refine and polish a single shape to a degree almost too precious.'[1] This is what many postwar sculptors have done, keeping their shapes simple and purified: Andy Goldsworthy, Alison Wilding, Richard Deacon, Stephen Cox, David Nash, Richard Serra, Donald Judd and Robert Smithson.

The influence of Brancusi is apparent in Minimal, Arte Povera and Postminimal sculpture. Robert Morris, Donald Judd, Carl Andre, Dan Flavin, Chris Drury and Goldsworthy have acknowledged Brancusi's art, in particular his *Endless Column* (1918). Andre's early work *Last Ladder* (1959, London) is something like Brancusi's *Endless Column* (putting Brancusi along the ground, as Andre put it).

Quite a few artists (not all of them sculptors) have expressed admiration for Brancusi's photographs, the way he would set up his sculptures in his studio and photograph them at particular times of day, when the lighting was just right. Goldsworthy said he admired how Brancusi created the conditions in his studio so that his work 'comes alive at a particular time of day as the light momentarily touches it'.[2] For Goldsworthy, Brancusi's works were at their best when they were arranged by the sculptor in his studio and photographed.[3] Somehow, it wasn't quite the same when they were displayed in modern art museums (such as the Pompidou Centre in Paris or the Museum of Modern Art in Gotham). The Brancusian ethics, of simplicity, purity, smoothness, inter-iority and organic form are found in the Minimal sculptors, as well as the Constructivist notion of working with materials in a 'natural' way, so that the material dictates the form one creates with it. Barry Flanagan has commented that sculpture works directly with materials:

the convention of painting has always bothered me. There always seemed to be a *way* of painting. With sculpture, you seemed to be working directly, with materials and with the physical world inventing your own organisations'.₄

KINETIC SCULPTURE

Time is fundamental to land art, which moves back and forth in time, much as Alexander Calder's mobiles, no matter what the scale, extend far beyond themselves, by virtue of their construction and motion. Like optical and light sculptures, Calder's mobiles create spaces around themselves which act on the viewer in a palpable manner, quite distinct from the relatively staid and stolid approach to sculpture of, say, Canova or Luca della Robbia. This is not to say that pre-20th century sculpture is immobile: far from it. Take Giovanni da Bologna's *Mercury* (1564, Florence) for instance: as the winged messenger of mythology, a 'static' depiction of Mercury or Hermes would be a mistake, and da Bologna's statue is full of movement. Gianlorenzo Bernini's *David* (1623, Rome) is similarly kinetic: the man's body is twisting, ready for battle, ready to carry out one of the most celebrated acts of murder in the history of art.

The kinetic dimension would be out of place in the sombre religiosity of Barnett Newman's or Constantin Brancusi's sculptures. There are some sculptor's work which just seems to be static and rock solid. Indeed if Michelangelo's statues of *Moses* (1513-16) or the *Pièta* (1498-99) were mobile, it would be utterly out of keeping with the tone and theme of these solemn, awe-inspiring sculptures. Other sculptors, though, actively developed motion in sculpture: Naum Gabo with his *Kinetic Construction* (1920), with its oscillating rod; Len Lye's magnetized steel *Loop* (1963) and *Fountain* (1959), which wafts from side to side; Marcel Duchamp with his *Rotorelief* (1920, Yale University Art Gallery), which span around, creating a circle; '*[m]ovement* is an important *dimension* in my art'

Hamish Fulton said (1995); Andy Warhol created a room full of silver balloon-pillows, which drifted about (*Clouds*, 1966, Leo Castelli Gallery, New York); George Rickey with his swaying rods of steel, as in *Peristyle III* (1966, Washington DC).

But the master of kinetic sculpture must be the rebellious Jean Tinguely, whose motorized sculptures mischievously create chaos. Tinguely's sculptures don't just move – in all directions – they are very noisy, with clatterings, bangs, pants, grinds and wheezes. The most famous, *Hommage à New York* of 1960, was a sculpture 'created for self-destruction'. The sculpture was intended to perform many bizarre actions. Daniel Wheeler describes Tinguely's monster machine:

> Few of these particular 'events' ever took place, owing to immediate and chronic breakdown, which almost invariably happened in Tinguely's Metamatic performances, but all kinds of other wonders did come to pass, which, being, unexpected, struck Tinguely as far superior to anything he had programed. (1991, 239-240)

LIGHT AND SPACE

Light: one recalls the reported dying words of Romantic artists like Goethe, who called for 'more light!', or J.M.W. Turner, who said 'the sun is god'. Numerous sculptors, installation artists and land artists have worked with light and lighting: Douglas Wheeler, Hap Tivey, Susan Kaiser Vogel, Larry Bell, and James Turrell with his 'skyspaces', Robert Irwin's reworked gallery spaces, Dan Flavin and his fluorescent tubes, Bruce Nauman, who made very narrow corridors lit by green fluorescents, Maria Nordman's extensions to studio exteriors, Nancy Holt's *Sun Tunnels*, Eric Orr's sound and light environments and DeWain Valentine's acrylic tubes hanging alone from gallery ceilings.

Eric Orr constructed a *Silence and the Ion Wind* installation (1980), a series of dark rooms culminating in the *Golden Room*, 'an

allusive structure for an elusive experience', approached through an ion wind.[1] In *Wall Shadow, Sky Lights, Sound Tunnel, Zero Mass, Sunrise, Blood Shadow, The Stone Snake, Prime Matter* and *Blue Void,* Orr deployed sound, light, wind, sand, ice and shadow. In *Prime Matter* (1981) Orr created fog and flames from a twenty foot tall metal column (a larger version was constructed outside the Mitsui Fudosan Building in L.A. in 1991). Orr has fired xenon lasers up into the sky on top of skyscrapers in Long Beach, CA (a permanent installation, *Landmark Lumière*, 1991).

Many artists have taken gallery spaces and reworked them, adding walls or scrims, or curtains, or false ceilings, or doorways, or new windows. Often these light and sound spaces look like empty gallery rooms: Eric Orr (*Light Space*, 1985), Hap Tivey's *Sodium Exchange* (1976), Susan Kaiser Vogel's *Point Conception* (1980), DeWain Valentine's *Curved Wall Spectrum* (1974), Larry Bell's *Leaning Room II* (1988), Bruce Nauman's *Yellow Triangular Room* (1973), Douglas Wheeler's *All Gray Graduating Light* (1976), Maria Nordman's *6/ 21/ 79 One Day Only* (1979), James Turrell's *Second Meeting* (1988), and Robert Irwin's Kansas *Installation* (1979). The forerunners of these light spaces includes Yves Klein's *Le Vide*. Some artists made the reconstituted gallery interior one of their trademarks. For example, Robert Irwin has made *Fractured Light – Partial Scrim Ceiling – Eye-level Wire* (1971), *Acrylic Column* (1970), *Eye-level Room Division* (1973), *Soft Wall* (1973), *Scrim Veil* (1975), *Wall Division – Portal* (1974), *Window Room* (1973), *Black-Line Volume* (1976), *Scrim Veil – Black Rectangle – Natural Light* (1977) and *Untitled (Three Triangulated Light Planes,* 1979).

3

The Birth of Land Art
(in 1960s Culture)

THE PRESENCE OF THE OBJECT: LAND ART, MINIMAL ART AND 'OBJECTHOOD'

With the rise of Minimal, 'cool', Process and Conceptual sculpture, in the 1960s, sculpture became all 'object'.[1] 'Objecthood' became crucial, the 'thing-in-itself', as the Existentialist philosophy of Jean-Paul Sartre and Edmund Husserl put it.[2] Inner and outer space became one, objects were simply what they are, without referring to anything outside themselves. Barbara Rose wrote that in the new Sixties art the 'thing…is not supposed to be suggestive of anything other than itself'.[3] It was Frank Stella who had emphasized the object-in-itself of art, and the objecthood of his paintings in particular. His paintings are objects which display openly their 'objecthood' (such as his *Ophir*, one of his shaped canvas, a zigzag shape with striped paint [1960-61, private collection]). 'What you see is what you get' he said. Stella influenced many of the key artists of the 1960s: Donald Judd, Carl Andre, Sol LeWitt, Robert Morris. Stella was an important artist in the world of 1960s Minimal sculpture: '[t]he idea that a painting is primarily a thing-in-itself has been around for a long time,' wrote Mel

Bochner, 'But before Frank Stella not much was done about it'.[4] Stella developed the notion of Barnett Newman's – of the unity or 'all-overness' of an artwork, so that it strikes the viewer all at once, every part at the same time. Stella said of his 'black paintings':

> I had to do something about relational painting, i.e. the balancing of the various parts of the painting with and against each other. The obvious answer was symmetry – make it the same all over.[5]

In Minimal sculpture, the object and its 'objecthood' is primary. As William Tucker wrote: '[it] is the matter-of-fact 'object-ness' of sculpture that has become in recent years its prime feature'.[6] The notion of 'objecthood' is problematic, theoretically and artistically, for the world is full of objects, it is a continuum of objects. As critics have noted, much of what makes sculpture sculpture is that the object is contextualized, physically as well as æsthetically and psychologically, as a sculpture. Context is crucial, as Julia Kristeva says, for context carries so much meaning.

Carl Andre explored the relation between real and represented objects with his controversial pile of bricks. The sculpture was 'controversial' because the general public (whoever they are) perceived, via the media, that Andre had simply stuck some bricks into a gallery. Or rather, that taxpayer's money had been used to purchase Andre's bricks (in the 1970s, the Tate Gallery was partly funded by public money). A pile of bricks on a building site is… a pile of bricks. A pile of bricks in an art gallery is… sculpture. Context is everything here. This is what Carl Andre explored, whether consciously or not: the *response*, affected by so much of culture, socialization, physical context, education, and so on, makes objects sculptures. People make art. A leaf simply exists, but if someone puts it in a gallery or an art book, it becomes art (as well as remaining a leaf). If people think something is art, then it's art, as Donald Judd said. As Garth Evans wrote:

> What happens to a sculpture is determined largely by factors outside

of itself. The fact of its being thought of as a sculpture is more critical to its existence, its life, than any other facts about it. This is a fundamental distinction between objects and sculpture.[7]

One can see the body written into, say, Andy Goldsworthy's delicate leaf sculptures, or Constantin Brancusi's extraordinary egg shapes, but not, perhaps, in the giganticism of Michael Heizer's *Double Negative*. Yet, even here, the human body is present – if only by the way it is violently dwarfed by the scale of Heizer's earthwork. Much of land art is vast. As Carl Andre said:

> I once described the change in sculpture in the 20th century as moving in its concerns from form to structure and now having a concern with place... I believe now you can make sculpture you can enter.[8]

In 1970, Heizer said that the old kind of sculpture had been replaced – 'destroyed, subverted, put down' (170). Kazuo Shiraga made works of art with his body, such as smearing mud on pieces of paper with his feet. His body-art was called 'the art of committing the whole self with the body'.[9] Minimal sculptures are not set on pedestals, like Renaissance or Greek sculpture; they sit on the floor, or lean against walls (as in Robert Morris's *Floor Piece*, or Carl Andre's *Cedar Piece*, 1959). The new sculptural space must have 'three, not two coordinates' said Robert Morris. 'The ground plane, not the wall, is the necessary support for the maximum awareness of the object'.[10] Minimal sculptures exist in the same space, on the same plane (the floor) as the viewer. They are, as Robert Morris said, in an in-between cultural space, somewhere between being monuments and being ornaments, between being architecture and jewellry.[11]

Minimal art had its limits, argued Dennis Oppenheim, which was why artists wanted to move beyond it, using phenomenology. 'We know that Minimalism quickly lifted off into phenomenology via the work of Bruce Nauman and Turrell and the writings of Robert Morris'.[12]

The world of Minimal art was clean, calm, devoid of unruliness, violence, even ambiguity. Something like an airport: white, spotless, spacious. Or a new shopping mall. A row of pristine supermarket shelves, stacked high with new cans of fruit, the labels all turned face-out. Minimal art was an art for the 1960s, an era of commodification of a global scale, and the increasing affluence in the West after the austerity of the 1950s, where mass production created a uniformity to the appearances of so much of street, home, personal, medical, transport and educational furniture (especially in Europe and America). Minimal sculpture, Barbara Rose remarked, looks 'machine-made, industrial, standardized, materialized or stamped out as a whole'.[1]

Other aspects of Minimal sculpture include the multiplicity of sculptural material (fluorescent lights, plexiglass, fibreglass, Formica, chrome, plastic), simplicity, surface, and the insistence on the environment and contextual space. Minimal sculptures are not set on pedestals, like Renaissance or Greek sculpture; they sit on the floor, or lean against walls (as in Robert Morris's *Floor Piece*, or Carl Andre's *Cedar Piece*). Minimal sculptures exist in the same space, on the same plane (the floor) as the viewer. They are, as Robert Morris said, in an in-between cultural space, somewhere between being monuments and being ornaments, between being architecture and jewellry.[2] In Minimal sculpture, surfaces were, typically, smooth, utterly smooth and 'pure'. Simplicity was exalted, and repetition, seriality, process, flatness (as well as volume and space). The many materials were flattened out and depersonalized. Gestures, so important to certain kinds of sculpture, such as traditional figuration, were suppressed. Indeed, the flatness of the surfaces, whether in Robert Morris, Donald Judd, Dan Flavin, Carl Andre, Ronald Bladen or Tony Smith, was crucial in Minimal art, and consequently some commentators called Minimal sculpture 'boring'.[3] For Peter Fuller, there was nothing 'spiritual' about Minimal art: he spoke of 'the numbing vacuity of works by artists

such as Carl Andre, Agnes Martin, Ellsworth Kelly or Brice Marden').4 The boringness, though, becomes a part of the metaphysics of Minimal sculpture, so that Lucy Lippard wrote: '[t]he exciting thing about... the "cool" artists is their daring challenge of the concepts of boredom, monotony and repetition... their demonstration that intensity does not have to be melodramatic.'5 Andy Warhol said 'I like boring things. I like things to be exactly the same over and over again'.6 And Donald Judd said about the charge of reductionism:

> I object to the whole reduction idea. If my work is reductionist, it's because it doesn't have the elements that people thought should be there. But it has other elements that I like.7

Boring art for some is exhilarating art for others, just as erotic art for some is pornography for others. Thus, James Mellow wrote that a Donald Judd show was 'one of the most provocative of the season',8 while Barbara Rose described Judd's art as 'our most radical sculpture, if not perhaps our fullest'.9 Certainly Judd's wall reliefs are beautiful, sensuous, luscious, sexy – whether constructed from traditional materials such as brass or copper or newer materials such as Plexiglas and red automotive lacquer. Judd combined the eroticism of industrial materials with cool geometric patterns. Judd, like other Minimal sculptors, combined austerity with sensuality, producing 'minimal forms at the service of glamorous, hedonistic effects of light' (Hilton Kramer).10 A s Barbara Haskell wrote:

> By coupling these luxurious materials with spare forms, he exploited their inherent "language". The opposition between the inert and rigorous geometry of his forms, and the opulent hedonism and shimmering colour effects of his surfaces accounted for the unexpectedly exultant lyricism of his work.11

Minimal artists such as Donald Judd, John McCracken, Carl Andre, Sol LeWitt and Robert Morris explored notions of 'boringness' and 'interestingness'. 'Boring art is interesting art', wrote

Frances Colpitt in her book on Minimalism (121). Donald Judd, the chief explicator of Minimal æsthetics, wrote: 'I can't see how any good work can be boring or monotonous in the usual sense of those words', adding: '[a]nd no one has developed an unusual sense of them'.[12] Clearly, the Minimal sculptors thought they were making 'interesting' art. Or at least, *they* were interested in it. If art's good, it can't be 'boring', said Judd, claiming that 'a work needs only to be interesting'. The discussion of discourses such as 'interesting', 'boring' and 'value' becomes a quagmire of semantics and the metaphysics of meaning. Language soon fails to describe the kinds of intentions that artists have, and the kind of responses that critics have to works. Robert Mangold commented, 'I certainly know whether I'm interested in the work or whether I'm not interested in the work'.[13]

Many land artworks appear to be 'simple', in that there doesn't seem to be much going on. But, as Donald Judd wrote in his influential "Specific Objects":

> it isn't necessary for a work to have a lot of things to look at, to compare, to analyze one by one, to contemplate. The thing as a whole, its qualities as a whole, is what is interesting.[14]

Some artists make a virtue of simplicity and ease: Jan Dibbets said he liked projects that anyone could do. For example, he chose four sites at random on a Netherlands map and went to each place and took a photo. It was '[q]uite stupid. Anybody can do that', Dibbets admitted. But Dibbets said he enjoyed searching for the places and photographing what was there. It was also silly for people to buy such works: 'it's stupid for other people to do it, or to buy it from me. What matters is the feeling'. And the feeling of the artist was something that couldn't be bought (1970).

On 'boringness', Robert Morris wrote that sculpture is found 'boring' by those who desire 'specialness':

> Such work which has the feel and look of openness, extendibility, accessibility, publicness, repeatability, equanimity, directness,

immediacy, and has been formed by clear decision rather than grop-ing craft would seem to have a few social implications, none of which are negative. Such work would undoubtedly be boring to those who long for access to an exclusive specialness, the experience of which reassures their superior perception. (1967, 29)

Some might see Minimal, Conceptual or mathematical art as too abstract, too unreal, too dry and clinical. But critics such as Robert Rosenblum claim that Conceptual art can be 'awesome'. Of LeWitt's art, Rosenblum writes that it 'elicits... an immediate awe that... has to be translated by the same feeble words – beautiful, elegant, exhilarating – that we use to register similar experiences with earlier art.'[15] One might see Minimal sculpture as so 'cool' it's lifeless. Yet, despite the profusion of smooth white surfaces, which evoke clinics and hospitals, there is much sensuality in Minimal sculpture.

Much of sculpture in the decades after WW2 consisted of hard-edged cubes or rectangular slabs. Whether this use of such stark mathematical forms like cubes is rational or intuitive, it takes a scientific, numerical approach to art to extremes. The idea, Donald Judd wrote, is to simply do 'the next thing'... 'one thing after another'. It is a strategy that is not called a strategy, a systemless system. Of Frank Stella's paintings, Judd wrote that the 'order is not rationalistic and underlying, but is simply order, like that of continuity, one thing after another'.[16] The notions of Minimalism – seriality, succession, progression, repetition, permutation – have been around for a long time. Leonardo da Vinci, one might say, painted the same picture in different ways, often abandoning projects before completion, while J.M.W. Turner seemed to be painting the same sky, attacking it from thousands of different viewpoints and different locations, from every coastline of Britain, and in France, Switzerland, Italy and Germany.

But – whether the 'system' is serial or modular, whether there is progression or simply repetition – the notion of Donald Judd's – 'doing the next thing', 'one thing after another' – explains so much of Minimal art. It explains so much of Judd's work, for

instance, those 'ladders' or 'sstacks' of forms ascending to the ceiling in bronze or plastic, and those long lines of curved shapes set on a wall. It also describes how artists simply go on making work, as variations, or repetitions, or progressions, like Mark Rothko with his many canvases that explore different combinations of purple or yellow clouds floating on oceans of red or blue, or Ad Reinhardt's seemingly repetitious but actually methodical explorations of five foot square black canvases. Minimal ethics can produce some extremes of mathematics and seriality.

Minimal sculpture is certainly austere – 'cool', as some critics call it. It is very cool, ascetic, restrained, flat, exact, with its smooth surfaces and precise square edges and angles. The body seems to have been erased from this 'cool' Minimal art. There is no space for the body, and the spectator is also 'erased', in some way. The ruthless asceticism of Minimal art denies the body, like early Christian theology.[17]

LAND ART AND CONCEPTUAL ART

Land art is related to – and is a part of – Conceptual art. Much land art exists only in photographs, memories, words, various texts which are not the land art itself. Works that can be seen and those that are hidden or 'invisible' have the same importance for the artist. One of the hallmarks of the 'ideal Conceptual work', as Mel Bochner says, is 'an exact linguistic correlative, that is, it could be described and experienced in its data and it could be infinitely repeatable'.[1] Land art is often Conceptual art: Dennis Oppenheim's *Whirlpool Eye of Storm* (a jet trail in the sky), Hans Haacke's balloons floating over Central Park and Robert Morris's steam pieces exist now only as photographs, memories and criticism.

By contrast, James Turrell wanted to place the viewer right in the midst of his artworks, so they could experience directly the subject of his art (light, the sky, celestial events) for themselves. It

71

was important for Turrell that his art wasn't a record or a photo-graph of something that happened elsewhere, that the viewer hadn't seen or couldn't see for themselves. Thus, at Roden Crater, Turrell constructed spaces that the spectator could enter physically, to experience light and the sky directly.

The pictorial or visual aspect of land art was over-emphasized by critics and viewers, Dennis Oppenheim argued in 1992. It was 'basically the *idea* of earthworks, the idea of the salt flats' that was important, not the visual element; '[t]he visual quotient is not as strenuous as you think'. Many land artworks were conceptual, mental, not visual or even physical. 'In other words,' said Oppen-heim, talking about Smithson's *Spiral Jetty*, 'it's about the salt, sub-mersions, the jetty, what is around the salt flats. In the end it's about mental configurations' (1992). This presents a problem, because most land artworks are known primarily in a visual form – in photographs. It'd be great if land artworks were visited or directly experienced, as Oppenheim and other intended, but they aren't. For Richard Serra, the 'focus of art for me is the experience of living through the pieces', but the actual work itself, the physical object, was not the whole point, or the whole pleasure, of making art: 'that experience may have very little to do with the physical facts of the work of art'.[2]

One of pluses of Conceptual art was that art could be just ideas, and the artist wouldn't have to carry around masses of materials. Dennis Oppenheim wrote:

> In 1968 and 1969 I lived in an apartment. I didn't need a studio. Everything that I had done as an artist was contained in one small case of slides. And it accounted for two of the most strenuous years of work in my whole life.[3]

Many sculptors have spoken of the importance of the *making* of the sculpture, its actual construction, with real (and sometimes org-anic, living) materials. As Barry Flanagan put it: '[m]y work isn't centred in experience. The making of it is itself the experience'.[4] In some artists, the material employed also has a symbolic or

added meaning, as in Joseph Beuys' *Fettecke* or 'fat corner', a sculpture with powerful autobiographical and semiotic associations. Beuys emphasized process, evolution, change: his sculpture, he said, was not 'fixed and finished. Processes continue in most of them: chemical reactions, fermentations, colour changes, decay, drying up. Everything is in a *state of change*'.[5]

Land art is meta-art, art about art, art that relies on other art to 'exist'. Land art exists for a brief moment, then becomes myth, gossip, photography, words (or more often, art criticism and journalism). Many of Richard Long's works are simply collections of words, printed in capitals, in Eric Gill's font, Gill Sans, on large pieces of paper. The text of one of Long's works can be printed here, and this text here will be very close to being a Richard Long artwork in itself (although he likes them printed much larger). Thus:

A MOVED LINE

PICKING UP CARRYING PLACING
ONE THING TO ANOTHER
ALONG A STRAIGHT 22 MILE WALK

MOSS TO WOOL
WOOL TO ROOT
ROOT TO PEAT
PEAT TO SHEEP'S HORN
SHEEP'S HORN TO STONE
STONE TO LICHEN
LICHEN TO TOADSTOOL
TOADSTOOL TO BONE
BONE TO FEATHER
FEATHER TO STICK
STICK TO JAWBONE

JAWBONE TO STONE
STONE TO FROG
FROG TO WOOL
WOOL TO BONE
BONE TO BIRD PELLET
BIRD PELLET TO STONE
STONE TO SHEEPS' HORN
SHEEP'S HORN TO PINE CONE
PINE CONE TO BARK
BARK TO BEECH NUT
BEECH NUT TO STONE
STONE TO THE END OF THE WALK

DARTMOOR 1983

That's a Richard Long artwork, and a real piece of land art. It seems as if Long has nothing much to 'say'. Well, he is a sculptor, so he wouldn't be so good at writing or speaking. Wrong. He's a land artist (though he dislikes the term 'land art'), and land artists are always much concerned with writing and written texts. A Richard Long exhibition, for instance, features written texts on display, and photographs, as well as installation works and sculptures.

The texts of land artists also draw on poetry, on concrete or 'visual poetry', or typewriter art. Long, for instance, prints his laconic texts in circles (*Full Moon Circle of Ground*, Dartmoor, 1983), in concentric circles (*Three Moors, Three Circles,* Liskeard to Porlock, 1982), in vertical lines, as in trendy style magazines (*The Isle of Wight as Six Walks*, 1982), and in curved swathes of text (*A Moved Line in Japan*, 1983).

Sixties Conceptual artist Lawrence Weiner produced text works, capital letters on a wall or in a book (Richard Long, Barbara Kruger, the Art & Language group and Michael Craig-Martin have also produced post-Conceptualist wall works).

Weiner's solution to making sculpture was that a sculpture on a plinth has to be 'translated' into language, so that people can understand it. Sculpture is language, and words are language, therefore, Weiner reckons, words can be sculpture:

> when you see a piece of wood lying on the ground with a piece of stone on top of it, you must translate that in your own head into language. What I try to do is present language itself as a key to what sculpture is about... It is a presentation of a piece of sculpture in language.[6]

Like John Baldessari and Sophie Calle, Weiner produces capital letters in short phrases which are about a viewer's relationship with an object. The words are a means or the expression of a relationship with something.

BILLOWING CLOUDS OF FERROUS OXIDE
SETTING APART A CORNER ON THE BOTTOM OF THE
SEA

This is a typical Lawrence Weiner artwork.[7] Here's another:

THINGS PUSHED DOWN TO THE BOTTOM AND
PUSHED UP AGAIN

Richard Long commented that '[t]he discovery [Weiner] made that art does not necessarily have to be made, that was a great breakthrough'.[8] Weiner is right, of course: words alone can be sculpture, for poets have long known that language is an *experience*, not simply abstractions or concepts. Language really does affect people – otherwise why would they spend so much time consuming language? That is, they consume 40 hours of broadcasting per week (in the UK) – that's over a day and a half spent consuming television and radio per week. So the words on a gallery wall of Weiner, Calle, Baldessari, Haacke and Fulton don't seem at first to be 'art'. They are not sensual and graspable in the

physical realm, like a marble statue. Yet those words, whether photocopied on cheap paper or printed in high quality typography on deluxe paper, or painted onto the wall, are 'art', they are communication, language – even sculpture.

Laid over Long's walks is the grid of the map: the maps in Conceptual art constitute a new landscape of the soul, as Robert Smithson wrote in 1968:

> A cartography of uninhabitable places seems to be developing – complete with decoy diagrams, abstract grid systems made of stone and tape (Carl Andre and Sol LeWitt), and electronic "mosaic" photomaps from NASA. (1968, 26)

Just about every land artist used maps in their work. Not just in the obvious sense of mapping (and finding) future sites for artworks, but as key elements in the artworks themselves. Jan Dibbets chose places on a map at random, visited them and took a photograph. Dennis Oppenheim made maps a central ingredient in his 2-D Conceptual works, which combined maps, text, photos and sketches. Richard Long based many walks around maps, such as in a circle on a map, or a straight line. Chris Drury cut up and wove maps together (a development of his love of basket-weaving). Robert Smithson made many mapworks, including map games, folded maps, aerial maps, and cut-up circular maps (*Untitled Circular Map*, c. 1968-70, *Entropic Pole*, 1967). Tom Van Sant collaged satellite maps. John Baldessari spelt out 'California' using maps in *The California Map Project* (1969). Charles Ross made star maps (1975-86). Jasper Johns painted a large map collage painting (1966-71). Nancy Holt buried poems (written for Carl Andre, John Perrault, Robert Smithson, Michael Heizer and Philip Leider) in remote locations, with a map marking the burial site (1969-71).

4

Land Art, Gender, Sexuality and the Body

GENDER AND SCALE IN LAND ART

> *The awareness of scale is a function of the comparison made between that constant, one's body size, and the object. Space between the subject and the object is implied in such a comparison.*

Robert Morris (1966, 21)

Postwar and contemporary artists, of all kinds, have made massive art. David Smith's *Wagon I* (1963-64, National Gallery of Scotland) and his *Cubi* sculptures are huge, heavy, chunky, truly colossal pieces which dominate their surroundings. Donald Judd wrote: '[t]his scale is one of the most important developments in twentieth century art' (1975, 200f). One of the largest earthwork projects is James Turrell's *Roden Crater Project*, a series of tunnels and chambers in an Arizonan extinct volcano, begun in 1974 and funded by the Dia Foundation. Turrell said '[m]y art is made for one person. I like the solitary experience. Standing alone at night, perceiving the Roden Crater and the moon and stars, you really feel the vastness of the universe and yourself entering into it'.[1] 'In sculpture, there's quite a concrete relationship between one's size

as a person and/or mass as a person and the mass of a piece of sculpture' remarked Carl Andre (1970, 57). Richard Long's art is not monolithic in scale, usually: but his works can stretch over many miles, far longer than even Christo's fences. The Abstract Expressionists, such as Helen Frankenthaler, Mark Rothko, Franz Kline and Barnett Newman, produced huge paintings, which swallow up the spectator when s/he moves close to them. One can get up close to a Morris Louis or Sam Francis canvas and be enveloped by it (creating a sense of intimacy was one of the chief motives for large scale, as Rothko asserted).[2] Similarly, postwar sculptors have made massive works. Artists such as Christo made pieces that were 24 miles long. Even medium-sized pieces, such as Donald Judd's wooden boxes, are sometimes seen as monumental. A critic on *The New York Times* called Judd's 1977 installation at the Heiner Friedrich Gallery a 'majestic and finely measured presence'.[3]

Lucy Lippard described scale not just as something mathematical, optical, *seen*:

> Most discussions of scale consider it a strictly optical experience... But a sense of scale is also a *sense* proper. Scale is *felt* and cannot be communicated either by photographic reproduction or by description.[4]

The bombastic, 'monumental', massive and brash 3-D art of modern sculpture was not made exclusively by male artists. Land artists Mary Miss, Nancy Holt, Sherry Wiggins, Donna Henes, Lynne Hull, Patricia Johanson, Alice Aycock and Agnes Denes have all made very large works. Other female architectural sculptors included Jackie Ferrara, Donna Dennis and Elyn Zimmerman. For feminist critics, these women artists were drawn to shelter imagery: the origins of 'shelter sculpture', as Lucy Lippard called it, were in female biology and the female body.[5] Mary Miss created a 5 acre scale work in Illinois,[6] Patricia Johanson designed a large lagoon park in Dallas (1981-86), while Nancy Holt produced gigantic *Sun Tunnels*, 18 foot long pipes that were 9

feet high with many holes punched in the side, to let light in.[7] Nancy Holt's art, with its large, heavy landscaping gestures (such as her *Dark Star Park*), is comparable with the male earth artists. The globes and pools of water, though, are traditional 'feminine' volumes, here given a new, monumental turn. Helen Escobedo created some huge concrete and steel sculptures which 'attempt to fuse hard-edge geometric forms with nature's organic manifestations', as she put it. Works such as *Snake* (1980-81) rise impressively from the Earth, celebrating the flux and movement of organic forms. Beverly Pepper's large, curving mirrored slabs of wood buried in sandy beaches (*Sand Dunes*, 1985), large, curving mirrored slabs of wood buried in sandy beaches, might be seen as a type of 'Earth Mother art', art which worships and works with the Earth, rather than, as in so much of male land art, cutting or penetrating it, phallically (like Michael Heizer, Robert Smithson and Walter de Maria).

Many of the celebrated products of postwar sculpture, however, have been made by male artists: Donald Judd's 'specific objects', blocks of aluminium and plexiglass that 'climb' gallery walls;[8] Tony Smith's monumental cubes with their *thereness* (celebrating the primacy of presence, not effect);[9] Dan Flavin's mesmeric fluorescent tubes, a sculpture of light and space;[10] Sol LeWitt's Conceptual cubes and wall drawings like enormous graphs; Richard Serra's huge 'walls' or slabs of steel leaning together;[11] and Carl Andre's plates of steel, copper and zinc laid on the floor.[12]

One of the most exciting developments of postwar sculpture and art is the installation, the taking over of a whole space or environment – the floor, walls and ceiling of a gallery, as in Rebecca Horn's *Ballet of the Woodpecker* (1986-87), a room full of mirrors, or Sylvia Stone's *Crystal Palace*. Many land artists' work are clearly related to the art installation: it is an art of environments, where the relatively small addition of a stack of stones forming a cairn sets alive the surrounding landscape. One sees the landscape in a new way: context is all-important.

LAND ART, SEXUALITY AND THE BODY

Sculpture is a three dimensional projection of primitive feeling: touch, texture, size and scale, hardness and warmth, evocation and compulsion to move, live and love.

Barbara Hepworth[1]

Much of sculpture in the modern era has been thoroughly traditional (conservative), and patriarchal, in its orientation and expression. Take Henry Moore, one of the most celebrated of Western sculptors, and one of the big names of modern British art. Moore's nudes, though, are no different from the conventional 'female nude lying down', found in so much of 'high art' from the Renaissance onwards. Moore's polished wood surfaces, so softly rounded and enigmatic, seem so enchanting. But, despite his formal innovation, Moore is as sexist and reactionary a sculptor as Francis Bacon is as a painter. Postwar figurative sculpture (not only made by men) has rarely escaped the usual confines of patriarchal art. David Smith's bronze sculpture *The Rape* depicted a woman being raped by a canon, a phallic gun which climbs over her. It is meant to be a savage and ironic comment on violation, but it isn't ironic enough, as with Maillol's relief of a man assaulting a woman, entitled – what else? – *Desire* (1903-05, Paris). Edward Kienholz's quasi-Surrealist *Back Seat of a '38 Dodge* (1964, the Kleiner Foundation, Los Angeles) is a reassembled car with all manner of bits added to it and inside it – what else? – two people make the beast with two backs.

But when sexuality is addressed, postwar (male) sculptors have rarely been ironic. Usually, the norms and dualities of male/ female, active/ passive, culture/ nature, good/ evil are exalted. The 'great' or celebrated names in postwar sculpture – Alberto Giacometti, Henry Moore, David Smith, David Hare, Eduardo Chillida, Pablo Picasso, Isamu Noguchi, Claes Oldenberug, Mark Di Suvero, Jean Tinguely – rarely tackled notions of sexuality in major works of sculpture. When Picasso incorporated eroticism, it

was invariably heterosexist, as in his *Bust* (1932, estate of the artist) with its gigantic breasts, echoing the "Stone Venuses" of yore. The 'great' works of postwar sculpture – David Smith's *Cubi XXVII* (1965, Guggenheim Museum, New York), Claes Oldenburg's soft sculptures and giant blow-ups of everyday objects, Alexander Calder's mobiles, Richard Serra's chunks of metal, John Chamberlain's squashed cars (1961, Art Institute, Chicago) – seem to eschew issues of sexuality. Not much of mainstream or 'malestream' postwar sculpt-ure concerns itself with eroticism without pain or violence, and hardly ever feminism.

Some (land) artists have thrown or splashed material. In Andy Goldsworthy's 'throws' and 'splashes', the arcs or trajectories of the material become the artwork in itself. The curve of the thrown earth or sticks against the sky actually *is* the sculpture. Similarly, Bruce Nauman – who is, like Yves Klein, another celebrated Conceptual artist – photographed himself as a water fountain (1966). Richard Long threw mud against walls, either in a curtain of mud, or in a circle. Kazuo Shiraga wallowed in mud and threw mud-balls (*Making a Work With His Own Body*, 1955). Guo Qiang Cai created miniature explosions with gun-powder to evoke the mushroom clouds of nuclear explosions (1996). Bruce McLean's *Splash Sculpture* and *Mud Sculpture* (both 1968) are precursors of Goldsworthy's splashes and throws. Goldsworthy's throws offer plenty of ammunition to critics who dislike his work, because someone making splashes in a river with a stick or throwing sand or leaves in the air is the kind of art denigrated by the tabloid press in the UK.

With Yves Klein's 'body-paintings', the intriguing thing was the manufacture of the painting (other artists have printed directly with the body). In Yves Klein's case, this involved women (nude, of course) being doused with blue paint (International Klein Blue, naturally) and writhing around on a huge canvas stretched on the floor. Klein's *Anthropometries of the Blue Period* were *avant garde*, self-conscious, ironic art happenings, accompanied by a string chamber orchestra (playing Klein's *Monotone Symphony*, natur-

ally).[2] All very French, bohemian, cool. The Austrian performance painter who enacted 'symbolic 'self-mutilations' and sadomasochistic actions',[3] Günter Brus, said: '[m]y body is the intention, my body is the event, my body is the result'.[4]

The body features occasionally in the art of Andy Goldsworthy in a direct manner. One sees the shape of Goldsworthy's body after a snowfall or rainfall (his *Rain Shadows*), or 'printed' onto frosty ground by his shadow at sunrise. Goldsworthy sometimes appears in photographs, beside his work. Goldsworthy's hands are seen, and other parts of the sculptor, but there is nothing in Goldsworthy's work (or that of Hamish Fulton, Richard Deacon, Stephen Cox or Barry Flanagan) that is as ferocious as feminist and women's body and performance art.

Feminist artists use the body to explore political, erotic, pornographic, æsthetic and philosophical discourses. As Lisa Tickner wrote: '[l]iving *in* a female body is different from looking *at* it, as a man. Even the Venus of Urbino menstruated, as women know and men forget'.[5] The female nude, for so long the model and image and object of lust in so many 'high art' paintings, has usurped the power relation between artist and art object, and between artwork and spectator. The woman is no longer content to be looked at and lusted after: she is making her own art, employing her body in a radical, challenging way. The 'Old Master/ *Playboy* tradition', as Tickner called it, has been smashed.[6]

THE SEXUALITY OF SCULPTURE

The sense of touch is supremely important to sculptors, as it is to most artists. Sculptors often describe the qualities of materials in terms of texture, surface, flexibility, malleability, viscosity, colour, strength, smell, associations, difficulty, and so on. Sculptors know that granite is quite a different material from steel, and certain woods – oak and holly, say – are different from pine, willow or

walnut. Sculptors have a heightened 'haptic' sense, a sense of touch which involves the whole body, not just the hands. Viewers of sculptures also react to them with all the senses, not just sight. One reacts to a sculpture with the whole body. This haptic sense is

> the means of touch reconsidered to include the entire body rather than merely the instruments of touch, such as the hands... It includes all those aspects of sensual detection which involve physical contact both inside and outsider the body.[1]

The sexuality of sculpture is everywhere affirmed in 'high art', and in 'high art' cultural criticism. This has to do with the eroticism of the nude human form, which thousands of sculptors have explored and exploited. Renaissance sculptors – Luca della Robbia, Ghiberti, Verrocchio, Lombardo, Colombe – systematically exaggerated the sexuality of the body. Donatello's famous *David*, for instance, is a highly camp, homoerotic boy, an icon of stylized homoeroticism. (A similar eroticization occurs in Verrocchio's *David*, Cellini's *Perseus* and Bologna's *Mercury*). This Renaissance sexualization of the human form finds its apotheosis in, of course, Michelangelo – his *Dawn, David*, early and late *Piètas*, and of course the most voluptuous of all figurative statues, the *Dying Slave*. The heroic homoerotic style of Michelangelo's sculpture continued throughout post-Renaissance sculpture. In, for instance, the bombast and masculine power of Canova's *Hercules and Lichas*, or Bernini's *David*.

WOMEN SCULPTORS AND LAND ARTISTS

Important postwar women sculptors include Nancy Graves, Eva Hesse, Niki de Sant-Phalle, Rebecca Horn and Louise Nevelson, and women land artists such as Mary Miss, Nancy Holt, Sherry Wiggins, Donna Henes, Ana Mandieta, Vijali, Betsy Damon, Phyllis Yampolsky, Jody Pinto, Viet Ngo, Helen Mayer Harrison,

Mel Chin, Karen McCoy, Meg Webster, Maya Lin, Martha Schwartz, Dominique Mazeaud, Lynne Hull, Doris Bloom, Patricia Johanson, Constance DeJong, Harriet Feigenbaum, Phyllidia Barlow, Debbie Duffin, Mierle Laderman Ukeles, Gloria Carlos, Agnes Denes and Alice Aycock.[1]

Eva Hesse, who died at the age of 34 in 1970, is especially interesting; her works repay many visits. Hesse was part of the group that included Carl Andre, Robert Ryman, Sol LeWitt and Mel Bochner. She worked in series, like other Process and Minimal artists. She called the repetitions 'sequels' and 'schemas'. Her artworks have an immediate, challenging impact. They hang from ceilings, in rows, made of rubber, latex, cloth, wire and fibreglass, evoking organic forms in ambivalent, sensual ways.[2] Pieces such as *Ingeminate* (1965, Saatchi, London) offer up a mysterious affirmation of life in the form of two coils of cord connected by a long piece of surgical hose. *Sans II* (1968, Saatchi, London), meanwhile, was a dozen rectangular 'compartments' made from fibreglass which hinted at some obscure systematization of flesh and organic form. Hesse wrote: '[i]f I can name the content... it's the total absurdity of life'.[3] As Anna Chave noted, Hesse's forms resemble abstract 'breasts, clitorises, vaginas, fetuses, uteruses, fallopian tubes', articulating a new feminine sexual subjectivity, utilizing the female, not the male gaze.[4] In a 1968 statement, Hesse said, sounding like Ad Reinhardt:

> I remember I wanted to get to non-art, non connative, non anthropomorphic, non geometric, non, nothing, everything, but of another kind, vision, sort. From a total other reference point. Is it possible? I have learned anything is possible.[5]

Sometimes loosely hanging, finding their own form, at other times Hesse's sculptures were bound with wire, as if 'making psychic models', as Robert Smithson said.[6]

Louise Nevelson produced huge reliefs or structures which were like Cubist or Constructionist altarpieces, full of objects, various articles made of wood, all painted in one colour, black, white

or gold: chair legs, railings, door knobs. Her sculptures were like magical cupboards, vertical dreamscapes made of boxes stacked on top of each other. Rebecca Horn's sculptures are based, like Barbara Hepwprth's, on natural forms, but also on movement, dance, time and environments. Horn's wonderful *Peacock Machine* (1982) is an exuberant activator of space, one of those pieces that aims for the essence of a natural form and captures it: a peacock's magnificent tail.[7]

Many women sculptors have explored 'feminine' imagery and issues. Lila Katzen set alive public spaces with her flowing, curling forms (such as *Guardian*, 1979). Louise Bourgeois (rightly one of the key female voices in the modernist era) explored the relations between form and eroticism, volume and psychology, shape and nature. Her forms were nearly always dealing with eroticism – her *Nature Study* (1984), for instance, featured those bulbous volumes which are practically her trademark, echoing breasts, clitorises, vulvas, buttocks, heads, hands, knees, tongues, all the parts of the eroticized body.

Alison Wilding directly embraced the potential for sculpture to be supremely sensual. Her abstract forms hint at alchemical transformations, intimate experiences, investigations of sexuality and the relations between space, imagination, fantasy and the body.[8] Wilding's *Hemlock III* (1986), for example, was, like her *Blueblack* (1984), a wooden dish containing hemlock, lead, lime and beeswax, allusive of arcane experiments. The dish with its dangerous substances was a kind of womb, a motif or experience that appears in much of modern sculpture, from Judy Chicago's *Dinner Party* (1979) to the womb interiors of Louise Bourgeoise and others.

Alison Wilding's sculpture often featured two elements, one was usually large, the other, small. These two elements are luscious and mysterious, part way beyond interpretation, though some critics interpret them as masculine and feminine elements, the twin poles of heterosexuality, which are involved in some arcane dance or dalliance.[9] Wilding herself stressed the enigmatic

nature of her work: '[t]he obverse of making is looking, not telling'[10] and she emphasized, as so many artists do, the making of the sculpture: '[t]he making and doing processes...[are] always the mainspring of the work'.[11] Alison Wilding, David Nash, Bill Woodrow and Andy Goldsworthy also iterate the making of sculpture.

Jackie Winsor took the cube as one of her major forms, but she manufactured her cubes from 'natural' materials, such as twine and wood. Winsor's cubes take the Minimal cube only as a starting point, because her series of cubes are explorations of the mysteries of ontology. Some of Winsor's works change or decay: the *Burnt Piece* (1977-78) cube burnt away, alchemically, when the artist fired its interior. As with the land artists, Winsor said: 'I was unable to see how the piece would look until the moment of completion'.[12]

Barbara Hepworth's organic forms, as with Constantin Brancusi, hovered between subjectivity and objectivity, between natural form and æsthetic abstraction (as in her *Two Forms*, for example). Like Brancusi, Hepworth maintained that she always returned to nature, and took her inspiration from nature. For her, nature meant the (Cornish) landscape, and the human body. 'We return always to the human form – the human form in landscape' she said. Her sculpture stems from emotion and expression, from feeling: 'I rarely draw what I see – I draw what I feel in my body' she said.[13] Hepworth's distinctive forms, with their smooth curves and holes, are clearly sensual objects. Hepworth acknowledged the sensuality of sculptural forms. Hepworth said that the natural setting was 'the most tremendously inspiring one to me'. Driving around Cornwall, Hepworth found that it was her personal (bodily) response to particular landscapes that mattered.[14]

The famous sexist and heterosexist depictions of people in modern sculpture include Alberto Giacometti's *Spoon Woman* (1926), a view of woman as Earth Mother, a totemic figure; Gaston Lachaise's *Standing Woman* (1912-27, Whitney Museum), one of those smooth, curvy Goddess types, also favoured by Aristide

Maillol; Hans Bellmer's bizarre *Dolls* (1936), where the slit of a vulva is where the head would be, and set amidst exaggerated, bulbous forms; Henri Gaudier-Brzeska's *Red Stone Dancer* (1914, Tate Gallery), though it attempts a new way of depicting gesture and posture in space, is still sexist; Elie Nodelman's *Dancer* (1918, New York), like Paul Manship's *Dancer and Gazelles* (1916, Smithsonian Institute, Washington DC), and Degas' *Dancer* sculptures, is also sexist; and Ernst Ludwig Kirchner's *Standing Nude* (1908-12, Stedelijk Museum, Amsterdam) is pornography masquerading as art, but then, many of Kirchner's depictions of women could be regarded as pornography.

By contrast, here are a few examples of feminist art: Carolee Schneemann pulled a scroll from her vagina and read from it in a famous performance piece.[15] Chila Kumari Burman made 'body prints'. Karen Finley poured 'a can of yams over her naked buttocks'. A spectator called her as 'a frightening and rare presence'.[16] In her work *Cut Off Balls,* Finley castrated Wall Street bankers.[17] Mary Duffy displayed her disabled body in performance and photographic sequences;[18] Jo Spence has photographed the 'unhealthy and ageing female body'.[19] Feminist body and performance art was a way of repossessing the body, sexuality, identity, power; it was a way of 'rewriting the body', in the terminology of French and postmodern feminism. It can be an act of transgression and subversion, which usurps the power relation between spectator and artwork, so that the (male) viewer's 'cloak of invisibility has been stripped away and his spectatorship becomes an issue within the work' as Catherine Elwes put it.[20]

One aspect of 'feminist' or 'women's' art was (is) embodied by the figure of the Goddess, the ancient and primæval Great Mother of all, celebrated then – and now – as Isis, Ishtar, Demeter, Kali, and so on. The Goddess embodying aspects of the 'feminine' – love, motherhood, purity, nobility, sacrifice, beauty, hunting, and so on. Since the 1960s, the Goddess has been variously interpreted as fact, experience, idea, æsthetic, cult, religion, pagan emblem and many other things by women artists and writers. There are a

host of artists who pursue what one might call 'Goddess art', art that employs the figure of the Goddess as an embodiment of female being or experience: Judy Chicago, Mary Beth Edelson, Miriam Schapiro, Niki de Sant-Phalle, Louis Bourgeois and Helen Chadwick. Mary Beth Edelson engaged in the resurgence of interest in the Goddess in her *Great Goddess* series (1975). Edelson has also produced a piece on menstruation, entitled, appropriately, *Blood Mysteries* (1973). In a performance, Catherine Elwes sat in an enclosed studio space and menstruated.[21] Judy Chicago looked to the flowers of Georgia O'Keeffe, which, she said, 'stand for femininity'.[22]

One might see Robert Smithson's spirals and circles as Goddess art, for the circles so clearly evoke Goddess themes such as time, cycles, (Moon) phases, dance, transformation, ritual, initiation, astronomy, and so on. The circle is also a profound shape for alchemists. As the *Rosarium Philosophorum* has it: 'make a round circle and you will have the stone of the philosophers'.[23] Richard Long created, in Ireland, an ancient maze form out of small stones set on grass (*Connemara Sculpture*, 1971), and Robert Morris has also made a labyrinth (*Labyrinth*, 1974). The shape of Long's and Morris's labyrinths directly recall the Cretan labyrinth of initiation and ritual, and the spirals at the entrance to Newgrange in Co. Meath, a huge passage grave some 4,500 years old.

Herman de Vries created a circular walled *Sanctuarium* (1997) in Westfalen, Germany. Alan Sonfist planted a maze from oak trees at TICKON in 1993. In Dennis Oppenheim's *Maze* (1970), cattle are lab rats running after corn in a field. Dan Graham combined hedges and mirrors in his *Two-Way Mirror Hedge Labyrinth* (1989). Chris Drury has made circular mazes (some of which are reworked dew ponds). Drury also carved a maze from snow on a Sussex hill (1999). Bill Vazan has fashioned a number of earthworks on the ground, including a *Stone Maze* (1975-76, reminiscent of Richard Long's Connemara labyrinth) and Richard Fleischner, Michelangelo Pistoletto, Hiroshi Teshigahara, and

Vong Phaephanit have also created maze structures (Fleischner built a maze from turf in 1974 and one from a chain link fence in 1978). A number of (land) artists have made miniature labyrinths – maze models: Charles Simonds, Terry Fox and Patrick Ireland. Andy Goldsworthy has drawn lines on sand, or stitched grass stalks pinned together, in swirling, spiralling shapes which echo the primæval forms of the snake, the spiral and the labyrinth.

5

Land Art and Religion

It's no surprise that the American form of land art should be sympathetic to Oriental mysticism, because Zen and Taoism were particularly prevalent in Sixties culture (in Jack Kerouac, Allen Ginsberg, the 'Beats' and the 'dharma bums', for example). It was a natural development, it seems, from Parisian Existentialism to Californian Zen Buddhism. Many of the chief precepts of Taoism and Zen Buddhism chime with those of land art, not only the American earthworks, but also the land art of Long, Laib, Nash and others. Matsuo Basho, an important Oriental poet, wrote:

> Go to the pine if you want to learn about the pine, or to the bamboo if you want to learn about the bamboo. And in doing so, you must leave your subjective preoccupation with yourself.[1]

And Makoto Ueda glossed Basho thus: '[f]or learn means to enter into the object, perceive its delicate life and feel its feelings.'[2] These notions of searching for the 'essence' are absolutely in tune with the æsthetics of Brancusi, Andre, Long and Judd. Goldsworthy spoke in exactly the same terms of trying to find the 'essence' of nature, of going out into the natural world in order to learn about it. Goldsworthy followed Basho's Taoist precepts to the letter. Minimal art pursued the oft-used tenet that 'less is more', a radical reductionism and simplification. Or as Carl Andre put it,

''minimal' means to me only the greatest economy in attaining the greatest ends'.[3] Michael Heizer confessed he preferred to see art more as a religion than a recreational activity: 'if you consider art as activity then it becomes like recreation. I guess I'd like to see art become more of a religion'.[4]

The Chinese Taoist mystic, Chuang-tzu (the 'Groucho Marx of Taoism' as Lawrence Durrell called him), wrote: '[l]eap into the boundless and make it your home.'[5] This statement perfectly describes the artist's act of faith and risk, which is so essential for good artistic creations. As Søren Kirkegaard said, without risk, life is not worth living. Again, these quasi-Existentialist/ Taoist notions of risk are perfectly in tune with 1960s earthworks art. John White, discussing Oriental art, makes points which can apply to land art:

> In Chinese art the surface emphasis is negative rather than positive. It is in close accordance with the calm acceptance, the contemplative natural mysticism, which reached its highest flowering in Taoism. The surface is left undisturbed. Colours are few, and soft. Ink, and delicate monotone washes are the characteristic media. Spiritual and decorative qualities are valued high above imitative naturalism, the evocative above the representational... The unmarked silk, or paper, is at once the atmosphere, the space, and the inviolate decorative surface. (67-69)

The relation between land art and Oriental mysticism, in particular, Taoism and Zen Buddhism, has been noted by many commentators. Zen and Taoism, for instance, speak of *(1)* the 'here and now', *(2)* spontaneity, *(3) satori* or enlightenment, *(4)* intuition, *(5)* nature, *(6)* emptiness/ void, *(7)* change, *(8)* meditation, *(9)* cosmic unity – all these qualities can be applied to land art, and are sometimes elucidated by land artists.

(1) For example, the Zen notion of the 'eternal now' or 'now-streaming' (*nunc fluens*) as Alan Watts called it. Zen philosophy makes the present moment primary, the only true reality, and land artists too work in the present. Sculptors continually evoke the transient nature of sculpture: Hans Haacke's fog pieces; Chris

Drury's fires; Ana Mandieta's snow and mud body prints; Wolf-gang Laib's pollen. Goldsworthy's poppy lines are only there for an instant, then they are blown away by the wind.

(2) Spontaneity: this is as crucial in land art as it is in Zen and Taoism. The land artist works with whatever materials are to hand; s/he does not (often) use tools or machines; changes in weather must be accommodated into the artwork.

(3) The experience of viewing land art is not quite Zen *satori*, in the strict definition of *satori* or enlightenment, but certainly land artists aim for an 'epiphany', as James Joyce called the æsthetic shock, however brief it may be. In land art as object, there are 'no strings attached', i.e., 'what you see is what you get', as Frank Stella put it. One sees the whole thing there, and that is every-thing one gets. This instantaneous aspect of land art, as also in postwar painting, is a Zen-like notion. *Satori*, too, has affinities with the descriptions of land art/ sculpture that some land artists have given (Robert Morris's objecthood, for example). Hui-Neng, the 8th century mystic, said that *satori* was 'seeing into one's own nature'. Some land artists have written of art as a journey towards some inner essence. D.T. Suzuki terms Zen *satori* an 'insight into the Unconscious'.

(4) Most land artists value intuition highly, as do most poets and artists. The land artist trusts her/ his instincts, and works grow organically. Systems are adhered to, but land artists often veer off into intuitive areas.

(5) Nature dominates Zen and Taoism, as it does in land art. One is always encouraged in Taoism and Zen to 'follow one's nature', and to co-operate with the universe. Nature is the teacher in Zen and Taoism, as it is in land art.

(6) Easy to see the lure of the void of religions in land art, in those wildernesses beloved of Heizer, de Maria and Oppenheim. Voids are found in much of postwar culture, from Samuel Beckett's sparse texts and 'fizzles', which painstakingly describe near-voids (the stone circle, so like a piece of land sculpture, in *Ill Seen Ill Said*, the sun setting over the hills in *Still* and the ruthless white

'inscape' of *Ping*), to Ad Reinhardt and Robert Ryman painting all-black or all-white canvases. In the paradoxical bliss of Oriental mysticism, emptiness is also fullness, and to 'have' nothing is to 'have' everything. Zen and Taoism thrive on paradox, on the 'not-this-not-that' dialectic of philosophy, as a way of getting at the unsayableness of the essence. Similarly, Goldsworthy, in a paradoxical manner, speaks of the monumental aspect of sculptures made from leaves: the very small can also be very big, he says:

The imagery of Zen and Taoism is also that of land art: stones, mountains, rivers, water, flowers. China has a long tradition of landscape painting, and it is easy to see the many connections between the contemplative aspects of Chinese landscape painting and postwar land art.

(7) Change is central to land art: all land art occurs within a changing landscape, whether it be the artificial (humanmade) changes in the gallery, or the natural changes of erosion, elements, water, light, season, and so on. Land art thrives on change, and many land artists have deliberately exploited time and change in their works, from Nancy Holt with her *Sun Tunnels*, which change as the sunlight pours through the holes in the concrete tubes, to the transience of Richard Long's *Mountain, Lake, Powder Snow* (1988), which the elements will swiftly erase.

In Taoism, everything changes, the *yin* and *yang* energies/principles create change, yet the Great Whole remains the same. In nature, everything is changing, transforming into something else, yet the Earth remains whole. Flow is crucial – so land art steps away from Western art, which stops life in snapshots or 'still life' paintings, and produces transmuting art, art which has change built into its design. In the West, there is much anxiety when artworks change (when paintings fade, for instance). On the one hand, there is the desire to keep everything 'natural', without being interferred with; on the other hand, museums and galleries constantly interfere with art – 'restoring' paintings, putting things behind glass, behind ropes, and so on. The very nature of 'preserving' art is controversial – witness the anger surrounding

the 'restoration' of Michelangelo's Sistine Chapel and Leonardo's *Last Supper*. Land artists, though, relish such changes and decay in artworks.

(8) Meditation is clearly not a goal of earth artists – they make no pompous claims concerning mysticism and meditation. Yet, clearly, meditation is a part of their work, as it is a part of all artists' work. Making land art often involves a mild form of meditation. Richard Long's walks, for instance, are meditations of a kind. 'A journey in the wilderness becomes a fantastic focus of concentration. I can get totally absorbed in the place and totally absorbed in my work' Long said.[6] Goldsworthy too speaks of an intense relationship with his subject as he works. The Cornish poet Peter Redgrove said that 'the ideal state for ordinary going about is the first stage of orgasmic arousal'.[7] This is 'walking' in the Taoist sense; that is, walking as another name for feeling ecstatic.

The very activity of walking releases chemicals in the brain that promote pleasure. Joggers get hooked on them sometimes. 'I think the sexual energy or the energy of creativity or the adrenalin energy you get from being on a mountain, sometimes they are all very close' Richard Long remarked.[8] The physical action of walking is soothing. Since time immemorial people have 'walked off' their problems, and many artists were famous for their walks: Schopenhauer and Kant took twilit walks; Thomas Hardy tramped through Dorset; Wordsworth and Coleridge walked in the Lake District; John Cowper Powys always took a morning walk from his home in rainy North Wales; Henry Miller was in ecstasy simply by walking around the backstreets of New York and Paris (as described in the *Tropic* trilogy and *The Rosy Crucifixion*); Bruce Chatwin made walking and nomadic existence his central theme – in his life as in his art.

(9) Land art is close to Taoism in its worldview: like Taoists, land artists believe in a holistic view of things, where each part affects the rest. This interconnected worldview (sometimes called 'Gaia-consciousness') is also the philosophy of ecology and the offshoots of the ecological/ green movement: eco-feminism, Godd-

ess religion, animal rights, eco-paganism, direct action, road activism, anti-hunting lobbies, and so on. Art now has a world consciousness, said Isamu Noguchi (1968).

In the Taoist view, inner and outer commingle, the individual and the mass interconnect. Land artists are (usually) very much concerned with ecological issues, and are careful to make sure their artworks do not scar the landscape. There is no litter in their photographs of their artworks. They are ecologically and societally conscientious artists, and thus Goldsworthy has been hailed as the UK's primary ecological artist. Long says, and Goldsworthy would agree with him, that his art is about finding a harmony between the human and the natural world, between the abstractions of humanity and the reality of nature. As Long puts it, his work is 'a balance between the patterns of nature and the formalism of human abstract ideas like lines and circles.'[9]

In *Being and Circumstance,* Robert Irwin proposed four types of land art: 'site dominant', such as monuments and murals; 'site adjusted', in which some considerations are made towards the site, but it's still studio-made; 'site specific', in which steps are made towards integrating the work into the site; and 'site conditioned', work which responds to its surroundings. The 'site determined' category is the one Irwin preferred: it is also the type of sculpture favoured by many land artists. Irwin defines 'site conditioned' work as an 'intimate, hands-on reading of the site', which results from 'sitting, watching, and walking through the site'; it means being aware of water, weather, sound, surface, movement, history, and so on; such considerations determine whether the response 'should be monumental or ephemeral, aggressive or gentle, useful or useless, sculptural, architectural, or simply the planting of a tree, or maybe even doing nothing at all' (1985).

The land artist orients her/ himself in terms of post-Renaissance space and time. The Neoplatonic, magical, neo-pagan view of the world in the Renaissance saw humanity at the centre of the cosmos, and humans were the microcosm reflecting the make-up of the macrocosm, the 'as above, so below' philosophy of Hermes

Trismegistus and the alchemists. In the view of Christianity, however, God was at the centre (as in Dante's extraordinary vision of a mechanical universe in which God is at the centre of the surrounding nine hierarchies of angels, and the rest of humanity around the edges). In the Renaissance one sees so clearly the crumbling of the hegemony of mediæval culture, where there was an unambiguous system of good and evil, God and 'man', us and them. In the Renaissance, this worldview falls apart, moving towards an emphasis on the individual, on the existential sense of beingness and being alone in the universe.

> Because his body exists in space [wrote Mircea Eliade], any man orients himself by the four horizons and stands between above and below. He is naturally the center. Any culture is always built on existential experience.[8]

This is what the land artist does: s/he orients her/himself to the four horizons, and to post-Renaissance time. The human level becomes the spiritual centre. The land art of whoever one cares to think of – in Nash, Erskine, Lipkis, Holt – puts people, not God or deities, at the centre of the cosmos. Land art, then, can be seen on one level as the reaffirmation of 'home', a re-instatement of the notion of 'homeland'. The 'homeland', though, is not primarily a physical place, but a cultural and spiritual space. Homeland is a state of mind as much as a landscape. Land art may be the manifestation of a spiritual re-orientation. In land art, the 'mythic centre' of one's life is reaffirmed.

Land artists always affirm the 'livingness' of their art, that they *live* their art. Their art, they claim, is not intellectually discussed or made at a critical distance. Rather, the artist is right in the middle of her/his art, living it. There is no separation of art and life. Land art is a way of mythicizing one's sense of being-in-the-world, a way of making presence visible, tactile, *there*. 'Presentness is grace' wrote Michael Fried in his influential essay "Art and Objecthood".[9] Germano Celant, one of the key theorists of Arte Povera, likened the sculptor and land artist to an

alchemist:

> The artist-alchemist organizes living and vegetable matter into magic
> things, working to discover the root of things, in order to re-find them
> and extol them... What interests him... is the discovery, the
> exposition, the insurrection of the magic and marvellous value of
> natural elements. (1969)

The Arte Povera-type artist-alchemist uses simple, natural
elements, said Celant: copper, zinc, earth, water, snow, fire, grass,
air, stone, gravity, growth. He rediscovers the magic of the world,
its composition, growth, precariousness, falseness, reality (1969).
'At the same time he rediscovers his interest in himself. He
abandons linguistic intervention in order to live hazardously in an
uncertain space... his availability to all is total. He accumulates
continuously desire and lack of desire, choice and lack of choice'
(1969). The Arte Povera artist works with life, within life, Celant
said, discovering the 'finite and infinite moments of life', art as
life, 'the explosion of the individual dimension as an æsthetic and
feeling communion with nature'; making art becomes identical
with living: '[t]o create art, then, one identifies with life and to
exist takes on the meaning of re-inventing at every moment a new
fantasy, pattern of behaviour, æstheticism, etc. of one's own life'.
Celant quoted from John Cage: '[a]rt comes from a kind of
experimental condition in which one experiments with the living'.
What counts is to live the work, Celant said, to be open to the
world, 'to be available to all the facts of life (death, illogic, mad-
ness, casualness, nature, infinite, real, unreal, symbiosis)' (1969).

Some land artists include autobiographical material in their
work. For some land artists, art and life cannot be easily separated
(a common philosophy in modern art). One feeds the other, in a
symbiotic relationship. One cannot say for certain where some
land art ends and the artist's life begins. Land artists like Andy
Goldsworthy and Richard Long see art as a continuation of life,
where the feelings artists of the past had about nature (for
example, Turner and Constable and the British landscapists) feed

on the same source as artists working today (that is, nature itself). Some people made their life their art (or was it the other way around?): Yves Klein, Salvador Dali, Joseph Beuys and Carolee Schneemann, among artists, and writers such as Quentin Crisp and Anaïs Nin. Most land artists are not quite larger than life personalities like Anaïs Nin or Quentin Crisp (yet). They often, however, keep a diary, and carefully record the daily progress of their art, and the manufacture of each work. Around each work, then, is an autobiographical residue.

Making land art is a religious activity because simply being in the world is religious. Land art, like all art, replays the primordial myth of Creation: each earthwork or land sculpture reaffirms the Creation.

> Once the center has been reached, we are enriched, our consciousness is broadened and deepened, so that everything becomes clear, meaningful...[11]

In archaic societies, through symbol and ritual, sites would become 'sacred'. For postwar, postmodern, post-everything people, any site can become 'sacred' if one thinks of it as sacred. If one thinks of this junk yard next to the car lot as a sacred space, why, then it is a sacred space. All that sacred spaces need is human consciousness. It is the level of *desire* that makes a place sacred. In olden times, one might have required a god or a government to have the 'authority' to make something sacred. In the postwar post-everything world, the individual is her/ his own government and God. If s/he says a place is holy, then it's holy.

Consecration of a sacred space may include any number of rituals. The simple fact of drawing out a circle in the sand on a beach isolates a sacred space in amongst profane space. By drawing the circle, one marks out a sanctuary or sacred zone. Magicians add to the glamour of creating a magic circle by drawing it with a knife, making it nine feet in diameter, and placing candles or some ritual objects at the four cardinal points. The magician's circle is simply a stylized, ritualized version of the land artist's circle.

The religionist or magician has the weight of religion or hermetic magic behind her/ him; the modern artist has the weight of art (culture) behind her/ him. One can't say that a church or a magic circle is 'holier' than a circle made with a stick by a child on a sandy beach. Cathedrals simply have the 'authority' of paternal figures behind them. The child making a sand circle doesn't seem to have the same 'authority', the same tradition of sombre theology and religious *gravitas*. Yet the child on a beach, or the land artist in a forest, is making a sacred space out of profane space.

Land artists do not think in these terms: or they may do, but they rarely admit it. For the land artist, as for any artist, it is perhaps embarrassing to admit that much of art is about 'childlike' feelings; that is, the 'simple' pleasures of making a line out of stones, or walking at dawn, or filling a room with soil. These are the basic pleasures of art, which both artist and viewer enjoy. They are, on one level, 'childlike', even 'infantile', psychologically. Sure. But many other grave, time-honoured institutions are founded on childish impulses: marriage, Catholicism, pop music, the insurance industry.

The land artwork, then, remakes the sacred in a profane world: 'the manifestation of the Sacred in any space whatsoever implies for one who believes in the authenticity of this hierophany the presence of transcendent reality' remarked Mircea Eliade.[12] Not only, then, do land artists make sacred spaces, as all artists do, they also create a sense of the 'real', a sense of beingness, a reaffirmation of the transcendent.

> The Sacred is that something altogether other to the Profane. Consequently, it does not belong to the profane world, it comes from somewhere else, it transcends this world. It is for this reason that the Sacred *is* the real *par excellence*. A manifestation of the Sacred is always a revelation of *being*.[13]

For the land artist, most, if not all, of the world is not just potential art material, but beautiful. Land artists, declining to

admit to being romantic or emotional, nevertheless create art that is Earth-loving, nature-loving, ecologically-friendly, that is, in short, full of emotion.

Not every critic exalts land art as spiritual. Peter Fuller, who advocates a distinctly *British* form of modern painting, sees spiritual bankruptcy in land art. Of Richard Long, Fuller intones:

> It is, I believe, a tragedy that consideration was given to inviting an artist such as Richard Long to create a piece within Lincoln Cathedral. His work, for me, is symptomatic of the loss of both the æsthetic and the spiritual dimensions of art. He shows little trace of imagination, of skill, of the transformation of materials. Seen in contrast to the greatest achievements of the British tradition in art, Long's relationship to the world of nature is simply regressive. His work is sentimental and fetishistic… claims that his work is worthy of 'spiritual' attention are preposterous…[14]

One sees clearly Fuller's outrage that Richard Long might sully the building beloved of Ruskin, Pevsner and D.H. Lawrence, one of the finest English cathedrals. But surely Fuller is missing the point with Richard Long, who is clearly as mystical, as in awe, as deep in his feeling for nature as Fuller's cherished Cecil Collins, Henry Moore, J.M.W. Turner or Patrick Heron.

In the land artist's veneration of particular plants, hills, rivers and stones, one is reminded again of novelist John Cowper Powys who, on his morning walks in North Wales, Dorset or upstate New York, used to kiss certain stones and trees. In upstate New York in the 1930s Powys went out walking every day and said his prayers and invocations to particular natural objects. He gave his beloved things names: there was the 'Dead Tree', the 'Skian Gates' (some stones), the 'Prometheus Stone', the 'Perdita Stone', 'the Flotsam', 'the Jetsam', the 'Unknown Stone', the '*Other* Unknown Stone', the 'Noble Wreck', the '*other* Apple Tree', the 'Thorn Bush' and the 'Sea Coal'.[13] One doubts if contemporary land artists kneel down and kiss the soil as they say their prayers, as John Cowper Powys did (Pope John Paul later made this act famous), but a lot of

land art is very much about this loving, holy relation with the natural world.

Many land artists have their favourite haunts. Andy Goldsworthy, for instance, revisits certain stones 'many times over',[16] and gets very attached to places, which become like homes.[17] He also admits 'I like touching stones touched many years ago.'[18] Like John Cowper Powys and the Romantic poets, like the archaic shaman, Australian aborigines and 'primitive' people, Goldsworthy goes out into the landscape and communes with it,[19] knows every inch of it, knows this stone and that pool, this place for gathering strong grass stalks and that dramatic hilltop viewpoint.

Uncomfortable as they are with notions of 'spirituality' or 'mysticism', land artists such as Richard Long, David Nash, Chris Drury and Robert Smithson are religious artists, sensitive to the emanations of particular places. Richard Long, for instance, concedes that 'art is magical', as of course it is.[20] Art has been deeply associated with magic and religion for at least 40,000 years, and probably millennia more. Land art, like all art, is full of deep emotions. These emotions collect in clusters around certain places. It is understandable, then, that critics and the public see these emotions as potentially religious.

6

Land Art and British Culture

LAND ART AND BRITISH SCULPTURE

Sculpture in the Sixties in Britain was connected with the art
schools (St Martin's, Slade, RCA); with teachers and modernists
such as Anthony Caro, Philip King, Hans Haacke, Lawrence
Weiner, Joseph Beuys and Henry Moore; with American Minimal-
ism and Conceptual Art; with New Realism; and with Italian Arte
Povera. The student days of artists such as Bruce McLean, Jan
Dibbets and Richard Long were summarized by David Lee:

> [at] St Martin's School of Art... the definition of sculpture was all-
> inclusively expanded to embrace a hike in the Hindu Kush, a sing
> song, an OS map with felt tip graffiti, a collection of empty bottles or a
> stack of horse blankets. Anything, in fact, providing it did not
> resemble in the smallest particular anything that sculpture had either
> used or made before.[1]

The 'new' British sculpture is loved and loathed passionately.
Amazingly, David Sylvester reckons that Richard Long 'has too
many admirers'. What does he mean? That people uncritically
adore Richard Long's works? Or that there is too much criticism
about him? Peter Fuller targetted Bill Woodrow's work as an
example of what he hates most in (postmodern) New Art.[2] Peter

Fuller loves artists who make 'beautiful' things, things that may be difficult or challenging, but which are also 'beautiful' (Maggie Hambling, Eric Gill, Turner, Paul Nash). But Woodrow's sculpture, like Tony Cragg's, Jean-Luc Vilmouth's and David Mach's, destroys the traditional notions of the 'beauty' of an art object. Stable (modernist) notions of 'purity' or 'meaning' in art are refuted by sculptors such as Cragg, Mach, Woodrow *et al*. Fuller's critique of such sculptors argues that their work lacks craft skills, that it's gimmicky.[3] This is often the way certain pop groups are criticized: 'they can't play their own instruments' pundits wail. But *it doesn't matter* if a pop musician can or can't play: what counts, in the postmodern era, is the text itself, the effect, the experience. What counts is the song, the sound, the image. The question in postmodern, post-Conceptual art is not: 'what does it mean?', but 'what does it feel like?'... 'what is the experience?'

It doesn't matter if there is no 'craft skill' or special techniques used in sculpture if there are a host of other things going on in it. As Donald Judd said, a work only has to be interesting. Richard Long claims his photographs are not made with great skill, but it doesn't affect the value they have as artworks. Similarly, Andy Warhol showed one didn't have to be as skilled as a Leonardo to be able to produce 'great art'. One needed to be a good publicist, good with mass mechanical production techniques, good at organizing other people.

Tony Cragg was known for his coloured spreads of found objects arranged in lines on the floor (such as his *New Stones*, 1978). Cragg's sculptures were constructed from all manner of found objects, each given the same status, in a non-hierarchical fashion, laid out on the floor (anti-hierarchical structures being one of the marks of postmodernism). Cragg's 1980 sculpture *Black and White Stack* contained bicycle tyres, tin cans, car radiator grills, the side of a child's crib and an ironing board.

Tony Cragg's sculptures, like Bill Woodrow's and David Mach's, are not simply sensual modernist objects but ironic, postmodernist commentaries on the social and political uses of

commodities (their work is sometimes dubbed 'post-industrial'). In Cragg, Mach and Woodrow familiar consumer durables and industrial materials are represented in an ironic, metaphoric and parodying manner.[4] Cragg, and other sculptors who trawl the dumpsters and junk yards of urban landscapes (Nash, Pope, Gormley, Woodrow), make ironic comments on scavenging and ecological recycling. Cragg was not interested, he said, 'in romanticizing an epoch in the distant past', but questioning the massive amount of commodity consumption in a late capitalist epoch:

> We consume, populating our environment with more and more objects, with no chance of understanding the making processes because we specialize in the production, but not in the consumption.[4]

The humour, scepticism, pathos and irony in Cragg, Woodrow, Mach, Gormley *et al* makes their post-Conceptual, post-industrial sculpture automatically disruptive. They evade categorization and easy definitions. It is this sense of shifting meanings and ambiguity in flux that makes much of New Sculpture and late modernist work disliked by some critics, because the work won't *keep still*. It won't be nailed down as an object of High Modernism, such as a family group by Henry Moore, or a Picasso nude.

One can understand the anger that much of postmodern or Conceptual or post-Conceptual art engenders. Walking into one of the big, white-walled brightly-lit modern gallery spaces around the globe, the art lover is often confronted by a series of baffling photographs, or 'found objects' placed in a line against a wall, or photocopies. It's definitely not Degas' ballet dancers or Jean Arp's sculptures. These shows seem full of worthless, everyday objects, things anyone can find anywhere. There seems to be nothing *special* about the objects in Tony Cragg's *New Stones* or Bill Woodrow's junk yard trawl works, or Lawrence Weiner's printed 'wall statements', or the deconstructionist projects of the Art and Language group. Why, the exasperated art lover fresh from a blockbuster show at the Kunsthalle or Metropolitan moans, 'there's

no *skill* here, no *talent*'. How many times have we heard that most common complaint of 'modern' art: *anyone could do that!* Yes, it does seem, at first, as if 'anyone could make' Andy Warhol's screenprints, Tony Cragg's spreads of found objects or Tim Head's display of sex aids and tape recorders (*State of the Art*, 1984). But no, art's not like that, it doesn't work that way. The argument that 'anyone could do that', such a common complaint, also lies behind Peter Fuller's 'high art' criticism. But it is such a simplistic view, revealing such a simplistic understanding of what art is, what it does, and how and why it is produced.

Postmodern/ post-Conceptual art ignites many important questions, such as: how does one know about the 'authenticity' or 'originality' of something when it is mediated by the mass media? How does one know something is 'the real thing', when all one knows of it is through images and sounds on radio, television, the internet and the press? Does it matter if the 'original' art work is fake when the mediated product has such 'truth'? Is an artwork that consists of photographs that refer to an artwork, an idea, an experience that exists elsewhere (Lawrence Weiner's printed words 'wall statement' *Sometimes Found*) as 'authentic' as a bronze sculpture by Rodin? Is the artwork that is an 'idea' as sensual or compelling as one made out of marble or oil? The 'new' British sculpture, with its scavenged objects and seemingly 'ordinary' objects displayed on the floor, disrupts modernist/ traditional not-ions of 'beauty', 'purity', 'tradition', 'objecthood', 'presence', 'value' and 'meaning'.

A noteworthy exhibition of Conceptual art was held at the Kunsthalle in Bern; some land artists were involved: Walter de Maria installed a telephone, with a message beside it saying the visitor could talk to him; Richard Long walked in the mountains and recorded his walk in a gallery statement; Jannis Kounellis put bags of grain on a stairway; Michael Heizer created *Berne Depress-ion*, smashing the pavement near the Kunsthalle with a wrecking ball; Joseph Beuys smeared fat along the walls.

THE BRITISH LANDSCAPE TRADITION

I actually believe in Modernism, in the excitement of new ideas. Art is anyway beautiful if the idea is beautiful, if it has clarity and truth. A lot of the history of landscape art has been to reveal the beauty of nature, a sort of religious celebration. All that beauty is still there and can be overwhelming, but I was always interested to develop landscape art in new ways.

Richard Long[1]

The influence of American/ New York/ Abstract Expressionist/ Minimal art and European Arte Povera are two strands in British sculpture, but another is the 'British' art tradition, and another is the British landscape. Land art in the UK is bound up with notions of Romanticism. For Robert Rosenblum, the Abstract Expressionists (in particular Mark Rothko) were the last in a long line of Romantic artists. Speaking of his book *Modern Painting and the Northern Romantic Tradition*, Rosenblum said 'were I to write a supplementary chapter to it – I stopped with Rothko and Abstract Expressionism – I would probably include earthworks of the late 1960s and 1970s. Those seem in some way to be the last gasp of that tradition of trying to find some sort of connection with the Great Beyond or the Void.'[2] Certainly the works of Fulton, Nash and Long *et al*, are part of this Romantic tradition, as expressed in British landscape art. Associated with land art was the group of British artists, the 'New Arcadians' or 'New Ruralists'.

The influence of British landscape on British sculpture is apparent in many, but by no means all, of British sculptors. Specifically *British* landscape, as opposed to other kinds of landscape, occur in David Nash, Hamish Fulton, David Tremlett, Chris Drury, Roger Ackling and Richard Long, as one might expect. It was Carl Andre who noted, quite rightly, that the British landscape is 'one vast earthwork'.[3]

Drury, Fulton, Nash and Long, in particular, evoke the British landscape tradition, the tradition of the pastoral, the sublime, the Arcadian. Fulton, Drury, Long and Nash are Romantic, in the

sense of British Romantic poetry (Blake, Wordsworth, Keats, Shelley, Coleridge); in the sense of the British Romantic painters (Turner, Constable, Girtin, Cotman, Wilson); and in the sense of the Romantic attitudes and aspirations of infinity, nostalgia, mythology, soul, magic, nature and the Gothic. In sculptors such as Tony Cragg, Hamish Fulton, Rachel Whiteread, Shirazeh Houshiary, Anish Kapoor, Richard Wentworth, Richard Long, David Nash, Bill Woodrow, Barry Flanagan, Ian Hamilton Finlay, Anthony Caro and William Tucker one can see the elements of British Romantic literature (as well as the Neo-Romanticism of the 1930s and 1940s): the anarchic idealism of Shelley, the luscious sensuality of Keats, the epic nature poetry of Wordsworth, the angelic visions of Blake and the synæsthetic poesie of Coleridge. The Romantic ethics of taking things to extremes, of going to the infinite and the eternal, are very much to the fore in land art, which is an art which quite definitely sustains Romantic myths and tenets.

There is a macho posturing to some land art theory (some of it no doubt unintentional) in which the relationship with nature is seen as 'fundamental', 'raw', 'violent' and 'intense'. British land artists, as well as American earthwork artists, speak of working in nature as difficult, dirty, uncompromising and exhausting. All this talk of raw, powerful essence in nature in British land art recalls one poet in particular – Ted Hughes, the stolid Yorkshireman whose books (*River, Hawk in the Rain, Lupercal, Wodwo, Remains of Elmet*) are full of post-Gerard Manley Hopkinsian evocations of wild shingle beaches, desolate moorland, ancient forests and craggy heights. (In America the poetic reference is Walt Whitman, as well as Thoreau, Longfellow, Twain, Melville and Emerson). If ever there was a poetic equivalent of Goldsworthy's boulders, Nash's oak tripods, Drury's cloud chambers and Long's circles, it is Ted Hughes' verse.

Another link is nature-man Mellors in *Lady Chatterley's Lover*, the no-nonsense outdoor man who is in fact a New Man, painfully sensitive and alive. The D.H. Lawrence connection with Andy

Goldsworthy is emphasized by Goldsworthy himself: in *Stone* he quotes from Lawrence's *The Rainbow,* one of those euphoric, ithyphallic passages about the ecstasy of consummation in an arch (one of Goldsworthy's favourite structures). Lawrence's intensely poetic novel about three generations of a Midland family (his 'Brangwensaga') is a strident inrush of energy into Goldsworthy's otherwise pedestrian prose. Goldsworthy might do better to leave his writing out of his books, and simply use quotes from Locke and Lawrence, as he does in *Stone*. His own pontifications are too often banal.

Land art is the sculptural companion of nature poetry. The connections between poetry and painting are ancient: Chinese landscape painters produced the voids found in *haiku* poetry; J.M.W. Turner and John Martin drew on Romantic poetry for their imagery; Renaissance painters drew on Classical poetry (such as Ovid and Virgil) in their depictions of myths such as Diana and Actaeon, or Leda and the Swan (Jupiter). While poetry and painting are often aligned in art history, poetry and sculpture are rarely mentioned. The importance of the British landscape in both poetry and painting has long been noted. Its importance in sculpture is not often acknowledged by art critics.

The relation between poetry and landscape is vividly described by Ted Hughes in his book *Poetry in the Making*. Hughes has many affinities with land artists, particularly the British ones: Hughes, and other British nature poets (Tony Harrison, Seamus Heaney, Alan Bold), celebrate rainy, grim, Northern landscapes, as beloved of Wordsworth, Clare and Coleridge. Hughes uses Gerard Manley Hopkins as an example of first-rate, visionary British landscape:

> In this... poem there is much more of what we might call straightforward description, but the vivid details are all aiming one way: it is a scene in sharp focus: all gloom and brilliance, the exhilaration and uneasy sunniness of a bleak, rather lonely place. It is the closest thing to a conventional beauty spot that I know of in poetry. And it is so clean and right that whenever I see anything like it in

actual scenery I think – "It's almost as good as *Inversnaid*" which is
the title of this poem by Gerald Manly Hopkins:

This darksome burn, horseback brown,
His rollrock highroad roaring down,
In coop and in comb the fleece of his foam
Flutes and low to the lake falls home.

A windpuff-bonnet of fawn-froth
Turns and twindles over the broth
Of a pool so pitchblack, fell-frowning,
It rounds and rounds Despair to drowning.

Degged with dew, dappled with dew
Are the groins of the braes that the brook treads through,
Wiry heathpacks, flitches of fern,
And the beadbonny ash that sits over the burn.

What would the world be, once bereft
Of wet and of wildness? Let them be left,
O let them be left, wildness and wet;
Long live the weeds and the wilderness yet.4

7

Land Art in the United States

ROBERT SMITHSON

> *Instead of putting a work of art on some land, some land is put into a work of art.*

Robert Smithson[1]

Robert Smithson was the chief mouthpiece of American earth/ site æsthetics, and is probably the most important theoretician among all land artists (he is also the premier land artist). Robert Smithson's theoretical statements were published in three essays. In "The Crystal Land" Smithson recounted a trip he made to a quarry with Donald Judd, the key Minimal artist. Robert Smithson evoked the decayed nature of the quarry, those aspects of entropy which would feature in his own work ('cracked broken shattered earth, of fragmentation, corrosion, decomposition, disintegration, rock crisis, debris slides, mud flow avalanche').[2] In the second article, "Entropy and the New Monuments" (1966), Robert Smithson discussed the important Minimal show *Primary Structures* at the Jewish Museum. Smithson's themes were entropy in nature and art; he used the science of crystals and minerals as paradigms of the new art. Robert Smithson had collected crystals and rocks as a child. Crystallography, for Smithson, offered 'a way of dealing

with nature without falling into the old trap of the biological metaphor'.[3] No wonder, then, that when Smithson saw Donald Judd's pink plastic boxes he compared them to 'giant crystals from another planet' (RS, 19). The dissolution of crystals also provided Smithson with another analogy for his theory of natural entropy. The third piece, "A Sedimentation of the Mind: Earth Projects" (1968), concerned notions of time and place. While sculptors such as Anthony Caro and his ilk still clung to the old-fashioned ideas of beauty, Smithson spoke warmly of artists such as Walter de Maria, Carl Andre, Michael Heizer, Dennis Oppenheim, Tony Smith and Douglas Huebler (RS, 85).

Robert Smithson was also interested in science fiction: the poetic elements of his art thus form a continuum: between the industrial wastelands he visited for his 'non-site' sculptures and the desolate planets of science fiction; between chaos theory in the New Physics and its exploration in postmodern science fiction; between the forms of crystals and Minimal sculptures, and so on. Robert Smithson's exaltation of lonely post-industrial sites was echoed in the speculative fictions of writers who evoked post- or near-holocaust worlds. J.G. Ballard, for example, wrote of post-industrial desert lands and run-down townscapes (in *The Drought, Vermilion Sands, High-Rise* and *Low-Flying Aircraft*). J.G. Ballard, as one would expect, took an eccentric view of Smithson's earth-works: Ballard mused on what kind of cargo might have been berthed at Smithson's *Spiral Jetty* a n d *Broken Circle*. Ballard wondered if the cargo was a 'very special kind' of clock... so many of Smithson's monuments seem to be a potent amalgam of clock, labyrinth and cargo terminal'.[4]

In the essay "Tour of the Monuments of Passaic", itself a sci-fi sort of title, Smithson wrote about 'great pipes, sand boxes, bridges with wooden sidewalks, all standing for the irreversibility of eternity. Under the dead light of the Passaic afternoon, the desert becomes a man of infinite disintegration and forgetfulness' (RS, 56). This sort of apocalyptic imagery is echoed in William Burroughs, J.G. Ballard, Tom Disch and other speculative fiction

111

writers. It's the desolate wasteland imagery of Andrei Tarkovsky's film *Stalker* (1979) and other post-apocalyptic visions.[5]

J.G. Ballard wrote:

> The *Amarillo Ramp* I take to be both jetty and runway, a proto-labyrinth that Smithson hoped would launch him from the cramping limits of time and space into a richer and more complex realm... I see Smithson's monuments [as] artifacts intended to serve as machines that will suddenly switch themselves on and begin to generate a more complex time and space. All his structures seem to be analogues of advanced neurological processes that have yet to articulate themselves.[6]

For Robert Smithson, Andre, de Maria, Heizer, Oppenheim and Tony Smith were 'the more compelling artists today, concerned with 'Place' or 'Site''.[7] Smithson was impressed by Tony Smith's vision of the mysterious aspects of a dark unfinished road and called Smith 'the agent of endlessness'. Smith's æsthetic became part of Smithson's view of art as a complete 'site', not simply an æsthetic of sculptural objects. Smithson was not inspired by ancient religious sculpture, by burial mounds for example, so much as by decayed industrial sites. He visited some in the mid-1960s that were 'in some way disrupted or pulverized'. He said he was looking for a 'denaturalization rather than built up scenic beauty.'[8]

Robert Smithson said he was concerned, like many land (and postwar) artists with the thing in itself, not its image, its effect, its critical significance: 'I am for an art that takes into account the direct effect of the elements as they exist from day to day apart from representation' (RS, 133). Smithson's theory of the 'non-site' was based on 'absence, a very ponderous, weighty absence'.[9] Smithson proposed a theory of a dialectic between absence and pres-ence, in which the 'non-site' and 'site' are both interacting. In the 'non-site' work, presence and absence are there simultaneously. 'The land or ground from the Site is placed in the art (Non-Site) rather than the art is placed on the ground. The Non-Site is a container within another container – the room' (RS, 115).

In a sense my nonsites are rooms within rooms. Recovery from the outer fringes brings one back to the central point... The scale between indoors and outdoors, and how the two are impossible to bridge... What you are really confronted with in a non-site is the absence of the site. It is a contraction rather than an expansion of scale. One is confronted with a very ponderous, weighty absence... There is this dialectic between inner and outer, closed and open, center and peripheral.[10]

Smithson proposed a schema for 'non-site' art in his essay "Dialectic of Site and Non-Site" which ran thus:

Site	Non-Site
1. Open limits	Closed limits
2. A series of points	An array of Matter
3. Outer coordinates	Inner coordinates
4. Subtraction	Addition
5. Indeterminate certainty	Determinate uncertainty
6. Scattered information	Contained information
7. Reflection	Mirror
8. Edge	Center
9. Some place (physical)	No place (abstract)
10. Many	One (RS, 115)

The 'non-site' works were permanent, gallery works. Smithson's *Mirror Displacements* (1968) consisted of putting some mirrors in various settings and taking photographs of them before moving them somewhere else. *Mirror Displacements* was documented in Smithson's *Artforum* article "Incidents of Mirror Travel in the Yucatan". Sometimes Smithson put soil on top of the mirrors, to dirty them up, to sabotage 'the perfect reflections of the sky'. Smithson liked dirt, gravel, sand, sludge and sediment – indeterminate, malleable substances. Land artists often sabotaged the clinical nature of much of art – putting soil or horses in the clean, white gallery space. Of his Italian horse piece, Jannis Kounellis said the aim was to increase awareness of the 'basic nature of a gallery, of its bourgeois origin', its economic and ideological aspects.[11]

Smithson's other projects of the time included putting raw, natural materials into Minimal spaces, creating a tension of dialectic between 'site and non-site', as he called it. *Ziggurat Mirror* was completed by the use of mirrors. The sculpture needed the mirrors to work properly. Using the mirrors to create repetition, Smithson pointed to the delimited nature of the sculpture: with the right use of mirrors, a sculpture could be extended infinitely. Endless repetition was central to Minimal and Sixties art (Warhol, LeWitt, Andre, Morris, Judd, Stella and others took a simple unit and endlessly repeated it).

Before he made the famous *Spiral Jetty* Smithson had already been considering the scientific notions of rotation and equilibrium. His sculpture *Gyrostasis* (1968) was a 75 by 57 by 40 inch painted steel structure based on the spiral. Smithson explained that *Gyrostasis*, as the title implied, was about how rotating bodies maintain their equilibrium. 'The work is a standing triangulated spiral. When I made the sculpture I was thinking of mapping procedures that refer to the planet Earth' (RS, 37).

Robert Smithson's famous *Spiral Jetty* is a 'monumental' earthwork, though the use of the spiral motif has connotations with the ancient symbols of the Goddess.[12] Of his *Spiral Jetty*, Smithson wrote:

> As I looked at the site, it reverberated out to the horizons only to suggest an immobile cyclone while flickering light made the entire landscape appear to quake. A dormant earthquake spread into an immense roundness. From that gyrating space emerged the possibility of the Spiral Jetty. No idea, no concepts, no systems, no structures, no abstractions could hold themselves together in the actuality of that phenomenological evidence.[13]

Smithson was impressed by the characteristics of the Great Salt Lake site, the pinkish mud, the faintly violet water surrounded by limestone hills, and the 'crushing light' of the sun. He had been reading about salt lakes in Boliva, where bacteria turned the water red to match the colour of the flamingos. Smithson found out that

the Utah salt lakes were also red and pink due to algæ and mineral waste. Smithson and his wife, Nancy Holt, surveyed the area and chose a lake at Rozel Point in Utah, which had a number of cracks in the mud under the shallow water. Smithson began building it in April, 1970, excavating 6,650 tons. *Spiral Jetty* was made from rocks, water, mud and precipitated salt crystals. It was 1,500 ft long and 15 ft wide. Smithson was aided by Virginia Dwan and the Ace Gallery of Vancouver. As with many other projects of the time a film was made of the construction of *Spiral Jetty*. Smithson related the work to spiral nebulæ, to salt crystals and microscopic organisms. Smithson thought in terms of eons of time, and mused on how entropy would overtake the site.[14]

Smithson used one of the primary forms of land art, the circle, in many works, combining it with ideas taken from science (such as *Gyrostasis*, which, said Smithson, 'refers to a branch of physics that deals with rotating bodies').[15] Smithson was not adverse to religious feelings about art: when he visited the site of his *Spiral Jetty*, in the Utah salt flats, he experienced a feeling of 'a rotary that enclosed itself in an immense roundness' (ib., 111). The two elements – rational, mathematical, scientific precision and intuitive, emotional, religious feeling – are two of the chief characteristics of land art. On the one hand, land artists talk about measurements, practical details, materials, maps and spatial data. On the other hand, they hint at religious awe, spiritual feelings, prehistoric art and the influx of the numinous into modern art.

Smithson also identified his *Spiral Jetty* with a mythic whirlpool that sprang up from a tunnel connected to the Pacific Ocean. His *Spiral Jetty* was an 'immobile cyclone', it spiralled inwards from the outside: the track leaves the shore and twists round and round to the centre. *Spiral Jetty* was also linked with notions of decay in nature. In "A Sedimentation of the Mind: Earth Projects" Smithson had written '[e]very object, if it is art, is charged with the rush of time, even though it is static' (RS, 90). Ironically, Smithson's *Spiral Jetty* was itself subject to natural entropy: the water level rose and *Spiral Jetty* was submerged under water. It

was ironic too that Smithson died in a plane crash while he was flying over and inspecting a site in Texas.

Smithson's 1971 *Broken Circle* was another large earthwork using circular motifs that was set adjacent to the land and extended out into a lake. Smithson chose a quarry site near Emmen, Holland. Again, the site had an interesting geological aspect, which was in keeping with Smithson's love of rocks and minerals. Glacial action had formed unusual layers of soil. Unlike *Spiral Jetty*, which was subsequently submerged, *Broken Circle* remains on display, and is maintained by local funds. It is a 140 foot circle comprising one half of soil and one half of water, with a twelve foot wide canal cutting round the earth section of the circle, forming a semicircle. At the centre of *Broken Circle* is a very large glacial boulder. It was supposedly one of the largest in the Netherlands. Significantly, Smithson allowed nothing at the centre of *Spiral Jetty*: the spectator walked round the inward-turning spiral to find nothing. Smithson was exasperated by the prehistoric stone at the centre of his *Broken Circle*, but he let this 'accidental center' stay there, commenting 'it became a dark spot of exasperation, a geological gangrene on the sandy expanse'.[16]

Smithson's last major work, before his untimely death, was *Armarillo Ramp*, one of many land artworks conceived as an observation structure. Nancy Holt worked with one of the major American sculptors of the era, Richard Serra, to complete Smithson's plans. *Amarillo Ramp*, 15 miles North-West of Amarillo in the Texas Panhandle, is a huge inclined ramp or road, made from quarried rocks. The summit of *Amarillo Ramp* is a viewing point.[17]

Taken together, Smithson's three large-scale earthworks, *Spiral Jetty*, *Broken Circle* and *Amarillo Ramp*, all revolve around circular or spiral motifs, a sense of temporality, of decay and transience, and each uses primitive, mythic forms and gestures in a monumental manner. Two of them are set in wilderness spaces, where the marks of humanity are at their weakest. Yet each earthwork of course speaks acutely of the mark of humanity upon the Earth, and a very particular kind of mark: that of late 20th

century American art-making.

Robert Smithson's influence on land art has been immense. One example would be Andy Goldsworthy's Durham earthwork *Maze* (1989, at Leadgate), which draws as much on the legacy of Smithson's art as also on ancient mythology and symbolism. It uses the labyrinth motif. Goldsworthy's *Maze* can seen a part of the resurgence of interest in mazes which occurred in the 1980s (aligned, as ever, with green/ eco-logical/ occult/ New Age trends). New mazes were commissioned, and 1991 was designated the 'Year of the Maze'. Like *Lambton Earthwork* (but unlike most of Goldsworthy's works), *Maze* was intended to be used by the general public. As with Smithson's *Broken Circle* or the *Armarillo Ramp* the public was invited to walk around Goldsworthy's earthworks. Both *Maze* and *Lambton Earthwork* were about responses to the energies in nature – thus the public was invited to explore similar things as they physically walked around the earthworks. Goldsworthy also designed an earthwork which was a curving ramp, exactly like *Armarillo Ramp*, though on a much smaller scale. Robert Smithson's influence on land art has been immense, probably more than any other single artist.

JAMES TURRELL: SKYSPACES

James Turrell's *Roden Crater Project* – 'skyspaces', tunnels, observatories and chambers in an extinct volcano near Flagstaff, Arizona – was (is) one of the biggest works of land and environmental art. Begun in 1974, it was funded by many different sources and administered by the Skystone Foundation.[1] The first stage of Turrell's on-going *Roden Crater* project involved bull-dozing 200,000 cubic yards of earth from the volcano's rim, 'so as to shape the sky'. Turrell planned tunnels, pools and viewing chambers at *Roden Crater*. There were spaces at *Roden Crater* where clouds were projected onto the floor during the day, which at night were

117

related to the procession of equinoxes. Many of the spaces planned at *Roden Crater* were built around celestial events, such as full moons, solstices, equinoxes, the movement of the sun, or just being able to view stars and some planets. The connection with the heavens was important for Turrell: most of his works have openings to the sky, and the relationship with the sky is the centrepiece of the works. It's important for Turrell, in short, to see the stars.

The *Roden Crater* work was about the relationship between the viewer and the elements, in particular the sky, celestial events, and light. Turrell said '[m]y art is made for one person. I like the solitary experience. Standing alone at night, perceiving the Roden Crater and the moon and stars, you really feel the vastness of the universe and yourself entering into it'.[2] The environment was a volcano, relating to geological time. 'The work I do intensifies the experience of light by isolating it and occluding all other light. Each space essentially looks to a different portion of sky and accepts a limited number of events' Turrell explained (1995, 67). Thus, each space at *Roden Crater* was designed to highlight some celestial event. The subject of some spaces was the vaulting of the sky, and the curvature of the Earth. Some were about daily events, such as sunrises and sunsets, or the movement of the stars.

The North section of *Roden Crater* is about looking North, the North Star, the rotation of the Earth, changing light, and includes a *camera obscura* (which projects whatever is overhead onto a white sand floor), and a seat for viewing Polaris. The Eastern space is for witnessing sunrise, and a 'skyspace' overhead. *Bath Space* projects a magnified image of the sky above onto a white sand floor, using a water bath above a large sphere as a lens. The *Sun and Moon Room* was constructed around the furthest south moonset (every 18.61 years), the furthest North sunrise and the Summer solstice. *Tso Kiva* is a hemispherical space in the centre of the volcano, for observing light, shadows, shapes and the horizon. The *South Space* is an astronomical observatory and star chart. The *West Space*, as one would expect, is for the sunset, and the 'twilight arch', the

projection of the Earth's shadow into the atmosphere at nightfall. Turrell said he didn't want Roden Crater to be 'a mark upon Nature, but to be enfolded in Nature in such a way that light from the Sun, Moon, and stars empowered the spaces' (1995, 66).

James Turrell's creative task as he saw it was not to impose his own vision or æsthetics on the viewer, but to encourage them to see things for themselves, to create the situation in which they could have their own experience. These were æsthetics common in much of land art. As he said in 1987, the goal was not to turn an experience into art, but 'to set up a situation to which I take you and let you see. It becomes your experience... not taking from nature as much as placing you in contact with it'.[3] Turrell regarded his art as a 'seeing aid', as showing the observer something that was already there but that they might not have noticed.

On the indoor-outdoor debate, which exercised so many land artists, James Turrell said that, instead of bringing nature into the museum, he wanted to 'bring culture to the natural surround as if designing a garden or tending a landscape' (1995, 66). The artwork became something to visit in itself, rather one of many artworks in a museum to see. The viewer travelled specially to see the artwork., as they visited *Double Negative,* or Marfa in Texas, or Robert Smithson's earthworks.

James Turrell's primary material was not earth or stone or the usual materials of land art, but light itself, what he called 'light in the space itself'. Turrell wanted to use light as a thing-in-itself, which had presence, just as the sculptor used a physical object which had presence. He achieved this, he said, by setting limits on the space in which light manifested itself: 'I give light thingness by putting limits on it in a formal manner. I do not create an object, only objectified perception' (1995, 65). Turrell was attempting to create spaces in which viewers could perceive the subject of his works, light itself, and celestial events. It was important also for Turrell that the viewer was able to enter those spaces physically, not virtually. Turrell's art was not about creating illusions or artificial scenarios or a record of the artwork. Turrell

called it 'non-vicarious seeing': '[t]he subject of my work is your nonvicarious seeing. You are not looking at a record of my seeing' (1995, 64). Thus, Turrell's art was not about recording some event that took place elsewhere, or taking photographs of his art, or writing down what happened, as in some land art. Rather, Turrell wanted to place the viewer right into the artwork, to have them able to walk into and around the artwork, and to experience of the artwork for themselves.

Many of Turrell's artworks were about working with not just light, but with the sky. The archetypal Turrell space was an enclosed area (a 'skyspace') which had an opening above onto the sky. Turrell spoke of the vaulting of the sky, how the sky looked when the viewer was standing up, or sitting down, or lying down.

Some of Turrell's 'skyspaces' – indoor rooms or spaces which are open to the sky above – include *Spaces That Sees* (1992) in Jerusalem, *Heavy Water* (1992, Poitier) and *Razor* (1991, London). *Kielder Skyspace* is open to the public, situated outside the village of Kielder near the Scottish border. Turrell has also constructed pools of water which combine water and light: in these works (at *Roden Crater*, and Poitier, France), the viewer is invited to dive under the water to reach a space beyond which's open to the sky.

James Turrell emphasized the spiritual aspects of light in his land art. 'I am interested in light because of my interest in our spiritual nature and the things that empower us. My art deals with light itself, the bearer of revelation, but as revelation itself' (1995, 64). The kind of effect Turrell was after in his light works he compared to staring into a fire, a kind of meditation or daydreaming. Turrell encouraged the viewer to sit or lie down and contemplate light itself, and the effects of light in a particular space. Thus, the spaces that Turrell constructed were furnished with viewing platforms, or benches, or places to lie down and look up at the sky. Situating the spectator in relation to the subject of the artwork (light itself) was Turrell's goal.

As well as drifting off by looking at a fire, Turrell also often spoke of the experience of flight, of being in a plane and rising

into new zones of light, different kinds of light. Turrell also spoke of the curvature of the Earth when seen from a plane (and how, between 600 and 3,000 feet, the Earth seems to curve the wrong way). The Roden volcano was chosen partly because of its relation at that particular place in the Painted Desert to the curvature of the Earth. The low mound of the volcano and its relation to the curvature of the Earth and the sky above had the right mixture of components Turrell was seeking.

DENNIS OPPENHEIM

Like Robert Smithson and James Turrell, Dennis Oppenheim was one of the most interesting of US earth artists, an artist who produced an amazing body of work. It's significant, for instance, that Dennis Oppenheim was the first US land artist to work with snow on a grand scale. Oppenheim began making snow works in the late Sixties. The only other important environmental artist who regularly used snow and ice, really, was Hans Haacke. But, more than any of the other first generation land artists, Oppenheim made snow one of his primary media.

Oppenheim's *Annual Rings* (1968), a series of concentric circles that straddled the Canadian/ American border, was made with snow (one of Oppenheim's recurring motifs was the border zone, margins and thresholds in time and space and concept). Oppenheim has drawn a number of snow works with a snowmobile: *One Hour Run* (1968) was a continuous track made in the snow in Maine. Two tracks, side by side, were carved in the snow between Fort Kent, Maine and Clair, New Brunswick, Canada, in 1968, for *Time Line*, a work which explored the different time zones. Oppenheim's *Negative Board* (1968) was a dark cut in the snow and ice in Maine.

Oppenheim burnt circles onto grass in *Branded Mountain*. *Accumulation Cut* (1969) was made at Cornell University: a hund-

red foot long cut made in the ice, running away from a waterfall. Also at Cornell, Oppenheim took the floor outline of gallery 4 of the Andrew Dickson White Museum of Art and drew it into the snow and ice outside (1969). Another *Gallery Transplant* was made in 1969, transplanting the floor plan of a gallery in the Stedelijk Museum in Amsterdam to a snowy hillside in New Jersey.

Oppenheim's *Whirlpool Eye of Storm* (1973) was an ephemeral piece of land art in the Hans Haacke vein: a jet trail created the sky by a plane flying above the desert at El Mirage Dry Lake in California. *Directed Seeding* (1969) parodied Action Painting by harvesting a wheat field. In *Cancelled Crop* (1969) Oppenheim cut a giant 'X' in a field in the Netherlands, and kept the grain, as if he were preventing the material he'd cultivated for his art from becoming the raw material for other (illusionistic) art: 'isolating this grain from further processing becomes like stopping raw pigment from becoming an illusionistic force on canvas'.[1] Another 'X' was laid onto the landscape at El Mirage Dry Lake out of asphalt primer (covering an area 610 metres square), entitled *Relocated Burial Ground* (1978) (The 'X' shape, as Lucy Lippard noted, was a favourite motif with male land artists: Chris Burden, Richard Long and Robert Smithson also created 'Xs').[2]

Many of Oppenheim's artworks are conceptual pieces in the great tradition of Sixties Conceptualism. That is, many are works made to be exhibited in galleries, on walls. They comprise photographs, drawings and maps, with Oppenheim's typewritten captions and explanations: *Three Downward Blows* (1977), *Salt Flat* (1969), *Boundary Split* (1968), and *Negative Board* (1968) (maps were central to Oppenheim's art). Many of Oppenheim's land artworks also existed as these framed photo-text-sketch-map works. One of Oppenheim's specialities was to impose humanmade geometries, symbols and ideas onto the landscape: to transpose map contours, for instance, or the rings of a tree trunk onto snow (in *Annual Rings*), or the International Date Line in snow (*Time Pocket*). Robert Smithson remarked that Oppenheim was 'transforming a terrestrial site into a map'.[3] Generally, Oppenheim tended to enlarge

symbols or ideas or images, and recreate them on a colossal scale in the landscape.

In *Time Pocket* (1968) Oppenheim 'drew' the International Date Line with a diesel-powered skidder in snow in Maine. In *Boundary Split* (1968) Oppenheim carved lines perpendicular to the Time Boundary between Canada and the US. *Star Skid* (1977) was Oppenheim's proposal for a series of concrete and glass stars that would look from the air as if they had landed on Earth and skidded to a halt.

In *Salt Flat* (1969) Oppenheim created a 'salt flat' (a favourite place for land artists to make work in the US) in New York City, with a thousand pounds of salt. The rectangle of salt was recreated in the sea in the Bahamas, and in the Salt Lake Desert. In *Directed Harvest* (1969) Oppenheim carved up fields of crops. Oppenheim set off underground explosions in *Three Downward Blows (Knuckle Marks)* in Montana in 1977.

In *Ground Mutations – Shoe Prints* (1969) Oppenheim created shoe print works over the course of three Winter months (by wearing shoes with a 1/4 inch groove cut in the sole and heel): 'I was connecting the patterns of thousands of individuals... My thoughts were filled with marching diagrams'. The use of shoes and prints links with Andy Goldsworthy's direct use of the body and Richard Long's walks.

Speaking in 1970, Oppenheim opined that art now 'more concerned with the location of material and with speculation' (i.e., locations or ideas). Now, art was meant to be visited (location) or 'abstracted from a photograph' (conceptualized).[4] Oppenheim moved towards a kind of art that would be discovered or visited by the spectator, rather than 'made' in the old, traditional manner (this was part of the 'dematerialization' of the art object in Sixties art). Oppenheim moved away from the idea of the special, unique art object, towards found objects, and utilizing existing sites. Oppenheim was replacing objects with locations. The *Site Markers* series (1967) comprised posts in locations which were documented with texts, maps and photos. The maps and photos explained

where the posts were situated, so that the location, rather than the object, became the centre of the piece. As Oppenheim pointed out, the *Site Markers* works were intended to be about the sites themselves, rather than the manipulation of replication of an object: 'beginning with the site-markers started in a sense a journey: art is travel'.[5]

One of Oppenheim's more Conceptual pieces (*Sound Enclosed Land Area*, 1969) comprised four tape recorders buried in cages in Paris enclosing an area 500 by 800 metres. Each machine played a tape loop which had voice repeating its position (North, South, East or West). *Contour Lines Scribed in Swamp Grass* (1968) transposed contour lines on a map in two different locations (a swamp and a mountain). The use of aluminium filings poured onto grass in concentric circles recalled Long's stone circles.

The contours of Oppenheim's own thumbprints were the basis for *Identity Stretch* (1970-75), where a truck sprayed white paint on the ground, using the thumbprint (which Oppenheim had elongated) as a guide, within a grid. In 1970 Oppenheim created a performance piece, entitled *Parallel Stress*, made between a collapsed concrete pier and a wall at Manhattan and Brooklyn bridges. Oppenheim stretched his body between the wall and the pier, echoing the New York bridges nearby. The same body position was recreated at an abandoned sump in Long Island.

Like many land artists, Oppenheim produced a maze (in 1970). But Oppenheim's *Maze* was just a little different: it was the design of a maze used in a scientific laboratory for rats transposed onto a large field, with cows as the rats, lured around the maze by the promise of food.

CARL ANDRE

Since the 1960s, the statements of a handful of artists have proved to be the most illuminating about 1960s art, and land art in partic-

ular. Smithson, Judd, Morris and Andre have been among the most lucid of theorists among artists (and Clement Greenberg, Michael Fried, Lawrence Alloway, Bruce Glaser, Mel Bochner, David Bourdon, Lucy Lippard and Harold Rosenberg among art critics). Carl Andre has many pertinent things to say about sculpture. His mid-1960s summary of the history of sculpture applies directly to land art:

> The course of development
> > Sculpture as form
> > Sculpture as structure
> > Sculpture as place.[1]

Andre's biography is often cited in accounts of his art. He worked on the railways, as a freight conductor and brakeman (in Newark, at the Pennsylvania Railroad) from 1960-64, and this is used to explain Andre's use of modules and units which join together to form a work. Like Sol LeWitt and Donald Judd, Andre took one unit and multiplied them until he had a line or a square. Before working on the railroad, Andre was 'a wood-carving disciple of Brancusi', carving chunks out of wood beams. For a long time the shadow of Brancusi lay over Andre's art. When he came to explain his floor-standing works, such as *Lever*, a line of firebricks, he said he was 'putting Brancusi's *Endless Column* on the ground instead of in the sky... Most sculpture is priapic with the male organ in the air. In my work, Priapus is down on the floor. The engaged position is to run along the earth'.[2] The sexualization of sculpture in Andre's remark is no accident: Andre has spoken in interviews that the best creative work is erotic. In a 1970 radio discussion (with Lucy Lippard, Douglas Huebler, Dan Graham and Jan Dibbets on WBAI FM), Andre said desires, not ideas, were important. 'I have very few ideas, but I have strong desires.... I agree with Dr Guillotine that all ideas are the same except in execution... You can't cut off desires except painfully'.[3] Nature was also crucial: Andre said he disliked Conceptual art because it was cut of from nature (ibid.). Andre said his art 'has

never been conceptual in any way'.[4]

While he was in New Hampshire in 1965, canoeing on a lake, Andre (apparently) realized that sculpture ought to be level, like water. After this, most of his sculpture was floor-standing and flat. Andre did not make boxes in the usual Minimal manner. Andre's sculptures were modular in the sense that one piece could be removed and put somewhere else without altering the whole (Andre's 'anaxial symmetry'). Lines of bricks or squares made from plates of metal were typical Andre works. Andre's use of materials was not 'poetic' or 'spiritual' in the usual sense of the word. In works such as *Cedar Piece* (1959/ 64), *Pyre* (1971, S. & C. Gilman), *Herm* (1976, Guggenheim), *Stile* (1975) and *Well* (1964), which were made out of wood, Carl Andre was using materials as themselves, but 'not to evoke nature'.[5] Andre did not intend his materials to refer to other things, to be allusive in the art historical or lyrical sense. His Styrofoam planks were not alluding to marble, as some viewers mistakenly thought.[6]

Carl Andre's notion of the 'dematerialization' of sculpture was central to his art, and also to land art. When they were not being exhibited, Andre's sculptures simply disappeared. They were not objects on permanent display, but were made specially for each occasion and space. Most land art is like this. Andre's works outside of shows exist as ideas, photographs, descriptions, memories, and so on, but not as actual works. Much of land art is also this ephemeral, made for a particular occasion then dismantled (Christo, Drury, Morris). This emphasis on the materiality and dematerialization of his works lead Andre to regard his art as non-spiritual. He said:

> My work is atheistic, materialistic, and communistic. It's atheistic because it's without transcendent form, without spiritual or intellectual quality. Materialistic because it's made out of its own materials without pretension to other materials. And communistic because the form is equally accessible to all men.[7]

This is a humble, self-effacing view of his own art. His art was

materialistic, Andre said, because it does not pretend to be anything else other than itself. However, at other times (in interviews, for example), Andre comes across as a warmly Romantic artist. It is this aspect of his art that annoyed people when the Tate Gallery in the UK bought, with public money, one of his piles of bricks. The form (a low oblong shape) and the material of the work (brick) seemed available to anyone who visited a household supply store and bought a few hundred bricks and arranged them in a certain way. Yet Carl Andre's art is of course not as simple as that, and not as easy to produce as that.

Carl Andre's *37 Pieces of Work* is a good example of Minimal æsthetic permutations taken to extremes. It is a sculpture that is typical of Andre's art:

> Taken as a whole *37 Pieces of Work* consists of 1,296 plates, 216 each of aluminium, copper, steel, magnesium, lead and zinc. Each metal appears alone in individual six-foot square plains. Then alternates with another, checkerboard fashion, in every possible permutation. Since each of the six metals in the large piece was laid out in the alphabetical order of its chemical symbol, alternating successively with the others, there are two versions of each combination.[8]

Many of Carl Andre's floor-pieces are similar (*Twelfth Copper Corner*, 1975, *Brooklyn Field*, 1966, Belgium, *8 Cuts*, 1967, Switzerland): the spectator is aware of the material first and foremost: the colour, mass, weight, size and texture of the metals. *37 Pieces of Work* is a 432 inch wide 'floor-hugging' square, in which the colours of the copper, aluminium, lead, steel, zinc and magnesium is to the fore.

Andre's *Element* series consisted of wood-carved beams that recalled Brancusi; Andre's *Equivalents* were 'floor-hugging' sculptures shown in 1966. The magnet pieces, which preceded the metal squares, also hugged the floor, so much so that the third dimension was nearly expunged. The floor-pieces neatly rid the sculptor of dealing with pedestals. They became 'place-markers'.[9] They have no space, according to one critic, they have 'no

appearance of inside or center. Rather they seem to be coextensive with the very floor on which the viewer stands'.[10] Place, not space or sky, became what matters for Andre. Andre's floor-pieces are viewer-friendly, too: the viewer is invited to (or allowed to) walk over them. Like Judd, Andre wanted his sculptures to be seen from a variety of viewpoints. Instead of a single viewpoint, one could have a number of angles; he compared viewing his sculptures to walking on roads: '[t]hey cause you to make your way along them or around them or to move... over them' (1970, 57).

Andre's works seem to be slight, almost insubstantial, but, simultaneously, 'their matter-of-factness that makes them in a multiple sense *present*'.[11] Stella influenced Andre's way of making sculpture: Andre often stayed with Stella in the early years, and worked in Stella's studio: when Andre was working on a large log, Stella told him that unworked wood could be sculpture too. Andre considered what Stella had said, and thereafter used materials in an untouched state, 'using them as 'cuts' in the space that surrounds them, shaping the space itself'.[12]

Carl Andre's works are extremely sensuous, with their shiny or dull surfaces of copper, zinc, steel or aluminium. Andre's *Sixteenth Copper Cardinal*, sixteen square copper slabs, is a work that could be described as luscious. People are used to marble and stone being beautiful, and also certain metals – bronze, silver and gold in particular have been central to sculpture for millennia. Why not zinc and copper, too? After all, much jewellery is made from copper. Carl Andre, like other Minimal sculptors, introduces the viewer to the sensuality of copper, bronze and zinc shaped into nothing more than... a simple shape, like a slab, put on the floor. Andre's slabs are not 'narrative' or anthropomorphic or literal or allusive; they do not 'depict' animals or gods or people; but they are no less beautiful, as objects in their own right. Spectators are invited to walk on his sculptures, offering a new relation with the work.

If land art is in a gallery, one sees it as art (and a particular kind of Western, bourgeois art, the sort of art that is exhibited in

Western, bourgeois galleries). Carl Andre explored the relation between real and represented objects with his controversial pile of bricks. The sculpture was 'controversial' because the general public (whoever they are) perceived, via the media, that Andre had simply stuck some bricks into a gallery. Or rather, that taxpayer's money had been used to purchase Andre's bricks. A pile of bricks on a building site is... a pile of bricks. A pile of bricks in an art gallery is... sculpture. Context is everything here. This is what Carl Andre explored, whether consciously or not: the *response*, affected by so much of culture, socialization, physical context, education, and so on, makes objects sculptures. People make art. A leaf simply exists, but if someone puts it in a gallery or an art book, it becomes art (as well as remaining a leaf). If people think something is art, then it's art, as Donald Judd said.

Andre commented, '[t]he materiality, the presence of the work of sculpture in the world, essentially independent of any single individual, but rather the residue of many individuals and the dream, the experience of the sea, the trees and the stones – I'm interested in that kind of essential thing'.[13] ('I will try to have in my work only what is necessary to it' Andre said [1984]).

Carl Andre's *Stone Field* (1977) was one of his site-specific works of the 1970s, consisting of 26 very large glacial boulders (one of his more obviously land art works). It was an imposing piece, introducing the idiosyncratic, organic shapes of nature into the 'geometric wilderness' (D.M. Thomas's term) of the city (Hartford, Connecticut). Andre made a line of hay bales, placed end to end, in a field in Vermont (*Joint*, 1968).[14] It was a line like Richard Long's stone rows, or Tony Cragg's floor spreads. 'Many of the activities in farm work are sculptural: stacking the hay bales, ploughing fields, feeding animals; also the marks left behind by the animals or made by farmworkers, tractors... the texture of the land' Goldsworthy remarked.[15] Andre made one of his floor pieces of slabs of metal deliberately so it would be altered by being outside. It was called *Small Weathering Piece* (1971), and contained a large number of metals (large for an Andre sculpture):

lead, zinc, aluminium, copper, steel and magnesium.

One of Carl Andre's most intriguing theoretical statements is this: 'my ideal piece of sculpture is a road'.[16] This applies not only to Andre's lines of bricks or hay bales, but to Long's lines of stones and walks along roads, to Christo's *Running Fence,* to Golds-worthy's stone walls, and to other land artworks. Andre's notion of the ultimate earthwork as a road has a parallel with the famous anecdote of US artist Tony Smith who, when driving along the New Jersey turnpike, was impressed by the 'dark pavements moving through the landscape of the flats, rimmed in the distance, but punctuated by stacks, towers, fumes, and colored lights'.[17] Something in such a long stretch of empty roads, as with airstrips (and, more dubiously, a drill ground at Nuremberg) impressed Tony Smith, who wrote '[i]t seemed that there had been a reality there that had not had any expression in art'.[18] Roads are not 'art', not wholly functional either – they have an aura or mystery which Smith tried to explain. Richard Long emphasizes the functional or workaday aspect of his walks. He sees his walks as hard work; roads, in the Tony Smith view, are also for and about labour and functionality. The road, for the Minimal or Process artist, in the Carl Andre manner, embody materially the sense of a sequence or process. One unit (the foot or brick or slab of tarmac or concrete) is placed next to another, forming a road. Artists such as Carl Andre (and LeWitt, Bladen and Judd) did exactly the same, putting one unit next to another, creating a line or sequence of units.

The road also may have no obvious end: endlessness was crucial to Minimal, Process and Conceptual art, as it is to land art. Many land artists emphasize art that goes on and on. Christo's fence, for example, goes on and on for 26 miles. One imagines that Christo would love a fence that could run across a whole country, or, even better, a whole continent. Similarly, Long's walks could extend far beyond their limits, and the modular art of Judd, Bladen, Morris and LeWitt could expand indefinitely, once the basic pattern had been established. The seriality or endless process of art was identified by Judd as the idea of 'one thing after

another'.[19] Andre's concept of the road as the ideal artwork fits in with this urge towards endless process and seriality. The road motif also fits in well with stereotypical American culture, with its love of the 'open road', Robert Frank's famous photograph, road movies (*Easy Rider, Duel, Thelma and Louise, Natural Born Killers*), the frontier spirit (in Westerns), and in hippy and beatnik culture (Jack Kerouac's *On the Road*, Allen Ginsberg and the 'dharma bums' who drifted around from state to state).

NEGATIVE PRESENCE: ROBERT MORRIS

Robert Morris is the genius of negative presence and the perversity of odd proportions that are subliminal in their aggressiveness. Works of art can in some sense be defined as those man-made objects that are designed solely to call attention to themselves. In this age of bombast, chatter, and random activity, that which does not move and that which is silent is often that which compels our attention and stimulates our awareness most effectively. Donald Judd, too, appears to have this "anti-art," pro-silence bias, and his works, although scrupulously elegant, are a well-formulated attack on "artistic" cliché.

John Perreault[1]

Robert Morris was one of the most eloquent theorists of Sixties, Minimal and Postminimal sculpture (along with Donald Judd and Carl Andre). Robert Morris had, like Donald Judd, begun by working in painting, but moved on to sculpture. Morris studied at Kansas City Art Institute, California School of Fine Arts and Hunter College, New York. In San Francisco in 1961 he worked with the dancer Anna Halprin. He was part of the Fluxus school, alongside Yoko Ono, Simone Forte, Walter de Maria and Henry Flynt. Morris wrote many artistic statements, the most famous probably being the articles published in *Artforum* entitled "Notes on Sculpture". For Morris, one of the things that was new about 1960s sculpture was the object's relationship with the viewer.

131

Before then, Morris argued, the viewer related to the object as something separate; the new æsthetic put the viewer into the same space as the object. 'One is more aware than before that he himself is establishing relationships as he apprehends the object from various positions and under varying conditions of light and spatial context.'[2] This is a crucial concept in Minimal art, which is nearly always viewed in an object-viewer continuous space.

Robert Morris's concept of 'objecthood' was central to his notion of sculpture. 'Morris wants to achieve presence through objecthood, which requires a certain largeness of scale, rather than through size alone' wrote Michael Fried (1967). Just as important as the object itself was the sense of space around it, the spatial context in which it was displayed. Robert Morris wanted to emphasize that 'things are in a space with oneself', rather than the notion that 'one is in a space surrounded by things' (ib., 127). The whole context of the object in its space ('the entire situation') was important to Morris's notion of the new sculpture. One might say the new, 1960s sculpture, like land art, was about the 'thing in itself', a notion borrowed from Existentialism, but also about the 'thing in its space'. Although Robert Morris denied being an 'environmental' artist, the context was important to his art.[3] For one critic, Morris's sculpture 'redirect[s] the entire environmental experience'.[4] Referring to Donald Judd's "Specific Objects" article, Robert Morris said he did not separate the two, he did not think that something must be either an object or an environment.[5] As he moved towards Postminimalism, Morris advocated doing away with a figure-ground relationship; instead, heterogeneous 'stuff' should be used, an 'accumulation of things or stuff'.[6] In 1975 Robert Morris wrote "Aligned with Nazca", an article in one of the key magazines of the period (*Artforum*) which related earthwork art with ancient art such as the Nazca lines. However, such connections with ancient art had already been made by artists and critics of land art.

Robert Morris's sculptures were often simple polyhedrons, such as cubes, circles, ovals and beams. They were modular and

serial. 'Unitary Objects' he termed them, recalling Judd's 'Specific Objects'. They appeared to be 'simple'; as with Donald Judd's sculptures, Morris's did not seem to be hiding anything. Yet just because they appeared 'simple' did not mean that their effects were simple: 'simplicity of shape does not necessarily equate with simplicity of experience' wrote Morris,[7] and Minimal art proved him right. Morris's art was by turns ironic, blank, unambiguously clear and frustratingly amorphous. Morris's *Battered Cubes* (1965/88, Margo Leaven Gallery, Los Angeles) were four boxes of painted steel that were set near each other. Each unit had a gently sloping outside face. His Unitary Objects were fashioned from materials such as wood, concrete, wire mesh, aluminium and granite. Morris also made felt works which could not be arranged the same each time, which determinedly refused to be locked into the Minimal æsthetic of straight edges and regularity. The felt was partly haphazard, relying on gravity, but it was also stiff enough to stay roughly where it was put. It was not final, but malleable.

Among Robert Morris's stranger concepts was his 'mobile' mausoleum: in an aluminium tunnel 3 miles long a coffin made from iron and suspended from pulleys would be moved intermittently. An attendant with a magnet would shift the coffin from above. By the entrance to the tube would be swooning maidens in marble, carved in the style of Canova.[8] 'If something is still capable of moving, is it dead?' Morris wondered.[9]

Morris produced some works of a highly 'ephemeral' nature, such as his 'steam piece' (*Untitled*, 1968-69), which was made out of doors on a patch of grass. How the work turned out was dependent upon physicalities such as humidity, air pressure, wind speed and direction, and temperature. Clouds of steam drifted over the grass.

British artist Rose Finn-Kelcey has produced a steam work: her *Untitled* (1992, London) comprised of water placed on a sheet metal base, with an extractor hood hung above it. In between the two was a cloud of steam, made dramatic by the lighting. Some of Hans Haacke's most intriguing works were with ephemeral

natural events such as steam, ice, condensation, fog and flooding. Peter Hutchinson made a cloud piece (*Dissolving Clouds*, 1970) using Hatha yoga meditation techniques, trying to dissolve clouds through thought. The work consisted of a sequence of 6 photographs of clouds. Alice Aycock also made a *Cloud Piece* (1971), photographs of cumulus clouds which melted after a few minutes.

Robert Morris's *Box With the Sound of Its Own Making* (1961) was precisely that: inside the box was a tape lasting 3 hours which replayed the sound of the box being constructed. The past history of the box and the processes which went towards its construction became available to the viewer – a new way of displaying self-reflexivity. Morris's *Box With the Sound of Its Own Making* combined the personal touch valued by modernism (the sound of the carpentry and hand saw); an emphasis on the process of manufacture, important for Sixties art (process, materiality); and the use of technology (the tape recorder), valued by Pop Art. *Box With the Sound of Its Own Making* was also a kind of performance art, and it was also the primary structure of Minimal art, the cube. For Frank Stella, the artist is a privileged participant in the making of art: the 'audience' or viewer is always one step away, is always 'after the fact': '[t]he sensation is one that the artist experiences as the first and only necessary viewer' (1986, 127).

Morris's *I-Box* (1962) was a jokey comment on Sixties art, on Constructivism and Minimalism. Morris's *I-Box* featured an I-shaped door which revealed a photo of Robert Morris in the nude, smiling. The Duchampian nature of Morris's *I-Box* recalled those paintings of Jasper Johns' which included bits of human anatomy (an arm, a pair of testicles) in amongst otherwise abstract works. The *I-Box* also recalled Johns' *Target* which put male genitals in a little niche above the target.

Robert Morris's *Untitled* (1968) was a pile of cotton waste and mirrors. The mirrors were seen sticking up in the cotton. An *Untitled* of 1969 comprised of little trees in soil set in rectangular boxes of steel; above the trees hung fluorescent 'grow' lamps. These works interfused the human or 'artificial' (the lamps and

mirrors) with the 'natural' or organic (the cotton and trees). A number of Robert Morris's works were what appeared to be piles of concrete and wool, large oblong blocks piled up on top of each other. Robert Morris produced both indoor and outdoor versions of these sprawls of oblong blocks. Sometimes they looked like the stacks of timber at a wood merchants on the outskirts of a town, or the detritus that's thrown into heaps beside sidings at railway stations. Morris's later works (in the Nineties) included wall drawings made blindfolded, and felt works, where an element of randomness and chance dictated how the felt strips would hang.

Robert Morris preferred not to give titles to many of his works. Instead, he employed the most common title for modern art: *Untitled.* He said:

> I think that the reason I don't title them is that I don't think the work is about allusions. And I think titles always are. And I think the work is very much about *that* thing there in space, quite literally. And titles seem to me to have some allusion to what the thing isn't, and that's why I avoid titles.[10]

In *Pace and Progress,* Robert Morris produced a work by walking a horse back and forth over a piece of grass until a path had been worn. The action of walking the horse rubbed down the grass. One of Morris's largest commissions was the *Grand Rapids Project,* in Michigan (1973-74), consisting of huge ramps leading up to a plateau. Another large Morris sitework was created in King County, Washington (1979), a series of oval terraces recalling Iron Age hillforts.

Morris's later works included the felt sculptures, where an element of randomness and chance dictated how the felt strips would hang. Each installation would be different. Some of the later felt pieces used thick felt (such as in *Untitled 1996* [collection: the artist]). Another work entitled *Untitled 1996* (collection: the artist) was modelled, the felt being draped symetrically over a pole. *Untitled 1996* recalled a human figure.[11] Morris's wall drawings were made by the artist covering his hands with graphite and

dabbing them on the wall blindfolded. The large areas of smeared graphite (in *Blind Time IV*, 1991, for example) recall Richard Long's mud wall drawings. The links between Morris and other land artists would include an emphasis on spontaneity, materiality, chance, randomness, change and ephemerality.

NEW STONE CIRCLES: NANCY HOLT

Nancy Holt married the key earthwork artist, Robert Smithson, in 1963. She worked with him on his non-site projects, including the famous *Spiral Jetty* and *Amarillo Ramp*. Nancy Holt's art, with its large, heavy landscaping gestures (such as her *Dark Star Park*), is comparable with the male land artists. The globes and pools of water, though, are traditionally seen as 'feminine' volumes, but here given a new, monumental turn. Holt's art concerns the movements of the heavens. Her sculptures focus the viewer on the motions of the earth, moon, sun and stars. Holt's art is concerned with the notion of time, in particular with geological time, the relation between time and the Earth. Holt was impressed by the desert when she visited it in the late 1960s with Smithson and Michael Heizer.

> Time is not just a mental concept or a mathematical abstraction in the desert. The rocks in the distance are ageless; they have been deposited in layers over hundreds of thousands of years. Time takes on a physical presence.[1]

Nancy Holt has said she is interested in 'conjuring up a sense of time that is longer than the built-in obsolescence we have all around us.' Hence she uses long-lasting materials, such as steel and rocks. Using enduring materials does not stem from a sense of vanity, of wanting one's works to last forever, but rather because Holt wants to create a sense of time that extends beyond the human lifespan.[2]

While working on Smithson's enormous *Amarillo Ramp* after his death in a plane crash, Holt developed the idea for the gigantic *Sun Tunnels*, 18 foot long pipes that were 9 feet high with many holes punched in the side, to let light in.[3] She searched for a suitable site – a desert floor surrounded by low hills. The site she chose (and bought) was in the Great Basin Desert of Utah. *Sun Tunnels* was finished in 1976, with holes in the side of each concrete tube 7, 8, 9 and 10 inches diameter. The holes corresponded with star constellations (Capricorn, Draco, Columba and Perseus), as with *Hydra's Head*. During the day the sun creates points of light on the bottom of the tunnels that move. The moon also shines through the holes by night. *Sun Tunnels* links together the movements of celestial objects and the viewer on the planet. Holt said she had the idea for *Sun Tunnels* while being out in the desert and watching the sun rising and setting. The flat desert area evoked 'a sense of being on this planet, rotating in space, in universal time' (1977). It is a cosmological piece of land art, something of an observatory, like the Bronze Age stone circles of Europe. 'I wanted to bring the vast space of desert back to human scale' (1977). The astronomical observatory has been an enduring theme in land art. Robert Morris, Michael Dan Archer, Julia Barton and Andy Goldsworthy have also made viewing sites.

Nancy Holt's *Hydra's Head* (1975) also concerned the relation between the heavens and earth. Next to the Niagara River at Art Park, Lewiston, New York, Holt sank 6 concrete tubes into the soil. Each three foot pipe was filled with water, so they formed circular mirrors flush with the ground. Again, Holt based the position of the concrete pits on a constellation (Hydra). *Hydra's Head* combined the presence and noise of the rushing Niagara River with the reflections of the sky, stars and moon. Holt's concrete pipe sculptures use the prime symbol of change and all things cosmic, the circle. The *Sun Tunnels* are like enormous telescopes or astrolabes, while *Hydra's Head* evokes six fallen stars, the circles of water reflecting the sky and stars.

Holt's romantic evocations of stellar, cosmological themes in

concrete and soil flourished again with *Stone Enclosure: Rock Rings* (1977-78) constructed at Western Washington University Bellingham. Holt's *Stone Enclosure* directly recalled, even emulated, prehistoric stone circles, in particular Stonehenge. Holt used ancient schist rocks, between 200 and 230 million years old (known as brown mountain stone) to construct two concentric rings 10 feet high. In each wall of stone Holt made 4 arches, each 8 feet high, and 12 'portholes'. It was not a large stone ring, in terms of diameter (outer diameter was 40 feet), but being ten feet high it was much taller than most Bronze Age stone circles. The arches and holes provided views to the cardinal points, and to NE, SW, EW, NW-SE.

Holt's *Stone Enclosure* makes the connections with ancient astronomy and stone circle building explicit, not slyly implied, as in much of land art. Holt is clear that she is dealing with the ancient astronomical realities of weather, seasons, cycles, stars and time. Another work, *30 Below* (1980), a tower with arches facing the points of the compass, was positioned around the North Star. The still point in the heavens, the Pole Star, was also one of the keys to *Stone Enclosure*, which, Holt said, related to a true North, a dead centre.[4] *Annual Ring* (1981) was an 'open hemi-dome' of steel bars, 30 feet in diameter and 15 feet high, constructed in Saginaw, Michigan. Again, Holt built the dome to highlight celestial events: the sun at the Summer solstice, the equinoxes, and the North Star. One of Holt's biggest projects was the *Sky Mound*, begun in the late 1980s (the first phase cost $11 million). Situated in amongst Amtrack and NJ Transit train tracks, highways, bridges, the Pulaski Skyway, the New Jersey turnpike, and metropolitan New Jersey and New York, with views over Newark and Manhattan, *Sky Mound* was a converted landfill which Holt turned into an observatory to mark solstices, equinoxes, and the stars Vega and Sirius.

THE UNDERGROUND LABYRINTHS OF ALICE AYCOCK

Alice Aycock's environmental artworks are much more ambiguous and deliberately problematic than Nancy Holt's or Carl Andre's works. Many of Alice Aycock's land sculptures involve underground passages and spaces. In 1972 she constructed a series of underground spaces in *Low Building Made with Dirt Roof (For Mary)* in Pennsylvania. The spectator entered the 20 by 12 feet work through a doorway thirty inches high. The work was experienced by crawling through it. Aycock's intention was to evoke an experience of claustrophia, of being in a cellar. Aycock's works had titles such as *The Machine That Makes the World* (1979), *A Theory of Universal Causality* (1983) and *How to Catch and Manufacture Ghosts* (1979) – Aycock is brilliant with titles.

Alice Aycock's sculpture explored the rationality of machines and technology and irrationality of ghosts and magic.[1] Aycock's 1972 *Maze* had direct parallels with the observatories and labyrinths of Robert Morris, Nancy Holt, Julia Barton and Michael Dan Archer. *Maze* consists of 5 concentric wooden rings, each six feet high, forming a 12-sided labyrinth. Essentially it is a fence maze, the kind that can be seen at theme parks and country houses. However, Aycock's New Kingston, Pennsylvania *Maze* is intended to be a labyrinth of the ancient type, a structure in which one is meant to get lost. Aycock stated that she wanted 'to create a moment of absolute panic – when the only thing that mattered was to get out.'[2]

Aycock's intentions, then, are quite different from, say, Nancy Holt's, who wishes to infuse a sense of celestial contemplation, or James Turrell's, who was after light and revelation. Aycock wants viewers to be confused, even frightened, by her underground passages and mazes. Aycock did not want the viewer to be able to get out of her labyrinth easily (it was partially based on a circular Egyptian labyrinth (designed as a prison), the Zulu kraal and the Amerindian stockade. Aycock also cited a circular Greek temple at Epidarus, a 'Place of Sacrifice').

Aycock has spoken of the relations between her art and her own childhood dreams and fears. Her works recreate disturbing moments from her childhood, such as when she was trapped in a revolving barrel at an amusement park. Aycock's works deal with such moments of fear, confusion, strangeness and risk. Aycock also remarked that her structures were inspired by visits to the Pyramids in 1970 and the Greek tombs at Mycenae, and fantasies of being buried alive.

Alice Aycock's *A Simple Network of Underground Walls and Tunnels* (1975) was made in a corn field at Far Hills, New Jersey. It consisted of 6 square wells in two rows of three excavated out of a 20 by 50 foot area. Two of the wells had 7 foot ladders that enabled the spectator to climb down and explore the dark connecting tunnels. Some of the wells were capped, others were open. The effect was a series of spaces that recalled 'ominous historical precedents, caves, catacombs, dungeons and beehive tombs' wrote Roberta Smith.[3]

Aycock's 1974's *Walled-Trench/ Earth Platform/ Center Pit* was a series of three concentric walls made from concrete blocks. A platform of earth was made between the inner two walls: it was possible to jump onto this platform over the outer pit. Only when the spectator is standing on the inner platform does another aspect of *Walled-Trench/ Earth Platform/ Center Pit* become visible: a tunnel which leads into a dark inner chamber.

The fear and fantasy element in Alice Aycock's land and site work found a new level of ambiguity in her 1976 *Circular Building with Narrow Ledge for Walking*. Again, the spectator was invited to explore this artwork physically (and psychologically). *Circular Building with Narrow Ledge for Walking* was a round structure thirteen feet high. Inside the well were three concentric ledges, only 8 inches wide. The wall went 7 feet into the ground, and was 'no more perilous or threatening than a treacherous cliff' the artist said, reassuringly.[4] Again, the spectator was invited to investigate the work by climbing a ladder outside the building, then edging her/ his way along the ledges. Indeed, the only way to fully

appreciate *Circular Building with Narrow Ledge for Walking,* as with Aycock's other works, was to experience it directly. Aycock experimented with installing guillotines and motorized blade machines in works such as *The Machine That Makes the World* (1979) and later pieces, such as *A Salutation To the Wonderful Pig of Knowledge (Jelly Fish, Water, Spouter... There's a Hole In My Bucket, There's a Hole In My Head, There's a Hole In My Dream* (1984).

The structure *From the Series Entitled How To Catch and Manufacture Ghosts* (1980) was a much larger development of the earlier *How to Catch and Manufacture Ghosts.* It was a combination of steel, pipes, spheres and galvanized drums that drew inspiration from early experiments with electricity and magnetism, Marcel Duchamp's *Bachelor Apparatus,* Montgolfier's balloon launch pad, and an oil refinery on the New Jersey turnpike. A later work, *Tree of Life Fantasy: Synopsis of the Book of Questions Concerning the World Order and/ or the Order of Worlds* (1990-92), drew on influences from Renaissance illustrations of people walking into the sky to Heaven, DNA helices, ancient Indian observatories, and Walter Gropius's designs for theatres.

With Aycock's bewildering and unsettling catacombs and mazes one had to move 'one's body through them', a process which also involved descending back through time and memory.[5] Confronted with the subterranean passage or the *Circular Building with Narrow Ledge for Walking* it is soon apparent to the spectator that one is not dealing simply with an art object to be admired for its formal characteristics alone. Aycock wants the spectator to become physically involved in the sculpture: the physical actions of climbing and scrabbling over and through the sculpture trigger an exploration of one's own psychology and memory.[6] The physicality of the body as a tool for exploration in Aycock's works soon becomes a pretext or an inspiration for an exploration of personal psychology. Spectators are invited to risk themselves in exploring her works. Her land/ site art offers seductive as well as potentially dangerous spaces. Aycock wants the spectator to enter, but then confronts her/ him with a door that opens onto a wall, or

a tiny passage to crawl through, or a ledge over a precipice, or a pit to vault over. Such devices go straight back to childhood, to acts of dare and bravado (such as walking along a high brick wall, egged on by other children).

CELESTIAL SCULPTURE: MARY MISS

Mary Miss attended the University of California at Santa Barbara. In Summer, 1963 she studied sculpture at Colorado College. After graduating in 1966 from the University of California Miss studied at the Rinehard School of Sculpture at the Maryland Art Institute until 1968. Early works included a 'water-line': at Fountain Creek in Colorado Miss suspended a double knot of hemp rope 100 feet over a dry riverbed; every twenty feet were lines of rope. At War's Island in New York Miss threw 15 foot long wooden stakes into the water which were weighted with rocks. In the middle of a wood in Connecticut in 1974 Miss made *Sunken Pool*: it was a circular wooden structure, 10 feet tall, filled with one foot of water in a galvanized steel interior. *Sunken Pool* was sunken because Miss set it in a hole three feet deep and 20 feet across. As with the large site work of Alice Aycock and Robert Smithson, the spectator was invited to explore Miss's *Sunken Pool* physically, either by stepping into the water, or by climbing up the outer part of the wooden structure and looking over the top. Like Aycock's underground caverns, Miss's *Sunken Pool* was secretive, hiding away in a dense wood, with tall wooden sides. It seemed to speak, like Aycock's works, of childhood memories and half-remembered spaces.

Mary Miss's 1978 work *Perimeters/ Pavilion/ Decoys* was constructed in Roslyn, New York, in a field that was part of the Nassau County Museum's ground. *Perimeters/ Pavillion/ Decoys* consists of three wooden towers, which look like tree houses with four platforms on stilts, two mounds of earth, and an underground

space which's accessed by a ladder. The wooden towers are not for climbing on, but for viewing. The tallest is 18 by 10 by 10 feet.

The subterranean atrium was for exploring. It was a 16 ft^2 pit with a seven foot hole acting as an entrance; visitors climbed down a ladder to explore the various underground spaces, some with wooden, others with soil walls. *Perimeters/ Pavillion/ Decoys* was related to Pueblo Indian strucutues, Pompeiian and Mexican courtyards, and Mesopotamian brick complexes. The site explored the physical and psychological aspects of 'inside/ outside, above/ below, light/ dark, open/ closed, nature/ artifice'.[1] Miss's works are often large, spreading over a wide area of ground. In Illinois she created a 5-acre scale work.[2]

DIGGING IN THE DIRT: MICHAEL HEIZER

My work is closely tied up with my own experiences; for instance, my personal associations with dirt are very real. I really like it, I really like to lie in the dirt.

Michael Heizer[1]

Land artworks have proved to be the most arrogant, phallic and patriarchal of postwar productions.[2] Christo works on a gigantic scale, for instance, wrapping buildings or stretching curtains across valleys or surrounding islands. Some of the most phallic, domineering works of land art are by Michael Heizer.[3] In his *Double Negative* (1969-70), his most well-known piece, and one of the most famous examples of land art, he took two chunks out of the earth, a gigantic 'violation' of the planet, in ecological/ green terms.[4] Heizer claimed *Double Negative* is 'the smallest piece I've done in relation to the size of the site'.[5] Heizer directed the gouging out 240,000 tons of earth from the site at Mormon Mesa in Nevada with bulldozers. The cuts are ramps, going down 50 feet through the cliff of the canyon. The spectator can walk down them. The

143

overall dimensions of *Double Negative* are 1,500 x 42 feet. Heizer is very much concerned with *scale*, as well as other formal characteristics of a work. Heizer said he liked working outside because of the scale; he could work large. He also said that '[m]an will never really create anything large in relation to the world.'[6]

Michael Heizer's *Double Negative* is a widely celebrated example of land art. The photographs of it have been reproduced in many art history books. *Double Negative* appeals to trendy 1960s notions of Zen, existentialism, negativity and emptiness. The point about *Double Negative* was its sense of symmetry and relationship, the one cut reflecting the other across the Nevada canyon. Some viewers saw Heizer's enterprise as combining the subliminity and grandeur of Abstract Expressionism with the emblematic forms of Minimalism. American earthworks art re-juvenated the myth of the sublime West.[7] Mary Miss was not convinced. When she looks at the work of Heizer or Smithson 'there's always been an aspect which impedes my relating to it... It's like a mark on the earth'.[8]

Heizer went on archæological digs as a child with his father. He started out with the ambition to be a painter, which he studied in San Francisco. He made his first earthwork in 1967, and accompanied Smithson on geological expeditions. In 1968, Heizer collaborated with Smithson and Nancy Holt on a Super-8 film, *Mono-Lake*. (Heizer had invited Holt and Smithson to his parents' house at Lake Tahoe). Heizer's motor-bike earthwork was entitled *Circular Surface Displacement*; it was made at Mono Lake.

Heizer's other works include gouging huge holes in the ground and putting great chunks of rock in them. *Nine Nevada Depressions* (1968) comprised five cuts in the Blackrock desert, each one twelve feet long in an area 50 by 50 feet. *Munich Depression* (1969) was another cut, a line 15 feet deep. Heizer's *Complex One* (1972) was a huge bunker-like mass of earth built with the aid of two assistants in Nevada. It was 23.5 feet high and 140 feet long. Each end of the hill had a cut-off triangle of reinforced concrete like giant book-ends. Over the work were cantilevered concrete beams. '*Complex One* is a magnificent spectacle. Even its minatory

look, suggesting a bunker, seems proper to the site – the edge of the Nevada nuclear proving-ground' remarked Robert Hughes.[9]

WALTER DE MARIA AND THE *LIGHTNING FIELD*

Walter de Maria made a dramatic land art gesture when he cut a 4.5 mile-long 6 foot-wide scar in the desert in Nevada with a bulldozer (*Las Vegas Piece*, 1969). Commentators have spoken of this cut as a 'wound' or 'scar' on the Earth (a wound in the body of the Earth in its Great Mother persona). The ultimate in ithyphallic, male land art must be de Maria's *Vertical Earth Kilometer*. At a cost of $500,000, de Maria sunk a one kilometre brass rod into the planet. Nothing can be seen of it except a 2 inch brass disc on the ground. The making of de Maria's work is perhaps far more interesting than the artwork itself. It must be the ultimate art statement/ non-statement. De Maria's *Vertical Earth Kilometer* remains practically invisible. It neatly melds two 1960s æsthetic movements: Conceptualism (wow, what an idea, sticking a kilometer of brass into the Earth!) and Minimal art (there's nothing to see of it except... a two-inch brass disc!). Yeah, that's *real art*, a kilometer-long piece of metal stuck into the ground with nothing of it showing except a tiny disc. This is, in Richard Long's words, '[t]rue capitalist art', an art of excessive cost, and maybe excessive waste (it took 79 days to bore the shaft).[1] Shown at Kassel Dokumenta 6 in 1977, de Maria's *Vertical Earth Kilometer* upset British artist Stuart Brisley so much he made *Survival in Alien Circumstances*. This was a hole in the earth dug with his bare hands, which Brisley lived in for 2 weeks, intending to mock de Maria's overblown American earthwork. But then, art has been full of idiotic amounts of money and out-size projects for ages. In 1979 de Maria exhibited *The Broken Kilometer*: 500 brass roads each two metres long arranged in rows on the floor of a New York gallery.

145

Walter de Maria started out as a musician rather than, like many land artists, as a painter or sculptor. He played drums with the art rockers Velvet Underground. One of his early ideas (in 1962) for an earthwork was a mile-long pair of walls that would be 12 feet high and 12 feet apart. De Maria said that 'when you walk between, you can look up and see the sky'.[2] After the four and a half mile bulldozer square cut in the Earth, de Maria made a chalk drawing in the desert.

De Maria's *Earth Room* was a gallery full of dark earth made in 1968 in Munich and later in New York (*The New York Earth Room*, SoHo Gallery, 1977). It consisted of 125 tons of soil, taking up 3,600 square feet, 22 inches deep. This was a vivid (and aromatic) example of bringing the Outside inside, one of land art's key projects. The contrasts were immediate, between the flat, clean, white, controlled gallery space and the 1,600 cubic feet of uneven, 'dirty', dark, organic soil. Roberta Smith said it was a 'shock' to see the soil taking up the interior space usually reserved for things such as furniture and people. 'The dirt carried its own absence, was somehow a living substance'.[3] A related work, *5 Continents Sculpture* (1987-88), comprised white rocks filling an area 42 by 77 feet in a Stuttgart gallery.

De Maria's *Bed of Spikes* (1969) was called 'a piece of Dadaist Sadism' by Harold Rosenberg.[4] *Bed of Spikes*, an installation at the Dwan Gallery, was 153 metal spikes set in five planks on the floor. Interestingly, spectators were asked to sign a release that exempted the gallery for being responsible for any accidents on viewing the installation. *Bed of Spikes* looked forward to *Lightning Field*.

Critic Kenneth Baker called Walter de Maria's most famous work, the *Lightning Field*, the 'grandest Minimalist work of the 1970s' and 'the closest thing to a masterpiece to come out of Minimalism'.[5] De Maria's first *Lightning Field* was sited 40 miles from Flagstaff in Ariz-ona, consisting of 2 inch diameter steel poles, 18 feet tall, 30 feet apart, in five rows of seven. The second, larger *Lightning Field* is a grid of 400 stainless steel poles, 16 along

the width, 25 along the length, each about 20 feet high, set in the New Mexico desert.[6] The poles were set in concrete, one foot below land, able to withstand winds of 110 mph. The site was chosen for its flatness, isolation and lightning activity. The most lightning activity occurs during May-September; there are about 60 days when thunder and lightning can be seen from *Lightning Field.*[7]

Lightning Field is about a mile by a kilometre in size. The poles in *Lightning Field* stand alone, about 220 feet apart. Nothing remains on the ground of the work needed to set them there. The tips of the poles define a plane in space parallel to sea level: the length of each pole varies according to the contours of the landscape. The *Lightning Field* is an exact, mathematically-precise human site laid onto nature, where the poles are tiny mirrors which mark out and calibrate the landscape. The site looks like a scientific or industrial project – like a radio telescope site, say, or a military communications centre. *Lightning Field* is spectacular, with masculine and phallic connotations (lightning is related in symbolism to male creativity, sperm, fire, power and shamanism).

Lightning Field is ambiguously associated with the Dia Art Foundation, which financed its construction. The site recalls technological experiments, while the poles themselves recall Brancusi's *Birds in Space,* and his *Endless Column.* Art critic Kenneth Baker relates de Maria's *Lightning Field* to issues of philosophy and politics:

> The piece also serves as an instrument for intensifying one's grasp of the beauty of the earth… The *Lightning Field* acquaints the visitor with the possibility that beauty may be the only conscionable and feasible refuge from history. That is, the apprehension of reality as everywhere *radiant with its being* may be the only bearable consciousness of life that does not entail repressing awareness of the horrors of our time. Beauty in this sense is just what the *Lightning Field* makes available… (127)

De Maria's *Lightning Field* attracts lightning, and a storm, as anyone knows, is about the most erotic and spectacular phenomenon in nature.[8] May to September is the season of the great

storms in the area, sometimes 'two or three a week cross this field of poles'.[9] Many poets have written of the eroticism of the wilder aspects of nature, among them Goethe, Dante, Pushkin, Villon, Spenser, Plath, Rimbaud, Brontë and Dickinson. In many poems, Peter Redgrove wrote of the sensualism of nature, thunderstorms being particular favourite natural phenomena. This is from 'The Pale Brows of Lightning':

> And lightning opens its shutter but an instant,
> When it catches you burn like a candle,
> What is that lambent shadow fluttering into the woods
> In its own blue light that illuminates primrose
> The ripped tree's flesh?[10]

Joseph Beuys produced a striking piece entitled *Lightning* (1982-85): a gigantic chunk of bronze, narrow at the top, splaying out towards the bottom, as if he was trying to make manifest the bolt of energy leaping down to the Earth. Justin Holland too used lightning in artworks; he collaborated with Westinghouse Electric, making humanmade lightning, and 'seeded' clouds to produce storms. Peter Hutchinson and Alice Aycock also made cloud works.

Incredible as Walter de Maria's *Lightning Field* is, or Christo's wrapped coasts and islands, far stranger and wilder are the constructions of modern science. The gigantic particle accelerators, for instance, where quarks, strangeness and charms are examined, are truly mind-boggling structures. 'Only by battering streams of other particles together in giant underground accelerators has it been possible to generate the energies necessary to create these elusive entities,' wrote Robin McKie.[11] There are plans to produce a Large Hadron Collider, using the existing 26 mile tunnel deep underground in Switzerland. These particle accelerators go far beyond most land art in creating sheer astonishment. Not the least amazing aspect about these circular tunnels is that they are so large, using gigantic machines set in caverns. The ironic thing is that such massive scientific equipment is being used to explore...

the tiniest, invisible objects, the most mysterious things in the New Physics: atoms, quarks, strangeness, charms, Higgs' bosons, neutrons and protons. If Christo's artworks cost a lot – 26 million dollars or whatever – this is chickenfeed to scientific and military experiments, which cost billions of dollars. The Large Hadron Collider, for instance, will cost $1.5 billion.

OTHER AMERICAN LAND ARTISTS

Some other artists living and working in North America include:

JAMES PIERCE

James Pierce created a series of earthworks at Pratt Farm in central Maine in the 1970s: there was a triangular turf maze; a small earth *Observatory*; a *Serpent* made from large rocks; a *Stone Ship*; a *Burial Mound*; a stone *Altar* (in the shape of male genitals); and various figures built out of grass and soil: *Earthwoman* and *Suntreeman*. Pierce's *Earthwoman* (1976-77) was a recumbent female shape, with prominent buttocks, evoking the erotic gardens of the 18th century, and the links between prehistoric earth mounds, fertility and femininity.

HERBERT BAYER

Herbert Bayer created earthworks which directly evoked prehistoric structures: Bayer's *Earth Mound* (1955) in Aspen, Colorado, contained the familiar motifs of ancient religions and cultures: a circular rampart enclosing a small mound; a standing stone and a hollow were placed beside the mound. In Kent, Washington, Bayer built a series of earthworks (*Mill Creek Canyon Earthworks*, 1979-82) which featured circular ramparts, circular moats, mounds surmounted by walkways, and circular ramparts split by a path. At a quarry in upstate New York William Bennett fashioned a *Wedge (Stone Boat)* (1976), an 80 foot long smooth-sided channel in the limestone.

Christine Oatman lit a fire on a frozen lake in the centre of a circle of tall icicles in *Icicle Circle and Fire* (1973). Elyn Zimmerman constructed large-scale ecological land art, such as her *Keystone Island* (1989), a 50-foot wide artificial island built on a lagoon in a mangrove swamp. Patricia Johanson's most well-known work is probably the large water park she fashioned in Dallas, TX, between 1981 and 1986. *Fair Park Lagoon* comprised a series of interlacing walkways above the pool in an 'organic', Gaudiesque manner, and cost over $2 million.

GORDON MATTA-CLARK

Gordon Matta-Clark transformed buildings by knocking enormous holes in them (*Conical Intersect,* 1975), or cutting a house in New Jersey in half (*Splitting*, 1974). But these were not sculpted spaces or physical gestures so much as Conceptual reorganizations of a structure. It's easy to discern the influence of Matta-Clark's interventions in houses and buildings (which he called 'unbuilding') on Andy Goldsworthy's holes and Rachel Whiteread's works (such as her impressions of rooms and houses). Matta-Clark bought up pieces of land in the borough of Queens (in 1973), in another Conceptual piece; none of them were big enough for housing of for much else (some were only 2 by 3 feet, tiny strips of land). *Reality Positions, Fake Estates* explored the notion of land ownership. Matta-Clark explained:

> One or two of the prize ones were a foot strip down somebody's driveway and a square foot of sidewalk. And the others were kerbstone and gutterspace. What I basically wanted to do was to designate spaces that wouldn't be seen and certainly not occupied. Buying them was my own take on the strangeness of existing property demarcation lines. Property is so all-pervasive.[1]

ANA MANDIETA

Ana Mandieta covered herself in mud (while nude, of course) and stood against a tree (for *The Tree of Life* series, 1977, made in Old Man's Creek, Iowa), a combination of Goddess art, performance art and environmental art. In *The Tree of Life* series, Mandieta

left the outline of her body in leaves on a tree trunk. In the *Silueta* series (1979), Mandieta imprinted her body in the snow in Amana, Iowa, and in mud on a river-bank, or set the form on fire in the earth, or made a silhouette from flowers. These pieces echo Andy Goldsworthy's rain and snow 'body prints' (however, Mandieta's art has an undisguised ideological, spiritual and ecological agenda; some of Mandieta's works are explicit performance explorations of rapes, and Mandieta was also exploring her Cuban and Latin American heritage).

In some pieces Mandieta remodelled the entrance of a cave and a ravine into her Goddess shape. She also buried herself under turf – a literal Earth-Goddess mound, and had herself photographed in an ancient Mexican stone grave.[2] Mandieta also lit fires in sculptures (such as *Volcano,* 1979), like Chris Drury and David Nash, and lit candles and fireworks in the shape of a woman. Teresa Murak, in a Mandietan gesture, covered her naked body with cress seeds, while lying in a bath (in *Seed,* 1989). 'They sprout, swell and begin after a few hours to grow right on my body'.[3]

DONNA DENNIS

Donna Dennis took the vernacular architecture of New York City as her starting-point in her 1970s works: *Tunnel Tower* was based on the entrance building to the Holland Tunnel. Later, nostalgic works, such as *Deep Station* (1981-85), recreated the shadowy recesses of subway stations (in full-scale, something like a movie set or an installation). Elyn Zimmerman created large-scale ecological land art, such as her *Keystone Island* (1989), a 50-foot wide artificial island built on a lagoon in a mangrove swamp. Jackie Ferrara's works include *Garden Courtyard* (1989), a large piece of landscape art involving steps, grass, trees, seating, platforms and walkways at the Fulton COunty Government Center in Atlanta.

CHARLES ROSS

Charles Ross constructed a large observatory, *Star Axis* (1989), which recalled the celestial viewing spaces of Turrell, Holt and Morris. It was designed for viewing the North Star (the North Star

was undoubtedly the land artists' favourite star – apart from the sun – appearing in works by James Turrell and Charles Ross, among others). Charles Simonds made an *Abandoned Observatory* (1976), in model form. Juan Geuer has also worked with the sky: he mounted four pairs of large mirrors in the National Gallery of Canada in order to reflect the sky in the glass cupola above (*Karonhia*, 1989).

DOUGLAS HOLLIS

Douglas Hollis constructed 'sound gardens' – a series of wind organ pipes mounted on towers beside the shore in Seattle, WA (1980). Hollis's *Field of Vision* (1980) comprised 900 wind vanes at Lake Placid, NY, to 'explore the choreography between windscape and landscape'.[4] In the Seventies Hollis experimented with sending up kites that emitted sound (*Sky Soundings*, 1975).

8

Land Art in Europe

THE ART OF THE WRAP: CHRISTO

Christo is perhaps most well-known land artist working today. He makes huge, very public gestures: tarpaulin and plastic shrouded buildings, the wrapped Pont Neuf and Reichstag, and curtains hanging across Colorado valleys. His art is not 'invisible' like Walter de Maria's kilometre-long brass rod which only reveals a brass disc on the ground, or Hamish Fulton's walks, which are only memories or text pieces. Born in 1935, in Bulgaria, Christo (Christo Javacheff) attended the Fine Arts Academy in Sofia. One of his early activities as a student involved tidying up the Orient Express railway route through Bulgaria by covering old farm machinery and haystacks with tarpaulin. At Prague Christo studied set design, and one of his mid-1960s works in New York involved making replicas of shopfronts, like a stage set, but the windows were covered with cloth or paper. In his early works, Christo wrapped up items such as books, bottles, tins and boxes. Other Assemblages or *empaquetages* (Assemblages as packages) included nude models, cars, chairs and motorbikes. Christo's most famous Assemblage, though, was on a larger scale, the *Wall of Oil Barrels – Iron Curtain* (1962). This was a pile of barrels stacked across and blocking one of Paris's oldest streets, Rue Visconti. *Wall*

of Oil Barrels – Iron Curtain parodied the Berlin Wall, which had recently been constructed. The sculpture annoyed the locals, and Christo's large-scale works have been upsetting neighbours, councils, politicians and pressure groups ever since.

Christo's first large-scale wrapping was to cover the Museum of Contemporary Art in Chicago with 10,000 square feet of brown tarpaulin. Christo's wrapping of the museum made it the focus of attention in the neighbourhood – some people hadn't realized the museum was there until it had been wrapped. The museum's director reckoned Christo had parodied 'all the associations a museum evokes: a mausoleum, a repository for precious contents, an intent to wrap up all of art history'.[1] Inside the museum was the *Wrapped Floor*, consisting of 2,000 square feet of rented drop cloths.

In 1969 Christo wrapped a mile-long section of the Australian coastline. The use of open weave cloth (1 million square feet) meant that wildlife would not be affected. *Wrapped Coast*, at Little Bay near Sydney, stayed in place for 4 weeks. It was a dramatic land art gesture, difficult to ignore. *Valley Curtain* (1972), at Rifle Pass in Colorado, did not last so long. It was blown down. The huge bright orange curtain hung across the valley, providing a passageway as well as a visual block to what was beyond.

> When I was doing *Valley Curtain* everybody knew that this is a huge curtain crossing a valley. Now everybody knew what it is that is behind the valley. The thing that is behind is not so important... only that motion, the passing through.[2]

The use of orange, as with the pink in *Surrounded Islands*, gave *Valley Curtain* a new æsthetic, more attuned to Matisse and Monet, quite different from the dull brown tarpaulin of the *Wrapped Museum*. Christo would continue to use such colours throughout his career on his major wrappings.

Many of Christo's large-scale wrapped works were situated next to water: *Running Fence* plunged into the sea; *Wrapped Coast* was submerged by the tides; *Surrounded Islands* floated on the

154

ocean; *Pont-Neuf* stretched over the River Seine. *Surrounded Islands* (1980-83) was one of Christo's largest works. Not a wrapping this time, but still involving masses of fabric (6 million ft^2 of it). With a budget of $3.5 million, 4 engineers, 2 ornithologists, a marine biologist, 2 attorneys and 430 helpers, Christo surrounded 11 little islands for 2 weeks in May, 1983. The choice of brilliant pink meant the enclosed islands stood out vividly against the green sea at Biscayne Bay in Florida. The pink-enclosed islands looked like flowers floating on the sea, recalling the Japanese Buddhist ceremony of setting flowers afloat. Or, more in tune with Western art history, recalling Monet's waterlilies.

Running Fence (1972-76) comprised 2,050 18 foot panels of white nylon attached to steel poles, running across Marin and Sonoma counties and 12 roads in California. As with Christo's other mammoth projects, there was much opposition to *Running Fence*. A committee designed to 'stop Running Fence' brought the subject to the Superior Court of the State of California 3 times. The subsequent report on the environmental impact of the *Running Fence* project found that there were no endangered species in the region, except for the Brown Pelican, and virtually no wildlife would be affected by it. *Running Fence* went ahead, and stayed up for two weeks in September, 1976.[3] When it was taken down, nothing remained of it in the area: the holes were filled in, and bare parts of soil were reseeded. As with other Christo projects, when it was taken away some locals were dismayed, the work had helped them realize the beauty of the area. Christo says his art is

> about displacement. Basically even today I am a displaced person. And this is why I make art that does not last. Of course, it will stay for ever in the minds of people.[4]

Christo here espouses the fundamental Romanticism in land art: that it will live on in the memories of people. Christo's large-scale projects – *Running Fence, Surrounded Islands, Wrapped Coast* – were spectacular works, part of the land art tradition which moved towards the sublime in landscape art (which has affinities with the

Abstract Expressionism of Rothko, Newman and Motherwell). The ocean end of *Running Fence* was particularly impressive: at Bodega Bay the *Fence* extended gracefully into the Pacific, 558 feet, descending from a height of 18 feet on land to 2 feet at the section which was anchored to the bottom of the sea. The *Umbrellas* stretched for 12 miles in Japan and 18 miles in California.

Christo's large-scale works are expensive: *Running Fence* cost over $3 million, *Surrounded Islands* cost $3.5 million, and *The Umbrellas* in Japan and California cost $26,000,000. Denigrators of Christo's work have noted the expense of the projects, but Christo pays for them himself, by selling photos, drawings, collages, models, lithographs and plans and other works, and by collaborating with industry.

HANS HAACKE

The German artist Hans Haacke has produced some of the most intriguing land art works (although Haacke is more usually linked with Arte Povera, Conceptual or process art, than land art). Many of Haacke's early works explored natural or organic systems. Later, Haacke moved on to social, economic and political systems (what Haacke called 'real-time systems'). Haacke's 1965 artistic statements included: 'make something that lives in time and makes the "spectator" experience time... articulate something natural'.[1] One of Haacke's tenets was 'the simpler the better'. *Grass Grows* (1966 and 1969) was a mound of soil with grass growing out of it. Haacke later fashioned a row of beans growing along string suspended at an angle, in soil mounted on glass on the gallery floor (*Directed Growth*, 1972), and in tropical plants growing on a circular area of soil, *Rye in the Tropics* (1972). *Condensation Cube* (1963-65) was a Plexiglas cube (a metre on each side) with water inside which condensed on the clear sides of the box, an exploration of process. 'It is changing freely, bound only

by statistical limits' remarked Haacke of his 'Weather Box'. In *Sky Line* (1967) Haacke released white helium balloons over Central Park. Hans Haacke commented that 'in spite of my environmental and monumental thinking I am still fascinated by the nearly magic, self-contained quality of objects. My water levels, waves and condensation boxes are unthinkable without this physical separation from their surroundings'.[2]

Many of Haacke's most compelling artworks were made to explore the ephemeral qualities of ice, snow, fog, steam, smoke and water. *Fog, Flooding, Erosion* (1969) employed a sprinkler system to turn a lawn in Seattle (WA) into mud. *Fog Dripping From or Freezing On Exposed Surfaces* (Boston, 1971) and *Spray of Ithaca: Falls Freezing and Melting On Rope* (1969) explored water and fog freezing on waterfalls and trees. One of Haacke's air and wind constructions comprised a fan blowing a seven by seven foot chiffon sail hung parallel to the gallery floor. Another air sculpture was a balloon balanced above an air jet (a favourite with science and natural history museums). He had proposals for monumental-sized windmills and sails, all naturally powered by the winds. Haacke preferred to use unmechanical sources of energy.

In *Rhine-Water Purification Plant* (1972), the process of purifying polluted river water was examined. Via a series of acrylic containers, filters, hoses and pools, the spectator could follow the process of the purification of the contaminated Krefeld sewage water. The final destination of the water flow was a square pool containing goldfish. *Rhine-Water Purification Plant* recalled the 3-D displays in science and natural history museums that explained the processes of nature and science.

In Haacke's piece *Ten Turtles Set Free* (1970), the animals were released in a forest near St Paul-de-Vence (France), a symbolic gesture about humanity's relationship with the natural world and its inhabitants. Haacke photographed seagulls feeding on bread scattered on a lake in *Live Airborne System* (1965/68).

Hans Haacke later considered economic systems in works such as *Shapolsky et al, Manhattan Real Estate Holdings, a Real-Time Social*

157

System (1971). For the *Information* show at Gotham's MOMA (in 1971), Haacke exhibited a poll about Governor Rockerfeller running for election, inviting visitors to vote. Haacke took on cultural institutions such as museums, landlords, and politicians such as President Reagan and British PM, Margaret Thatcher. On a few occasions Haacke's proposals were negated by the authorities of the Guggenheim, Wallraf-Richartz and Metropolitan museums, with works and shows being cancelled as a result. Other artists (such as Daniel Buren) protested in support of Haacke.

CHRIS DRURY

Chris Drury was born in 1948 (in Sri Lanka) and educated at Camberwell School of Art in London in the late Sixties. Drury is a British artist who has made works with numerous links with those of Andy Goldsworthy. Drury is 8 years older than Goldsworthy and belongs to the generation of Alan Sonfist, Charles Simonds, Michael Heizer, William Furlong, Alice Aycock, Mary Miss, David Nash and Richard Long (all born between 1944 and 1946). Drury had begun with figurative sculpture. Among the artists that Drury admired were Roger Ackling and Constantin Brancusi (Drury said he found Joseph Beuys 'immensely irritating' and 'too self-obsessed').[1] Drury has exhibited in many solo shows, including the Henry Moore Centre in Leeds, Royal Botanic Gardens in Edinburgh, and London's Serpentine Gallery).

The art of Drury and Goldsworthy share so many elements: they are both British land artists, both emphasize spirituality, both use similar forms (cairns, shelters, globes, spirals, circles), use similar materials (boulders, grass, willowherb stalks, wood, snow, clay), and both have worked and exhibited in similar territories: Japan, the US and Scotland (Drury has made works, though, in places Goldsworthy has not been associated with, such as Ireland, Italy, Denmark and Spain, and Drury has made many works near

his home in Lewes, Sussex). They also share the same book publishers (Thames & Hudson and Cameron Books), the same art critics who've written about their work (Paul Nesbitt and Terry Friedman), and have worked with the same institutions (such as the British Council, Common Ground, the Henry Moore Foundation, Sustrans, the Scottish Arts Council and the Arts Council).

One of Drury's concerns was human history, the relation between people and the land: his artworks re-use dewponds and stone walls, draw attention to tumuli by building domes over them, and altering maps, one of the most elegant manifestations of human history. *A Dense History of Place* (1996) was one of Drury's map works which combined maps with written text (a common motif in land and Conceptual art). Dense lines of text spread outwards in a circular pattern from an area near the coast in Sussex depicted in an Ordnance Survey map, an area which has many personal associations for Drury.

Another form of Drury's is the globe set on the ground. Drury has created spheres from pine cones (1984), deer bones and deer scats (*Four Spheres,* 1984), and bamboo, ginkgo, vines, moss and seeds (*Shimanto River Spheres,* 1997, Japan). In *Bound Oak* (1990), made in Sherwood Forest, Drury wrapped a rope of grass around an old oak tree.

Drury's art departs from Goldsworthy's art at many points, however: the use of materials such as animal bones, antlers, horns, and feathers, the basket weaving, the spherical 'baskets' like pots, the kayaks, and the cloud chambers. Drury is much more inclined than many land artists to use in his sculpture material from animals, such as whale bones, or reindeer antlers, or ram's horns, or elk bones, or gull's feathers, or cow dung. In the *Adharc* pieces (1991-92), Drury took the form of a ram's horn and multiplied it in peat and bronze. Drury affirms the community aspect of his art more than some land artists, and the spiritual dimension (he speaks of meditation and the Buddhist void, for instance).

A key sculpture in Chris Drury's *œuvre* was his *Medicine Wheel* (made in 1983), a calendar work which collected 365 found

159

objects strung on bamboo stalks mounted around the edge of plant papers and a mushroom spore at the centre. Drury wrote his diary in lines spreading outwards from the centre (a recurring motif in his work). Among the objects were hen feathers, wheat, runner beans, snail shells, pebbles, twigs, bark, berries, acorns, flowers, seeds, fish bones, grass, grapefruit, cherry blossom, hawthorn, crab, mussels, sheep bone, mistletoe, seaweed, cork, walnuts, quinces, rabbit skin, figs, and a cat's skull. The *Medicine Wheel* inspired many new forms in Drury's art:

> out of that came different categories of work. It started me off on making shelters and baskets, and then the shelters led to cloud chambers, and the baskets and the large, woven works I've made outside led me to the dewpond works. I've made woven maps, weaving ideas of landscape. And then there are the found objects.[2]

Like many land artists and sculptors, Chris Drury has made many works near his home in Lewes, Sussex (like Goldsworthy in Penpont, Nash in Blaenau-Ffestiniog and Long in Bristol and the South-West). Drury's works in Sussex include *Vortex* (Lewes Castle), *Cuckoo Dome*, *Beehive Shelter* (Goodwood), *Holding Light* (Brighton), *Guardian Shelter* (Sheffield Forest), *Chalk Chamber* (a barn in Sussex), *Rhythms of the Heart* (Hastings), *Heart of Reeds* (Lewes), Towner Art Gallery, Eastbourne, *Seven Sisters Bundles* (near Eastbourne), and the dewponds.

Drury stated that his work was not self-referential, that it referred to things outside of itself. (One of Drury's criticisms of Joseph Beuys was that his work was too self-obsessed). However, there was plenty of self-referentiality in Drury's art: the *Medicine Wheels*, for example, comprised diary entries for every day of the year. Another work also heavy with thousands of closely written words, *A Dense History of Place*, was full of autobiographical associations. The emphasis on cataloguing also had a biographical element, as did the penchant for works linked to Drury's home-ground of Lewes in Sussex. Then there's the emphasis on community projects, where the artist interacts with a local community.

Those personal interactions, which Drury cherishes, also contain a strong biographical element.

Basket weaving is one of Drury's passions, and he has created many forms using weaving, including a large open dome from hazel branches (*Cuckoo Dome*, 1992), kayak forms (*Kayak Bundles*, 1994), globular forms (*Basket For the Forest Deer*, 1987), and small vessels (*Basket For the Trees*, 1988, *Hollow Vessel*, 1989). Many of Drury's baskets are recognisable traditional baskets: *Five Sisters* (1994), *Basket For the Moment Between Life and Death* (1985) and *Dream Basket* (1985). In *Basket For the Crows* (1986), the distinctive black crow feathers are employed to weave a basket, placed on the floor, with a long row of feathers suspended above it.

Linked with the basket woven pieces are the small bundles of found objects (such as *Cholla Bundles*, 1993, *Beaver Sticks*, 1991, and *Stick Bundle*, 1992). *Seven Sisters Bundles* (1994), for instance, comprises objects found at the famous Sussex cliffs (driftwood, flint, chalk and fishing twine). The bundles, for Drury, were 'talismans of time and place, souvenirs, made simply at a campsite, or alternatively made at a later date as an act of remembering' (1998, 58).

An off-shoot of Drury's penchant for weaving is the inter-lacing of maps (maps being one of the key components of land art). Thus, Drury has interwoven a map of Manhattan with one of the Hebrides (1996) and West Cork with New Mexico (1995). Like Tony Cragg, Drury has collated found objects into patterns (such as *Tidelines*, 1985, made from pieces of plastic, metal, rubber, driftwood and feathers).

Some of Drury's vessels have been woven from willow (1994), or bamboo (1997), some have been covered with cow dung (1992), and some have been made with turf (1991). Some of Drury's wall drawings, made with river mud (*River Vortex*, 1998), recall Richard Long's mud wall drawings.

Drury's art tended to be interconnected: the baskets and woven vessels were linked to the woven maps, and the woven globes, and also some of the larger shelters. The dewponds were

patterned after baskets. 'On occasion I have taken a basket weave, enlarged it, and turned it upside down to act as a shelter or as valve between inner and outer... basket to shelter, shelter to basket... A web of interconnections links all these works' (1998, 22-23).

One of Chris Drury's most striking sculptures was *Stone Whirlpool* (1996), built from river stones arranged into a spiral in a Japanese river (in Okawa-mura), near a waterfall. It was one of a number of Drury's works which explored vortexes and spirals. An associated work which took on currents of energy was *Edge of Chaos* (2000), a large paper work covered with handwritten texts describing the world's ocean currents and winds. One of Drury's largest vortex works was *Heart of Reeds* (2000).

Drury has reclaimed and reworked dewponds, mainly in Sussex (*Basket Dewpond*, 1997 and 1999), some of which are quite ancient. In these shallow dips in the landscape Drury has fashioned his favourite motifs of spirals and vortexes from grass and snow. *Snow Vortex* (1999) was a labyrinth with paths dug out of snow on Firle Downs in Sussex. Drury has also made a dry stone vortex maze and a 'wave garden'. (Drury has his favourite motifs: the mushroom gill form, the dome, and the spiral or vortex, which recur in so many sculptures.)

Boats, kayaks and 'vessels' are another recurring form in Drury's art. Some of the vessels are enormous cannibalized stone walls (such as *Long Vessel*, 1995) or heaps of stones willow and reeds woven on top of them (such as *Shelter Vessel*, 1988, made in County Galway). Some of the vessels are basket woven (such as *Connemara Vessels*, 1988). *Air Vessel* (1994), woven from willow, is one of Drury's most intriguing sculptures: in the form of a kayak, a skeletal form of woven twigs, it was exhibited hanging in space in the gallery, evoking all sorts of associations (with boats as flying transports, or the rich symbolism of flight, or shamanic flight). For Drury, *Air Vessel* was about journeying, the 'moments of exhilaration on mountains where I have experienced a feeling akin to flying' (1998, 12). Some of the shelters, Drury said, were 'like

overturned boats and denote journey, movement' (ib., 20).

Chris Drury has treated his cairns in different ways: many of the stone cairns have had fires lit inside them, such as *Midsummer Fire Cairn* (1989), *Falling Water Fire Cairn* (1997, Norway), *Fire Cairn* (1993, Ireland), *Fire Mountain Cairn* (1996, Japan), and *Fire Cairn* (1989, Colorado). Some cairns have been enclosed with basket weaving (such as *Basket Cairn*, 1991) and *Covered Cairn* (1993, Denmark). Like Long's stone rows or Goldsworthy's cairns, Drury's stone cairns are usually erected in wilderness or spectacular scenery: Norway (1988), New Mexico (1993), De Lank River, Cornwall (1990), Lappland (1988), Webster Ross, Scotland (1992), Kintail, Scotland (1994), Ladakh (1997) and Colorado (1989). For Drury, the cairns are about commemorating a particular moment in a special place: 'they're just saying, 'this is an extra-ordinary place. Grab a few rocks, put them up before the moment's gone and photograph it'' (2002, 79). If the shelters were the stopping-places on a journey, the cairns were the 'markers of highpoints/ moments of exhilaration along the way' (1998, 58).

Another favourite Drury motif is the shelter: low, squat structures, sometimes like teepees or witches' hats, some like prehistoric beehive huts. The shelters were often made from stone (but also in chalk, turf, ice, wood, plants and coal. Some of these materials, such as turf, coal and chalk, are unexpected, and give Drury's shelters a very particular quality). The shelters are usually (but not always) constructed at human scale. That is, in the correct scale for someone to enter them bodily. *Beara Shelter* (1995), in West Cork, Ireland, was a squat, square, stone structure, with views of the sea and Bulls Rock. 'The intention was to provide a space for being and contemplation' (1998, 20). Some of the shelters, such as *Shelter For the Winds That Blow From Siberia*, made near Drury's home in Lewes in 1986, have a distinctly Goldsworthyan flavour: blocks of ice mounted on a hazel frame, looking like an igloo. *Shelter For the Northern Glaciers* (188) was constructed in the spectacular coastal setting of Seiland island, in Norway, surrounded by snow-capped mountains. Geoffrey Harris has also

constructed wooden shelters in forests (*Hollow Spruce*, 1988).

Some of the shelters, as with the cairns, have had fires lit inside them (*Shelter For Dreaming*, 1985). Some of the shelters are open structures, without a covering (rather like a frame tent before the canvas is pulled on top). Others are a frame which's wrapped with ice, or turf, or reeds (such as *Shelter For Herbs and Healing*, 1986). *Tree Mountain Shelter* (1994, Italy) was a stone cairn enclosed with a cone of hazel branches. *Turf Chamber* (1992) comprised sections of turf laid on top of a hazel branch frame. The *Wave Chamber* (1996) was constructed beside a flooded valley in Northumberland, and contained a mirror and lens in a steel periscope mounted atop the structure so that the image of the waves could be projected inside, onto the floor.

Chris Drury's shelters have all sorts of connotations, stretching back thousands of years (shelters must have been one of the first structures that humans ever built – shelter being one of the primal human needs). 'Shelter is a basic human need and a manifestation of human presence' remarked Drury (1998, 20). Drury's shelters have obvious affinities (with Celtic and Bronze Age huts and houses in Britain, for example), but they are also about 'organic' forms, forms which repeat endlessly, and geometrically, like crystals. They are stopping and resting places, and also enclosing spaces. 'I like the way this interior space draws you inside yourself, enclosing, protecting, just as mountains pull you outside yourself, pushing mind and body beyond their usual confines' (ibid.).

The shelters are also about the landscapes in which they are constructed, like land art in general. They tend to be built in rural or wilderness zones, and are the only structures of that kind in the area (they stand out as artworks, not as part of the agricultural machinery, for instance). The shelters are thus also free-standing sculptures, artworks which draw attention to themselves. The shelters are also about land art concerns, such as the tensions between what's inside and what's outside, between the human-made structure and a 'natural' context (the landscape), about the relation between form and function, æsthetics and use. The

shelters draw attention to the landscape around them.

One of Drury's shelters, *Covered Tumulus* (1997), took on the theme of human history directly, and the sense of revealing what's there: Drury built a dome of hazel branches over a prehistoric mound on the South Downs in Sussex. The *Hut of the Shadow* (1997) was sited in North Uist in the Scottish Western Isles with the local community in mind. In *Covered Cairn* (1993), made at TICKON in Denmark, Drury placed a hazel and willow twig frame dome over a stone cairn, an approach that combined the Druryan motif of the open, woven frame, with the stone cairn created by balancing rocks atop each other. 'The woven dome is a division between outside and in,' commented Drury, 'which nevertheless allows a transition from one to the other, a free flow of inner to outer. The experience inside it is different from the experience outside' (1998, 80).

One of Drury's more unusual shelters was *Mind Wave* (1996), made in the Botanic Gardens in Copenhagen: Drury combined a couple of his favourite forms: the mushroom-shaped text drawing, and the dome. In *Mind Wave*, Drury opted to adapt a geodesic dome greenhouse, which he painted in blue and scratched the words 'mind' and 'wave' in the paint, spreading outwards from the centre of the dome, in the pattern of the gills of a mushroom.

Some of Drury's most appealing sculptures are 'cloud chambers', developments of his shelter form: these are basically circular stone or wooden shelters with holes and mirrors in the roof which act as lenses and reflectors. In these *camera obscuras*, the spectator can observe the sky above projected onto the floor below. The cloud chambers (constructed in many areas) articulate classic land art concerns: the dialectic between inner and outer, indoor and outdoor, stillness and movement, nature and culture. Drury's cloud chambers include *Coppice Cloud Chamber* (1998, Kent), *Cloud Chamber* (Piccadilly, London, 1993), *Cloud Chamber* (1994, Aberdeen), *Eden Cloud Chamber* (2002, Cornwall), *Reed Chamber* (2002, Arundel), *Cedar Log Sky Chamber* (1996, Japan), *Hut of the Shadow* (1997, Western Isles), *Clohan Cloud Chamber* (1992, Dublin), *Cloud*

Chamber (1990, Belgium), *Cloud Chamber For the Trees and Sky* (2003, North Carolina) and *Wicklow Cloud Chamber* (1990, Glencree, Ireland). The cloud chambers are 'still, silent, meditative and mysterious places' Chris Drury wrote on his website.

Drury's cloud chambers are linked with historical structures, such as the Roman Pantheon, which contains a hemispherical dome 142 above the floor (built in the 2nd century AD). At the apex of the dome is the *oculus* (eye), which lets in light: it was associated with the 'eye of Heaven'. Even though they are much smaller in scale than the beautiful Pantheon in Rome, then, Drury's meditative cloud and wave chambers have symbolic and religious connotations.

Some of Drury's larger works, such as *Vortex* (an enormous hollow cone of woven hazel and willow made at Lewes Castle in 1994), have aspects in common with artists such as Tony Cragg or Richard Deacon. Another large work, *Heart of Reeds* (2000), was a proposal for a spiral vortex on five acres of reclaimed land in Lewes, Sussex (due to start work in 2004).

A later development of Drury's art was to see the (human) body as 'landscape', to explore the processes of the body, and the relationships between the body and the Earth. Manifestations of this development in Drury's interests were the Lewes *Heart of Reeds* project (which was based on the human heart), *Heart River* (1999), a pattern on paper from a cross-section of the heart, and the various works Drury has made in conjunction with hospitals (such as *Rhythms of the Heart*, 2000, made at Hastings). In these works, Drury has explored the flow of blood and water in the body, wave patterns from echocardiograms, and the formations in rocks, trees and the landscape.

For Chris Drury, there wasn't a separation between humans and nature, no 'us and them' (or, rather, 'us and it'): nature was all around, inside as well as outside: '[w]e ourselves are nature... '[w]e're a part of nature' (2002, 79.) Drury was interested in exploring the relation between inside and outside, nature and culture, and how 'nature is really culture' (ib., 76). For Drury, the

natural world could never be 'natural', on its own, completely distinct from humanity – at least as far as humans were concerned. The natural world was always totally enculturated. In other words, if humans were looking at nature, they could only ever see nature in human terms.

> When you're out in the countryside, culture, or our view of nature, determines how you see what's in front of you. So you never see a thing as it is, you always see it in the way that you've been programmed to see it. And you can't get away from that, ever... We *are* nature, we have to touch nature, we touch it every single second of the day, we breathe it.[3]

Drury said he went out into the countryside (into the 'natural' world) to make art because it was inspirational, it was away from telephones, people, cars, etc, and it was different from human-made environments (like cities). Also, work made outside tended to be less self-conscious (2002, 72).

A work being 'site-specific' was important for Drury: it was about the place, the uses of the place, the history of the place, and the people who lived in the place. 'It's made there, it's made out of the material that's there and it's made by people who live there. All those elements come into it and it has to find its place with the landscape but also within the culture relative to what those people are' (2002, 73).

Drury saw the spaces he made that people entered as 'meditative spaces'. They were direct experiences. The cloud chambers, for example, were 'very still, meditative places' where visitors would not sit and think but sit and experience the place directly. The effect the cloud chambers had depended upon the person. They worked best when they encouraged the viewer to sit still for a moment and reflect (2002, 76). The idea of the *Beara Shelter* was 'a space for being and contemplation' (1998, 20).

One of the developments of 1960s land art was to put the artist *inside* the art. In the traditional manner of painting the landscape, the artist was viewing the landscape from a distance, standing

back; but 'since the 1960s artists have been putting themselves into it' Drury observed (2002, 76). For Drury, the photograph is a poor substitute for the work itself. Drury said he had taken photographs of ephemeral works (such as the cairns), but was more interested in working 'with people in the real world' (2002, 81).

Unlike some of his British contemporaries (Goldsworthy, Long, Fulton), Drury encouraged people to visit the sites of his works. He published a website and postcards with instructions on how to find them. 'In no way could that work communicate itself through a photograph because it's an experience, and nothing you could bring to a gallery would get anywhere near what the thing is about' (2002, 81). In this respect, Drury has more in common with American earth artists, such as Dennis Oppenheim or Robert Smithson, who exalted site and location.

Going out and walking or making work from time to time is important for Drury – especially if he hasn't done any travelling or walking for a while. 'I'm really fortunate to be invited to extraordinary places to go and make work' (2002, 79). However, it wasn't the object itself that was the really valuable aspect of travelling or working on commissions for Drury, but the process and experience of making it, interacting with people, living in particular environments. 'The main thing you bring back is how the experience has changed you inside' (ibid.). So some of the pieces Drury makes are not about specific places or times, but 'the whole activity of being out there in those places'.

> In a sense you can't not be a conceptual artist these days, because you have to think about the world and if you don't you're not contributing to the debate in any useful way. But at the same time, in order to make art that's really interesting you have to stop thinking.[4]

Drury said he didn't think of himself as really fitting into the land art or art and nature genre. 'As soon as you say 'art and nature', it makes people think of fiddling about with sticks, which is really not what I'm interested in' (2002, 90). Although labelled as a land artist, Drury preferred to see himself as an artist who

'explores nature and culture, inner and outer'.[5] There was no division between art, nature and humanity, for Drury: the artist – and art – was always part of nature ('there is no division between man, art and nature').[6] Drury did not think of himself, either, as the kind of artist who had something to express, who wished to make statements about issues or the world. 'Personally I have nothing to communicate, consciously or unconsciously; the work simply reflects the moving from moment to moment in the world as it is, and so it is nature itself that communicates' (ibid.). In this view, Drury saw himself as a shamanic translator of nature and the world, a creative interface between the world and the viewer. As well as shamanism, critics have also linked Drury's art to Buddhism. Rather than an 'creator' of art, or an 'expresser' of emotions or statements or views, then, Drury would be seen as a 'reflector' of nature and the world, someone who does not 'create' art but reflects what is already in the world and in nature (and in himself and in other people). In this view, Drury's output is a manifestation of his being-in-the-world, so to speak. It's an art of ontology, of beingness, of being in the moment, of reflecting the moment (or the passing of moments), rather than the traditional (Western) view of art as being about personal expression, about crises of subjectivity, about angst and suffering, about visionary creativity, and all the rest of the Freudian, Nietzschean, psychological baggage. It's not an art of putting a personal stamp on the world (such as making the big earthworks gestures in the American desert), or promoting ego and self (and celebrity and fame), or advertizing a set of philosophical or ideological views. 'Making art, for me, is never the means of finding insight. It is rather the reflection of a growing consciousness'. Drury spoke in Zen Buddhist terms of his artistic process: 'I go to 'outer nature', which is thoughtless, void, in order to see the whole. From the void comes insight, which makes art'.[6]

DAVID NASH AMONG THE ELEMENTS:
WOOD, WATER, EARTH, FIRE AND SNOW

One of the most intriguing and sensual of land artists working in
Britain is David Nash (born in the same year as Richard Long –
1945), with whom Andy Goldsworthy worked. Nash's æsthetics
chime with those of Richard Long, Chris Drury and Andy
Goldsworthy among British artists.[1] Hugh Adams saw David
Nash as a kind of 'fixed abode Richard Long', working from one
place (North Wales), while Long travels the globe, regarding the
whole world as his studio, as material for making art. Hugh
Adams writes:

> Nash is Long in microcosm: the sensibility is the same but, whereas
> Long travels the world, making, marking, and recording, in distant
> places, Nash is more sedentary, and content to do the same thing
> where he has made his home.[2]

Nash built a number of 'stoves' and 'hearths', out of natural
materials – snow, slate, wood. These structures burn away – fire as
'living' sculpture (like Chris Drury's cairns or Ana Mandieta's
Volcano). *Snow Stove*, made in Japan in 1982, burnt beautifully – a
snow pyramid, fusing those two eternal mysteries – fire and snow,
fire and ice. Nash also made a *Wood Stove* (1979), a *Slate Stove*
(1981) and also a *Sea Hearth*.[3] Anyone who's lit a fire right next to
the ocean will know what a magical experience it can be, and
Nash's *Sea Hearth* is certainly rich in magic (there is something
fascinating about fire next to water). Nash set his fire built of large
stones inches from the waves, to accentuate the contrast between
the two elements. Nash's stoves and hearths are rich in alchemical
and elemental allusions: they are a poetry of elements, the basic
elements out of which everything is made. (William Jackson
Maxwell has created burnt tree stumps, like Nash).[4]

Nash loved working with wood: his *Wooden Boulder* (1978) was
exactly that – a huge, near-spherical chunk of oak. Nash tipped
the boulder into a stream near his studio at Blaenau Ffestiniog,

(1988, collection: the artist), and *Red Throne* (1989, collection: the artist). *Started Beech* (1989, collection: Eric Franck, Switzerland) was a tree trunk split into a series of thin planks, still connected at one end to the end of the beech tree trunk. The ends of the planks fanned outward slightly, creating the 'skirt effect'. At Grizedale Nash's *Horned Tripod* (1977) was a tall tripod made from straight trees, a large scale work. *Crack and Warp Column* (1989, collection: the artist) was a tower made from thin squares of wood, piled on top of each other. *Crack and Warp Column* was irregular; each slab of wood bends slightly. In *Crack and Warp Column*, the warped slabs were more severely bent, but the size and shape of each slab was still controlled. The now-destroyed column of 1970 was one of the most Brancusi-like of Nash's sculptures: it was fashioned in sections, one tapering into the next. The tall, vertical Nash sculptures recall not only Brancusi's *Endless Column* but also Barnett Newman's *Broken Obelisk* and notions of growing upwards, skywards, verticality, and are related to Nash's idea of a tree as a fountain of energy.

Some more of David Nash's works include: *Vessel and Volume II* (1988, General Mills), a hollow boat form in black, next to a similarly-shaped boat, as if one could fit inside the other. *Serpentine Vessels* were also boat shapes (1989, collection: the artist), but their prows and sterns were tilted up, away from the floor. These were large objects, basically two slabs of wood fixed together. *Three Longboats* (1986, in oak) were hollow boat-forms, set on pieces of wood (Chris Drury has also made groups of boat forms). These are not boats that will float; they are bottomless. *Descending Vessel* (1988, collection: the artist) was another boat-form, again hollow, set upright on top of a wooden plinth-wall, more a tower. The end of the vessel was slid into a crack in the top of the tower.

Quite a few of Nash's sculptures consisted of two objects seen in tandem, one above the other. Like *Descending Vessel*, *Comet Ball* (1989, Trans Art, Cologne) was one object above the other – a tall curving piece of wood was stuck into a near-spherical globe of

173

wood. Like *Descending Vessel, Comet Ball* recalled Constantin Brancusi – *Descending Vessel* was particularly reminiscent of *Birds in Space*. To emphasize the inspiration for the 1990 *Comet Ball*, Nash built a fire under it. Nash has also made waterfalls and streams from hollowed-out tree trunks, entitled *Wooden Waterways* (1978, Grizedale and 1982, Japan), in which water from a stream was diverted along the trunks of a fallen oak tree, an ash, a sycamore, and onto more troughs.

David Nash has produced giant-size versions of common, domestic forms, such as *Ancient Table, Table with Cubes, Oak Spoon, Branch Chair* and *Bowl and Platter*. *Ancient Table* (1983, collection: Capel Rhiw), which has huge weathered trunks for the table's legs; *Table with Cubes* (1971, National Museum of Wales, Cardiff) has a variety of sizes of cubes on it; *Elm Bowl* (1988, collection: the artist) was a large, thin bowl, irregular, the outside smooth, the inside showing the marks of a chisel on top of a chunky wooden pedestal; *Bowl and Platter* (1988, collection: the artist) set the oversize objects on a large, thick table. Other large scale versions of everyday objects included *Big Ladder* (1984, Japan), *Branch Chair* (1976) and *Standing Frame* (1987, Walker Arts Center). Nash took the common form, put it into wood, roughed up the outlines and textures, and enlarged the forms. Some of his most intriguing works were spindly, expanded versions of household items. *Branch Chair*, for example, was a recognisable chair, but with twigs and branches poking out of it; *Branch Cube* (1982, private collection) was a recognisable cube, but with twigs and branches sprouting out of it, making it a much larger sculpture than it would be if it was just a cube.

Some of Nash's sculptures were slotted together, extended forms, one form expanding outwards to produce a series of forms, as in *Extended Cube* (1986, collection: the artist), where the cube spilled out over the floor, in ever-decreasing sizes. *Slot Table* (1979, collection: the artist) was a tree trunk with a large slot cut in it, and displaced slightly. *Extended Length* (1980, Rijksmuseum Kroller Muller) was a large oblong which was dissected, so that the inner

part slide out, showing its internal perspectives. *Nature to Nature* (1987, Walker Arts Center) took three simple forms – globe, cube and pyramid – and made them out of solid wood. Nash put the three solids together in a row and built a fire under them. The blackened solids were shown in a gallery, with charcoal drawings of them on the wall behind.

In *Sod Swap* (1983), Nash took sods of grass from Caen-y-Coed in North Wales to Kensington Gardens (and vice versa), planting the grass in a circle. Later Nash works included charred wooden sculptures based on the yew hedge 'twmps' which Nash had seen at Powis Castle garden in mid-Wales (such as *Beak Twmp*, 2000).

RICHARD LONG: THE ART OF THE WALK

The central fact and act and experience of Richard Long's art is walking. Long's work is founded on the art of walking, the act of walking. On walking as art, as act, as experience. His walks become 'artwalks', art-walks which become artworks. For Richard Long, (art)walking is (art)working. As he walks he works. He makes art-walk-works. Art-walking and art-working become interchangeable. 'I have met with but one or two persons in the course of my life who understood the art of Walking, that is, of taking walks – who had a genius, so to speak, for *sauntering*' wrote Henry David Thoreau.[1]

Born in 1945, the same year as David Nash, Richard Long studied at the West of England College of Art (Bristol) and St Martin's (1966-68). In 1967 Long made his first important walk-work, *A Line Made By Walking*. Like most land artists, Long makes indoor (gallery) works and outdoor works (not intended for public consumption). He also produces art books, which are not typical exhibition catalogues, but artworks in their own right, usually with text works, photo works, and sometimes map works. Long has had one-man shows in most of the major Western galleries,

175

including the Whitechapel (1971), MOMA, New York (1972), Venice Biennale (1976), Arnolfini (1983), Fogg Art Museum (1980), Stedelijk, Amsterdam (1973), Guggenheim, New York (1986), Hayward Gallery, London (1991), and many one-man shows at Anthony d'Offay Gallery in London, which have produced art books (*Mountains and Waters*, 1992, *Sixteen Works*, 1984, *Five, Six, Pick Up Sticks*, 1980, *Old World New World*, 1988, *Kicking Stones*, 1990, *River Avon Book*, 1979).

Long is associated with the American land, Minimal, process, Conceptual and postmodern artists (such as Lawrence Weiner, Michael Heizer, Walter de Maria, Dennis Oppenheim, Nancy Holt, Mary Miss, Alice Aycock, Judy Pfaff, Donald Judd, Robert Smithson, Eva Hesse, Richard Serra, Tony Smith, Robert Morris, Jackie Winsor, Sol LeWitt, and especially Carl Andre), and with European Arte Povera and Minimal/ Conceptual artists (Hans Haacke, Christo, Jannis Kounellis, Lucio Fontana, Alberto Burri, Piero Manzoni, Daniel Buren, Giovanni Anselmo, Mario Merz). Other key names one might link with Richard Long include Joseph Beuys, Yves Klein, Constantin Brancusi, Isamu Noguchi, Mel Ramsden, Joseph Kosuth, Bruce Nauman, Barnett Newman, Anthony Caro and Henry Moore.

Fellow students of Richard Long's at St Martin's included Gilbert & George, Bruce McLean and Barry Flanagan. Long is also associated, at various times, by various critics, with other British sculptors such as Tony Cragg, David Nash, Richard Deacon, Shirazeh Houshiary, Ian Hamilton Finlay, Michael Craig-Martin, Nicholas Pope, Peter Randall-Page, Stephen Cox, Bill Woodrow, Anish Kapoor, Hamish Fulton, Alison Wilding, Richard Wentworth, Boyd Webb and the Art & Language group. These sculptors are sometimes grouped together as the 'New British Sculptors' or 'the New Sculpture'. Key exhibitions included *The New Art* (Hayward, 1972), *Objects & Sculpture* (ICA/ Arnolfini, 1981), *British Sculpture in the 20th Century* (Whitechapel, 1981), *Figures and Objects* (Southampton, 1983), *New Art* (Tate, 1983), *The British Art Show* (Arts Council, 1984), *The British Show* (Australia, 1985),

The Poetic Object (Dublin, 1985), *Entre el Objeto* (Madrid, 1986) and *Gravity and Grace* (Hayward, 1993). Long contributed to many of these shows. He still lives in Bristol, and is very active, travelling the world, making art, and having exhibitions.

Long appears as a late British Romantic landscape artist, someone who fuses Sixties Conceptualism with 1800s pantheism; he's something of a High Modernist and a postmodernist Conceptualist. He has been described a 'traveller, explorer, pilgrim, shaman, magician, peripatetic poet, hill-walker' as well as an artist.[2] He says it is not enough for him to have an idea or concept: he has to make it.[3] His stone circles espouse the sensuality and beauty of the post-Romantic and modernist art object (as in sculpture by Rodin, Picasso, Maillol, Moore, Kollwitz), while his photographs and text works exhibit the cool, philosophic distantiation and ideations of Process, serial, ABC, Conceptual and Minimal art. Long's mud and stone and terracotta works are real, sensual objects, which satisfy the modernist critics who exalt the art object. The text and photographic pieces, however, 'feed the imagin-- ation', as Long puts it.[4] They are only understandable, like television shows or traffic signals, by a heavily enculturated imagination. The text pieces are lingual structures, dependent for their effect on what the viewer brings to them.

Like Hamish Fulton and Andy Goldsworthy, Long has travelled to some wild places in pursuit of interesting spaces: Lappland, Africa, Australia, Peru, Alaska and the Himalayas. It's easy to see Long's and Goldsworthy's art as simply pure Romanticism, a 'back to the land' art that utterly ignores political, societal, ideological, racial, economic and gender issues. True. Their art does not seem to be concerned with the urban 'real world' at all. And it looks odd to see their work in galleries in cities, to see the stones and stalks in a setting quite different from the wilderness. Rather, the art of Andy Goldsworthy, Richard Long, Chris Drury and David Nash comes across as deeply poetic, personal, subjective and romantic. It is *all* about a response to nature, about getting into connection with nature.

Richard Long's art mixes postwar, (post)modernist and Romantic (traditional) æsthetics. For Anne Seymour, Long 'has not only penetrated more deeply into the world of natural landscape than anyone since Turner, he has taken abstract art with him, creating a new art which allows all parties to retain their full identities'.[5] Mary Rose Beaumont also placed Long within a British Romantic tradition. This was a tendency of art criticism of the 1980s, as espoused by fine art gurus such as Peter Fuller and Robert Rosenblum. There was much talk in the 1980s of New Romantics/ Neo-Romantics/ New Ruralists, and so on. Whether High Modernism or postmodernism, Long's art is certainly a romance with nature, but always in an ecologically-friendly fashion. Long lives in Bristol, which could be described as not right-wing, left-wing or liberal, but pagan. Certainly, the pagan/ New Age/ hippy influence is very prominent in Bristol, and in all points south and west of Bristol, in Britain's West Country. Like Goldsworthy, Drury and Fulton, Long uses his hands and feet to make his art, and not an array of machines and tools. The aim is to be unobtrusive, 'invisible', in tune with the Earth. So Long acts like many walkers and hikers: he covers his tracks, does not leave behind trash, does not harm nature. So fierce is the 'right on', politically correct eco-friendly tendency of some walkers and campers, they worry about leaving even a footprint in grass as they pass by. Hamish Fulton declines to make any mark on the world as he moves through it, except footprints. 'The natural environment was not built by man and for this reason it is to me deeply mysterious and religious', remarked Fulton.[6]

For Richard Long, walking itself is the primary act of his art. Walking is mainly what he does, as an artist. His talent, he said, is to be able to walk. Walking clears the mind, it is a process and experience of simplification and purification. It purges the soul, Long remarked, it forces the self to concentrate on simple things such as air, sky, earth, rock.

Like art itself, it [walking] is like a focus. It gets rid of a lot of things

and you can actually concentrate. So getting myself into these solitary days of repetitive walking or in empty landscapes is just a certain way of emptying out or simplifying my life, just for those few days or weeks, into a fairly simple but concentrated activity which, as you say, is really quite different from the way that people normally live their lives, which is very complicated. So my art is a simplification.[7]

For Richard Long, as for many people, walking is a way of simplifying life, of cutting through the clutter. When walking, one moves into a different space, a space set quite apart from the rest of life. The time of walking is not the everyday, day-in-day-out time of the working world. It is not the profane, boring time of working at a check-out in a supermarket, or slaving away in some hideous South American factory. Walking takes one right away from that sort of everyday time. Walking takes one into a non-profane time and space. Walking in fact sacralizes space and time. As the walk takes places, sacred time is reinstated. Walking therefore has a religious or philosophical dimension, which sounds odd only if terms such as religion or art sound odd to the ear. In walking, in travelling, in holidays or other escapes and escapades, people put themselves back together. Walking in wildernesses, people say, is invigorating and refreshing: walking returns people to themselves, and of course renews their contact with nature. These things can sound stupid – 'renewing one's contact with nature'. Wow, maaan, it sounds hippy-dippy, doesn't it? But one can't avoid nature in the wilderness – it surrounds the self entirely.

I do the things that have a deep meaning for me. I have the most sublime or profound feelings when I am walking, or touching materials in natural places. That is what I've decided to do and that is what I am showing you in my art.[8]

Perhaps Long should move into multi-media, interactive and technological presentations. Perhaps he ought to have the sound of recorded atmospherics and wind from his walks in the gallery. Perhaps Long ought to try bringing more of the multi-sensory

experience of a walk into the gallery space. Perhaps he ought to encourage someone to spend a proportion of the next exhibition budget on employing some museum designers and curators to create a multi-media *Walk Show*. Sounds tacky? But isn't having a framed Ordnance Survey map on a wall and calling it an artwork tacky? One knows it doesn't cost much to produce a map work (eight bucks for the map, one fifty for the frame, a few cents for the pen to mark on the map). The stone circles 'cost' nothing, it seems, like the River Avon mud. Long's main 'materials' for his sculpture seem to be 'free' – the walk itself is 'free'. Seen in one way, Long's works can strike the viewer as 'cheap', tacky and pretentious. Mr Joe, the (non-existent) Mr Average, might wander into a Richard Long show and exclaim, *it's just a few stones on the floor, innit? Jeez, anyone could do that!* This was the furore that Carl Andre's bricks generated. Bricks on the floor? Six thousand pounds? So Richard Long's works can appear extremely tacky, 'cheap' and pretentious. But Long doesn't 'risk' everything on the socio-cultural context of a gallery. As his sculptures relate to walks, they always have a solid, straightforward, no-nonsense element. No one can argue with the importance of walking. Walking is not namby-pambying around with a paintbrush and canvas like a Sunday school amateur painter. No, walking is good, solid, dependable work. It's only when walking is portrayed as 'art' that the problems occur.

Art possesses nature and yet does not possess nature: something always remains elusive. What's there, in nature, is no longer there in the artwork. As David Reason noted of Hamish Fulton's work, and this applies to Richard Long's text pieces: '[i]n the work, everything derives from what cannot be shown and shared – walking and camping in close relationship to a specific patch of the natural world.'[9] The viewer does not experience the real subject of the work, which is the walk. Instead, the viewer has to place her/ himself into the role played by the artist, as s/he walks in the landscape. Land art text pieces can be seen as sophist-icated forms of holiday snaps, those little coloured slips of plastic,

pixels and photochemicals which record two weeks' escape from labour.

Richard Long's text works do not 'describe' the landscape, in the usual manner. Short phrases, and sometimes (as in Fulton's work) single words stand in for (a description of) the landscape. Long's text works do not claim 'this is the world', but record tiny parts of the world seen from a particular subjective perspective on a particular day in a particular season and frame of mind. The particularity of each work is emphasized in Long and Goldsworthy by the artists' placing of the time and place in the final sentence of each text piece. Sometimes, as in Long, Fulton and Goldsworthy, a distinct date is mentioned; at other times, just the year. The duration of each of Long's walk is also critical: thus the viewer can get an idea of when and where the walk took place, how much mileage was covered in a certain amount of time. Instead of trying to depict or describe nature, then, Long's art (like Fulton's) may be about the impossibility of representing landscape in art. At the same time (here's the paradox again) both Long and Fulton (and Nash, de Maria, Heizer *et al*) are consciously making art in or about the landscape. Even though the impossibility of the project is stressed, they are still making art. That is, still indulging in a particular kind of Western, bourgeois, intellectual, creative activity.

Whether presented as a map (*Low Water Circle Walk*, 1980) or text (*A Circle of Middays*, 1997), Richard Long's circular walks are designed as fascinating artworks. While some people might organize a circular route in a town (bank to post office, then to the grocery store then home), Long makes the circular walk a matter of Conceptual art and geometry. The casual circular walk of everyday life (once along the boardwalk and back through the town, or once round the power plant, or skirting the town centre to avoid the local lowlife) becomes in Long's art a living sculpture founded on 'universal and common' principles. 'My work has become a simple metaphor of life... I am content with the vocabulary of universal and common means,' writes Long, 'walking,

181

placing, stones, sticks, water, circles, lines, days, nights, roads'.[10]

Richard Long, who is not a poet of the stature or talent of John Cowper Powys or Arthur Rimbaud, is not adept at communicating the experience of a walk in words. Why, then, is Richard Long's work so popular? It must be that before he made the text pieces he made very sensual works to which people could relate instantly. Long's (relative) fame or popularity must stem (partly) from his stone and slate circles, which people can see and touch and walk on and discuss. If Long had never made a stone circle, would he be as popular as he is today? That is, has a painter or sculptor become successful simply by sending words to a typesetter to be printed and framed and put on gallery walls? It's an interesting question. Of course, Long was making the text works *as well as* the slate rings. Even Conceptual artists such as Gilbert & George had actual objects people could see. They might have been 'living sculptures', but they also made colourful works. There are few artists, it seems, who have become famous merely by manipulating and exhibiting words in frames.

The other factor explaining Long's success is his use of the Great Outdoors, the wilderness landscape which is so dear to Anglo-American-European art audiences (the photos depict gorgeous wild zones in Bolivia, Iceland, Scotland, the Sahara, Nepal). In the stinking, sweltering/ freezing, grey and drab cities of the West, Long's works suggest wide open spaces, vast cloudscapes, cycles of growth and decay which have been long obliterated from the Western city.

One knows about Long's walks from the maps, text and photos. So, as he walks, Long is making art. It is not quite the same with Joseph Beuys or Gilbert & George, who were performing, who were 'living sculptures'. Long's absence from his photos and texts is part of his ecologically-friendly, non-destructive stance. Long's walks, though, are not a 'performance'.[11] The walk is not 'performing' something, a performance *of* something, a representation. It is about movement in space, a lived experience.[12] The walk is the walk. To call it art is also to call it life, in Long's view.

The two things are continuous. The central thing to grasp with Richard Long's art, as also with other land artists, such as Heizer, de Maria, Nash, Fulton, Aycock and Holt, is the essence of their work, the mythic centre, which may be an idea, an essence, a structure or an experience.[14]

Richard Long, though, does polarize critics and art consumers. People seem to love him or loathe him. For fans, Long's a New Age, eco-friendly mystic, making cool, Conceptual art that doesn't harm the environment. For sceptical critics, Long's pretentious, shallow, repetitive and unoriginal. Modernist critics moan that there's no object to grasp in Long's art – for them it's a series of empty Conceptual gestures. Postmodernist fans can admire how Long plays the art market, trouncing conventional views of the art object. For Long, a sculpture can be two hundred and thirty miles long if he wishes. If a sculptor wants to make a 'real', physical object 230 miles long, s/he has to have a lot of money (like Christo with his *Running Fence*). Long, however, retorts that his 230 mile-long sculpture really is a physical thing: he walked those 230 miles, physically. He might record sensual aspects of the walk: wind direction, incidents along the way, weather, and so on. So, 'conceptual' though it seems, Long's sculptures are 'real', physical objects. A walk, after all, is one of the most physical, and fundamental, activities for humans.

Denying it or hinting at it, Richard Long's sculpture is definitely 'religious'/ 'mystical'/ 'spiritual'. Walking itself is sacred; making art is sacred; the allusions to stone circles are religious; circles themselves are religious; the awe with which viewers regard the sculpture has a religious aspect, and so on. Not all of Long's works are circles – there are always the lines. Long continued to make lines in the shape of a cross from time to time, such as in *Two Places* (Bolivia, 1972), where a small cross is made on marshland in a pile of stalks. Another cross was made in Iceland from some stones (*Stopping Place Stones*, 1974). The crosses are very much like geometric marks 'drawn' onto the landscape, as if to mark a place. Most of the single straight lines are short,

like the crosses, such as *Walking Without Travelling* (Sahara, 1988). Occasionally, Long makes a square zigzag line: short right angles are marked upon bare soil, as in *Campfire Ash* (Bolivia, 1972 – all these works are from *Mountains and Waters*). Another zigzag line sculpture, in Antwerp in 1973, extends outwards to take over the gallery: each Long sculpture is made for a particular space, and expands to consume the gallery floor. The zigzag lines recall the Peruvian Nazca animals and symbols drawn on the lava plain (Long had walked along one of the desert lines in 1972: he also made sculptures which employed symbols such as the puma, condor, falcon, moon, sun and rain.) Like most artists, Long has his visual motifs which he returns to time and again (circles, lines, rows, and, lately, ellipses and arcs).

Long spoke warmly of Carl Andre and Lawrence Weiner, important Sixties Minimal and Conceptual artists.[14] It is significant, too, that Long felt he was working on his own in Britain, that there was nobody else doing his kind of art. When he stepped out of Britain he realized there was 'a whole new world of ideas going on'. Long noted, perhaps wryly, that '[t]here was an immediate interest and understanding of my work as soon as I stepped outside England'.[15] Long himself declined being described as a Conceptual artist ('[m]y work is real, not illusory or conceptual. It's about real stones, real time, real actions').[16] He spoke sympathetically of Arte Povera, the use of 'simple, modest means and procedures'.[17]

Some commentators have negated the tendency to view Long in Romantic terms. 'Richard Long's landscape is... as modern (in feeling) as the city of Bristol from which he sets out for a walk' claimed R.H. Fuchs (1986, 43). Long, Fuchs opined, tries to play down 'as much as he can the romantic/ Romantic, poetic connotations' of his locations (ib.). Yet, surely wildernesses such as Dartmoor, Mexico, Ecuador, Nepal, Canada and Lappland, where Long makes his art, have been inscribed with connotations of Romanticism. They are places now described in terms of 'spirit' and 'soul', spaces that in contemporary romantic, nostalgic culture

imbue one with a sense of infinity, solitude, pantheism, awe, eternity and all the rest of the Romantic æsthetic baggage. 'A walk is also the means of discovering places in which to make sculpture in 'remote' areas, places of nature, places of great power and contemplation' remarked Long, speaking in Romantic terms of his walks.[18] In a walk such as *Straight Miles and Meandering Miles* (1985) Long walks some 'straight miles' along the way, between Land's End and Bristol. As expected, these 'straight miles' are walked in wilderness or countryside or 'Romantic' locations, such as Bodmin Moor, Exmoor and the Mendip Hills. The starting points and the end points of the *Four Walks* (1977) sound like a list of destinations a landscape painter might make for a 1790s Grand Tour of Britain: the source of the River Severn, Snowdon, Chesil Beach, Sherwood Forest and Carantouhil peak.

Although he may downplay the Romantic associations with the art made in or about landscape, Long described landscape in romantic, emotional terms. He reacted to landscape directly, facing it straight on, as is apparent in all his interviews and writings. He spoke of the need for transcribing landscapes purely and clearly. So, for instance, his photographs are simply taken, without too much trickery, and they are printed in a straightforward manner.[19] At the same time, Long described 'places of great power and contemplation', terms which Wordsworth might have used a hundred and fifty years before Long, or Henry Vaughan, the Metaphysical poet born on the Welsh borders, before that.

Stressing the Romantic heritage/ tradition of Richard Long's art though, only makes up part of the picture. Like other artists of the Sixties (whether Pop, Conceptual, Minimal, process, ABC, 'cool', Arte Povera, body, performance or other art), Long suppressed notions of poetry and Romanticism. 'My art is not urban, nor is it romantic' Long said.[20] Looking at *A Line in Iceland* (1982), a line of boulders in a wilderness space, shot against a brooding sky and a backdrop of snowbound mountains, one can see the affinities with the High Romanticism of Wordsworth's poeticizing of the Lake District, J.M.W. Turner and his

watercolours of Snowdonia or the Alps, or John Ruskin and his evocation of the Sublime. 'Working out there in nature, then, Long is a performer in the open-air theatre of the sublime' wrote David Sylvester. True, *Red Slate Circle* (1980) in the Fogg Art Museum in Cambridge (MA), or *Sandstone Spiral* (1983) in the National Gallery of Canada, or the *Puget Sound Driftwood Circle* (1996) in Houston, or *Forte de Vinadio Circle* (Italy, 2001), are set on museum floors, in the clean, sparse gallery environment, and look Minimal. What concerns Richard Long is that '[e]ach work is appropriate to its place and context', and the wilderness works and the museum pieces are 'equal and complementary'. What counts, Long asserted, is the feelings that the work, whether inside or outside, aroused: 'my ambition is basically with the emotional power of the work, in both idea and image.'[21] Walking, nature and the landscape are at the heart of Long's work,[22] but Long knows, as any professional artist must know, that the art world conducts its business indoors.

Richard Long's slate, stick and wood circles look like late 20th century artworks, not 'Romantic', but Minimal, Conceptual and Arte Povera, like Carl Andre's copper and zinc plates. They have a coolness and clarity that one associates with Dan Flavin, Robert Morris, Tony Smith and Sol LeWitt. Long's stone circles make sense partly because of the viewer's grounding in the discourses of postwar and contemporary art. Without a knowledge of the myriad discourses, analyzes and signs that flow around contemporary art, one might not know how to make full sense of Long's circles. True, the circle as a shape has been around for eons, but only in the contemporary era have circles been made out of bits of the landscape, in galleries and in landscape settings in this particular way.

The *Tarahumara Circle* (Mexico, 1987) is what seems at first to be a simple shape. But it's not 'simple'. It's a 'negative circle', a circle made into a circle by the ring of rocks around it. The line of rocks marks out the circle, but not evenly. Some of the rocks are piled deeper on one side of the circle. Hardly anyone will have

seen this circle intact, in its situation, so one knows it only from a photograph. The seemingly straightforward approach of Long's photography has made a few æsthetic decisions, which shape spectators' perception of this artwork. For instance, one sees the stone circle in the centre of the frame, in the lower third, in the sort of classical composition that was taught in the fine art academies of yore. Behind the circle one sees the trees and hills of Mexico. Long's photograph thus 'captures' the stone ring amidst the Mexican landscape, placing it firmly within a wilderness landscape. The setting is impressive and it is meant to be. With its wooded slopes and hills receding into the blue haze, the photograph is worthy of the ærial effects described by Leonardo da Vinci in his treatise of Renaissance painting. The composition of *Tarahumara Circle*, the more one studies it, becomes increasingly 'classical': there are even two small trees either side of the stone circle, in the foreground, framing the circle, a compositional device favoured by Turner, Girtin, Cotman and other late 18th century landscapists.

Long's *Brough of Birsay Circle* (Orkney, 1994) is a large open circle which relies on plants and their blooming in summer to make it work. Like his late 1960s lines made by walking, Long has walked in a large circle on a field of flowers. The flowers have been pressed flat, leaving a circular mark. The largest of Long's circles are of course the circular walks he makes, which could be many miles in diameter. Some of these are on maps, some are suggested through words. These are 'imaginary' circles but no less significant than the tactile stone circles. It's the same with science: the largest scientific experiment in the world is not the particle accelerator buried underground in Switzerland, it's those astronomical observations which use radio telescopes on either side of the Earth to correlate data from deep space. The diameter of the planet is the size of the experiment. The telescope is as large as the Earth. There are even larger astronomic experiments: the journeys to Mars and Venus, for instance, or the grand tours of the Solar System of the Voyager spacecraft. But even larger than these

million-mile space voyages are the radio telescope investigations, which cross interstellar space at the speed of light. Conceptually, then, humans have made experiments – or art – that stretch away from Earth at light speed. That is, if radio waves have been beamed into the cosmos for, say, ninety years, then the extent of the human touch in the universe is something like 5.3×10^{14}, or 530,000,000, 000,000 miles. It is a reach that is expanding 186,000 miles every second.

One or two of Long's stone circles are small – *Circle of Standing Stones* (1983), which is 26 stones arranged in a circle of a half metre in diameter, *Cornwall Slate Circle* (1982), 34 stones in a 2 metre circle, and *Standing Stone Circle* (1982), 36 stones in a similar size circle. The small stone circles are often made of standing stones, and many of the outdoor circles are of this type (*Evening Camp Stones*, 1995, for instance). Long's use of standing stones, rather than ones laid flat, echoes prehistoric stone circles – for instance, the Scottish stone circle *Stones and Stac Pollaidh* (1981), or *Sincholagua Summit Shadow Stones* (1998). Long's small stone circles are intimate works compared to the broad, large pieces. In Britain there are a number of small stone circles which produce similar atmospheres of human-scale and intimacy (such as the small circles on the ridges of hills in Dorset). 'I like simple, emotional, quiet, vigorous art' remarked Long.[23] While the large circles in the galleries of Western cities spoke of polished, upmarket art, the small, 1.5 metre stone circles evoked small wayside shrines. The large gallery circles are planned and organized months in advance, but still look spontaneous. Long's small outdoor stone circles, though, are direct and spontaneous responses to a landscape.

Some of Richard Long's techniques echo Goldsworthy's: Long sprinkles snow in a circle, or smears mud, often from the River Avon near his home in England, in huge circles or lines or arcs on walls, or he makes marks on grass using his feet. The use of hands, feet, the body, mud, soil, stones, snow and sand chime with many of the standard practical methods of land art.

I like the idea that I can make a show anywhere by just going down to the river taking a few handfuls of mud... and literally get on a plane and go anywhere and make a big show with the mud from my bag.[24]

Long's art ethic – *have mud, will travel* – fits in with the notion of a pared-down, simplified, 'essential' æsthetic that was current in the 1960s and 1970s. The great thing is not so much that Long can splatter mud on a wall and call it art (he does the former, not the latter), but that people around the world accept mud splattered on wall as art. Richard Long – one of the success stories of the British art school system (along with David Hockney, Patrick Caulfield, Peter Blake, Barry Flanagan and Shirazeh Houshiary) – knows only too well from his days at St Martin's College of Art that he is lucky to be able to travel the world with a bit of Avon river mud in his bag, and have gallery audiences lap it up, because for every major (successful) artist there are thousands of students pouring out of the art colleges each year. These art students are often producing work just as rich and challenging as that of Inshaw, Blake, Houshiary, Kapoor, Gormley, Vilmouth, Cragg, Woodrow, Hockney and Flanagan.

HAMISH FULTON

For Hamish Fulton, the walk is central to – *is* – the artwork. If there is no walk, there is no work: 'no walk, no work', as Fulton put it. Most of his walks have been made alone, Fulton said. But not every walk needed to be be made into a work of art. They were sufficient unto themselves.[1] On the other hand, Fulton commented that he had to walk to be able to make a work of art. The artwork came out of the work, and if he didn't walk, there couldn't be any art.

As with Richard Long, Fulton rarely included images of people in his art, but his art 'should not be thought of as anti-

189

people' (1995). Instead, Fulton's photographs are of wildernesses (mountains, fields and country lanes). Fulton separated the walk from the artwork. 'The artwork cannot represent the experience of a walk' Hamish Fulton affirmed (1995). Aspects of the work could remind the artist of making the work, but could not communicate the experience of the work to the viewer. 'The texts are facts for the walker and fiction for everyone else' (1995).

Fulton said he preferred to walk rather than sit in a train or plane or car. Travelling (sitting) was of 'little interest' to him (1995). And when he embarked on a walk, Fulton said he walked directly from his home, rather than use transport. The walk was the thing, always. 'I am an artist who walks, not a walker who makes art' (1995). Fulton complained that he seemed to spend more time on organizing exhibitions, on admin and paperwork, than walking (1995).

The typical Fulton artwork is a large black-and-white photograph in a frame with a short piece of text in capitals underneath (the look of Fulton's text and photo pieces recalls Long's art). Fulton's work include *Rock Fall Echo Dust* (1988), recording a walk made on Baffin Island; *The Crossing Place of Two Walks at Ringdom Gompa* (1984), *Rock Path, Switzerland* (1986), *Grims Ditch* (1969-70), *Night Changing Shapes* (1991) and *Gazing At the Horizon Line, Sky Horizon Ground* (Australia, 1982). Some of Fulton's works consist only of text in capitals painted on a wall in a gallery: *No Talking For Seven Days* (1993) and *Rock Fall Echo Dust* (1988). Among Fulton's influences were artists such as Marina Abramovic, Nancy Wilson, Roger Ackling and Richard Long, Tibetan religious art, American Indian culture, mountaineers, *haiku* poetry from Japan, and 'the walking peoples of the world from all periods of history' (1995).

Like many British land artists, Fulton didn't want to make massive and long-lasting marks on the landscape. On the contrary, it was totally the opposite. Fulton said his art was not aggressive or technological: 'I do not directly rearrange, remove, sell and not return, dig into, wrap or cut up with loud machinery

any elements of the natural environment' Fulton asserted, clearly having various well-known land artists in mind (1995).

TIME AND NATURE: ANDY GOLDSWORTHY

Andrew Charles Goldsworthy was born in Sale Moor, Cheshire, in 1956. Goldsworthy and his three siblings grew up in Cheshire, and on a housing estate on the edge of Leeds (in Alwoodley). Goldsworthy worked on a farm part-time (Grove House Farm, Alwoodley) from age thirteen. Goldsworthy later said (in 2000) that working on the farm had been as important as attending art college. Goldsworthy failed the 11-plus exam, for the grammar school system, and went to Harrogate High School instead. Goldsworthy would subsequently fail to gain entrance to his chosen foundation and degree colleges. (Ironic, perhaps, because his father was Professor of Applied Mathematics at Leeds University).

As a young art student, Andy Goldsworthy spent much of his time outside college, working on the beaches at Morecambe and Heysham. Goldsworthy preferred to learn by direct experience, finding out about leaves, mud, stone, rivers and tides by living amongst them. Goldsworthy would go into college for one or two days a week, for the art history classes. This was not enough for the lecturers, who suggested that he spend more time in college, including attending life drawing classes. Little did Goldsworthy's lecturers know – that their errant student, who spent hours clambering around the muddy reaches of Heysham Head and Morecambe Bay instead of dutifully attending college classes, would one day become an artist of international renown, with exhibitions and commissions around the world. At the time (*circa* late-1970s), Goldsworthy must have seemed just another crazy art student, pursuing his own wacky ideas (British art schools contain plenty of kooky folk – not all of them students). Hearing of his beach-mud-stone-tide antics, Goldsworthy's tutors must have sighed heavily

and put another stroke through the 'absent' column on his attendance record. Amazing to think that this artist-in-the-making would one day be exhibiting at the one of the most prestigious museums in the world (the British Museum), designing Royal Mail stamps, and making a Holocaust memorial in New York. For Goldsworthy, the time spent working at Grove House Farm and the Lancashire beaches was as critical as his art education: '[t]he energy and unpredictability of art outside the studio and gallery were important to me. Going outside art college felt so much more raw, and that's what interested me' (*Time*, 180).

There's not a lot of anger, or angst, or suffering, or self-doubt, or lust, or violence, or propaganda, or neurosis, or disturbance in Andy Goldsworthy's art (many land artists are similarly laid-back). He's definitely not a haunted, tormented artist like Vincent van Gogh, or an aggressive, flamboyant self-publicist like Salvador Dali or Andy Warhol, or an ironic, fey commentator on the postmodern condition, like Jeff Koons or Robert Rauschenberg, or a stridently ideological combatant like Ana Mandieta or Karen Finley, or a crazy performance artist like Stuart Brisley or Annie Sprinkle, or a darling of the *avant garde* scene, like Yoko Ono or Matthew Barney.

'My art', Andy Goldsworthy noted in *Time*, 'is rooted in the British landscape, and this is the source to which I must return' (*Time*, 7). In 1986 Goldsworthy moved from Yorkshire and Cumbria, where he'd spent most of his life, to Penpont in Dumfriesshire, where he has remained ever since. This's where Goldsworthy produces most of his work. A nearby $2^1/_2$ acre piece of land (dubbed Stone Wood by the artist) was leased from the Bucclech estate in the late 1980s. The River Scaur, one of Goldsworthy's most beloved spots, is on one side. Goldsworthy's first *Wall*, and many other works, were made at Stone Wood.

Many of Andy Goldsworthy's site-specific works and commissions have been in (and about) the North of Britain: the giant maze and *Lambton Earthwork* (at County Durham, 1988-89), the Grizedale Forest site works (1984 onwards), residencies at

Yorkshire Sculpture Park (1987-88), the Lake District National Park (1988), and St Louis Arts Festival (1986), *Sheepfolds* (1996-) and so on. Large Northern commissions included *Sidewinder* (1985) and *Seven Spires* (1984), *The Wall That Went For a Walk* (1991) at Grizedale, Cumbria, *Lambton Earthwork* and *Maze* in Durham (1988), *Stone Gathering* at Northumberland (1993) and *Enclosure* in Edinburgh (1990). It's Goldsworthy's contemporary, though, Anthony Gormley, who has made the sculpture in Northern Britain that has bedded itself in the public consciousness since the late Nineties: the *Angel of the North, a* 65 foot tall steel figure at Gateshead (1998). Goldsworthy has made a work at Gateshead, a steel cone (1991) constructed on the site of a foundry (this was part of a proposal to build a group of cones, which was unrealized).

Andy Goldsworthy has created land art in Grise Fiord, the North Pole, in Japan, upstate New York, California, Castres, Digne, La Rochelle and Sidobre in France, the Australian outback, and in Haarlem, Holland. The first work that Andy Goldsworthy sold was a bunch of photographs to the Arts Council (via Andrew Causey at North West Arts). He has had one-man shows in France, Japan, Holland, the US and the UK, and participated in groups shows in Italy, Germany, and the US. A major retrospective, *Hand to Earth: Andy Goldsworthy: Sculpture: 1976-1990*, was held at the Henry Moore Centre for the Study of Sculpture, Leeds City Art Gallery: the show also travelled to the Royal Botanic Gardens in Edinburgh, Stedelijke Musea, Gouda and Centre Regional d'Art Contemporain Midi-Pyrénées in Toulouse. This show also produced the most useful and detailed publication to date on Goldsworthy's art (*Hand to Earth*, later reprinted – see bibliography, with 2000's *Time* as a handy update).

In the 1990s, Andy Goldsworthy's art began to rise in popularity: the glossy coffee table book *Stone* became a bestseller (bear in mind it was priced at 35 pounds or about 55 dollars). In 1994 Goldsworthy took over some West End galleries with a large one-man show, *Stone* (this included *Herd of Arches*, also made for the Hathill Sculpture Foundation at Goodwood in Sussex, and

ultimately finding a permanent home in Cornwall).[1] In 1995 he took part in an intriguing group show, *Time Machine: Ancient Egypt and Contemporary Art,* at the British Museum in London and Museo Egizio, Turin, creating sculptures, along with Richard Deacon, Peter Randall-Page and others, in amongst the monumental statuary of the famous Egyptian Hall. Also in 1995, Goldsworthy designed a set of Royal Mail stamps. As well as commissions, installations, TV and radio programmes, and books, Goldsworthy has also produced limited edition prints (the pictures of cairns were made with Eyestorm, in editions of 500, priced at $720 each).

Other Goldsworthy shows and projects of the 1990s and after included *Mid Winter Muster* in Australia (1991), sand and mulga branch-works; *Seven Holes* (for Greenpeace, 1991); *Black Spring* in Adelaide (1992); a large gateway at Hooke Park in Dorset (1987); various wall commissions (such as in New York, 1993, 1996 and 1997); various *Cones* (New York and Oxford, 1995); *Four Corner Stones* (Nice, 1993); *Rockfold* (Northumberland, 1993); *Fieldgate* (New York, 1993); clay holes and throws at Runnymede Sculpture Farm, California (1992); *Two Autumns* in Japan (1994); *Breath of Earth* at San Jose Museum of Art (1995); a clay installation (a hole) in L.A. (at the Getty Center for the Arts, 1997; later destroyed by a burst pipe); 'ice houses' and stick lines made in Alaska (1995); a slate cone and chamber for British Airways at their West Drayton HQ in 1998; cairns and 'refuges' at Digne les Bains in 1998; new groups of work at the National Museum of Scotland in Edinburgh (1998); the new *Wall* at Storm King (1998); another wall at Storm King (*Folded Wall,* 1999); a large stone arch in Montréal (1998); *Snowballs in Summer* in London (2000); and *Garden of Stone,* a memorial for victims and survivors of the Holocaust, sited in Manhattan (2003).

Goldsworthy worked at TICKON (Tranekær Internationale Center for Kunst og Natur) in Denmark in 1993, Alfio Bonnaro's art park (other artists invited included David Nash, Nils Udo, Chris Drury, Karen McCoy and Alan Sonfist). In 1999 he was

appointed Senior Lecturer/ Practitioner in Fine Art at the University of Hertfordshire. In June, 2000, he was appointed Visiting Professor at the University of Glasgow, and in July Andrew D. White Professor-at-Large at Cornell University.

Goldsworthy continues to work in countries such as Japan, Australia, Canada, North America and France, but his home ground of Dumfriesshire in Scotland remains (at) the heart of his work. (From the mid-Nineties, Goldsworthy worked increasingly frequently at Digne in South France; it became one of the most valuable places for the sculptor outside of his home in Scotland, and was the site of a major commission, *Refuges d'Art*).[2]

It's significant, I think, that Goldsworthy worked as a gardener for the first half of the Eighties. Goldsworthy's art parallels development and trends in gardening in Britain and elsewhere. For instance, the use of stones and pebbles in the gardens as ornaments or sculptures. The popularity of Goldsworthy's art, I would argue, is in tune with events such as the rise in gardening shows on TV (and those shows' links with house, food and interior design programmes), the spread of DIY stores and gardening centres, more gardens open to the public (including many more private gardens), the interest in ecological and environmental politics, anti-pollution and recycling drives, and the increase of New Age and mind/ body/ spirit pursuits (such as *feng shui*). One of the things that fuels this revived (or new) interest in gardens, art and the environment, of course, is an increase in leisure time (and money for entertainment), an aging population (which also lives longer), new technologies, and new distribution and consumption networks.

Goldsworthy has not created art everywhere. There are plenty of places Goldsworthy has not visited for making art. Even in the British Isles, Goldsworthy has not made much art in Cornwall or Devon or the South-West, or the East (Norfolk, Suffolk, the fens), not much in the English Midlands, only a few works in Wales, and hardly any in Ireland. If Goldsworthy makes work in the UK, it's usually Scotland, Northern Britain (Cumbria and Yorkshire,

but not so much the North-East), or London.

Around the world, Goldsworthy has concentrated on Western-ized territories: on America, of course (it's the centre of land art), Western Europe, Australia and Japan (with the odd excursion to exotic spots, such as the North Pole). Goldsworthy has not made much art in Eastern Europe, in Russia, in mainland China, in India, in Africa or South America. (Goldsworthy did visit Russia in 1991, but 'administration difficulties' prevented the intended work in Siberia).[3] Visits to India, Africa, China and so on will probably come.

Andy Goldsworthy works with the natural world, and within nature. He uses natural materials in (apparently) natural shapes and forms set in natural contexts. Goldsworthy takes his cue from nature: as Jan Dibbets put it in 1969: 'I realized that if you want to use nature, you have to derive the appropriate structure from nature too'.[4] Andy Goldsworthy seems to be a particularly gentle and sensitive artist, compared to many sculptors and land artists: he stitches together leaves to forms lines (which're often placed in water, or over branches), or makes circular slabs of snow, or entwines twigs in an arc. He creates a delicate spiral of chestnut leaves, called *Autumn Horn* (1986); he pins bright yellow dande-lions on willowherb stalks in a circle, on bluebells (1987); he makes lines and cairns of pebbles; a horizontal line of red sumach leaves was pinned to a willow (at Storm King in 1998); he rubs red stones to stain rockpools; he pins leaves to tree trunks; he makes hollow, circular structures, recalling igloos, from slate, leaves, driftwood and bracken; he makes long wavy ridges in Arizonan and Australian desert sand; he throws sand and sticks in the air and photographs the moment; he makes arches, globes, hollow spheres, slabs, spires, spirals and star-shapes out of snow and ice. Very impressive it all is. The sculptures made of sticks, for instance, stuck together in an arch, or a line, reflected in the mirror-like water of Derwent Water in Cumbria in 1988, are indeed wonderful. The sculptures exude tranquillity, an early morning calm (quite the opposite of another water work, Klaus

Rinke's *Water Sculpture*, where a water canon blasted water over visitors as they approached a gallery, or Jim Sanborn's 1995 *Coastline*, which employs a wave generator to simulate waves in a Maryland garden).

Then there's the globe made from oak leaves in various states of autumnal decay, superb (Dumfriesshire, 1985). Or the globe of sticks made in Fairfax, California (1995), set next to a sheltering tree. Or the sand serpent in the British Museum (1994). Or the globe made out of snow, and perched amidst some young trees (1980), or the slabs of snow, set up in a line with slits cut in them (1988).

Goldsworthy said: 'I want an intimate physical involvement with the earth. I must touch'.[5] Touching is 'deeply important' for Goldsworthy.[6] Only touching gives the artist the deep understanding of his materials and nature, he asserted.[7] Goldsworthy's *Forked branch and twig* is exactly that: a forked branch with a twig suspended between the two parts of the branch. The photograph of this 1978 work shows a space enclosed by the twig and branch, a rough circle of air and sky enclosed by the twig and branch. Goldsworthy rarely uses animals in his art; stones and vegetation are his usual materials. Some sculptures refer to animals (such as sheep and cows). One or two pieces were made from feathers (*Goose feathers*, 1983, *Wood pigeon wing feathers*, 1977, *Feathers plucked from a dead heron*, 1982, and *Wet feathers wrapped around a stone*, 1999). And some from wool (*Wool line*, 1995).

The eroticism of Andy Goldsworthy's sculpture is readily apparent, but the sensuality of Goldsworthy's art is non-human; there are no 'human' figures in his work, though there are vaginal openings, phallic rocks, mounds like breasts or pregnant bellies, and stalks that bend gracefully like ballet dancers: if one wants to anthropomorphize and sexualize Goldsworthy's art, it's easy. Goldsworthy himself anthropomorphizes his work. He says the cones on a hillside are like sentinels or a group of people.[8] Goldsworthy spoke of stones and seeds in terms of phallic tumescence and orgasmic release: 'I found an energy in stone that

can best be described as a seed that becomes taut as it ripens – often needing only the slightest of touch to make it explode and scatter its parts' (*Wood*, 23).

Goldsworthy has made more 'traditional' forms of art in galleries: his bracken, fern and horse chestnut stalk works, for instance, were made by pinning the materials onto white gallery walls. These works – *Bracken fronds* (Ecology Centre, London, 1985), *Reeds, bracken and horse chestnut stalks* (Centre d'Art Contemporain, Castres, and Galerie Aline Vidal, Paris, 1989) and *Reed line drawing* (Paris, 1990) – were essentially free, open wall drawings, often employing basic motifs such as the circle and open curve. Hanging screens of plants that Goldsworthy made in galleries include the *Susuki grass* and *Horse chestnut leaf stalks* (both made in Japan in 1993), *Horse chestnut leaf stalks* (1994, Japan), *Yucca blades* (New Mexico, 2000), and *Rushes thorns* (1992, San Francisco). *Rosebay willowherb* (1990) was crafted in Goldsworthy's studio.

Although he has carved stone from time to time, in the traditional sculptural manner, and also modelled clay, he disliked both processes. Although both methods have been central to sculpture for centuries, Goldsworthy rarely used them. 'I dislike the malleability of modelling and the imposition of carving as processes. Carving is a process that relies upon the integral strength of the block of stone'.[9] Instead, Goldsworthy preferred to employ drawings or shaping with his hands, or weaving stalks or plants or leaves, or rubbing stone to make powder, or splitting stone to make walls or cairns, or piling up snow, or throwing stalks in the air, or balancing rocks.

Andy Goldsworthy always speaks of the significance of the surrounding environment in his works. His sculptures are as much about the surroundings in which they are situated, as about the 'sculptures' themselves. An exhibition inside, in a gallery, is always going to be a problem, then. The contemporary gallery, with its sparse settings, white-washed walls and trendy magazines and postcards, is a powerfully *cultural* environment. The

contemporary gallery is not 'natural' at all, it is not 'nature', it is not a place of mist, wind, skies and soil. No wonder, then, that earth artists such as Walter de Maria wanted to fill a whole gallery with dark soil, to bring nature into the contemporary gallery in a big way.

Goldsworthy's shows are something of a disappointment, in one way, because the works have to breathe without their usual natural surroundings. Goldsworthy did emulate Walter de Maria in a direct way: in November, 1992, he covered the interior of the London gallery of his agent with clay (*Hard earth – Dorset clay smoothed out, left to dry*). The exhibit began as a smooth creamy-white expanse of wet clay/ earth. It looked as if the gallery was empty, said Goldsworthy (*Stone,* 64), recalling Yves Klein's empty gallery show, *Le Vide,* of 1958). *Hard earth* directly re-echoed de Maria's *New York Earth Room*: the natural world was present in the gallery in both works in force: in de Maria's *New York Earth Room* (1977) the dark soil had a solemn, weighty, fecund presence; in Goldsworthy's *Hard earth* time and transformation played a part: gradually, the clay dried and cracked, allowing the Goldsworthyan vision of the dark energies of nature to well up: nature was erupting into the gallery space.

Goldsworthy's writings are sometimes simple, matter-of-fact, and sometimes blunt – in a stubborn, Northern fashion. Goldsworthy comes across a rugged man of the wild, a 'whole earth man', ecologically sensitive, someone 'in touch' with nature, working with his bare hands, in boots, hat and an anorak, often in Winter. There is a macho posturing to this (no doubt unintentional) in which the relationship with nature is 'fundamental', 'raw', 'violent', 'intense'. Goldsworthy sees working in the hard conditions of Winter a challenge, a 'test of my commitment to the landscape'.[10] Goldsworthy has spoken about being 'shocked' by small-scale natural events, about work suddenly becoming 'intense', about the 'raw energy' of colours. Goldsworthy's writings are marked by words such as 'powerful', 'wildness', 'deeper', 'rooted', 'flesh and bone', 'feeling', 'essential', 'sense', 'energy',

'touching' and 'essence' (these words are taken from one page of Goldsworthyan philosophy, in *Stone*, 6).

All this talk of raw, powerful essence in nature suggests one poet in particular – Ted Hughes, the stolid Yorkshireman and former Poet Laureate whose books (*River, Hawk in the Rain, Lupercal, Wodwo, Elmet*) are full of post-Hopkinsian evocations of wild shingle beaches, desolate moorland, ancient forests and craggy heights. If ever there a poetic equivalent of Goldsworthy's boulders, melting snowballs, slate cairns and red mud 'throws', it is Ted Hughes' verse. Another link is nature-man Mellors in *Lady Chatterley's Lover* (1928), the no-nonsense outdoor man who is in fact a New Man, painfully sensitive and alive. The D.H. Lawrence connection with Andy Goldsworthy is emphasized by Goldsworthy himself: in *Stone* he quoted from Lawrence's *The Rainbow* (1915), one of those euphoric, ithyphallic passages about the ecstasy of consummation in an arch. Lawrence's intensely poetic novel about three generations of a Midlands family (his 'Brangwen-saga') is a strident inrush of energy into Goldsworthy's otherwise pedestrian prose in *Stone*. Goldsworthy might do better to leave writing out of his books, and simply use quotes from Locke and Lawrence, as he does in *Stone*. His own pontifications can be banal.

Of a cairn made out of scrap steel which was placed next to an old foundry, Goldsworthy said that the cairn 'touches the nature of an urban environment' (*Stone*, 35). Does it 'touch the nature' of the place? What is the nature of the place? How can a human 'touch the nature' of the place? What is the quality of this touching? What kind of touching is it? And what is the nature of 'the nature of an urban environment'? How does the artist know he's touched it? Simple: he believes wholeheartedly in his subjective, intuitive feelings. Of steel, for example, the artist stated: 'I can feel its source' (ibid.). What does this 'source' 'feel' like? And what is the 'source' of steel? The Earth? The energies that formed it? The people that dug the source material out of the ground and shaped it? How, too, does the viewer know about this feeling for the

source of a material? Is it expressed in the work? How can the audience test the authenticity of the artist's feelings? These are questions which one can (and should) fire at any artist. Goldsworthy's art is often unsure about the answers. It knows it is about nature, ecology, place, organic form, and so on, but its views on these matters, and its relation to them is often confused, ambiguous, banal or simplistic.

A dandelion work such as *Dandelions* (1993)[11] highlights the recurring problems with Goldsworthy's sculpture: it has instant appeal: brilliant yellow dandelions are set in a mossy, pitted rock next to a stream. The work seems to emphasize the relative beauty of both the flowers and the setting: the 'organic', individual shape of the rock pool, the contrasts in brightness and colour in nature (grey and green rock, yellow dandelions), the transience of nature (the dandelions' colour will fade; the flowers will be pummelled by the next rain, or swept away when the river rises). Yet the sceptical viewer might also say, well *anyone* could make that work (or many other Goldsworthy sculptures). There is little 'technique' or skill involved: one simply places dandelions in a pool (or rocks on top of each other, or wraps boulders in clay, or rubs the bark off twigs, or cracks open pebbles, and so on). *Dandelions* seems so simple, so easy, like so many of Goldsworthy's sculptures (*Beech leaves, Balanced stone, Balanced rocks, Two Scaur Water snowballs, Red river rock pools, River rock, Peat, Clay-covered rocks, Torn stones, Red sand thrown into a blue sky, Orange stones* and *Yellow elm leaves*, to cite some works from *Stone*). Hang on, the sceptic might claim, the charlatan has simply stuck some flowers in a pool! That can't be 'art'! Easy to see how Goldsworthy's art can seem a sham, like Carl Andre's bricks, or Yves Klein's leap, or Andy Warhol's six hour film of someone sleeping. *Come on*, the sceptic'll say, this can't be *serious*.

Andy Goldsworthy sculptures such as *Yellow elm leaves, Red maple leaves, Beech leaves, Red river rock pools* and other riverside works seem so simple, so easily put together. But Constantin Brancusi's eggs and fish and heads are also very 'simple' shapes

and forms: he reduced and rationalized natural forms until he reduced them to an 'essence' (the 'essence' of a fish, of a head, of a bird in flight). Yet Brancusi does not get accusations of superficially and banality thrown at him. Indeed, his sculpture is really powerful precisely because he radically simplified it. (What the viewer doesn't see in the gallery, of course, are the hundreds of failed attempts, the mistakes, and the years of research and refinement to get to that stage).

With Goldsworthy, though, the simplicity is of a different order: is the confusion and criticism of Goldsworthy's work because he is using the *actual* material of nature? An actual leaf, rock, petal, ice sheet, not an imitation or image of them? Is it that anti-Goldsworthy critics see a rock covered with real leaves, not a mock-up made in an artist's studio, or a bronze or marble interpretation? Is it that Goldsworthy is getting so 'close' to nature that he is using the very materials of nature themselves, without altering them much at all? Goldsworthy doesn't seem to *do* much with his materials: he wraps them round a rock, sticks them in a pool, builds a mini tower out of 'em, takes a photo, and then it's 'art'. Is it that his art does not do anything more than this?

This is how the art of postwar (postmodern) artists such as Goldsworthy, Yves Klein, Andy Warhol, Joseph Beuys and Carl Andre differs from traditional Western art. They use the *actual object*, a process begun by Marcel Duchamp with his *Urinal* and developed by Kurt Schwitters. Schwitters' reasoning was along the lines of: why not stick on some real objects? Jasper Johns said the same thing: he preferred the real object itself to a representation of it. Instead of using a replica or imitation or image of a rock or icicle, Goldsworthy uses the rock and icicle themselves. The confusions of this relationship between reality and illusion, object and image, life and art in Goldsworthy's art are compounded by his use of photography, which instantly renders everything an image, a mode of representation, a simulation, a copy, subject to all the strictures and structures of art and representation. Goldsworthy's photographs are plainly *not* the object in itself, but a repre-

sentation of it, which is very different, and much more complicated.

Goldsworthy has to face up to the fact that most people know about his art (and love his art) from photographs. Most people who know of Goldsworthy have *not* seen a Goldsworthy exhibition; have *not* seen his art in its outdoor environment; have *not* seen Goldsworthy making a work. They have bought the book *Time,* or seen photos of his art in magazines and books. For the punter who consumes art in books and printed material (or on TV or radio or the internet) the 'real' art object doesn't need to exist: what counts is the media representation of it. But this would upset a realist/sensualist (modernist) like Goldsworthy, who so passionately needs 'to touch' ('I must touch' as he puts it). A world of computerized virtual reality would be abhorrent to him. Yet that is how his art is mainly consumed. Punters have bought the books, seen the photos in magazines and that, for them, is Andy Goldsworthy art. Thus, the *photographs* of Goldsworthy's sculptures are *already* 'so real' that they have, for the consumer, replaced his art. Goldsworthy has said that it is important for the viewer of his art to fill in the gap between the photograph of the sculpture and the real sculpture that he made someplace else. The photographs are incomplete on their own, as artworks: they require the spectator to create the rest of the artwork by using their imagination and memory, by remembering what it was like to be cold or wet or in a wood. To recall what it was like to be a child, touching leaves or snow or ice).[12] The viewer, then, supplies the 'reality', the 'real' experience, the effect, which the photographs suggest but cannot complete. (This could be another reason for Goldsworthy's popularity: that his art leaves some part of the sculptures incomplete, and the viewer can supply the rest from their many memories of the real world. A kind of art of interactivity, fed by nature photography). It's also a not insignificant fact that by the time the photographs are published or exhibited in a gallery, most of Goldsworthy's sculptures have already ceased to exist (they're been blown away, collapsed, eroded, dissolved, etc).

Of course, art consumers would probably like to know that the stones *really were* balanced on top of each other on the Welsh coast, or the icicles *really were* stuck to a wall in Dumfriesshire. It's probably essential, in fact, for many spectators to think that Goldsworthy really made those works. But Yves Klein faked his *Leap*, and invited people to see an empty gallery. In the age of art impresarios and art 'terrorists' (such as Yves Klein, Andy Warhol, Claes Oldenburg, Jeff Koons, Bruce Nauman, Piero Manzoni, Gilbert & George, the KLF), when art works are only known through radio, TV, the web and the press, Goldsworthy could have faked everything. (There are numerous techniques to fake images – not just with modern computers, digital manipulation and Photoshop, but older methods such as montage, airbrushing and printing separate negatives. Consider masters of photographic superimposition such as Oscar Rejlander, Henry Peach Robinson, Alexander Rodchenko, Max Ernst or John Heartfield).

For Richard Long, Andy Goldsworthy is a 'second generation' artist, and is 'decorative (!)'.[13] Most critics, though, have been extremely praiseworthy of Goldsworthy. Neil Hedges wrote: '[t]The artist always achieves his goal, establishing and stimulating our own senses to view or touch conversant shapes and materials with much delight' (73). Andy Goldsworthy uses 'feminine' modes of art-making: *weaving* stalks or *stitching* leaves together. Weaving, sewing and stitching are regarded as 'feminine' means of production, linked with art and craft, and denigrated by masculinist criticism.

The suspended leaf shield turned out to be 'one of the best pieces I have ever made', as Goldsworthy put it. The hanging leafworks enable light to become a key element in the sculpture: the translucence of the leaves was highlighted. The sun completed the sculpture, making the leafwork as 'extraordinary as going to the Arctic'.[14] Light is one of the key formal elements that Goldsworthy explores in his sculpture. Critics have spoken of Goldsworthy's 'stunning effects of light and atmosphere'.[15] The two leafworks of October, 1997, at Storm King (orange and yellow

stuck onto a rock), were made specifically to catch the morning sunlight.[16] Another shield, *Horse chestnut leaves* (Yorkshire, 1987) was deliberately made for darkness, hanging in amongst some rhododendron bushes. The Getty Institute clay hole was positioned so that the sun would shine on it once a year, at Midsummer. Some of Goldsworthy's *Refuges d'Art* were constructed to take advantage of certain lighting effects (such as the rising sun at certain times of the year).[17]

Because place is so important,[18] light (and colour) becomes a primary tool. Some Goldsworthy works pivot very much on luminosity and opacity, not just the leaf shields, but some of the snow walls, the holes in sand, and so on, so that without the right sort of lighting, they do not work properly. Some sculptures are created in response to certain lighting conditions – the stick sculpture in the Lake District (1988), made in the pale, liquid light of dawn, for example. 'When I work with the land I work with the sky. When I work with water I am working with the clouds' Goldsworthy stated.[19] The branches from a mulga tree in Australia (in 1991) were edged with red sand in order to catch the light of the setting sun: set end to end, the red-edged branches looked like a snake (appropriate for the Australian outback). Some of Goldsworthy's weakest works were made in Australian in 1991: *Mulga branches* had the branches laid on the red sand in two directions; they changed colour as the light changed. Other sculptures are seen in a variety of lighting conditions – stormlight, snowlight, misty skies (the snow wall at Blencathra in Cumbria, is an obvious instance). Some of the brightest of Goldsworthy's leaf-works were made in Japan, where the maple leaves are dazzling in October and November (in, for example, *Maple patch*, November 22, 1987, or *Japanese maple*, November 21-22, 1987).

Andy Goldsworthy's flower pieces are inevitably 'pretty'. It's difficult to use flowers, in poetry, sculpture, painting or performance, without appearing 'pretty' (Goldsworthy realizes this).[20] Think of Rainer Maria Rilke's many flower poems (to roses, irises, lilies), or the beautiful, sonorous flower watercolours of the

German Expressionist Emil Nolde. Like Nolde's radiant flower-pieces, like the flowerpieces of Flemish and Dutch art, Goldsworthy's flower sculptures are luminous. The dandelion piece (April 28, 1987), which is a spread of flowers making a hole in the middle, is powerful not because of the shape the artist's made, but because of the vibrant yellow of the flowers.

It is the *colour* of Goldsworthy's 'red splashes' or 'throws' that contributes much in making them powerful. Goldsworthy has spoken of the significance of using the colour red: in Japan, he remarked, he learnt about a 'deeply disturbing' red (*Wood*, 15), a 'heightened awareness of red. A bright red maple tree in the middle of a green forest, like an open wound' (in ib.). Goldsworthy often uses red in his art – in the boulders covered in red maple leaves (1991) or the poppy-leaved covered stones (1989), or poppy petal-covered branches (1992), or the ridged holes made on the beach at the Isle of Wight with red edges (1987, AG). Red maple leaves climb up rocks or are layered on top of little rockpools (1993). Goldsworthy relates red to the iron in human blood.

The Harrlemmerhout, Holland work, *Poppy petals* (1984), was a seven-foot long line of poppy petals held together with spit which was hung from an elderberry. It was, a critic said, 'one of the most impressive and poetic works' Goldsworthy made during his time at Haarlem.[21] At Hampstead Heath (in London) an associated work, a line of beech leaves, was floated over a pool.[22] Red-tinted water spread like blood over the floor of the Barbican Centre in London, melted from inside a snowball (2000). In Australia the colour red did not arrive in Goldsworthy's work, as one might expect, from flower petals or red stones, but from red sand: Goldsworthy rubbed the sand into the bark of a mulga tree (1991). Gathering rain clouds and a brilliant, low sun created the right lighting conditions to bring out the red tree against the brooding grey sky.[23] Goldsworthy said that the red of the Australian outback was 'deeply moving spiritually'. 'I have tried to touch that colour not just with my hands, but also with light' (*Wood*, 15).

Goldsworthy's photographs present an idealized world, veritably the pastoral world of ancient times. Goldsworthy's Arcadia, though, is definitely a Northern European pastoral realm, not the Southern, Mediterranean paradise of satyrs, shepherdesses, gods and wild animals. Goldsworthy's 'pastoral sublime', to use the phrase applied to a category of J.M.W. Turner's works, is a Northern European realm, very much in the tradition of Turner's paintings of the Alps, with lowering, gloomy skies, raging wind, snow-capped mountains and mossy riverbanks. John Martin, Thomas Girtin, John Sell Cotman, John Constable and Turner made many paintings of the landscapes Goldsworthy works in. Apart from Australia and Japan, Goldsworthy's art centres around cold, rain-sodden, Northern landscapes. True, there is much sunlight in his photographs of Australia, photographs that evoke the colonial view of the outback as a rugged, inhospitable place where the white people sit around camp fires. Goldsworthy's Japan is a more sublime, rarefied place, though it is still rough and distinctly non-human.

Goldsworthy photographs his sculptures often looking down on them, so the surrounding landscape is not seen. He edits out unsightly buildings or roads, but art has always involved much more editing than many artists would admit. Goldsworthy knows that what one leaves out of a work is as important as what one puts in. Goldsworthy said that photographs were 'very important to me as a working record', and that he had a record of nearly everything he'd made, which he could look on and use.[24] 'A good work is the result of being in the right place at the right time with the right material' said Goldsworthy.[25]

Some of Andy Goldsworthy's earliest works were tidal, beachbound sculptures which relied very much on the power and majesty of the sea to make them work. Some were works which required the action of the tide to complete them. They were fabricated specifically so that the sea would cover them up. At Morecambe Bay in Lancashire in October, 1976, Goldsworthy buried a serpentine line of stones and photographed them as the

tide came in. Another work, at Heysham Head, comprised the now-familiar Goldsworthy motif: a series of rocks on a tidal pedestal: as the water rose, the sculpture altered. Goldsworthy's later sea sculptures of balanced rocks are essentially no different from these early Lancashire works. The early works, like the latest sea pieces, employ the formal elements of the littoral environment: the presence of the sea, the changing levels in water, the reflectivity of the water, the colour of the sea, and sky, the movement of the water, and so on. These elements are incorporated into Goldsworthy's sea sculptures. Later tidal works included *Eleven Arches* (1992, Carrick Bay), *Sand Stones* (1992, California), *Beach Holes* (1990, Morecambe), *Balanced Rocks* (1993, Porth Ceiriad, Wales), *Sand Holes* (1997, Rockcliffe), *Cairn* and *Stick Dome Hole* (both 1999, Nova Scotia). Goldsworthy's very early works were consciously irregular and 'organic' in shape and form, rather than the more geometric forms he later adopted (such as circles, spirals and lines).

Many (land) artists have worked with the tide: Barry Flanagan, Christo, Dennis Oppenheim, Michael McCafferty, Michelle Oka Doner, Chris Drury and Jan Dibbets. Jan Dibbets had a tractor plough the sand on a beach which would then be covered by the tide, in a film made for television (in 1969), for a *Land Art* exhibition.

Much of Andy Goldsworthy's art is about and made from ice and snow. Other artists who have worked with snow include Dennis Oppenheim, Joseph Beuys and Hans Haacke. Goldsworthy is distinctly a 'Northern' artist, who makes work in landscapes that come out of the 'Celtic fringe', out of the sort of landscapes that Celtic culture exalts: misty, rocky hillscapes; sodden Autumnal forest floors knee-deep with leaves; wild snowscapes; cold, clear streams banked with large mossy boulders; still lakes at dawn. Goldsworthy's landscapes could have mythical figures such as the Lady of Shallot, Lancelot or King Arthur riding through them without altering anything. They are the landscapes of Merlin, Taleissin and Morgan Le Fay, of Welsh legends such as *The*

208

Mabinogion, of historical events shrouded in mists, of historical figures such as Robert the Bruce, Owen Glendower, King Edward and Boadiccea. The places associated with Goldsworthy – his studio at Penpont, Scaur Water in Dumfriesshire, Carlisle, Yorkshire Sculpture Park, Grizedale in Cumbria, Leeds, Leadgate in Durham – are all Northern British sites. And the stereotypes of Britain's North – grimy towns, rain, bleak moors, gloomy skies, grim humour, down to Earth and no-nonsense attitudes – all chime with Goldsworthy's sculpture.

One wonders whether Goldsworthy would like to work in snow and ice more than in any other medium. His notes and titles record many frustrations stemming from working with snow. In temperate snowlands, though, one feels Goldsworthy is very much at home. Snow has the right sort of qualities Goldsworthy looks for in a material: it is malleable, it melts and changes, its whiteness makes for good, contrasty imagery, and it seasonally alters the landscape, and later dissolves into it. In Goldsworthy's snowworks one senses also the sheer fun of working with snow. For people in most of Britain, snow is not a definite event each year, as it is in, say, Northern Russia or Alaska. For children, snow can be an exciting event (while British adults usually gripe about it). Snow was a perennial delight and 'shock' for Goldsworthy. In *Midsummer Snowballs* he wrote that '[e]ven in winter each snowfall is a shock, unpredictable and unexpected.[26] Goldsworthy retained the child-like enjoyment of snow falling in Britain throughout his life. While much of the UK grinds to a halt at the sight of a snowflake, Goldsworthy has the child's joy when it snows (school's cancelled, snowball fights, ice skating, sledging, and making snowmen and snowballs).

Goldsworthy speaks in wonder and awe of 'the effect, the excitement' of the first snowfall.[27] Some of this excitement comes across in Goldsworthy's snowworks. He has made, for example, patterns in the snow by rolling a snowball around a field, exactly as kids do when it snows (*Snowball trail*, Brough, Cumbria, 1982 and Yorkshire Sculpture Park, 1987). Linked to the snowball trail

was a rectangular wall of snow built on the hills in Penpont in March, 1998. Some of Goldsworthy's earliest works with snow were large snowballs. In some of these early snow works, Goldsworthy placed snowballs in areas such as woods or fields which didn't have any snow, so the snowballs stood out against the trees and grass (as in Ilkley, Yorkshire, 1981). Into some snow-balls Goldsworthy inserted branches and other material (as Clapham, Yorkshire, 1979, Bentham, 1980, and London, 1985).

The biting cold maybe gives Goldsworthy a sense of heroism, for suffering invariably enhances a work (as in, 'this work was difficult, made under adverse conditions'). After all, Goldsworthy is not an artist who makes work in the 'comfort' of a home or studio (working indoors doesn't feel 'real' to him). No: he goes out into the wilderness, where it can be uncomfortable and challenging. He claims to know the landscape around his studio in Penpont, Scotland, very well, so that the snow does not hide the world: 'I know what lies under the snow – I know the earth beneath' (HE). Always Goldsworthy stresses the intimate relationship he has with nature. Part of this intimacy comes from returning to the same patch of land again and again. Through successive visits, layers of touch and meaning in the landscape are uncovered by the artist. The artist returning to the same space always works in time as well as space, for s/he creates a personal history of that place. S/he works with her former selves, as well as in the present – with the artist and ideas she had two years ago, ten years ago, twenty years ago. 'Some places I return to over and over again, going deeper – a relationship, made in layers over a long time'.[28]

The personal dimension is important in Goldsworthy's work. His work is not 'impersonal' in the sense that it could be made 'anywhere'. It is, like most land art, always a product of a relationship between an artist and a particular place. Making the art itself, the doing of it, is important for Goldsworthy. So that when people ask the eternal question, *but is it art?*, he retorts, well, he doesn't know and doesn't care, but 'it is important and

necessary for me as a person.'[29]

Sceptics can claim that many of Goldsworthy's sculptures gain much of their fire from their situation in wilderness landscapes. They would be right. Although Goldsworthy states that many of his sculptures are made in built-up areas, areas of dense population and human activity, a glance through any Goldsworthy book or a visit to a Goldsworthy show will reveal the large proportion of wilderness or rural landscapes in his art. He expunges all the trash, houses, telegraph poles, apartment blocks, cars and roads from his photographs, and presents lush streams, moorland, forests and hillsides. There are no people at all in his art, except Goldsworthy himself, who is sometimes seen, with his beard, sweater and jeans, making a piece of art. In this sense, Goldsworthy's work is not at all figurative – but neither is it 'abstract', in the Mark Rothko or Piet Mondrian sense, for real, recognisable objects appear in his work. This is one of the reasons for the growing popularity of his work: apart from the Eighties ecological/ Green movement, and the accessible, decorative quality of his work, it is thoroughly countrified and rural, quite in keeping with primæval desires for escape into the country, that nostalgia for nature that lies behind the pastoral and landscape tradition in Britain.

Goldsworthy's skill is not just to 'touch nature' (whatever that means) but to touch the chords of desire for nature in people. Goldsworthy's art is popular partly because of this powerful desire among Western audiences for contact with the natural world, an appetite which is manifested in natural history programmes on television, in jaunts to zoos, gardens, windswept hillside car lots, in Constable, van Gogh and Monet posters and prints, in gardening magazines and gardening centres and plants in the house, in the popularity of English rural novels by George Eliot, Thomas Hardy and Emily Brontë. The eco/ green movement (and its associated movements in pagan/ New Age/ road, anti-capitalist, anarchist and animal activism) taps into this nostalgic love of an urban-centric culture for all things 'natural'.[30] The

natural world seems to be green and life-giving and untarnished by the complexities of modern life. The natural world, which is Goldsworthy's world, is a place of leaves, rivers, animals and stones, a place seemingly devoid of people, the ones who fuck things up, who complicate things, who introduce the concepts and realities of neurosis, confusion, waste, violence, consumption and politics into the 'pure' natural world.[31] It's not like that at all, but these eco/ Green/ pastoral feelings are powerful. Goldsworthy's art, like the pastoral novels of Eliot and Hardy, like Green politics or the money-spinning popularity of van Gogh and Monet, trades on the desires for an earlier, ancient Paradise, a time when things were simpler, richer, deeper. This is the 'green world' of child-hood, a time of playfulness and living close to the Earth, enjoying the seasons passionately but also freely, in a relaxed manner. In mythology, it is the 'Golden Age', *il illo tempore, ab origine*, in the Creation era, at the origin of the world, before the Fall of Adam and Eve into sin, a time before œdipal anxiety and patriarchal psychosis, a Gaia time, a whole earth time, all 'natural' and recycled and vegetarian, a holistic time, a time of social unity, when everyone felt as one in communities and loved each other, a time of maternal bliss, when women were nurturing Mother Goddesses and men could be sweetly dreaming babies without feeling embarrassed. Goldsworthy's art books, commissions and shows trade on this pastoral imagery and desire: they allow stressed, confused, overworked and neurotic city dwellers time out from staring at the control screens (TV, computers) of the megavisual world, encouraging a little day-dreaming into the soft greens and greys of wild moorlands. Goldsworthy's art may be increasingly successful because it reminds people that, yes, one does love nature after all: one came from it, one'll go back into it, in the end, in death.

Goldsworthy's art may hit home because it does *not* bombard people with telephones, computers, cars, factories, radios, TVs, microwaves, washing machines, hoovers, irons, faxes, all those machines that connote *labour*, that are the symbols and mechan-

isms of working life. In Goldsworthy's green world, all is natural, untechnological, with artifacts that connote a return to basics: stone, wood, leaves, ice.

Andrew Goldsworthy's most dramatic work to date is probably *Touching North* (1989), four circular arches made of snow. It is dramatic partly due to its location, that space so thoroughly a masculine 'wild zone', the place of macho adventures, colonization and courage: the North Pole. The project was organized by the Fabian Carlsson Gallery, London (one of Goldsworthy's dealers at the time), and overseen by Fabian Carlsson. In March and April, 1989, the expedition visited Montreal, Resolute, Grise Fjord,Camp Hazen and the North Pole., and the show travelled to London, Edinburgh and L.A. through 1989.

Snowballs In Summer (a.k.a. *Midsummer Snowballs*, 2000) was one of Goldsworthy's larger, more complex installations. Fourteen snowballs were gathered from the snowfields of Dumfriesshire and Perthshire in 1999 and 2000, kept in storage, transported to London and exhibited on the streets of the City of London. This, coupled with the show *Time*, at the Barbican Centre (in August-October), made 2000 the most prominent display of Goldsworthyania for some years in the UK. Goldsworthy liked the idea of the snowballs appearing in the middle of Summer in an urban setting. The snowballs were not 'made for people. They are about people'.[32]

One of the problems Andy Goldsworthy's art addresses head on is the age-old tension between the 'real world' and art, between objects as they are in the everyday world, and objects as they are represented in art. Goldsworthy encourages the viewer to look again at the natural world: not just at the beauty of it, but at the multitudinous variety of forms in nature. The snowball in the *Snowballs* installations (1989 and 2000) is not plastic or concrete masquerading as a snowball, but a real snowball. Similarly, the twigs and stalks and needles and pebbles folded into the snowballs are real. What's amazing is the actuality of nature: the variety of forms (the way the branches twist, for instance).

Goldsworthy's sculptures used all the tricks and devices of post-Renaissance illusion and representation, including figure-ground relationships, negative space, perspective, selective view-point, *chiaroscuro*, silhouettes, outlines, and so on. A good example of the strong pictorial element in Goldsworthy's art are the sculptures that use negative space to create the illusion of continuous form: these sculptures typically have loops of ice or sand on two sides of a rock or a tree. In, for instance, *Reconstructed refrozen icicles* (1999).[33]

Goldsworthy's ethics are those of Chris Drury, Hamish Fulton, Richard Long, David Nash (he has worked at Nash's Blaenau-Ffestiniog studio) and other British land artists: a mystical feeling for the landscape, expressed by an exquisite sensitivity of *touch*, that all-important component in the eroticism of sculpture:

> Movement, change, light, growth and decay are the lifeblood of nature, the energies that I try to tap through my work, I need the shock of touch, the resistance of place, materials and weather, the earth as my source.[34]

As Goldsworthy affirmed, he *must* touch. A world in which he would not be allowed to touch would be hateful. A world in which the trees had 'DO NOT TOUCH' signs on them would be horrendous. Significantly, Goldsworthy works mainly in areas in which the ownership of the land is not contested. He operates in landscapes where he has been given permission to work. No 'DO NOT TOUCH' signs for him.

Indeed, when it comes to drawing on the sand on a beach, Goldsworthy will not use a stick, as many folk would. Instead, he uses his hands. His *Dark dry sand drawing* is worked by hand, dribbled onto the sand on the Isle of Wight (1987). The result, all swirls and curves, comes directly from Jackson Pollock. Goldsworthy has also drawn lines on frozen water (Nova Scotia, 1999). A lot of work Goldsworthy has done in deserts has been with carved sand (in New Mexico, Arizona, California and Australia). In a way, these drawings and sculptures of sand (in the shape of

214

spirals, snakes, zigzags and boulders) are basically developments of the work with sand on the beaches of Northern England Goldsworthy undertook in the late 1970s.

Land artists such as Andy Goldsworthy use their hands, primarily, as their means of making art. Goldsworthy does not go out into the landscape with anything, except a knife.[35] Perhaps he should, to be really purist, make do without even a knife? Anyway, he *does* really go out into the landscape with 'tools' – the camera not least among them (also spare film too, maybe an extra lens filter or two, and a tripod). Without that camera, the viewer wouldn't know about many of his works. Ditto with all land artists. Without the camera, their work is 'lost'. That is, not really 'lost', but the camera means the viewer too can share in the work. Without the camera, the viewer would have to rely on written texts, perhaps, as a means of 'recording' artworks. Photography is also 'a way of communicating' Goldsworthy told an interviewer, 'and we wouldn't be sitting here if I didn't take the photographs.'[36] Here Goldsworthy admits that without the photographs there would be not much communicating going on with his art: it needs photography to work. But, as one can see, Goldsworthy and other land artists are not writers. Indeed, their writings are, well, often in note form, designed as a 'record' for themselves, or as notes towards some artwork. While there have been any number of painters and sculptors who were also good writers who provided many insights – Leonardo da Vinci, Ad Reinhardt, Vincent van Gogh, Donald Judd – Goldsworthy is not among them. So, relying on photographs, the viewer gets to find out about many works of land art that might otherwise have never known. The camera is thus an essential 'tool' for the land artist. Goldsworthy also goes out with many other invisible tools of his craft – his awareness of land art, his education, his knowledge of other sculptors and art history, his memory of previous works, and so on. No artist works alone, culturally. Goldsworthy's art, like all land art, like all art, works within a culture and tradition and history of postwar and contemporary art. Tracing the links with

215

Minimalism, Arte Povera and Conceptualism, for instance, is only one way of looking at Goldsworthy's art.

Goldsworthy's sculptures are marked by a number of elements familiar in land art: transience, domination, penetration, circular forms (globes, circles, spirals, snakes, cones) and nature mysticism. The ephemerality of the pieces, for instance, is a key component. Snow and ice will melt away, leaves will disintegrate, stones will be blown over. Each Goldsworthy sculpture has a date printed with its title. Not just a year, as in the usual artwork, but a specific day. Thus, one of his best pieces, the delicious poppy covered boulder, has the title: *Poppy petals wrapped around a boulder held with water*, with the time and place inscribed as: Sibobre, France, June 6, 1989. The petal-covered rock, with its brilliant red colour, nestled in some mossy boulders, looking very much like one of Constantin Brancusi's 'cosmic eggs' (egg-shaped sculptures which Brancusi titled *The Beginning of the World*). The red colour revealed the rock's shape, size and form, its position amongst and relation to other rocks. Not wishing to disturb or move the rock (it's not that small really), Goldsworthy's act of covering it in wet poppy petals drew attention to this particular egg-shaped rock, *this* one and *not* the others (although the surrounding boulders also became the subject of the sculpture: attention was drawn to them as well as to the red rock). In *Poppy petals wrapped around a boulder held with water*, then, the place becomes as crucial as the centrepiece, the red rock.

In 1994's *Herd of Arches* in London, Goldsworthy had fitted together masses of small slabs of stone, with tiny pebbles and wafer-thin stones wedged in, to hold the arch tightly together. Roger Partridge has made an arch out of stone (1983, private collection) which recalls Goldsworthy's *Herd of Arches*. Alan Sonfist's *Rock Monument of Rocky Mountains*, very much an ancestor of Goldsworthy's arches, was made in 1971.

The ancestors of Goldsworthy's snow prints are Conceptual pieces like Bruce McLean's *Seascape* and *Treescape* (both 1969), where the artist wrapped paper around trees and photo-sensitive

paper on the ocean. A variation on the snowball prints were the 'sheep paintings' which Goldsworthy embarked upon in 1998, part also of Goldsworthy's fondness for the agriculture industry (sheep footprints were recorded on pieces of white canvas, with feed containers situated in the centre of the canvas). (Goldsworthy had also combined elements of seal and caribou on the Arctic expedition). The snowball prints (which Goldsworthy makes by allowing snowballs to melt onto big pieces of paper) are disappointing, really. A snowball melting on a sheet of paper is too random and easy, perhaps.

The largest section of Andy Goldsworthy's book *Wood* (1996) is devoted to the *Capenoch Tree* series of works, made between 1994 and 1996 in Dumfriesshire in the UK. The 'Capenoch tree' was an old oak tree standing slightly apart from other trees on private land. Goldsworthy concentrated not on the whole tree, its trunk or its branches (as he often did), but on one particular branch that grew sideways out from the tree, horizontally, a few feet above the grass. As Goldsworthy explained, '[t]he long branch that has grown horizontal to the ground has taught me that the tree is the land. The branch is like the landscape' (*Time*, 195). So Goldsworthy treated the branch as a landscape in miniature, a small-scale setting for a range of sculptures which represent all of Goldsworthy's work in microcosm.

The *Capenoch Tree* series was unified by its location: every work was centred on the tree and its long branch. The unity of the series was enhanced by Goldsworthy publishing only photographs of each piece taken from the same angle, the same side of the tree. In nearly all of the photographic records of the *Capenoch Tree* series in *Wood* the same elements are present: the trunk on the right, the branch extending across the picture plane from right to left, the ground underneath and the background of trees. Goldsworthy returned to the Capenoch tree in all seasons, but favoured Autumn and Winter – the best works in the *Capenoch Tree* series are those made in Winter.

In a way, the *Capenoch Tree* series offered a summary of all of

Goldsworthy's land art techniques: there were leaves pinned along the branch; wood and snow cairns and globes placed next to the tree; snowballs set in the tree; arches made out of ice and stone on the branch; screens of willowherb and rosebay; walls of snow (some serpentine, some holed); lines of dandelions; and holes in the ground.

Goldsworthy, like Turrell, Aycock and Smithson, has made some huge pieces, such as the long 'snake' and the 'pool' or maze, in Country Durham, large works which take up a lot of space, and certainly *dominate* the surrounding landscape. Goldsworthy's large-scale outdoor works often use the serpent coil as a fundamental form. Goldsworthy maintained, however, that his 'snake-like' or serpent-shaped sculptures does not refer directly to snakes.[37] Instead, he preferred to call one of his favourite motifs a 'river of earth', or a tree root, or a river.[38] Whatever the artistic intention, however, it is impossible to limit readings of sculptures such as *Sidewinder, Lambton Earthwork* or the serpentine shapes in the British Museum's Egyptian Hall to responses to the environment. The serpent as symbol connotes time, change, seasons, birth-and-death-and-rebirth, eternity, sexuality, evil, the cosmos, and so on. Goldsworthy might wish to determine how viewers read his serpent-shaped forms, and emphasize the response he makes to the natural environment, but consumers of art will make any interpretation they like, and some they might wish to suppress (snakes also connote dirt – they slide on the dust; and excrement; the alimentary canal; eating and defecating; poison; reptile life, and so on). In 1998, Goldsworthy confessed:

> after working for many years, I have to admit that I have a fascination for the snake. For me it is perfect sculpture. It's so simple. The way it moves on the ground or in the water, it draws the place. It's so expressive of the place it moves through. It's not like any other animal. It actually moves with the surface of the land.[39]

While Goldsworthy insisted that he wasn't interested in the symbolic associations of the snake, or in the snake as an animal,

he did link his use of the snake to Brancusi's birds and fish (Brancusi sculpted radically simplified, abstract versions of birds and fish). For Goldsworthy, the serpent wasn't a totemic or symbolic creature, but a form that expressed 'the energy of movement' (ib, 113).

The theme of the winding serpent was especially pertinent to Goldsworthy's installations in the Ancient Egyptian galleries of the British Museum and the Museo Egizo in Turin in 1994. Goldsworthy's large sculpture was made with local sand on the floors of the museums, snaking in between the exhibits of Egyptian artifacts. It was there for one day then dismantled (after being photographed, of course – the photographic record incorporated the themes of time and death just as piquantly as the sculpture itself). Even if not explicitly like 'snakes', these sculptures evoked the Ancient Egyptian preoccupation with time, death, eternity and immortality. Goldsworthy spoke of the sand snake flowing 'through the room – touching the sculptures and incorporating them into its form to give a feeling of the underlying geological and cultural energies that flow through the sculptures'.[40] The sweet chestnut leafworks which accompanied the sand serpent also evoked time – they were spiral shapes, set in an Egyptian sarcophagus and a libation bowl.[41] Of his serpentine form Goldsworthy commented in 1999: 'I have to stop making this form. It is becoming obsessive' (*Time*, 167).

Andy Goldsworthy's large-scale works, like Turrell's, Holt's or Bayer's, are monumental works, which sprawl across the landscape. *Sidewinder* and *Seven Spires*, at Grizedale (a Forestry Commission site between Windermere and Coniston Water), are trunks of trees stripped of their branches, and pinned together. In *Sidewinder*, the curved trunks were placed on the ground, to form a long snake-like sculpture: the form rests on the ground then curves into the air. The impression was of sliding, arching kinetic energy. In other words: a huge serpent slithering along the forest floor. In *Seven Spires* the trees were pined together to form tall spires. The result was a series of enormous edifices made of wood

in amongst other trees. Goldsworthy wanted to harness the sense of the 'almost desperate growth and energy driving upward' in the pine wood, and to evoke a cathedral-like atmosphere, with the spires stretching skyward with the brown gloom underneath.[42] It is, at first, not clear which is a tree and which is sculpture. Both, of course, are made of wood: Goldsworthy has simply drawn together the surrounding trees, it seems, but in doing so, he re-defines the surrounding forest. *Seven Spires* looks at first to be a gentle sculpture, blending in with the surrounding forest. 'In avoiding monumentality, however, Goldsworthy's sculptures do not forego grandeur' wrote Andrew Causey.[43] Yet they do stand out, really, they are distinctly works of art, existing in a para-doxical relationship with the environment. A 'collaboration' is a polite way of saying what Goldsworthy's *Seven Spires* is about: a 'collaboration with nature', a phrase used about much of his art. Other spires, made at the same time, include *Bracken Spires* (1983) and *Stone Spire* (1983).

Commissioned by Sustrans and Northern Arts, *Lambton Earthwork* (1988) was a quarter-mile long bank which coiled along the ground near Chester-le-Street in County Durham. The site was associated with railways and industry, but Goldsworthy turned it into something wholly concerned with æsthetic and religious themes. The long spiralling banks of earth clearly derived from the earthwork sculptures of Robert Smithson and American earth art (Goldsworthy said he is wary of using the 'overblown spiral', the too-obvious spiral as a shape).[44] Goldsworthy spoke of the serpentine shape as being like a river winding through a valley, or the root of a tree.[45]

The other Durham earthwork (*Maze*, 1989, at Leadgate) also used ancient mythology and symbolism, this time the labyrinth. Like *Lambton Earthwork* (but unlike most of Goldsworthy's works), *Maze* was intended to be used by the general public. Both *Maze* and *Lambton Earthwork* were about responses to the energies in nature – thus the public was invited to explore similar things as they physically walked around the earthworks. The usual

experiences of the maze were apparent in Goldsworthy's *Maze* – not being able to see the whole plan from above; being enclosed by high banks; a bewildering series of turns and paths. The interwoven series of embankments also recalled Iron Age forts (of which there are many in Britain), such as the complex (and enormous) array of defences at Maiden Castle in Dorset. The comparison between Goldsworthy's sculpture and Iron Age hillforts, though, is not quite fair: Iron Age earthworks were not made by bourgeois contemporary artists for the purposes of providing an interesting æsthetic experience, but were made to protect small, tough communities who wouldn't hesitate to stab the enemy in the heart if attacked (Maiden Castle witnessed some bloody battles – especially when the Romans conquered the site).

Other large-scale Goldsworthy works include installations *Slate Wall* and *Clay Wall* (1998, Edinburgh), *Clay Wall* (1996, San Francisco) and *Clay Wall* (2000, London). The installation work *Stone sky* in Brussels (1992) comprised flat pieces of slate covered the entire floor of the large space, with a whitish circle in the centre, made by scratching the slate. The circle recalled Richard Long's slate circles, but the title, *Stone sky*, referred directly to nature: the circle could be read as the sun, the moon, the sphere of the heavens, the orbits of planets, and so on. One or two of Andy Goldsworthy's works directly recall those of Richard Long: Goldsworthy's *Burnt sticks* (1995), for example, is reminiscent of some of Long's and Nash's installations which form circles from stone slabs on gallery floors. *Burnt sticks* consisted of sticks charred at one end, the blackened parts of the sticks were put together to form a circle on the gallery floor. The *Fall Creek* installation, at the Herbert F. Johnson Museum of Art at Cornell University (in 2000), comprised a group of low holed mounds fashioned from hundreds of branches on the floor. Goldsworthy has worked at Cornell a number of times: the university has a long history of land art links: one of the important land exhibitions, *Earth Art*, took place in 1969 (it featured Long, Oppenheim, Smithson, Morris and Heizer).

One of the most important of Goldsworthy's later commissions was the installation *Garden of Stone* (2003) at the Museum of Jewish Heritage in Lower Manhattan. *Garden of Stone: A Living Memorial* was a group of 18 hollowed Vermont granite glacial boulders, with an oak tree inside (dwarf oaks, which only grow very slowly). The largest boulders weighed 13 tons. *Garden of Stone* was situated on the second floor garden, and cost a million dollars (the Public Art fund collaborated with the museum), making it easily Goldsworthy's most expensive commission to date.

Garden of Stone was made as a memorial for the victims and survivors of the Holocaust. Goldsworthy was an unusual choice, perhaps, for an artist to tackle such a massive political and ideological issue. Goldsworthy has not been known for addressing issues such as the Holocaust in his art. Certainly he could not be described as a high profile political artist. He has also not had much of a connection with Jewish culture or history.

Many of Andy Goldsworthy's cairns are fabricated from slate (such as *Slate cone*, 1987, 1988); others from branches (*Oak branches*, 1990); or sandstone (*Sandstone*, 1990). Others are put into groups (such as the proposals for stone cone groups at Vassivière, Newcastle and Penpont). Two later cairns include the commissions *Logie Cairn* (1999) in Aberdeenshire and *Hollister Cairn* (1999) in California. The first cairn Goldsworthy made (in Cumbria) he related to the rock formations in that part of North-West England (called the Nine Standards). For Goldsworthy, that pile of stones were guardians – and the idea of sentinels watching over the landscape remained with the sculptor ever since, becoming the fundamental interpretation of all his cairns and cones. Part of the *Sheepfolds* project were the *Nine Pinfold Cones*, stone cones sited within pinfolds made in 'counterpoint and dialogue' with the Nine Standards. As well as 'sentinels', guardians of a place, the cairns were also memorials to a place, or a people (Goldsworthy has linked stone cairns to burial mounds),[46] or monuments that crown a summit.

In 1994-95 a new form appeared in Goldsworthy's *œuvre*, the

'stone house', usually consisting of a hollow stick cairn or cone with a round or elliptical opening. Sometimes the cairns or chambers are constructed from stones, like Goldsworthy's stone walls, but the basic structure is the same: an enclosed space, often with a hole to see in (and out), and often with an object (a boulder, a tree) sitting inside. (Chris Drury has made the shelter one of his primary forms). Inside Goldsworthy balanced a column of stones. Examples of the 'stone house' include those constructed at Digne les Bains and Mt. Kisco, New York (both 1995). Like Chris Drury, Goldsworthy has occasionally enclosed his cairns with other materials, such as the slabs of ice surrounding a stone cairn (1996), and the stone spire inside a stick cairn (1995). A *Stone House* made in Melbourne (Australia) in 1997 took the form of a rectangular wall with a circular opening and boulder placed inside.

'Cone' is perhaps not quite the right term for an image or expression of fullness and ripeness: Goldsworthy's 'cones' look more like fruit. The imagery of fruit would accord with Goldsworthy's ripeness discourse. 'Cairn' is also not quite the right word either, though some of the 'cones' on rocky mountainsides (*Cone to mark day becoming night* at Glenleith Fell, and *Cone to mark night becoming day*, Scaur Glen, both 1991) have affinities with natural cairns and outcrops of rock. Some of the cairns were built at night, to be seen at night, as hymns to the night, or the dawn, or the sunset. Working on the Yorkshire *Ice hole* (1987), Goldsworthy spoke of 'working with the moonlight' which was a 'very strange intense light'.[47] Working at night, Goldsworthy described approaching 'the most beautiful point, the point of greatest tension, as one moves towards daybreak'.[48] The *Clearing of Arches* installed at Goodwood in Sussex (1995) were made to be viewed in moonlight. In Australia Goldsworthy constructed cairns 'for the moonlight', or 'for the day' (*Stone,* 43). Like the mulga tree branches edged with red sand to catch the setting sun, these stone cairns were made for particular lighting conditions: the orange-coloured stones made into a cairn were associated with (and completed by) the setting sun. The stone cairns were the sculptural

equivalent of lighting a fire in order to celebrate Midsummer or sunset; or erecting a little shrine for a minor deity. They were small-scale celebrations of the daily festivals of dawn, moonlight, noon and sunset, sacred moments that occur every day, but which are no less holy for their common recurrence. Here Goldsworthy is working 'with the sky', with large-scale events such as nightfall and moonlight.

One of Andy Goldsworthy's favourite structures is the stone wall. The wall he made (his first) between his land and a neighbouring farmer's at Stone Wood, Penpont, in Scotland, was snake-like sculpture (*The Wall*, 1989). *The Wall* was a 'monument to walls',[49] a neat way of creating, on Goldsworthy's side of the wall, a sculpture, and on the farmer's side, a sheepfold. Goldsworthy's walls have a dual purpose: practical, and æsthetic. The walls are boundaries or sheepfolds as well as artistic objects. Their æsthetic derives from their practical applications (*Stone,* 106). While later walls (such as *Room* or *The wall that went for a walk* or the *Storm King Wall*) did not have a 'practical' or agricultural function, Goldsworthy still related them to the practicalities of stonewalling. Goldsworthy spoke proudly and sentimentally of the practice of stonewalling: he talked in terms of 'tradition', 'history', 'years of experience' (*Stone,* 106).

The wall that went for a walk (1990, Grizedale) was a 150-yard long wall that literally snaked through the forest. The serpentine form of *The wall that went for a walk* related to *Lambton Earthwork* and *Sidewinder* (another Grizedale sculpture). *The wall that went for a walk* has no 'proper' function – i.e., no 'practical' function. It weaves between the trees and follows the lay of the land. Instead of ploughing through trees or rocks, Goldsworthy's curving wall assiduously avoids them. 'The wall itself is an expression of movement; a line moving through the landscape'.[50] However, the wall doesn't need to be there in the first place (a notion that Goldsworthy cannot quite resolve: in the book *Stone* he related *The wall that went for a walk* to the old fields that were at Grizedale before the forest, but it's not a convincing argument). At 2,278 feet

long, the *Storm King Wall* was not only Goldsworthy's biggest wall, it was one of Goldsworthy's most significant works. Other artists who had work at the Storm King Art Center included Richard Serra, Louise Nevelson, David Smith, Mark di Suvero, Isamu Noguchi, Alice Aycock and Alexander Calder.

In the mid-1990s, Andy Goldsworthy developed the *Sheepfolds* project: building or renewing a hundred sheepfolds in the north of England. The *100 Sheepfolds* project was funded by public money from the National Lottery (who contributed a grant of £340,000 or about $480,000). The project included exhibitions in Cumbria, St Albans and London, TV documentaries, and books by Goldsworthy (*Sheepfolds, Arch*). 1996, the Year of the Visual Arts, was the launch of *Sheepfolds*; the completion date was later extended to 2003 and beyond. Initially, the *Sheepfolds* proposal was presented to local councils, environmental agencies, countryside agencies, educational institutions, land owners and arts development boards. The *Sheepfolds* project – Goldsworthy's largest undertaking to date – revolved around sheep farming, the herding, washing, cleaning, branding, breeding, rearing, and shearing of sheep. Goldsworthy saw the *Sheepfolds* project as a 'monument to agriculture' (Sh, 16). There were six different variants of sheepfolds in the project; cairn folds (pinfolds), boulder folds, drove arch folds (folds restored for the *Arch* project), restored folds, touchstone folds, which have works built into the walls, and the ephemeral pieces made on the Coleridge walk route. The sheepfolds containing cairns were built near the Nine Standards in Cumbria, rock formations which have long fascinated Goldsworthy.

Goldsworthy has continued to build arches: it has become one of his most distinctive motifs. No other land artist had employed the arch so often as a key structure in their *œuvre*. Goldsworthy's arch sculptures include the offshoot of the *Sheepfolds* project, the *Arch* project of 1996-97; a number of 'herds' of stone arches (such as *Herd of Arches* and *A Clearing of Arches*); arches exhibited in Montréal (1998); a private commission made near the Storm King Art Center, *Eleven Arches* (1997); and some large commissioned

arches: a stone arch sited in Montréal (1999) and Rainscombe Park, Oare, Wiltshire (2000), both constructed from red Scottish sandstone. Of the *Montréal Arch*, commissioned by Cirque du Soleil for its HQ, Goldsworthy remarked: '[t]he arch is heavy and strong, expressing permanence, but it is in fact about change, movement and journey' (*Time*, 60).

In July, 1995, Andy Goldsworthy constructed a multilayered cairn within sight of Mont St Vincent (in the river Bès valley). The cairn began as a mound of yellow stones, on top of which Goldsworthy placed a different layer of material over a series of days: grey stones, different coloured stones (brown, yellow, white), then blue and yellow stones, then stalks with charred ends, then grey stones, then mud, which Goldsworthy wet, then a layer of sticks around the whole cairn, followed by more grey stones, and finally a 'house' of sticks with a large hole round hole. The form of the cairn echoed the mountain in the distance, while the changing state of the cairn each day evoked the constant processes of growth and decay in nature.

The cairn was built in South France, at Digne les Bains, which became one of Goldsworthy's favourite spots (which he has returned to nearly every year since). The rocky, wooded hills and icy, rushing rivers of this beautiful area of South France became a kind of Mediterranean version of Goldsworthy's homeground of Dumfriesshire in Scotland: it had the rivers, the valleys, the forests and the hills which Goldsworthy loved, but lit by a Mediterranean light (and quite a bit warmer than Scotland, too – in fact, Goldsworthy found the heat a little uncomfortable, and took to working early in the morning and late in the afternoon. Keeping Mediterranean hours, in other words). And Digne offered a Southern, Mediterranean culture to Goldsworthy's usual stamping ground of Northern European culture. Goldsworthy was pleased to have cracked creating sculptures under the harsh, bright sun of South France. One of his methods was to submerge stones in the River Bès (which he had tried once or twice before). 'I like the way that the water confuses the form of the stones, so you forget the

stone and all you see is the colour' Goldsworthy commented.[51]

Part of Goldsworthy's Digne works were the three *Sentinels* – very large stone cairns which marked the walking route in the three valleys. Another important commission was the five *Water Cairns*, built at the Réserve Géologique on the route to the car lot. These sculptures employed the sound of water flowing inside them (a common device in land and environmental art, but rare in Goldsworthy's *œuvre*). Also part of the Digne projects was the clay wall (*River of Earth*, 1999) constructed in the museum in Digne and filmed, to form a backdrop for Régine Chopinot and the Ballet Atlantique and their *Danse du Temps* (2000).

Mysticism is emphasized in Andy Goldsworthy's writing, as also in the 'enigmatic' statements of Robert Smithson, David Nash, Hamish Fulton and Walter de Maria.

My art is unmistakably the work of a person – I would not want it otherwise – it celebrates my human nature and a need to be physically and spiritually bound to the earth.[52]

Goldsworthy's æsthetics are those of a neo-pagan, shamanic, American Indian, Maori, pantheistic, nature worshipping kind, the sort of beliefs that some people call Goddess worship, and others kinda pagan or 'New Age'. Goldsworthy evokes the earth's energies and atmospheres. His talk of 'earth energies' recalls ley lines, the so-called 'dragon lines' or *feng shui* of Chinese geomancy. Goldsworthy has emphasized his notions of 'energy' in nature by 'drawing' around stones.

Goldsworthy's main visual motif is the circle, whether as a globe made of leaves, slate or snow, or a cone or cairn (often made of slate or snow), or circles made of leaves half-frosted or stone rubbed with red powder, or circles cut into snow or leaves. The circle is 'such a fundamental form, one can never get away from it altogether' says Goldsworthy,[53] though his circles are usually deliberately slightly irregular – he avoids the connotations of traditional symbolism.[54] There are many 'negative' circles, made by the surrounding material. The 'feminine' quality of this

primary circular symbol has already been mentioned. It sounds too obvious to say that Goldsworthy's circles, globes, cones and rings should have 'feminine', maternal connotations, but it is precisely in this sort of simple world of equivalents and responses that Goldsworthy operates. The simplicity of the structures, such as a circle, cannot be improved upon, but no matter how 'natural' the circle is as a shape, it always looks humanmade in Goldsworthy's art. His circles of white leaves in amongst dark leaves (1981, Yorkshire) always stand out from the surroundings. The viewer is always aware that a human has made those marks, or arranged the leaves in that way. The globe made from oak leaves (1985), for instance, is typical of Goldsworthy's melding of the 'natural' and the human. Yes, the viewer has perhaps seen oak leaves many times, or any sort of leaves. Yes, the viewer has probably admired the multicoloured leaves of Autumn. But Goldsworthy's sphere of leaves in the forest is not an object the viewer might expect to come across on a walk. The oak leaf globe asserts itself instantly as *art*, as a humanmade artifact. Yet how right these globes of ice, snow, slate and leaves can appear. The simplicity of the structure (the circle) makes these sculptures seem curiously 'obvious' and 'natural'. Like a really good pop song or film, one wonders: *why haven't they been made before?*

Andy Goldsworthy's snowball and rain shadow prints, then, are – like Yves Klein's *Anthropometries* – records of far more intriguing events that occurred elsewhere, during the artwork's manufacture. Goldsworthy produced a series of works in the 1980s which directly recall Klein's body paintings. Goldsworthy laid down on the ground when it was raining or snowing: the result was the outlines of his body left upon the ground. The title for these works (reproduced in various Goldsworthy books) is: *Lay down as it started raining or snowing/ waited until the ground became wet or covered before getting up.* Goldsworthy 'prints' himself onto the ground negatively, his body covers the dry earth, while around his body the earth (usually stones) is darkened by the rain. Goldsworthy has also 'printed' his shadow on frosty ground

in the early morning. Goldsworthy has made rain, frost and shadow prints outside the Royal Museum of Scotland, at Cornell University, Central Park, Yorkshire, Cumbria, Holland, Japan, Angers (France), Australia, Denmark and Ciudad Real (Spain).

Yves Klein exhibited a gallery full of empty space – *Le Vide* (void) – and Goldsworthy made his own version of Klein's non-sculpture in his *Hard earth*. The Conceptualism and New Realism of Klein and his contemporaries (Beuys, Nauman, Manzoni, Burgin, Ono) seems far removed from Goldsworthy's land art. Yet Goldsworthy cites Klein's dramatic (but faked) leap into the air as a powerful example of catching a moment in time: '[t]his amazing tension in the moment of suspense! It's like he's been there for ever, or he's gone in a moment. It's like one of my throws'.[55] For Goldsworthy, moments are intense precisely because they are only momentary: *pace* his icicle spiral sculpture of 1996, Goldsworthy said that 'intensity can only be shown for a short time. In fact, the moment is intense only because it lasts for a short time, and it would be wrong for such an intensity to last longer than that' (*Wood*, 10). In fact, it's difficult for the spectator, let alone the artist, to sustain that kind of æsthetic intensity.

Goldsworthy said that he is really working with time. 'If I had to describe in one word what I do, I'd say I work with *time*'.[56] Although it seems, at first glance, to be all about space, about particular spaces and how materials react with certain locations, time is an important element in Goldsworthy's art. The mystery of time, and the relentless, unstoppable, implacable, unforgiving force of it.

Time was central to Goldsworthy's collaboration with a dance troupe. In 1995 the Ballet Atlantique-Régine Chopinot company put on a dance-based performance called *Végétal* at La Rochelle in France. *Végétal* consisted of five sections: earth, seed, root, branch and leaf. For the backdrop Goldsworthy made a wall drawing from ferns and bracken stuck on with rabbit skin glue in serpentine patterns. The ballet featured Goldsworthy's installations, which included sculptures (using stones, sticks, leaves and earth)

that were built and taken down by the dancers. Goldsworthy explained in *Wood* that collaborating on a dance work was quite natural for him, because the body plays such a large part in making sculpture: 'the body as the sculpture. I've always seen myself as an object in the work; that I'm nature too' (*Wood*, 7). Goldsworthy had already used the body directly in many works – the various 'throws', for example, or the 'prints' and 'shadows' made by lying on the ground during rain or snow. Another performance by the ballet group, *La Danse du Temps*, took place at La Rochelle in France in November, 1999, and the Barbican Centre in London in September, 2000.

Andy Goldsworthy can be expected to explore more collaborations, such as live performance, dance, maybe video or installations and the like. But the core, the spiritual heart, the essence of his art, will continue to be his work within the landscape – and mainly on his own, and mainly in South-West Scotland.

OTHER LAND ARTISTS IN EUROPE

Other British and European land and site artists include Graham Moore, whose works include three circles of mown grass, entitled *Herbe Garden* (1989, Christchurch Park). This work echoed Richard Long's early turf circles. Gwen Heney made a 30 metre long snake out of bricks at the Garden Festival Wales show (1992). Also at Garden Festival Wales was Mick Petts' *Mother Earth,* created out of a huge pile of slag which was required to be disguised. Valerie Pragnelli made a spiral from rocks in a stream (*Langslie Spiral,* Milepoint). Ron Haselden produced a dance of lights, called *Fete* (1992), out of strings of lights hung from a group of willow trees. One of the largest of contemporary garden and landscape design projects was Giuliano Gori's Parco di Celle.
 PAUL RUSSELL COOPER

British sculptor, Paul Russell Cooper (b. 1949), has produced a distinctly Goldsworthyan sculpture, *Two Circles in a Stone Bridge*. This is a large dry stone work at Portland in Dorset (1983). Two circles are made with the stones, one 'positive', the other 'negative': the 'negative' circle was a large hole like an archway. Other works by Paul Russell Cooper include *Quincunx*, a series of five globes in concrete set in an open space at Rufford Country Park (near Newark, 1983). The globes sit open partially to display something different in each globe: water, rocks, burning detritus from the garden and a sundial. Cooper's *Quincunx* is based on natural forms – in this case, five-petalled plants.

MICHAEL DAN ARCHER

Michael Dan Archer's *Observatory* (1994) recalled Robert Morris's *Observatory*: it was basically a low circular embankment, the kind seen in Iron Age hillforts or in some Bronze Age stone circles in the United Kingdom (Archer's *Observatory* in particular recalled Avebury stone circle in Wiltshire). A stone shaped like a post and lintel (as at Stonehenge) marked the entrance, and two broken circular stones did for benches in the centre of *Observatory*. Patricia Leighton reworked the earth at the side of the M8 motorway, turning it into a series of *Sawtooth Ramps*. Julia Barton created *A Rural Landmark: Viewing Platform* (1994) in Yorkshire stone at Kirklees Way: the circular platform was cut into a hillside, backed by a low wall and clad in stone. There were no signs to indicate what to look at, as in municipal viewing sites (the sort of tourist brass discs found on hilltops that state '25 miles to Hay Bluff'). British filmmaker Chris Welby is a kind of land artist; he explores the relation between landscape and humanity, nature and mind, in films which experiment with film speed and time-lapse photography (*Seven Days* and *Stream Line*).

PETER RANDALL-PAGE

Peter Randall-Page, one of the most appealing of contemporary sculptors in Blighty (certainly one of the most accomplished of the members of the Royal Society of British Sculptors), created an interaction between modern sculpture and

mediæval architecture when he sited some of his boulders made from Finnish glacial granite at Wenlock Priory in rural Shropshire. *Boulders and Banner Boulders: Secret Life I, II, III, IV* (1994) contained sculptures that were split open like gigantic seeds. Randall-Page's sculptures were suitably monumental (and abstract) for the architectural space of the ruined Priory.

At Grizedale, Helen Stylianides produced a tree sculpture that looked like a tree with the branches cut off, about five feet from the trunk. A tree with no leaves, but stumps for branches (*Tree Sculpture*, 1984). Collins made a 40 foot diameter steel ring that was set, vertically, next to a tree. The enormous ring, *Ting*, was entangled in the branches: the aim was that the circle of steel could not be seen as a whole, in one view, but only glimpsed in parts through the leaves. Alyson Brien fashioned *A Curve Around a Lime Tree* (1987) which looked like a low fence of stripped wood. Eric Geddes bent two young trees over and tied them to a central tree, so they formed a semi-circular arch, with the tree in the centre standing upright.

YVETTE MARTIN

In the Forest of Dean a number of interesting commissions took place in the late 1980s. Yvette Martin's *Four Seasons* was an environmental, 'land' sculpture. The first work, *Spring* (1986), was an oval-shaped pond with copper coloured water, a marshy space surrounded by webs of twigs and branches. It was a womb-like space, with a sense of being closed-in.[1] The branches on the trees growing on the bank of the small pond were bent down to add to the feeling of enclosure. Martin's *Spring* was the sort of space novelists such as Thomas Hardy and John Cowper Powys would like, for secluded pools recur in their fictions (Rushy Pond in *The Return of the Native*, and the haunting Lenty Pond in Powys's great novel of nature mysticism, *Wolf Solent*). Like other land artists, Yvette Martin spoke in terms of 'growth cycles', the 'cycle of life from conception, emergence, growth, reproduction, maturity, decay and death' (ib., 75). The pond or pool is a recurring favourite in land (it's found in Chris Drury, Patricia

Johanson, Mary Miss, James Turrell, Evelyn Zimmerman, and Jim Sanborn, among many others).

CORNELIA PARKER

The most exciting sculpture at this time in the Forest of Dean was Cornelia Parker's *Hanging Fire*, a large ring of iron hung 25 or so feet above the forest floor. Parker created a ring of iron flames, which were rusted overnight in salt water. They hung upside down from the ring. Parker wanted to portray the idea of a perpetual flame, a 'flame that would perpetually burn because it was cast in iron' (ib., 89). Hanging sculptures, as Alexander Calder showed time after time, are usually intriguing, and Parker's *Hanging Fire*, though made of heavy materials, floated in the trees. She also wanted to incorporate the notion of a 'circle or fairy ring', and a crown, and to use iron because iron was mined in the Forest of Dean. Parker's most famous work was probably *Cold Dark Matter: An Exploded View* (1991), an installation of a garden shed that Parker had blown up by army experts, exhibiting the debris hung from wires in the gallery (it became a favourite at London's Tate Modern). Parker's installation concerned cosmological themes of opposites, inhaling and exhaling, centripetal and centrifugal motion.

PETER HUTCHINSON

Peter Hutchinson was born in England (in 1930), but spent most of his artistic career in the US (based in Massachusetts). He collaborated with Dennis Oppenheim on a series of underwater works: fruit, vegetables and bread were packed in plastic bags and suspended from a fishing line in the West Indies (1969). Hutchinson also planted flowers in the sand underwater, and made a dam from sand bags in Tobago (*Underwater Dam*, 1969). Along the rim of a volcano (Paricutin, 1970), Hutchinson sited a 76 metre line of white bread wrapped in plastic. Hutchinson recorded the growth of mould and decomposition. Later works include *Ice Sandwich* (1994), a Brancusi-like tower of slabs of wood interlaced with blocks of ice, and 'thrown ropes' of flowers planted in the ground in the shape of a rope that Hutchinson threw (1996).

Hutchinson preferred works that combined his love horticulture, science, art and botany.[2]

NICHOLAS POPE

Nicholas Pope (b. 1949) is an artist whose works recall Barbara Hepworth's and Stephen Cox's – in particular Pope's outdoor works, such as *The Arch* (1985). Made from oak, the arch is large (18 feet long). It is the arch itself that fascinates Pope, for the arch is such an elegant structure, as anyone who has seen ancient Roman architecture (such as the Pont du Gard or Colosseum) can appreciate. Pope's *Arch* was dove-tailed and pegged together, made from two young trees and one mature tree. Pope was consciously trying to make a work with oak, not just with any wood. 'I wanted to make an oak-wood arch not an arch made from wood.'[3] Like Carl Andre, Nicholas Pope has placed large stones in an urban environment. Pope's *Three Wilderness Stones* (1980, South-ampton) and *Five Amorphous Shapes* are huge boulders of Forest of Dean stone in humanmade environments. Pope's stones spread out across parkland or the forecourts of modern business complexes, bringing the individual, irregular forms of nature into the angular, linear environment of the city. Like Barbara Hepworth and Constantin Brancusi, Pope was fascinated by stones. Hepworth loved the white granite rounded stones of West Penwith, and scattered them around her studio in St Ives. It's easy to see how some of Hepworth's sculptures took some of their inspiration from the beautiful granite boulders of Cornwall. David Nash made a large wooden boulder, while Anthony Gormley (b. 1950) emulated a large granite glacial boulder in 1981. Each of Gormley's *Two Stones* is nine feet high, one made of granite, the other of bronze. Set beside an artificial lake in Kent, the 'natural' granite stone was already contextualized as a work of art by its placement in such a setting, just as Carl Andre's boulders on the city street are made into art by their context (ditto with Andre's infamous bricks).

Another sculpture venture, the New Milestones Project in Dorset, set up by Common Ground, threw out some accomplished

works. Such as Simon Thomas's *Seed Forms* (1988), oak shapes placed on the Dorsetshire downs; or Peter Randall-Page's *Wayside Carving* (1988), a large spiralling cone in blue Purbeck marble, a response to Dorset's richness in fossils.

RICHARD HARRIS

Richard Harris (b. 1954) has produced a wall sculpture, *Dry Stone Passage* (1982). Harris wrote: 'I want the sculpture to become a living and working part of the existing environment'.[4] Harris made a *Willow Walk* (1990), a walk lined with willow branches. Richard Harris's works at Grizedale, apart from *Dry Stone Passage*, included *Cliff Structure* (1978), slate slabs set on split oak, and *Quarry Structure* (1977), a 'bridge' of slate and oak sticks.

Nigel Lloyd's *Red Deer Wallow* (1983, Grizedale) was a horseshoe-shaped stone wall enclosure. Also at Grizedale is a large circular enclosure made from wickerwork and larch posts, by Keir Smith (b. 1950). Smith is sensitive to the work done by people in a landscape, to the sense of labour: thus, Smith includes in the enclosure hints of human activity, such as stag antlers, which suggest human hunting, while a pair of shears allude to 'sheepshearing and animal husbandry'.[5]

Like Goldsworthy, Guiseppe Penone has made sculptures with trees, such as his *I Wove Together Three Trees* (1968), made in the Maritime Alps. In another group of tree trunks tied together, Jackie Winsor's 1971 piece *30 to 1 Bound Trees*, the binding of the trees, as in much of Jackie Winsor's work, relates to autobiographical, childhood experiences, often painful, as well as the formal aspects of density, weight and repetition.[6] Jan Dibbets produced a tree-work, *Construction of a Wood,* in 1969.

Gabriel Orozco worked with snowballs – in *Planets of the Volcano* (1992) he placed small snowballs on top of some posts near Popocatepetl volcano. Anish Kapoor's *Void Field* (1990) comprised twenty large pieces of sandstone with small holes bored in the top, which were painted black inside. Chris Jenning's *Vault* (1992) reacted to the Museum of Installation's space by filling it with curving metal rods which connected the walls and floor together.

The thin rods curved through space. Bill Viola brought a whole tree into the Newport Harbor Art Museum in California for his *Theatre of Memory* (1985), the branches were hung with bells blown by electric fans. The tinkling tree faced a giant video image of hissing static.

Recalling Wolfgang Laib's pollen floor pieces, Shelagh Wakely covered the marble floor of the British School at Rome with a layer of tumeric spice (*Curcuma sul Travertino*, 1991). Anthony Gormley covered the entire area of a gallery floor in his *Field* installation (1991) with over 35,000 small humanoid figures. Giovanni Anselmo used stone like painted canvases, mounting thin slabs of granite on a Paris gallery wall like paintings (*Meeting of Two Works*, 1990). Some installation artists used liquid to cover the floor area: in Glen Onwin's alchemical installations in Halifax (1991), water, wax and black brine were poured into a large concrete pool. Richard Wilson's *20/50* (1987) was a steel pool of sump oil with a walkway into the middle of it. Per Barclay also used pools of oil: in *Old Boathouse* (1990) an oil pool was set in a Norwegian boat-house beside the sea; in *The Jaguar's Cage* (1991), made at Turin Zoo, a large oil pool was set behind bars. Rasheed Araeen spoofed Richard Long's art in his 1988 London installation: a Longian floor circle was made with empty wine bottles, and a Long-like row was made with bones. Eve Laramee spread a rectangular mound of cobalt glass on the gallery floor in her *Requiem For a Blue Fluid* (1991).

SJOERD BUISMAN

Sjoerd Buisman constructed a floating mound of willow sticks on a wooden frame in the moat of the Old Castle at Jeemstede (Netherlands, 1995-98). In 1975 Buisman knotted a willow tree stem which the tree absorbed into itself as it grew (*Knotted Willow Branch*). In 1991 Buisman constructed an 'arch' of lime trees (at Haarlemmerhout, Netherlands), which formed a low curve along a road. Using petals and berries, some of Nils Udo's sculptures are uncannily like Goldsworthy's use of the same materials. Udo has, for instance, pressed berries into the bark of an old tree.

Nikolaj Recke planted a field of clover in a gallery (1999) covering the whole floor in a carpet of green plants. Although the result recalled land art gestures such as Walter de Maria's *Earth Room*, the aim, according to Recke, was to explore the folklore of four-leaf clovers. Guiseppe Penone's *To Breathe Shade* (1997-99) was a human shape made from bronze bay leaves installed in five bay trees, and his *Skins of Leaves* (2000), a 'skin' of bronze leaves in humanoid form.

While some land artists died young (such as Robert Smithson), and others seem to have completed their best pieces, and are in their 70s and 80s, many others are still very active, and will no doubt continue to produce work in this thriving area of contemporary art.

Notes

Bibliography

Illustrations

Notes

1 INTRODUCTION

1. R. Krauss, "Sculpture in the Expanded Field", *October*, 8, Spring, 1978.

2 THE ALCHEMY OF MATTER

SPIRIT OF PLACE: LAND ART, NATURE POETRY AND NATURE MYSTICISM

1. H. Moore, "The Sculptor Speaks" in *The Listener*, Aug, 1937, quoted in H. Chipp, 595.
2. In B. Redhead, 24-25.
3. In B. Redhead, 22.
4. J.C. Powys, 1955, 926.
5. J.C. Powys, 1937, 353.
6. In *The Power of Myth*, 118.
7. On the 'pollen path', see J. Campbell, *The Power of Myth*, 230; on Australian 'dreamtime' see P. Devereux: *The Dreamtime Earth and Avebury's Open Secrets*, Gothic Image, Glastonbury, Somerset, 1992, 7-12.
8. See J. Cowan: *The Mysteries of the Dream-Time*, Prism Press, 1989; B. Chatwin: *The Songlines*, Picador, London, 1988; L. Levy-Bruhl: *Primitive Mythology*, University of Queensland Press, 1983.
9. J. Turrell: *Mapping Spaces*, Peter Blum, New York, NY, 1987.
10. P. Redgrove, letter to the author, Mch 5, 1993.
11. J.C. Powys, *In Defence of Sensuality*, Gollancz, London, 1930, 104.
12. From *The Countess of Pembroke's Arcadia*, in G.G. Miller, ed. *Poems of the Elizabethan Age*, Methuen, London, 1977, 215.

DEUS LOCI IN MODERN LITERATURE

1. L. Durrell, in *The Big Supposer*, ed. M. Alyn, Grove Press, New York, NY, 1974, 90.
2. L. Durrell, *Nunquam*, Faber, London, 1970, 211.

3. L. Durrell, *Justine*, 156.

4. L.W. Market: "Symbolic Geography: D.H. Lawrence and Lawrence Durrell", in M. Cartwright, ed: *On Miracle Ground: Proceedings From the First National Lawrence Durrell Conference/ Deus Loci: The Lawrence Durrell Newsletter*, V, 1, Autumn, 1981, 90f.

5. L. Durrell, *Spirit of Place*, 156.

THE LAND ART SUBLIME: LAND ART AND ROMANTICISM

1. "David Smith Makes a Sculpture", 1951, in D. Smith, 149.

2. *Nature*, 1836, in H.E. Hugo, 1957, 386-7.

3. R. Hughes, 1991, 386.

4. Wolfgang Goethe, *The Sorrows of Young Werther*, tr. M. Hulse, Penguin, London, 1989, 44.

5. E. Burke wrote: '[t]he passion caused by the great and sublime in *nature*, when those causes operate most powerfully, is astonishment: and astonishment is that state of the soul in which all its motions are suspended, with some degree of horror'. (E. Burke, in *The Philosophy of Edmund Burke*, University of Michigan Press, Ann Arbor, 1967, 256.)

6. C. Greenberg: "Abstract, Representational, and so forth", in 1961, 133.

7. There is eroticism in Tony Cragg's steel vessels, or Anne and Patrick Poirier's long, elegant *Archæological Model*, or Jannis Kounellis' *Cotton Sculpture*, a mass of cotton stuffed into a large steel container – a sculpture of contrasts between the softness of the cotton and the rigidity of the steel, or Jackie Winsor's *Burnt Piece*, a 3 ft cube made of concrete, wire and burnt wood. Tony Cragg has spoken of having 'an erotic response to the external world', something which, it seems, all artists have, or have to have, to be truly 'great' artists (quoted in D. Wheeler, 1991, 324). See also T. Neff, 1967; Jones, 1977, 16; L. Ponti, 50-51; Lamaitre, 1985, 7-11; G. Celant, 40-46.

8. J.C. Powys, *Autobiography*, 168-9.

9. Quoted in N. Lynton, 1982, 2.

10. M. Eliade: "The Sacred and the Modern Artist", *Criterion*, 4, 1965, and in M. Eliade, 1988.

11. W. Laib, in A. Benjamin, 91.

LAND ART AND GARDENS

1. S. Ross, 1993, 161.

2. S. Ross, 1998, 23.

3. R. Smithson, paraphrased by Lucy Lippard (1983).

4. R. Rosenblum, 1988, 11.

'TRUE CAPITALIST ART'?: THE COST OF LAND ART

1. A. Henri, *Total Art*, 81-82.

2. Richard Long, quoted in S. Gablik: *Has Modernism Failed?*, Thames & Hudson, London, 1984, 44.

3. 'I make art in the capitalist system which in itself is a political statement (selling art for the next walk)', remarked Hamish Fulton (1995).

4. In A. Haden-Guest, 40.

LAND ART AND PHOTOGRAPHY

1. S. Mills: "Special Kaye [Tony Kaye]", *Sunday Times Magazine*, June 12, 1994, 55.

2. D. Smith, c. 1953-54, in D. Smith, 158.

3. In N. Hedges, 77.

4. E. Hesse, in *Eva Hesse*, Guggenheim, New York 1972.

5. J. Dibbets, 1970.

6. R. Long, Santa Fe interview.

7. R. Long, in W. Malpas, 1995.

8. R. Long, 1985, 1, 1.

9. Jasper Johns explained why he used 'real objects' stuck onto his paintings:

My thinking is perhaps dependent on a realization of a thing as being the real thing… I like what I see to be real, or to be my idea of what is real. And I think I have a kind of resentment against illusion when I can recognize it. Also, a large part of my work has been involved with the painting as object, as real thing in itself. And in the face of that 'tragedy,' so far, my general development… has moved in the direction of using real things as painting. That is to say I find it more interesting to use a real fork as painting than it is to use painting as a real fork. (Quoted in D. Sylvester, op. cit., 15-16)

10. R. Smithson, in C. Robins, 1984, 78.

INSIDE – OUTSIDE

1. Robert Smithson reckoned that a 'work of art when placed in a gallery loses its charge and becomes a portable object or surface disengaged from the outside world.' (*Selected Writings*, 132).

2. D. Oppenheim, 1992.

3. In A. McPherson, 30.

4. In M. Heizer, 1970.

5. In ib.

6. L. Weiner, in *Avalanche*, Spring, 1972, 67.

7. A. Goldsworthy, *Time*, 11.

CHANGES, CYCLES, SEASONS

1. J. Beuys, in *Documenta 7*, 2, Documenta, Kassel, 1982.
2. R. Smithson: *Writings*, 56-57; C. Robins, 1984, 80.
3. R. Long, 1986, 1, 9.
4. R. Long, in *Words After the Fact*, in R. Fuchs, 1986, 236.
5. 'Goldsworthy's pieces dig at the roots of our relationship with nature, he is conducting an interrogative process with the fundamentals of our world – water, stone, earth, growing things and – latterly, in his work with volcanic rock and 'fired' stones – fire' (P. Whitaker, 1995, 109).
6. In B. Redhead, 19.
7. See J. Burnham, 1971.
8. Quoted in G. Baro, 1969, 122; see C. Harrison, 1968, 266-8; J. Kirshner: "Barry Flanagan", *Artforum*, 23, 10, Summer, 1985, 112.

LIVING PLANTS

1. J. Koons, in A. Muthesiues, ed. *Jeff Koons*, Cologne, 1992.

TREES

1. Writers on the symbolic and religious aspects of trees include Mircea Eliade (*Patterns of Comparative Religion*), Robert Graves (*The White Goddess*), James G. Frazer (*The Golden Bough*), and J.R.R. Tolkien, among others.

HOLES

1. C. Koelb: "Castration Envy", in P. Burgard, 1994, 79.

STONE CIRCLES: LAND ART AND PREHISTORIC ART

1. See M. Berger, 1989.
2. Quoted in L. Lippard, 1967c, 26.
3. The allusions to prehistory would be quite different if Richard Long had stuck a picture of the Cerne Giant next to himself instead of the Wilmington Man. The meaning then might be that Long was a superstud, for the Cerne Giant has the biggest penis in public (or any) art (at least in the United Kingdom).
4. R. Long, 1972, in *Fragments of a Conversation I-VI*, in *Walking in Circles*, 38.

LAND ART AND CONSTANTIN BRANCUSI

1. H. Moore, in *The Listener*, 1937, quoted in H. Chipp, 595.
2. A. Goldsworthy, *Refuges d'art*, 85.
3. A. Goldsworthy, *Sheepfolds*, 22-23.
4. B. Flanagan, quoted in the catalogue of *Entre el Objeto y la Imagen: Escultura britanica contemporanea*, Palacio de Velasquez, Madrid, 1986, 233.

LIGHT AND SPACE

1. Quoted in J. Butterfield, 161.

3 THE BIRTH OF LAND (IN 1960S CULTURE)

THE PRESENCE OF THE OBJECT: LAND ART, MINIMAL ART AND 'OBJECTHOOD'

1. On Minimalism, see M. Tuchman, 1967; F. Tuten: "American Sculpture of the Sixties", *Arts Magazine*, 41, 7, May, 1967; I. Sandler, 1965; R. Wollheim: "Minimal Art", *Arts Magazine*, 39, 4, Jan, 1965; D. Mayhall, 1979; R. Krauss, 1973; B. Reise, 1969; P. Tuchman, 1988.
2. See C. Robins, 1966; M. Fried: "Art and Objecthood", 1967.
3. B. Rose: "ABC Art", 1965, 66.
4. M. Bochner: "Systematic", 1966, 40.
5. F. Stella: "The Pratt Lecture", 1960, in B. Richardson, *Frank Stella: The Black Paintings*, Baltimore Museum of Art, Baltimore, MD, 1976, 78.
6. W. Tucker, 1969, 12-13.
7. G. Evans, 1969, 62.
8. C. Andre, 1978, 31.
9. See J. Yoshihara, in B. Bertozzi & K. Wolbert: *Gutai: Japanese Avant-Garde*, Darmstadt, 1991.
10. R. Morris, 1966, in G. Battock, 1995, 224.
11. R. Morris, 1966, 20-23. See also: P. Patton, 1983.
12. D. Oppenheim, 1992.

MINIMAL ART, POSTMINIMAL ART AND LAND ART

1. B. Rose, 1964, 41.
2. R. Morris, 1966, 20-23; P. Patton, 1983.
3. See I. Sandler, *American Art*, 245f, L. Lippard, 1966b, 62, R. Morris: "Notes on Sculpture", op.cit., K. McShine, 1966, R. Lund, 1986.
4. P. Fuller, 1993, xxxv.
5. L. Lippard, 1966a, 50.

6. A. Warhol, in K. Stiles, 340.

7. D. Judd: "Questions to Stella and Judd", in G. Battock, 1995, 159.

8. J. Mellow: "New York Letter", *Art International*, April 20, 1966, 89.

9. B. Rose, 1965a, 34.

10. H. Kramer: "Display of Judd Art Defines an Attitude", *The New York Times*, May 14, 1971, D48.

11. B. Haskell, *Donald Judd*, 72.

12. In K. McShine, 1966.

13. R. Mangold, in F. Colpitt, 121.

14. D. Judd: "Specific Objects", in G. de Vries, 1974, 128.

15. R. Rosenblum: "Notes on Sol LeWitt", 1978, 15-16.

16. D. Judd, 1965, 82.

17. Rosalind Krauss wrote:

The art of [Rodin and Brancusi] represented a relocation of the point of origin of the body's meaning – from its inner core to its surface – a radical act of decentring that would include the space to which the body appeared and the time of its appearing. What I have been arguing is that the sculpture of our time continues this project of decentring through a vocabulary of form that is radically abstract. The abstractness of Minimalism makes it less easy to recognize the human body in those works and therefore less easy to project ourselves into the space of that sculpture with all of our settled prejudices left intact. Yet our bodies and our experience of our bodies continue to be the subject of this sculpture – even when a work is made of several hundred tons of earth. (1977, 279)

LAND ART AND CONCEPTUAL ART

1. "Mel Bochner on Malevich", 1974, 62.

2. R. Serra, in *Richard Serra, Interviews,* Hudson River Museum, New York, NY, 1980, 37.

3. D. Oppenheim, in 1992.

4. B. Flanagan, 1969.

5. J. Beuys, in *Documenta 7*, 2, Documenta, Kassel, 1982.

6. L. Weiner, in E. Lucie-Smith, 1987, 117.

7. L. Weiner: *Billowing Clouds...*, 1986, 86.2 x 17.5 in, Anthony d'Offay Gallery, London.

8. R. Long, 1985, 2, 24.

4 LAND ART, GENDER, SEXUALITY AND THE BODY

GENDER AND SCALE IN LAND ART

1. In A. Benjamin, 47.

2. Mark Rothko wrote of his intentions with regard to scale thus: 'I paint very large pictures… The reason I paint them… is precisely because I want to be very intimate and human. To paint a small picture is to place yourself outside your experience, to look upon an experience as a stereopticon view or with a reducing glass. However you paint the larger picture, you are in it. It isn't something you command.' (1951)

3. "Donald Judd", *The New York Times*, Apl 1, 1977, C20.

4. L. Lippard, 1968, 42.

5. L. Lippard, 1979, 88.

6. See L. Anderson, 1973; *Mary Miss: Interior Works*, Bell Gallery, University of Rhode Island, Autumn, 1981.

7. See N. Holt, 1975, 1977; T. Castle, 1982.

8. See D. Judd, 1975; W. Agee, 1975, 40-49; P. Carlson, 1984, 114-8; D. Kuspit: "Donald Judd", 1985; B. Haskell, 1988; B. Smith, 1975.

9. Such as Tony Smith: *Die*, 1962, 72 x 72 x 72 in, Paula Cooper Gallery, New York, NY. See L. Lippard, 1972a; G. Baro, 1967; E. Greene: "Morphology of Tony Smith's Work", *Artforum*, April, 1974.

10. Such as Dan Flavin: *Untitled (to the "innovator" of Wheeling Peachblow)*, 1968, Museum of Modern Art, New York; *Untitled*, 1976, pink, blue, green fluorescent light, Saatchi Collection, London. See I. Licht, 1968, W. Wilson: "Dan Flavin: Fiat Lux", *Art News*, Jan, 1970; J. Burnham, 1969.

11. Such as Richard Serra: *Clara-Clara*, 1983, Cor-Ten steel, installation, Jardin des Tuileries, Paris; *Prop*, 1968, 96in high, sheet 60 x 60 in, Whitney Museum of Art, New York See R. Krauss, 1972, D. Crimp: "Richard Serra: Sculpture Exceeded", *October*, Fall, 1981.

12. See K. Baker, 1980, 88-94; D. Waldman, Oct, 1970, 60-62, 75-79; P. Tuchman, 1978, 29-33; E. Develing, 1969.

LAND ART, SEXUALITY AND THE BODY

1. B. Hepworth, quoted in A.M. Hammacher, 1968, 99.

2. See D. de Menil *et al*: *Yves Klein: 1958-62: A Retrospective*, Institute for the Arts, Rice University, Houston, TX, 1982.

3. In K. Stiles, 755.

4. G. Brus, in *Günter Brus*, Whitechapel Gallery, London, 1980.

5. L. Tickner, "Body Politic", op.cit., 239.

THE SEXUALITY OF SCULPTURE

1. K. Bloomert, 34; see also J. Gibson, 1966.

WOMEN SCULPTORS AND LAND ARTISTS

1. Other artists who have worked in postmodern, feminist modes include Cindy Sherman, Mary Kelly, Marie Yates, Yves Lomax, Martha

Rosler, Sutapa Biswas, Mitra Tabrizian, Zarina Bhimji, Mona Hatoum, Lubaina Himid, Barbara Kruger, Jenny Holzer, Rose Garrard, Susan Hiller, Nancy Spero, Rosa Lee and Rachel Whiteread.

2. In C. Nemser, 62.

3. See B. Barrette: *Eva Hesse's Sculpture*: Catalogue Raisonné, New York, NY, 1989; R. Krauss & E. Hesse, 1979; C. Nemser, 1973, 12-13.

4. A. Chave, in H. Cooper, ed. *Eva Hesse*, Yale University Press, New Haven, CT, 1992, 100f.

5. In L. Lippard, 1976.

6. Quoted in L. Lippard, ib., 6.

7. See M. Roustayi: "Getting Under the Skin: Rebecca Horn's Sensibility Machines", *Arts*, May, 1989; M. Kimmelman: "A Sculptural Circus of Whips and Suspense", *New York Times*, 23 Sept, 1988.

8. See H. Gresty, 1993; G. Hilty, 1991; A. Wilding, 1994.

9. See L. Cooke, 1985; L. Biggs, 1986; W. Beckett, 116; T. Neff, 43-45.

10. In W. Beckett, 116.

11. In T. Neff, 45.

12. D. Wheeler, 1991, 323.

13. In A. Hammacher, op.cit., 98.

14. B. Hepworth, in W. Forma, 1965.

15. See Carolee Schneemann: *Interior Scroll*, 1975; *More than Meat Joy: Complete Performance Works and Selected Writings*, ed. Bruce MacPherson, Documentext, New York, NY, 1979

16. C. Carr: "Unspeakable Practices, Unnatural Acts", *Village Voice*, June 24, 1986.

17. See A. Adler: "Dangerous Woman: Karen Finley", *Chicago Reader*, Oct 26, 1990; R. Lacayo: "Talented Toiletmouth", *Time*, June 4, 1990; M. Joseph: "Further Finley", *The Drama Review*, Winter, 1990, 13; K. Larson: "Censor Deprivation", *New York Times*, Aug 6, 1990; C. Schuler: "Spectator Response and Comprehensions: The Problems of Karen Finley's *Constant State of Desire*", *The Drama Review*, Spring, 1990, 131-145; C. Barnes: "Finley's Fury", *New York Post*, July 24, 1990; T. Page: "Karen Finley's Tantrum, Amid Chocolate", *New York Newsday*, July 24, 1990.

18. M. Duffy: *Cutting the Ties That Bind*, 1987; *Stories of a Body*, 1990; see H. Robinson: "The Subtle Abyss: Sexuality and Body Image in Contemporary Feminist Art", unpublished dissertation, RCA, London, 1987; M. Duffy: "Cutting the Ties that Bind", *Feminist Art News*, 2, 10, 1989, 6-7; M. Duffy: "Re-dressing the Balance", *Feminist Art News*, 3, 8, 1991.

19. J. Spence and T. Sheard: *Narratives of Disease*; see J. Spence: *Putting Myself in the Picture: A Political, Personal and Photographic Autobiography*, Camden Press, London, 1986; P. Holland, J. Spence and S. Watney, eds: *Photography/ Politics: Two*, Commedia, London, 1986; D. Grigsby: "Dilemmas of Visibility: Contemporary Women Artists' Representations of Female Bodies", *Michigan Quarterly Review*, 29, 4, Autumn, 1990, 584-

618.

20. C. Elwes: "Floating femininity: a look at performance art by women", in S. Kent & J. Morreau, eds: *Women's Images of Men*, Pandora Press, London, 1985, 172.

21. C. Elwes, ib., 182.

22. Quoted in l. Lippard, 219; see also L. Lippard, 1980, 122.

23. *Rosarium Philosophorum*, quoted in A. Mann, 87.

5 LAND ART AND RELIGION

1. Basho, *The Narrow Road to the Deep North and Other Travel Sketches*, tr. N. Yuasa, Penguin, London, 1966, 33.

2. M. Ueda: *Matsuo Basho*, Twayne, New York, NY, 1970, 167.

3. C. Andre, in *Carl Andre: Sculpture*, 1984.

4. M. Heizer, 1970.

5. Chuang-tzu, *Basic Writings*, tr. B. Watson, Columbia University Press, New York, NY, 44.

6. Richard Long, 1985, part 1, 14.

7. R. Long, 1985, part 2, 22.

8. P. Redgrove, letter to the author, Apl 20, 1994.

9. R. Long, interview with R. Cork, in D. Sylvester.

0. Mircea Eliade, 1984, 136.

10. M. Fried, "Art And Objecthood", 1967, in G. Battock, 1995, 28.

11. M. Eliade, 1984, 185.

12. M. Eliade: "Sacred Architecture and Symbolism", in *Eliade*, ed. C. Tacou, L'Herne, Paris, 1978, and in M. Eliade, 1988, 107.

13. P. Fuller, 1993, xxxvi-xxxvii.

14. J.C. Powys: *Petrushka and the Dancer: The Diaries of John Cowper Powys, 1929-1939*, Carcanet/ Alyscamps, 1995, 98, 136.

15. A. Goldsworthy, *Stone*, 6.

16. A. Goldsworthy, *Hand to Earth*, 58.

17. A. Goldsworthy, sketchbook no. 22, 1988, *Hand To Earth*, 150.

18. Goldsworthy dislikes geometry being 'imposed upon nature' (HE, 162), though all his sculpture (like all art) can be seen as something 'imposed upon nature'. Even the most ephemeral and minuscule of Goldsworthy sculptures, such as the tiny flower or leafworks, are impositions and additions to the natural world. They are events which do not happen 'naturally'.

19. R. Long, 1985, 2, 17.

6 LAND ART AND BRITISH CULTURE

LAND ART AND BRITISH SCULPTURE

1. D. Lee: "Wimbledon Sculpture", in G. Hughes, ed: *Arts Review Yearbook 1989*, 25.
2. P. Fuller: "Likely Prospects: A British Art Questionnaire", *Artscribe*, 50, Jan, 1985, 27-28; "Onward Christian Soldiers", *Artscribe*, 52, July, 1985.
3. P. Fuller: "Black cloud over the Hayward", *Art Monthly*, 70, Oct, 1983, 12-13; "Lee Grandjean and Glynn Williams", *Art Monthly*, 51, Nov, 1981, 15-18.
4. J. Roberts, 1990, 111f.
5. T. Cragg, in E. Lucie-Smith, 1987, 130.

THE BRITISH LANDSCAPE TRADITION

1. R. Long, interview, 1985, 2, 9.
2. R. Rosenblum, 1988, 7.
3. C. Andre, quoted in A. Causey, 1977, 126.
4. T. Hughes, 1969, 79-80.

7 LAND ART IN THE UNITED STATES

ROBERT SMITHSON

1. In C. Robins, 78.
2. Robert Smithson, in *Selected Writings*, 20, hereafter indicated as RS.
3. R. Hobbs, 12.
4. J.G. Ballard, in R. Smithson, 1997.
5. Smithson labelled pre-existing sites land artworks, non-sites, such as the pipes, boxes and walkways of an industrial zone in *Monuments of Passaic* (1967)
6. J.G. Ballard, in R. Smithson, 1997.
7. R. Smithson, "A Sedimentation of the Mind: Earth Projects", in *Selected Writings*, 85.
8. R. Smithson, "Discussion with Heizer, Oppenheim, Smithson", *Avalanche*, 1970, and in E. Johnson, 1982, 182.
9. C. Robins, 1984, 82.
10. In L. Lippard, 1973, 88.
11. J. Kounellis, in W. Sharp, 1972.
12. See M. Gimbutas, 1989.
13. R. Smithson: "The Spiral Jetty", unpublished MS, quoted in R.

Krauss, 282. See R. Hobbs, 1981.

14. I. Sandler, 1990, 60.

15. *Selected Writings*, 37.

16. J. Coplans: "Robert Smithson: The Amarillo Ramp", in R. Hobbs, 53.

17. In R. Hobbs, 212.

JAMES TURRELL: SKYSPACES

1. Dia Foundation, the McArthur Foundation, the National Endowment for the Arts, the Lannan Foundation, the Canon Company, the Bohen Foundation, the Martin Bucksbaum Family Foundation, Count Guiseppe Panza di Buimo, Dr Pentti Kouri, Jean Stein, plus other donors.

2. J. Turrell, in A. Benjamin, 47.

3. J. Turrell, 1987.

DENNIS OPPENHEIM

1. In D. Oppenheim, 1992.

2. L. Lippard, 1983, 52.

3. In M. Heizer, 1970.

4. D. Oppenheim, in M. Heizer, 1970.

5. In D. Oppenheim, 1978.

CARL ANDRE

1. C. Andre, quoted in D. Bourdon: "The Razed Sites of Carl Andre", in G. Battock, 1995, 103.

2. ib., 104.

3. L. Lippard, 1973, 157.

4. C. Andre, in *Carl Andre: Sculpture*, 1984

5. L. Lippard, 1965, 58.

6. C. Andre, 1970, 61.

7. In ib., 107.

8. D. Bourdon, 1978, 56. See M. Bochner, 1967, 39-43.

9. D. Bourdon, in G. Battock, 1995, 107.

10. R. Krauss, 1977, 271f.

11. M. Bochner, in G. Battock, 1995, 94.

12. C. Tomkins, 1989, 155.

13. C. Andre, in L. Lippard, 1970, 7.

14. Carl Andre, *Joint*, 1968, 183 units, each 14 x 18 x 36 in, installation at Windham College, Putney, Vermont.

15. A. Goldsworthy, *Time*, 180.

16. C. Andre, quoted in D. Bourdon, in G. Battock, 1995, 108.

17. T. Smith, quoted in M. Fried, 1967, in G. Battock, 1995, 131.

18. ib., 131.

19. David Lee said that 'Andre repeats one thing in each piece; Smithson repeats one thing but increases its size' (1967, 44).

NEGATIVE PRESENCE: ROBERT MORRIS

1. J. Perreault, 1995, 259.
2. R. Morris, quoted in M. Fried, 1967, in G. Battock, 1995, 126.
3. M. Friedman, 1966, 23.
4. D. Factor, 1966, 13.
5. In M. Compton, 1971, 16.
6. R. Morris, "Notes on Sculpture", 4, 51.
7. In D. Wheeler, 1991, 221.
8. B. Rose, 1965.
9. D. Sylvester, 1996, 243.
10. In M. Compton, 1971, 19.
11. J. Haldane, 1997, 56.

NEW STONE CIRCLES: NANCY HOLT

1. N. Holt, "Sun Tunnels", 1977, 34.
2. In T. Castle, 1982, 88.
3. See N. Holt, 1975, 1977; T. Castle, 1982.
4. C. Robins, 1984, 10.

THE UNDERGROUND LABYRINTHS OF ALICE AYCOCK

1. H. Risatti, 37.
2. A. Aycock, quoted in E. Johnson, 1982, 223.
3. R. Smith, 1975, 68.
4. Aycock, quoted in N. Rosen: "A Sense of Place: Five American Artists", *International Sculpture*, Merriewold West, 1975.
5. E. Johnson, 1982, 221.
6. A. Aycock, 1977.

MARY MISS

1. R. Onoratio, 1978, 32. See also Onoratio, 1979; K. Linker: "Mary Miss", *Mary Miss*, ICA, 1983.
2. See L. Anderson, 1973; M. Miss, 1981.

DIGGING IN THE DIRT: MICHAEL HEIZER

1. M. Heizer, 1970.
2. See A. Sonfist, 1983; J. Beardsley, 1984.
3. Sol LeWitt was sceptical of enormity: '[i]f it's so big that you can't

really comprehend it except by its emotive force then I don't want it' (in F. Colpitt, 77). And Robert Morris wrote that 'beyond a certain size the object can overwhelm and the gigantic scale becomes the loaded term' (1966, 21).

4. See J. Brown, 1984; G. Müller, 42-45.

5. In H. Smagula, 1983, 286.

6. M. Heizer, in J. Bell: "Positive and Negative", *Arts Magazine*, Nov, 1974, 55.

7. R. Hughes, 1997, 571.

8. M. Miss, 1981, 6-7.

9. R. Hughes, 1991, 386.

WALTER DE MARIA AND THE *LIGHTNING FIELD*

1. Walter de Maria proposed another shaft, *Olympic Mountain Project* (1970) – never made – which would have been 400 ft deep and 3 ft wide.

2. Quoted in H. Smagula, 289.

3. R. Smith, 1978, 104.

4. H. Rosenberg, 1972, 36.

5. See D. Bourdon, 1968, 39-43, 72, M. Winton, 1970, 18-19; R. Smith, 1978, 102-5.

6. K. Baker, 1988, 125-7.

7. W. de Maria, 1980.

8. See P. Redgrove: *The Black Goddess and the Sixth Sense*, Bloomsbury, London, 1987; *The Cyclopean Mistress*, Bloodaxe, Newcstle, 1993.

9. H. Smagula, 290. De Maria himself thought that a lightning strike is a 'false climax' to the work, which really needs to be seen over a period of time to appreciate its qualities.

10. P. Redgrove: *The Man Named East and other new poems*, Routledge & Kegan Paul, London, 1985, 9.

11. R. McKie: "Why we are so positive", *The Observer*, May 1, 1994.

OTHER AMERICAN LAND ARTISTS

1. G. Matta-Clark, "Interview With *Avalanche*", *Avalanche*, Dec, 1974.

2. See L. Lippard, 1983, 49.

3. T. Murak. in B. Nemitz, 94.

4. D. Hollis, in B. Oakes, 107.

8 LAND ART IN EUROPE

THE ART OF THE WRAP: CHRISTO

1. J. Marck: *Wrapped Museum*, Museum of Contemporary Art, Chicago, 1969.

2. Christo, quoted in E. Johnson, 1982, 198.

3. See W. Spies: *The Running Fence Project, Christo*, Abrams, New York, NY, 1977.

4. Christo, in A. Haden-Guest, 40.

HANS HAACKE

1. H. Haacke, in J. Burnham, 1967.

2. H. Haacke, in ib.

CHRIS DRURY

1. C. Drury, 2002, 91.

2. C. Drury, 2002, 72, 76.

3. C. Drury, 2002, 76, 84.

4. C. Drury, 2002, 90.

5. Statement, on C. Drury's website.

6. C. Drury, in 1998, 6.

7. C. Drury, 1998, 7.

DAVID NASH

1. See A. McPherson, 1978; H. Adams, 1979; D. Nash, 1980.

2. H. Adams, 1979, 46-47.

3. D. Nash: *Sea Hearth*, 1981, Isle of Bute, Scotland, *Wood Stove*, 1979, Maentwrog, Wales, *Slate Stove*, 1981, Blaenau Ffestiniog, Wales, *Snow Stove*, 1982, Kotoku, Japan.

4. At the University of Colorado, 1991.

5. D. Nash, in K. Martin, 1990, 66.

6. H. de Vries, in H. Gooding, 2002, 69.

7. D. Nash: *Fletched Over Ash Dome*, planted, 1979, Caen-y-Coed, Maentwrog, Wales.

8. D. Nash, in Welsh Sculpture Trust, 120.

9. In A. Causey.

RICHARD LONG

1. H. Thoreau. in *Walking*, 1861, in *The Portable Thoreau*, ed. C. Bode, Viking, New York, NY, 1980, 592.

2. A. Seymour, "Walking in Circles", 1.

3. R. Long, in *Walking In Circles*, 23.

4. R. Long, letter to the author, in W. Malpas, 1995.

5. *Old World, New World*, 54.

6. H. Fulton, in M. Auping, in *Common Ground*, John & Mable Ringling Museum of Art, Sarasota, 1982.

7. R. Long, in *Walking In Circles*, 1986, 23.

8. R. Long, in ib., 224.

9. D. Reason: "Echo and Reflections", in S. Bann, 169.

10. R. Long, interview, Santa Fe, 1993, 236.

11. R. Long, in *An Interview With Richard Long*, R. Cork, in Long, *Walking In Circles*, 20.

12. J. Augoyard: *Pas a Pas. Essai sur le cheminement quotidien en milieu urbain*, Paris, 1979; C. Norberg-Schultz: *Existence, Space and Architecture*, London, 1971.

13. Kate Blacker, discussing Richard Long, Finlay and Willats wrote:

I don't think Long ...reversed anything. They just weren't concerned with the same things as their predecessors were. Long went to St Martin's and was introduced to a very strict set of self-perpetuating rules. He seems to have spent no time considering what [Anthony] Caro or [Philip] King had to say. Instead he placed himself in another British tradition: that of landscape. Regardless of the format of how to display the sculpture, he was the first British artist to bring landscape indoors. It's no longer a framed picture, a window onto the landscape, as it was in Constable or the Norfolk School. He brings the sense of scale, the whole sensibility of that tradition, into three dimensions. (K. Blacker, in P. de Monchaux, 1983, 92.)

14. R. Long, 1985, 2, 24.

15. R. Long, 1985, 1, 17.

16. In R. Long, interview, Santa Fe, 1993, 236.

17. R. Long, interview with G. Lobacheff, 1994, 6.

18. R. Long, interview, Santa Fe, 1993, 236.

19. Richard Long wrote: '[e]ven though it is necessary to get a good photograph, the photographs should be as simple as possible... the photographs have got to be fairly simple and straightforward, so that the feeling of the work somehow accurately comes through.' (R. Long, in *An Interview With Richard Long*, R. Cork, in Long, *Walking In Circles*, 24).

20. R. Long, interview, Santa Fe, 1993, 236.

21. *An Interview with Richard Long*, Santa Fe.

22. R. Long, interview with G. Lobacheff, 1994, 8.

23. R. Long, 1985, 1, 12.

HAMISH FULTON

1. H. Fulton, 1995.

TIME AND NATURE: ANDY GOLDSWORTHY

1. Many of the big names in British sculpture have exhibited works at Goodwood, including Elisabeth Frink, David Mach, Phillip King, David

Nash, Eduardo Paolozzi, Bill Woodrow, Tony Cragg, Ian Hamilton Finlay, Stephen Dilworth, Anthony Caro and Anthony Gormley.

2. A. Goldsworthy, *Time*, 82.

3. A. Goldsworthy, *Time*, 193.

4. J. Dibbets, in D. Ashton, ed. *20th Century Artists on Art*, Pantheon, New York, NY, 1985, 174.

5. A. Goldsworthy, in A. Causey, 1980.

6. A. Goldsworthy, in *Aspects*, 1986.

7. A. Goldsworthy, ib., *Hand To Earth*, 165.

8. A. Goldsworthy, *Sheepfolds*, 17.

9. A. Goldsworthy, *Refuges d'Art*, 105.

10. Interview with T. Friedman, *Third Ear*, June, 1989 in *Hand To Earth*, 166.

11. A. Goldsworthy, *Stone*, 21.

12. A. Goldsworthy, *Stone*, 120.

13. R. Long, letter to the author, in W. Malpas, 1995.

14. A. Goldsworthy, *Hand To Earth*, 167.

15. K. Carter: "*Stone*", *New Welsh Review*, 27, Winter, 1994-95, 100.

16. A. Goldsworthy, *Wall*, 68-69.

17. A. Goldsworthy, *Refuges d'Art*, 85.

18. 'My strongest work is so rooted in place that it cannot be separated from where it is made' Goldsworthy wrote in *Stone* (6).

19. A. Goldsworthy, *Hand To Earth*, 167.

20. A. Goldsworthy, *Stone*, 6.

21. H. Voegls: "Haarlemmerhout", in *Hand To Earth*, 54.

22. A. Goldsworthy, 1985, *Hand To Earth*, 59.

23. A. Goldsworthy, *Stone*, 54-55.

24. In A. Papadakis, 1991, 250.

25. In J. Beardsley, 1984, 134.

26. A. Goldsworthy, *Midsummer Snowballs*, 31.

27. A. Goldsworthy, *Hand To Earth*, 165.

28. A. Goldsworthy, quoted in *Andy Goldsworthy*.

29. A. Goldsworthy, interview, Dec 9, 1987, in *Hand To Earth*, 163.

30. 'Urban living has always tended to produce a sentimental view of nature' wrote John Berger (*The White Bird: Writings by John Berger*, London, 1988, 7).

31. 'Nature for me is the clearest path to discover – *uncluttered by personalities* or associations – *it just is*' says Goldsworthy in a telling statement (my emphasis, sketchbook no., 19, 1988, *Hand To Earth*, 150).

32. A. Goldsworthy, *Midsummer Snowballs*, 33.

33. A. Goldsworthy, *Time*, 112.

34. A. Goldsworthy, *Andy Goldsworthy*, Viking, London, 1990, no page numbers; and in N. Hedges, 67; *Hand To Earth*, 160-1.

35. A. Causey: "Environmental Sculptures", in *Hand To Earth*, 128.

36. A. Goldsworthy, *Third Ear*, BBC Radio 3, June 30, 1989, in *Hand To*

Earth, 168.

37. 'Some works have qualities of snaking but are not snakes. The form is shaped through a similar response to environment' (*Andy Goldsworthy*).

38. A. Goldsworthy, *Refuges d'Art*, 113.

39. ib., 113.

40. A. Goldsworthy, *Time Machine*.

41. Goldsworthy wrote that a 'work made with leaves is a celebration of growth, yet cannot work without expressing some anticipation of death, in a way that understands that death is a part of growth. The sarcophagi are not just containers of death, they are containers of life, in that out of death comes life' (*Time Machine*). Goldsworthy had also made snaking sand sculptures in Australia (*Sand | brought to an edge | to catch the morning light*, in 1991).

42. In Davies, 1984, 151.

43. A. Causey, 1990, 128.

44. A. Goldsworthy, *Hand To Earth*, 163.

45. A. Goldsworthy, unpublished notes, 1988, in *Hand To Earth*, 134-5.

46. A. Goldsworthy, *Refuges d'Art*, 89.

47. 1987, *Hand To Earth*, 147.

48. In Y. Baginsky, 1989.

49. A. Goldsworthy, quoted in T. Friedman: "Monuments", in *Hand To Earth*, 154.

50. A. Goldsworthy, *Sheepfolds*, 12.

51. A. Goldsworthy, *Refuges d'Art*, 111.

52. A. Goldsworthy, *Stone*, 50.

53. A. Goldsworthy, *Hand To Earth*, 19.

54. A. Goldsworthy, *Winter Harvest*; *Hand To Earth*, 162.

55. A. Goldsworthy, quoted in M. Church.

56. A. Goldsworthy, in M. Church; and *Stone*, 120.

OTHER LAND ARTISTS IN EUROPE

1. R. Martin, 31.

2. Nemitz, 78.

3. N. Pope, quoted in W. Strachan, 70.

4. R. Harris, quoted in D. Petherbridge, "Public commissions and the new concerns in sculpture", in P. de Monchaux, 136.

5. In W. Strachan, 179.

6. See R. Parker, 1987, 316; L. Lippard, 1976, 203.

Bibliography

L.S. Adams. *A History of Western Art*, Abrams, New York, NY, 1994

S. Adams & A. Robins, eds. *Gendering Landscape Art*, Manchester University Press, Manchester, 2000

C. Adcock. *James Turrell*, University of California Press, Berkeley, CA, 1990

W. C. Agee. *Don Judd*, Whitney Museum of American Art, New York, NY, 1968

—. "Unit, Series, Site: A Judd Lexicon", *Art in America*, May, 1975

—. *The Sculpture of Donald Judd*, Art Museum of South Texas, Corpus Christi, TX, 1977

L. Aldrich. *Cool Art: 1967*, Museum of Contemporary Art, 1968

L. Alloway. "The American Sublime", *Living Arts*, 1, 2, June, 1963

—. *Systematic Painting*, New York, NY, 1966

—. *Christo*, Abrams, New York, NY, 1969

—. "Robert Smithson", *Artforum*, 11, Nov, 1972

—. "Residual Sign Systems in Abstract Expressionism", *Artforum*, Nov, 1973

W. Andersen. *American Sculpture in Process, 1930/1970*, New York Graphics Society, Boston, MA, 1975

L. Anderson. "Mary Miss", *Artforum*, Nov, 1973

C. Andre. "Frank Stella: Preface to Stripe Painting", in Miller, 1959

—. "An Interview with Carl Andre", P. Tuchman, *Artforum*, 8, 10, June, 1970

—. *Carl Andre, Sculpture, 1958-1974*, Kunsthalle, Bern, 1975

—. "Object v Phenomenon", *Sculpture Today*, The International Sculpture Center, Toronto, 1978

—. *Carl Andre: Sculpture*, State University of New York Press, Albany, NY, 1984

—. *Carl-Andre: works on land*, Exhibitions International, 2001

J. Andrews. *The Sculpture of David Nash*, Lund Humphries, London, 1999

M. Andrews. *Landscape and Western Art,* Oxford Paperbacks, Oxford, 1999

E. de Antonio & Mitch Tuchman. *Painters Painting,* Abbeville Press, New York, NY, 1984

D. Ashton. *Modern American Sculpture*, Abrams, New York, NY, 1968

—. *American Art Since 1945*, Thames & Hudson, London, 1982

M. Auping. *Common Ground,* John and Mable Ringling Museum of Art, Sarasota, 1982

—. "Hamish Fulton", *Art in America*, 71, Feb, 1983

A. Aycock. "Work", "Maze", 1975, in A. Sondheim, 1977

J. Baal-Teshuva, ed. *Christo: The Reichstag and Urban Projects,* Prestel Verlag, Munich, 1993

E. Baker: "Judd the Obscure", *Art News*, 67, 2, 1968

K. Baker. "Andre in Retrospect", *Art in America*, Apl, 1980a

—. "Reckoning with Notation: The Drawings of Pollock, Newman, and Louis", *Artforum*, 18, 10, Summer, 1980b

—. *Minimalism: Art of Circumstance*, Abbeville, New York, NY, 1988

S. Bann & W. Allen, eds. *Interpreting Contemporary Art*, Reaktion Books, London, 1991

—. "Shrines, Gardens, Utopias", *New Literary History*, 24, 4, Autumn, 1994a

—. "The Map As Index of the Real: Land Art and the Authentication of Travel", *Imago Mundi*, 46, British Library, London, 1994b

S. Barnes. *The Rothko Chapel,* Rothko Chapel, Houston, TX, 1989

G. Baro. "Toward Speculation in Pure Form", *Art International*, Summer, 1967

—. "American Sculpture", *Studio International*, 172, 896, 1968

C. Barrett. *Op Art*, Viking, New York, NY, 1970

G. Battock, ed. *The New Art*, Dutton, New York, NY, 1966

—. *Idea Art*, Dutton, New York, NY, 1973

—. "Art in America: Confusions", *Domus*, Mch, 1975

—. ed. *New Artists Video*, Dutton, New York, NY, 1978

—. ed. *The Art of Performance*, Dutton, New York, NY, 1984

—. ed. *Minimal Art: A Critical Anthology*, University of California Press, Berkeley, CA, 1995

G. Bazin. *A Concise History of World Sculpture*, David & Charles, Newton Abbot, Devon, 1981

J. Beardsley. *Probing the Earth: Contemporary Land Projects,* Smithsonian Press, Washington DC, 1977

—. *Art in Public Spaces*, Partners For Liveable Places, Washington DC, 1981

—. *Earthworks and Beyond: Contemporary Art in the Landscape*, Abbeville Press, New York, NY, 1984/ 1998

M.R. Beaumont. "Romantic Sculpture", in A. Papadakis, 1988

—. "Andy Goldsworthy", *Arts Review*, July 14, 1989

M. Beeren. *Century in Sculpture*, Stedelijk Museum, Amsterdam, 1992

D. Belgrad. *The Culture of Spontaneity: Improvisation and the Arts in Postwar America*, University of Chicago Press, Chicago, IL, 1998

A. Benjamin, ed. *Installation Art, Art & Design*, 30, 1993

L. Bennett. *The Life and Work of Andy Goldsworthy*, Heinemann, London, 2005

N. Bennett, ed. *The British Art Show: Old Allegiances and New Directions, 1979-1984*, Arts Council/ Orbis, London, 1984

M. Berger. *Labyrinths: Robert Morris, Minimalism, and the 1960s*, Harper & Row, New York, NY, 1989

F. Berthier. *Reading Zen in the Rocks: The Japanese Dry Landscape Garden*, University of Chicago Press, Chicago, IL, 2000

L. Biggs: *Between Object and Image*, British Council, London, 1986

M. Bloem, ed. *Lawrence Weiner*, Stedelijk Museum, Amsterdam, 1989

K.C. Bloomert & C.W. Moore. *Body, Memory and Architecture*, New Haven, 1977

M. Bochner. "Art in Process – Structures", *Arts Magazine*, 40, 9, 1966a

—. "Primary Structures", *Arts*, June, 1966b

—. "Systematic", *Arts Magazine*, 41, 1, Nov, 1966c

—. "Serial Art Systems: Solipsism", *Arts Magazine*, 41, 8, Summer, 1967

—. "Mel Bochner on Malevich", interview with J. Coplans, *Artforum*, June, 1974

S. Boettger. *Earthworks*, University of California Press, Berkeley, CA, 2002

Y. Bois. *Donald Judd*, Galerie Lelong, Paris, 1991

D. Bonetti, David. "Facing Eden: 100 years of landscape art in the Bay Area, is a show that limns a strong tradition", *San Francisco Examiner*, June 25, 1995

D. Bourdon. "The Razed Sites of Carl Andre", *Artforum*, 5, 2, Oct, 1966

—. "Walter de Maria: The Singular Experience", *Art International*, Dec 20, 1968

—"The Mini-Conceptual Age", *Village Voice*, Oct 17, 1974

—. "You Can't Tell a Painter By His Colors", *Village Voice*, Mch 24, 1975

—. *Carl Andre: Sculpture, 1959-1977*, Jaap Rietman, New York, NY, 1978

C. Brown. "Natural arts", *The Magazine,* July, 1987

D. Brown. "New British sculpture in Normandy", *Arts Review*, Feb 10, 1989

J. Brown *et al*. *Michael Heizer: Sculpture in Reverse*, see M. Heizer, 1984

—. ed. *Occluding Front: James Turrell*, Lapis Press, Larkspur Landing, CA, 1985

D. Bruckner. "Earth works", *New York Times Book Review*, Jan, 1996

T. Burckhardt: *Sacred Art in East and West*, Perennial Book, Middlesex 1967

P. J. Burgard, ed. *Nietzsche and the Feminine*, University Press of Virginia, Charlottesville, VI, 1994

J. Burnham. *Beyond Modern Sculpture*, Braziller, New York, NY, 1968

— . "A Dan Flavin Retrospective in Ottawa", *Artforum*, 8, 4, Dec, 1969

— . "Robert Morris", *Artforum*, 8, 7, 1970

— . "Haacke's Cancelled Show at the Guggenheim", *Artforum*, June, 1971

— . *Great Western Salt Works*, Brazillier, New York, NY, 1974

— . "Hans Haacke: Wind and Water Sculpture", 1967, in A. Sonfist, 1983

K. Bussman & F. Matzner, eds. *Hans Haacke*, Cantz, Stuttgart, 1993

J. Butterfield. *The Art of Light and Space*, Abbeville Press, New York, NY, 1993

N. & E. Calas. *Icons and Image of the Sixties*, Dutton, New York, NY, 1971

D. Cameron. "When is a door not a door?", *XLIII esposizione Internazionale d'Arte La Biennale di Venezia*, Edizioni La Biennale, Venice, 1988

— . "Art for the new year: who's worth catching?", *Art & Auction*, Jan, 1994

J. Campbell. *The Power of Myth*, with B. Moyers, ed. B. Flowers, Doubleday, New York, NY, 1988

P. Carlson. "Donald Judd's Equivocal Objects", *Art in America*, Jan, 1984

T. Castle. "Nancy Holt, Siteseer", *Art in America*, Mch, 1982

A. Causey. "Space and Time in British Land Art", *Studio International*, 193, 98, Feb, 1977

— . *Nature as Material: An Exhibition of Sculpture and Photographs Purchased For the Arts Council Collection*, Arts Council, London, 1980

— . "Environmental Sculptures", in Goldsworthy, *Hand to Earth*, 1990

— . *Sculpture Since 1945*, Oxford University Press, Oxford, 1998

G. Celant. "Introduction", *Arte Povera*, Praeger, New York, NY, 1969

— . *Conceptual Art, Arte Povera, Land Art*, Galeria Civica d'Arte Moderna, Turin, 1970

— . "Tony Cragg and Industrial Platonism", *Artforum*, 20, 3, Nov, 1981

— . *Dennis Oppenheim*, Edizioni Charta Srl, 1997

A. Chave: "Minimalism and the Rhetoric of Power", *Arts*, Jan, 1990

N. Childs & J. Walwin, eds. *A Split Second of Paradise: Live Art, Installation and Performance*, Rivers Oram Press, 1998

H.B. Chipp, ed. *Theories of Modern Art*, University Press of California, LA, CA, 1968

M. Church. "A shower of stones, a flash in the river", *The Sunday Telegraph*, 10 April, 1994, 6

F. Colpitt. *Minimal Art: The Critical Perspective*, University of Washington Press, Seattle, WA, 1990

B. Commoner. *The Closing Circle: Nature, Man and Technology*, Knopf, New York, NY, 1975

M. Compton. *Some Notes on the Work of Richard Long*, British Council, London, 1976

— . & D. Sylvester. *Robert Morris*, Tate Gallery, London, 1971

Concept Art, Minimal Art, Land Art, Edition Cantz, Stuttgart, 1990

L. Cooke. "Richard Long replies to a critic", *Art Monthly*, 68, July, 1983

— . *Alison Wilding*, essay by Lynne Cooke, Serpentine Gallery, London, 1985

—. "Between Image and Object: The "New British Sculpture"", in T. Neff, 1987

J. Coplans. "Serial Imagery", *Artforum*, 7, 2, Oct, 1968

—. *Donald Judd*, Pasadena Art Museum, CA, 1971

—. "Robert Smithson", *Artforum*, Apl, 1974

P. Crowther. "Barnett Newman and the Sublime", *Oxford Art Journal*, 7, 2, 1984

—. ed. *The Contemporary Sublime, Art & Design*, 40, 1995

T. Cragg. *Writings*, Editions Isy Brachot, Brussels, 1992

—. *Sculptures on the Page*, Henry Moore Institute, Leeds, Yorkshire, 1997

M. Craig-Martin. *Minimalism*, Tate Gallery, Liverpool, 1989

D. Crane. *The Transformation of the Avant Garde: The New York Art World, 1940-1985,* University of Chicago Press, Chicago, IL, 1987

P. Crowther. "Barnett Newman and the Sublime", *Oxford Art Journal*, 7, 2, 1984

—. ed. *The Contemporary Sublime, Art & Design*, 40, 1995

P. Curtis. *Modern British Sculpture from the Collection*, Tate Gallery, Liverpool, 1988

A. Davies. "Richard Long and Hamish Fulton", *Art Monthly*, 25, April, 1979

H. Davies *et al. Blurring the Boundaries: Installation Art 1969-1996*, Museum of Contemporary Art, San Diego, CA, 1997

R. Davies & T. Knipe, eds. *A Sense of Place: Sculpture in Landscape*, London, 1984

W. de Maria. "The Lightning Field", *Artforum,* 18, 8, Apl, 1980

P. de Monchaux, *et al,* eds. *The Sculpture Show*, Arts Council of Great Britain, London, 1983

A. Dempsey. *Styles, Schools Movements*, Thames & Hudson, London, 2002

J. De Mul. *Romantic Desire in (Post)Modern Art and Philosophy*, State University of New York Press, Albany, NY, 1999

N. de Oliveira *et al. Installation Art*, Thames & Hudson, London, 1994

—. *et al,* eds. *Installation Art in the New Millennium*, Thames & Hudson, London, 2003

R. Deutsche *et al. Hans Haacke*, MIT Press, Cambridge, MA, 1986

E. Develing. *Carl Andre*, Gemeentenmeuseum, The Hague, 1969

—. & L. Lippard. *Minimal Art*, Stadtische Kunsthalle, Dusseldorf, 1969

J. Dibbets, in L. Bear & W. Sharp: "DIBBETTS", *Avalanche*, 1, Autumn, 1970.

R. Donnell. *Double Vision: Perspectives On Gender and the Visual Arts*, Farleigh Dickinson University Press, Rutherford, NJ, 1995

L. Dougherty. "Art in nature: a new site for sculpture in Denmark", *Maquette*, Sept, 1994

C. Drury. *Shelters and Baskets*, Orchard Gallery, 1988

—. *Vessel: Sculpture 1990-95*, Towner Art Gallery, 1995

—. *Stones and Bundles*, Rebecca Hossack Gallery, London, 1995

—. *Silent Spaces*, Thames & Hudson, London, 1998/ 2004

—. *Journeys On Paper*, Stephen Lacey Gallery, 2000

—. interview with W. Furlong, in M. Gooding, 2002

—. *Defying Gravity*, North Carolina Museum of Art, NC, 2003

—. *Heart of Stone*, Aberystwyth Art Gallery, Wales, 2003

M. Duncan. "On site: straddling the great divide", *Art in America*. 83, 3, Mch 1995

—. "Live from the Getty", *Art in America*, 86, 5, May, 1998

L. Durrell. *Justine*, Faber, London, 1963

—. *Spirit of Place*, Faber, London, 1971

A. Dyson. *Richard Long: Sao Paulo Biennial 1994*, The British Council, 1994

J.C. Eade, ed. *Projecting the Landscape*, Humanities Research Centre, Canberra, 1987

M. Eliade. *Ordeal by Labyrinth*, University of Chicago Press, Chicago, IL, 1984

—. *Symbolism, the Sacred and the Arts*, Crossroad, New York, NY, 1985

G. Evans. "Sculpture and Reality", *Studio International*, 177, 908, Feb, 1969

J. Fabricus. *Alchemy: The Medieval Alchemists and Their Royal Art*, Aquarian Press, Northants, 1989

D. Factor. "Los Angeles", *Artforum*, 4, 9, May, 1966

S. Farr. "Andy Goldsworthy: stone works in America", *Reflex*, 8, 6, Dec, 1995

R. Ferguson *et al*, eds. *Discourses: Conversations in Postmodern Art and Culture*, MIT Press, Cambridge, MA, 1990

S. Field. "Touching the Earth", *Art and Artists*, 8, Apl, 1973

J. Fineberg: "Robert Morris Looking Back", *Arts Magazine*, 55, 1, 1980

—. *Art Since 1940: Strategies of Being*, Laurence King, London, 1995

A. Fisher & G. Gerster. *The Art of the Maze*, Weidenfeld & Nicholson, London, 1990

—. & J. Saward. *The British Maze Guide*, Minotaur Designs, London, 1991

—. & D. Kingham. *Mazes*, Shire Pulications, London, 1991

J. Fisher. "Richard Long", *Aspects*, 14, Spring, 1981

B. Flanagan. "Sculpture made visible: Barry Flanagan in discussion with Gene Baro", *Studio International*, 178, 915, Oct, 1969

S. Foley. *Unitary Forms: Minimal Structures by Carl Andre, Donald Judd, John McCracken, Tony Smith*, Museum of Modern Art, San Francisco, CA, 1970

N. Foote. "Long Walks", *Artforum*, 18, Summer, 1980

W. Forma. *Five British Sculptors*, New York, NY, 1965

F. Frascina. *Pollock and After*, Harper & Row, New York, NY, 1985

—. *et al*, eds. *Modern Art and Modernism: A Critical Anthology*, Paul Chapman, 1988

M. Fried. "New York Letter", *Art International*, 8, 3, Apl, 1964

—. *Three American Painters: Kenneth Noland, Jules Olitski, Frank Stella*, Fogg Art Museum, Harvard University, Cambridge, MA, 1965

—. "Shape as Form: Frank Stella's New Paintings", *Artforum*, 5, 3, Nov, 1966

—. "Art and Objecthood", *Artforum*, 5, Summer, 1967

—. *Morris Louis*, Abrams, New York, NY, 1970

M. Friedman. "Robert Morris: Polemics and Cubes", *Art International*, 10, 10, Dec, 1966

—. *14 Sculptors*, Walker Art Center, Minneapolis, MN, 1969

E. Fry. *Alice Aycock*, University of South Florida Art Galleries, Tampa, FL, 1981

—. "The Poetic Machines of Alice Aycock", *Portfolio*, Nov, 1981

—. *et al. Robert Morris*, Museum of Contemporary Art, Chicago, IL, 1986

R.H. Fuchs. "Memories of Passing: A Note on Richard Long", *Studio International*, 187, 965, Apl, 1974

—. *Carl Andre*, Van Abenmuseum, Eindhoven, 1978

—. *Richard Long*, text, in R. Long, 1986

T. Fulgate-Wilcox. "Force Art: a New Direction", *Arts Magazine*, Mch, 1971

P. Fuller. *Peter Fuller's Modern Painters: Reflections on British Art*, ed. J. McDonald, Methuen, London, 1993

H. Fulton. *Hamish Fulton: Selected Walks, 1969-89*, Albright-Knox Art Gallery, Buffalo, New York, NY, 1990

—. "Into a Walk Into Nature", *Thirty One Horrors*, Lenbachhaus, Munich, 1995

—. *Walking Artist*, Annely Juda, London, 1998

S. Gardiner. "Their medium is nature", *Landscape Architecture*, 80, Feb, 1990

M. Garlake. "Andy Goldsworthy", *Art Monthly*, 93, Feb, 1986

J. Gear. "Andy Goldsworthy", *Review*, Dec. 1, 1996

G. Gelburd, ed. *Creative Solutions to Ecological Issues*, Council For Creative Projects, New York, NY, 1993

H. Geldzahler. *New York Painting and Sculpture*, MOMA, New York, NY, 1969

L. Gendron. "Le sculpteur d'éphémère", *L'actualité*, 22, 12, Aug, 1997

J. Gibson. *The Senses Considered as a Perceptual System*, Houghton Mifflin, Boston, MA, 1966

J. Giovannini. *Mary Miss*, Architectural Association, London, 1987

M. Glimcher. *The Art of Mark Rothko*, Barrie & Jenkins, London, 1992

T. Godfrey, Tony. "Richard Wilson's watertable, Andy Goldsworthy", *Burlington Magazine*, 136, 1096, July, 1994

—. *Conceptual Art*, Phaidon, London, 1998

E. Goheen. *Wrapped Walk Ways*, Abrams, New York, NY, 1978

R. Goldberg. *Performance: Live Art Since the 60s*, Thames & Hudson, London, 1998

A. Goldsworthy. *Andy Goldsworthy, Alan Rankle, Nigel Jepson*, Brampton Banks, Cumbria, 1982

—. *Rain sun snow hail mist calm: Photoworks by Andy Goldsworthy*, Henry Moore Centre for the Study of Sculpture, Leeds, Yorkshire, 1985

—. *Land Matters*, Blackfriars Arts Centre, Reed Press, 1986

—. & J. Fowles. *Winter Harvest*, Scottish Arts Council, 1987

—. *Mountain and Coast: Autumn Into Winter: Japan 1987*, Art Data, 1988

—. *Parkland*, Yorkshire Sculpture Park, West Bretton, 1988

—. *Touching North*, Fabian Carlsson, London, 1989

—. *Snowballs in Summer Installation*, Old Museum of Transport, Glasgow, 1989

—. *Leaves*, Common Ground, London, 1989

—. *Andy Goldsworthy*, Viking, London, 1990

—. *Hand to Earth: Andy Goldsworthy, Sculpture, 1976-1990*, Henry Moore Centre for Sculpture, Leeds, Yorkshire, 1990

—. interview, *Third Ear*, BBC Radio 3, June 30, 1989, in 1990

—. "Geometry and Nature", interview, *Art & Design*, in A. Papadakis, 1991

—. *Sand Leaves*, Arts Club of Chicago, IL, 1991

—. *Ice and Snow Drawings*, Fruitmarket Gallery, Edinburgh, 1992

—. *Andy Goldsworthy: Breakdown*, Rose Art Museum, 1992

—. *Stone*, Viking, London, 1994

—. *Black Stones, Red Pools*, Pro Arte Foundation, 1995

—. *Wood*, Viking, London, 1996

—. *Sheepfolds*, Michael Hue-Williams Gallery, London, 1996

—. *Végètal*, Ballet Atlantique-Regine Chopinot, La Rochelle, France, 1996

—. *Alaska Works*, Anchorage Museum of History and Art, Anchorage, AK, 1996

—. *Andy Goldsworthy: A Collaboration With Nature*, Abrams, NY, 1996

—. *Andy Goldsworthy: Jack's Fold*, ed. Judy Glasman, University of Hertfordshire, 1996

—. *Hand to Earth: Andy Goldsworthy Sculpture*, T. Friedman, Thames and Hudson, London, 1997 & 2004

—. *Cairns*, Musée departemental de Digne, Reserve Geologique de haute Provence, 1997

—. *Andy Goldsworthy*, Musée d'art contemporain de Montréal, 1998

—. *Arch*, with D. Craig, Thames & Hudson, London, 1999

—. *Wall*, intr. K. Baker, Thames & Hudson, London, 2000

—. *Time*, Thames & Hudson, London, 2000

—. *Midsummer Snowballs*, intr. J. Collins, Abrams, New York, NY, 2001

—. *Andy Goldsworthy – Refuges D'Art*, Editions Artha, 2002

—. *Passages*, Thames & Hudson, London, 2004

R. Goldwater & M. Treves, eds. *Artists on Art*, John Murray, London, 1975

—. *What is Modern Sculpture?*, MOMA, New York, NY, 1969

E.H. Gombrich: *Norm and Form: Studies in the Renaissance I*, Phaidon, Oxford, 1985

—. *Symbolic Images, Renaissance Studies II*, Phaidon, Oxford, 1985

M. Gooding & W. Furlong. *Song of the Earth,* Thames and Hudson, London, 2002

E.C. Goossen. "The Philosophic Line of B. Newman", *Art News,* Summer, 1958

—. *The Art of the Real: USA 1948-1968,* MOMA, New York, NY, 1968

A. Gopnik. "Basic Stuff: Robert Smithson, Myth, Science and Primitivism", *Art Magazine,* Mch, 1983

J. Grande. *Balance: art and nature,* Black Rose Books, Montréal, 1994

—. "Back to nature?", *Sculpture,* 13, 4 July/ Aug, 1994

—. *Art Nature Dialogues,* State University of New York Press, NY, 2004

N. Graydon. "Magic in the field", *Ritz,* 133, 1989

B. Graziani. "Robert Smithson's Picturable Situation", *Critical Inquiry,* 20, 3, Spring, 1994

C. Greenberg. *Art and Culture,* Beacon Press, Boston, MA, 1961

H. Gresty & D. Reason. *Landscape,* Kettle's Yard, Cambridge, 1986

—. *Bare: Alison Wilding: Sculptures, 1982-1993,* Newlyn Art Gallery, Cornwall, 1993

H. Haacke. *Framing and Being Framed,* New York University Press, New York, NY, 1975

A. Haden-Guest. "The King of Wrap", *The Sunday Times Magazine,* Jan, 1994

O. Hahn & P. Restany. *Christo,* Editioni Apollinaire, Milan, 1966

J. Haldane. *A Road From the Past To the Future,* Crawford Arts Centre, St andrews, 1997

C. Hall. "Shared earth", *Arts Review,* 43, June 14, 1991

—. "Site lines", *Arts Review,* 46, Oct, 1994

D. Hall & S. Fifer. *Illuminating Video,* Aperture Foundation, NY, 1990

A.M. Hammacher. *The Sculpture of Barbara Hepworth,* Abrams, New York, NY, 1968

—. *The Evolution of Modern Sculpture: Tradition and Innovation,* Abrams, New York, NY, 1969

C. Harrison. "Barry Flanagan's Sculpture", *Studio International,* 175, 900, May, 1968

—. "Sculpture's Recent Past", in T. Neff, 1987

B. Haskell. *BLAM! The Explosion of Pop, Minimalism, and Performance, 1958-64,* Whitney Museum of American Art, New York, NY, 1984

—. *Donald Judd,* Whitney Museum of American Art, New York, NY, 1988

—. *Agnes Martin,* Whitney Museum of American Art, New York, NY, 1992

N. Hedges. "Growth, decay and the movement of change", *World Magazine,* 45, Jan, 1991

M. Heizer, D. Oppenheim & R. Smithson. "Discussion", *Avalanche,* 1, Autumn, 1970

—. *Sculpture in Reverse,* Museum of Contemporary Art, LA, CA, 1984

A. Henri. *Environments and Happenings,* Thames & Hudson, London, 1974

—. *Total Art,* Praeger, New York, NY, 1974

J. Heslewood. *The History of Western Sculpture: A Young Person's Guide*, Belitha Press, London, 1994

A. Hess. "Technology Exposed", *Landscape Architecture*, May, 1992

T. Hess. *Barnett Newman*, Walker, New York, NY, 1969

—. & L. Nochlin. *Woman as Sex Object: Studies in Erotic Art*, Newsweek, New York, NY, 1972

—. & E. Baker. *Art and Sexual Politics*, Art New Series, Macmillan, New York, NY, 1973

Galerie Max Hetzler. *Carl Andre, Gunther Forg, Hubert Kiecol, Richard Long, Meuser, Reinhard Mucha, Bruce Nauman and Ulrich Ruckreim*, Cologne, 1985

Greg Hilty. *Recent British Sculpture*, Arts Council, London, 1993

—. *Alison Wilding: Immersion/ Exposure*, Tate Gallery, Liverpool, 1991

J. Hobhouse. *The Bride Stripped Bare: The Artist and the Nude in the 20th Century*, Cape, London, 1988

R. Hobbs. *Robert Smithson: Sculpture,* Cornell University Press, Ithaca, NY, 1981

—. "Earthworks", *Art Journal*, 42, Fall, 1982

N. Hodges ed. *Art and the Natural Environment*, *Art & Design*, 36, 1994

—. ed. *The Contemporary Sublime, Art & Design*, 40, 1995

N. Holt. "Amarillo Ramp", *Avalanche*, Fall, 1973

—. "Hydra's Head", *Arts Magazine*, Jan, 1975

—. "Sun Tunnels", *Artforum*, Apl, 1977

K. Honnef. *Concept Art*, Phaidon, Oxford, 1971

P. Hovdenakk. *Christo: Complete Editions*, Schellman & Klüser, Munich, 1982

S. Hubbard, intr. *Sculpture At Goodwood: A VIsion For 21st Century British Sculpture*, Sculpture At Goodwood, Sussex, 2002

R. Hughes. *The Shock of the New*, Thames & Hudson, London, 1991

—. *Nothing If Not Critical: Selected Essays on Art and Artists*, Collins Harvill, London, 1990

—. *American Visions: The Epic History of Art In America*, Knopf, New York, NY, 1997

T. Hughes. *Poetry in the Making*, Faber, 1969

H.E. Hugo, ed. *The Portable Romantic Reader,* Viking Press, New York, NY, 1957

S. Hunter, *American Art of the 20th Century*, Thames & Hudson, London, 1973

—. *New Images/ Pattern and Decoration*, Kalamazoo Institute of Arts, Kalamazoo, 1983

—. ed. *An American Renaissance: Painting and Sculpture Since 1940*, Abbeville Press, New York, NY, 1986

L. Iizawa. "Earth work", *Studio Voice*, Mch, 1988

G. Inboden & T. Kellein. *Ad Reinhardt*, Staatsgalerie, Stuttgart, 1985

—. *Frank Stella*, Staatsgalerie, Stuttgart, *1988* R. Irwin. *Being and Circum-*

stance, Lapis Press, CA, 1985

P. Inch. "Andy Goldsworthy", *Arts Review,* 42, July 13, 1990

R. Ingleby. "Visual arts: Andy Goldsworthy", *The Independent,* Nov 8, 1996

In Praise of Trees, Salisbury Festival, Wilts., 2002

G. Jellicoe. *The Studies of a Landscape Designer Over 80 Years,* Garden Art Press, Woodbridge, Suffolk, 1996

R. Jensen & P. Conway. *Ornamentalism: The New Decorativeness in Architecture and Design,* Potter, New York, NY, 1982

G. Jeppson. *Richard Long,* Harvard College, Cambridge, MA, 1980

C. Joachimides & N. Rosenthal, eds. *American Art in the 20th Century,* Prestel Verlag, Munich, 1993

E.H. Johnson, *Modern Art and the Object,* Harper & Row, New York, NY, 1976

—. ed. *American Artist on Art,* Harper & Row, New York, NY, 1982

W. Johnson. *Riding the Ox Home: A History of Meditation from Shamanism to Science,* Rider, London, 1982

B. Jones. "A New Wave in Sculpture", *Artscribe,* 8, Sept, 1977

D. Judd. "Frank Stella", *Arts Magazine,* 36, Sept, 1962

—. "In the Galleries", *Arts Magazine,* 37, 10, Sept, 1963

—. "Local History", *Arts Yearbook 7,* 1964

—. "Black, White and Gray", *Arts Magazine,* 38, 6, Mch, 1964

—. "Specific Objects", *Arts Yearbook,* 8, Art Digest, New York, NY, 1965

—. "Barnett Newman", *Studio International,* 179, 919, Feb, 1970

—. *Complete Writings, 1959-1975,* Nova Scotia College of Art and Design, Halifax, Canada, 1975

—. *Complete Writings, 1975-1986,* Van Abbemuseum, Netherlands, 1987

E. Juncosa. "Landscape as experience", *Lapiz,* 61 Oct, 1989

D. Karshan. *Conceptual Art and Conceptual Aspects,* Farleigh Dickinson University, 1970

J. Kastner, ed. *Land and Environmental Art,* Phaidon, London, 1998

R. Katz. *Naked By the Window: The Fatal Marriage of Carl Andre and Ana Mandieta,* Atlantic Monthly Press, New York, NY, 1990

B. Kedar & R. Werblowsky, eds. *Sacred Space: Shrine, City, Land,* New York University Press, Albany, NY, 1998

S. Kemal & I. Gaskell, eds. *Landscape, natural beauty and the arts,* Cambridge University Press, Cambridge, 1993

G. Kepes, ed. *Arts of the Environment,* Brazillier, New York, NY, 1972

P. King *et al.* "Colour in Sculpture", *Studio International,* 177, 907, 1969

M. Kirby. *Happenings,* Dutton, New York, NY, 1966

C. Knight. *Art of the Sixties and Seventies: The Panza Collection,* Rizzoli, New York, NY, 1987

N. Konstam. *Sculpture: The Art and the Practice,* Collins, London, 1984

R. Kostelanetz. *The Theatre of Mixed Means,* Dial, New York, NY, 1968

—. *On Innovative Performance(s),* McFarland, Jefferson, NC, 1994

R.E. Krauss. "Richard Serra: Sculpture Redrawn", *Artforum*, May, 1972

—. "Sense and Sensibility: Reflection on Post '60s Sculpture", *Artforum*, 12, Nov, 1973

—. *Passages in Modern Sculpture,* Thames & Hudson, London, 1977

—. "Sculpture in the Expanded Field", *October*, 8, Spring, 1979

—. *Eva Hesse*, Whitechapel Art Gallery, London, 1979

—. *et al. Robert Morris*, Abrams, New York, NY, 1994

Z. Kraus, ed. *From Nature to Art, From Art to Nature*, Venice Biennale, Milan, 1978

D. Kuspit. "Sol LeWitt", *Art in America*, 63, 5, 1975

—. "Authoritarian Abstraction", *Journal of Aesthetics and Art Criticism*, 36, 1, Autumn, 1977

—. "Robert Smithson's Drunken Boat", *Arts Magazine*, Oct, 1981

—. "Aycock's Dream Houses", *Art in America*, Sept, 1985

—. "Donald Judd", *Artforum*, 23, 5, Feb, 1985

J. Kutner. "Brice Marden, David Novros, Mark Rothko: The Urge to Communicate through Non-Imagistic Painting", *Arts Magazine*, 50, 1, Sept, 1975

I. Lamaitre. "Interview with Tony Cragg", *Artefactum*, 2, Dec, 1985

T. Lang. "News from the imagination", *Issues in Architecture, Art & Design,* 3, 1, 1993

Land Marks, Edith C. Blum Art Institute, Bard College, Annadale-on-Hudson, 1984

D. Laporte. *Christo*, Pantheon Books, New York, NY, 1985

B. Laws. "Where Art and Nature Meet", *The Telegraph Weekly*, Nov 12, 1988

D. Lee. "Serial Rights", *Art News*, 66, 8, Dec, 1967

—. "London Ecology Centre, Exhibit", *Arts Review*, 38, Jan 17, 1986

—. "Great art of the outdoors: bio-degrading sculptures", *Country Life*, 181, 35, Aug 27, 1987

—. "Pure, ephemeral spires", *The Times*, June 26, 1989

—. "Opinion: Richard Long and Hamish Fulton", *Arts Review*, July 26, 1991

—. "In profile: Goldsworthy", *Arts Review*, 47, Feb 1995

A. Legg, ed. *Sol LeWitt*, Museum of Modern Art, New York, NY, 1978

P. Leider. "Literalism and Abstraction: Frank Stella's Retrospective at the Modern", *Artforum*, 8, Apl, 1970

—. "For Robert Smithson", *Art in America*, Nov, 1973

—. *Stella Since 1970*, Fort Worth Art Museum, Texas, TX, 1978

K. Levin. "Robert Smithson", *Art News*, Sept, 1982

—. "Reflections on Robert Smithson's *Spiral Jetty*", *Arts Magazine*, May, 1978

F. Licht: *Sculpture, 19th and 20th Centuries*, Michael Joseph, London, 1967

—. "Dan Flavin", *Artscanada*, Dec, 1968

L. Lippard. "New York Letter: Apl-June, 1965", *Art International*, 9, 6, 1965

—. "New York Letter: Recent Sculpture as Escape", *Art International*, Feb, 1966a

—. "An Impure Situation", *Art International*, May 20, 1966b

—. *Ad Reinhardt*, Jewish Museum, New York, NY, 1966c

—. *Pop Art*, Oxford University Press, New York, NY, 1966d

—. "The Silent Art", *Art in America*, 55, 1, Jan-Feb, 1967a

—. "Sol LeWitt: Non-Visual Structures", *Artforum*, Apl, 1967b

—. "Tony Smith", *Art International*, Summer, 1967c

— "Rebelliously Romantic?", *New York Times*, June 4, 1967d

—. "Escalataion in Washington", *Art International*, 12, 1, Jan, 1968

—. ed. *Surrealists on Art*, Prentice-Hall, Englewood Cliffs, NJ, 1970

—. *Tony Smith*, Thames & Hudson, London, 1972a

—. *Grids*, Philadelphia Institute of Contemporary Art, PA, 1972b

—. *Six Years: The Dematerialization of the Art Object from 1966 to 1972*, Praeger, New York, NY, 1973

—. *From the Center: feminist essays on women's art*, Dutton, New York, NY, 1976

—. *Eva Hesse*, New York University Press, New York, NY, 1976

—. *et al. Sol LeWitt*, Museum of Modern Art, New York, NY, 1978

—. "Complexities: Architectural Sculpture in Nature", *Art in America*, Feb, 1979

—. "Dinner Party", *Art in America*, Apl, 1980

—. *Ad Reinhardt*, Abrams, New York, NY, 1981

—. *Overlay*, Pantheon, New York, NY, 1983

C. Loeffier, ed. *Performance Anthology*, Contemporary Art Press, San Francisco, CA, 1979

R. Long. *Touchstones*, Arnolfini, Bristol, 1983

—. *Richard Long: In Conversation*, Parts 1 & 2, MW Press, Noordwijk, Holland, 1985-86

—. *Richard Long*, text by R.H. Fuchs, Thames & Hudson, London, 1986

—. *Old World New World*, Anthony d'Offay, London, 1988

—. *Richard Long: Walking in Circles*, Hayward Gallery/ Thames & Hudson, London, 1992

—. *Kicking Stones*, Antony d'Offay Gallery, London, 1990

—. *Richard Long: Mountains and Water*, Anthony d'Offay, London, 1992

—. *Circles, Cycles, Mud*, D. Friis-Hansen, Contemporary Arts Museum, 1996

—. *From Time to Time*, DAP, 1997

—. *Richard Long*, Hatje Cantz, 1997

—. *A Walk Across England*, Thames & Hudson, London, 1997

—. *Mirage*, Phaidon, London, 1998

—. *Selected Walks, 1979-1996*, Morning Star Press, 1999

—. *Richard Long: a Moving World*, Tate Publishing, London, 2002

—. *Richard Long – Walking the Line*, Thames and Hudson, London, 2002

E. Lucie-Smith: *Sculpture Since 1945*, Phaidon, Oxford, 1987

—. *Art Today,* Phaidon, Oxford, 1989

—. *Sexuality in Western Art,* Thames & Hudson, London, 1991

R. Lund. "Why Isn't Minimal Art Boring?", *Journal of Aesthetics and Art Criticism,* 45, 2, Winter, 1986

N. Lynton. introduction to *Tony Cragg,* Fifth Triennale India, British Council, 1982

—. *The Story of Modern Art,* Phaidon, London, 1989

—. *David Nash: Sculpture, 1971-90,* Serpentine Gallery, London, 1990

R. Mabey. "Art and ecology", *Modern Painters,* 3, 4, Winter, 1990

F. MacCarthy: *Eric Gill,* Faber 1989

D. Macmillan. "David Nash: Brancusi Joins the Garden Gang", *Art Monthly,* 65, Apl, 1983

L. MacRitchie. "Ancient Egypt", *Financial Times,* Dec 12, 1994

—. "Residency on earth", *Art in America,* 83, 4, Apl 1995

S. Madoff. "Andy Goldsworthy", *Garden Design,* 13, June, 1994

F. Malina, ed. *Kinetic Art,* Dover, New York, NY, 1974

W. Malpas. *Richard Long: The Art of Walking,* Crescent Moon, 1995/ 1998

—. *Andy Goldsworthy,* Crescent Moon, 1996/ 1998

—. *The Art of Andy Goldsworthy,* Crescent Moon, 1998/ 2004

A.T. Mann. *Sacred Architecture,* Element Books, Shaftesbury, Dorset, 1993

J. van der Marck. *Wrapped Museum,* Museum of Contemporary Art, Chicago, IL, 1969

—. *Herbert Bayer,* Dartmouth College Museum, Hanover, NH, 1977

M. Marmer. "James Turrell", *Art in America,* 69, May, 1981

A. Martin: *Agnes Martin,* Institute of Contemporary Art, Philadelphia, PA, 1973

R. Martin. *The Sculpted Forest: Sculpture in the Forest of Dean,* Redcliff, Bristol, 1990

B. Matilsky. *Fragile Economies,* Rizzoli, New York, NY, 1992

W.H. Matthews. *Mazes and Labyrinths,* Dover, New York, NY, 1970

J. May. "Landscape Fired by Ice", *Landscape,* Dec, 1987

D. Mayhall: *The Minimal Tradition,* The Aldrich Museum of Contemporary Art, Ridgefield, CT, 1979

B. McAvera. "Public art: site sensitivities", *Art Monthly,* 215, Apl, 1998

T. McEvilley. *The Exile's Return: Towards a Redefinition of Painting in the Postmodern Era,* Cambridge University Press, Cambridge, 1993

D. McKinney. *Yves Klein, Brice Marden, Sigmar Polke,* Hirschl & Alder Modern, New York, NY, 1989

A. McPherson. "David Nash: interviewed by Allan McPherson", *Artscribe,* 12, June, 1978

K. McShine. *Primary Structures,* Jewish Museum, New York, NY, 1966

—. *Information,* Museum of Modern Art, New York, NY, 1970

—. *An International Survey of Recent Painting and Sculpture,* MOMA, New York, NY, 1984

H.C. Merillat: *Modern Sculpture: The New Old Masters,* Dod, Mead & Co,

New York, NY, 1974

J. Meyer, ed. *Minimalism*, Phaidon, London, 2000

U. Meyer. *Conceptual Art*, Dutton, New York, NY, 1972

D.C. Miller, ed. *Sixteen Americans*, Museum of Modern Art, New York, NY, 1959

M. Miller. *The Garden as an Art*, State University of New York Press, Albany, NY, 1993

C. Millett. "De Kooning, Newman, Rothko: des bâtards", *Art Press International*, 26, Mch, 1979

M. Miss. *Mary Miss: Interior Works*, Bell Gallery, University of Rhode Island, Autumn, 1981

K. Moffert. *Kenneth Noland*, Abrams, New York, NY, 1977

J. Morland. *New Milestones: Sculpture, Community and the Land*, Common Ground, 1988

H. Morphy & M. Boles, eds. *Art from the Land*, University of Washington Press, 2000

R. Morris. "Notes on Sculpture", *Artforum*, Feb, 1966, Oct, 1966, June, 1967, Apl, 1969

—. "Aligned with Nazca", *Artforum*, Oct, 1975

—. *Robert Morris: Mirror Works, 1961-1978*, Leo Castelli Gallery, New York, NY, 1979

—. *et al. Earthworks*, Seattle Art Museum, Seattle, WA, 1979

—. *Selected Works*, Contemporary Arts Museum, Houston, TX, 1981

—. *Continuous Project Altered Daily*, MIT Press, Cambridge, MA, 1993

S. Morris. "A Rhetoric of Silence: Redefinitions of Sculpture in the 1960s and 1970s", in S. Nairne, 1981

J. Morland. *New Milestones: Sculpture, Community and the Land*, Common Ground, London, 1988

H. Morphy & M. Boles, eds. *Art from the Land*, University of Washington Press, 2000

S. Morris. "A Rhetoric of Silence: Redefinitions of Sculpture in the 1960s and 1970s", in S. Nairne, 1981

J. Morrison. "Landmatters", *British Journal of Photography*, 133, June 6, 1986

A. Morgan. "Maze and labyrinth", *Sculpture*, 14, 4, July/ Aug, 1995

D. Morse. "At Runnymede Farm, the crop is sculptures", *San Francisco Examiner*, May 2, 1997

M. Mosser & G. Teyssot, eds. *The History of Garden Design*, Thames & Hudson, London, 1991

A. Moszynska. *Abstract Art*, Thames & Hudson, London, 1990

G. Müller. "Michael Heizer", *Arts Magazine*, Dec, 1969

—. "The Earth, Subjected To Cataclysms, Is a Cruel Master", *Arts Magazine*, Nov, 1971

S. Nairne & N. Serota. *British Sculpture in the Twentieth Century*, Whitechapel Art Gallery, London, 1981

—. *State of the Art: Ideas & Images in the 1980s*, Chatto, London, 1987

H. Nakamura. "Andy Goldsworthy and Anthony Green", *Ikebana Ryusei*, 38, Apl, 1988

D. Nash. *Fletched Over Ash*, AIR Gallery, 1978

—. "David Nash", *Aspects*, 10, Spring, 1980

—. *Stoves and Hearths*, Duke Street Gallery, London, 1982

T.A. Neff, ed. *A Quiet Revolution: British Sculpture Since 1965*, Thames & Hudson, London, 1987

B. Nemitz. *Trans Plant: Living Vegetation in Contemporary Art*, Hatje Cantz, 2000

C. Nemser. "An interview with Eva Hesse", *Artforum*, May, 1970

—. "My Memories of Eva Hesse", *Feminist Art Journal*, Winter, 1973

P. Nesbitt. "At Home with Nature: Andy Goldsworthy in Scotland", *Alba*, Spring, 1989

—. "A Landscape Touched by Gold", in G. Hughes, 1990

B. Newman. *Selected Writings*, Knopf, New York, NY, 1990

M. Newman. "New Sculpture in Britain", *Art in America*, Sept, 1982

I. Noguchi. *A Sculptor's World*, Harper & Row, New York, NY, 1968

A. Le Normand-Romain *et al. Sculpture: The Adventure of Modern Sculpture in the Nineteenth and Twentieth Centuries*, Skira, Geneva, 1986

J. Norrie. "Andy Goldsworthy", *Arts Review*, 3 July, 1987

B. Oakes, ed. *Sculpting the Environment*, Van Nostrand Reinhold, New York, NY, 1995

P. Oakes. "The Incomparable Andy Goldsworthy", *Country Living*, 48, Dec, 1989

B. O'Doherty. *Inside the White Cube*, Lapis Press, Santa Monica, CA, 1976

R. Onoratio. "Illusive Spaces: The Art of Mary Miss", *Artforum*, Dec, 1978

—. *Mary Miss - Perimeters/ Pavilions/ Decoys*, Nassau County Museum, 1979

D. Oppenheim. *Dennis Oppenheim*, Musée d'Art Contemporain, Montréal, 1978.

—. *Selected Works, 1967-1990*, Abrams, New York, NY, 1992

P. Osborne, ed. *Conceptual Art*, Phaidon, London, 2002

E. Osaka. *Andy Goldsworthy: Mountain and Coast: Autumn Into Winter*, Gallery Takagi, Nagoya, 1987

W. Packer. "Andy Goldsworthy's Transient Touch", *Sculpture*, July, 1989

—. "Sculpture from the countryside", *Financial Times*, July 7, 1987

T. Padon. "New York, New York", *Sculpture*, 13, 1, Jan/ Feb, 1994

E. Panofsky: *Studies in Iconology*, Harper & Row, New York, NY, 1972

A.C. Papadakis, ed. *British and American Art: The Uneasy Dialectic, Art & Design*, 3, 9/1, Academy Group, London, 1987

—. ed. *Abstract Art and the Rediscovery of the Spiritual, Art & Design*, 3, 5/6, Academy Group, London, 1987

—. ed. *The New Romantics, Art & Design*, 4, 11/12, Academy Group, 1988

—. *et al*, eds. *New Art*, Academy Group, London, 1991

271

R. Parker & G. Pollock. *Old Mistresses: Women, Art an Ideology*, Routledge & Kegan Paul, London, 1981

—. *Framing Feminism*, Pandora Press, London, 1987

D. Parr. "City focus: St. Louis: 'a different kind of energy'", Art News. 95, 3, Mch, 1996

J. Partridge. "Forest work", *Craft*, 81, July/ Aug, 1986

A. Patrizio. "Cube garden: sculpture at the Edinburgh Festival 1990", *Arts Review*, 42, July 27, 1990

P. Patton. "Robert Morris and the Fire Next Time", *Art News*, 82, 10, Dec, 1983

E. Pavese, ed. *Christo: Surrounded Islands*, Abrams, New York, NY, 1986

N. Pennick. *Mazes and Labyrinths*, Hale, London, 1990

J. Perreault. "A Minimal Future? Union-Made: Report on a Phenomenon", *Arts Magazine*, 41, Mch, 1967

J. Perrone. "Seeing Through Boxes", *Artforum*, 15, Nov, 1976

K. Petersen & J.J. Wilson: *Women Artists: Recognition and Reappraisal from the Early Middle Ages to the Twentieth Century* Women's Press, London, 1978

R. Pincus-Witten. "Systematic Painting", *Artforum*, 5, 3, Nov, 1966

—. "Ryman, Marden, Manzoni: Theory, Sensibility, Mediation", *Artforum*, 10, 10, June, 1972

—. "Sol LeWitt", *Artforum*, 11, 6, Feb, 1973

—. *Postminimalism*, Out of London, New York, NY, 1977

—. *Entries: Maximalism*, Out of London Press, London, 1983

—. *Post-Minimalism into Maximalism*, UMI Research Press, Ann Arbor, MI, 1987

J. Poetter. *Donald Judd*, Cantz, Stuttgart, 1989

M. Poirier. "Color-coded Mysteries", *Art News*, Jan, 1985

—. "The Ghost in the Machine", *Art News*, Oct, 1986

—. & J. Necol: "The '60s in Abstract Painting: 13 Statements...Brice Marden", *Art in America*, Oct, 1983

G. Pollock: *Vision and Difference: femininity, feminism and histories of art*, Routledge, London, 1988

L. Ponti. "Tony Cragg", *Domus*, 611, Nov, 1980

F. Popper. *Art, Action and Participation*, New York University Press, New York, NY, 1975

J.C. Powys. *Maiden Castle*, Cassell, London, 1937

—. *A Glastonbury Romance*, Macdonald, London, 1955

—. *Wolf Solent*, Penguin, London, 1964

—. *Autobiography*, Macdonald, London, 1967

A. Price. "A Conversation With Alice Aycock", *Architectural Design*, Apl, 1980

G. Prince. "With mud on their hands, growth, decay and the movement of change", *World Magazine*, Jan, 1991

J. Prinz. *Art Discourse*, Rutgers University Press, New Brunswick, NJ, 1991

S. Prokopoff. *A Romantic Minimalism*, Institute of Contemporary Art, Philadelphia, PA, 1967

J. Prown *et al. Discovered Lands, Invented Pasts*, Yale University Press, New Haven, CT, 1992

E. Rankin. "Popularising public sculpture in Britain: from landscape gardens to forest trails", *de Arte*, 53, Apl 1996

C. Ratcliff. "Robert Ryman's Double Positive", *Art News*, Mch, 1971

— . "Once More With Feeling", *Art News*, 71, 4, Summer, 1972

— . "Abstract Painting, Specific Spaces: Novros and Marden in Houston", *Art in America*, 63, 5, Nov, 1975

— . *In the Realm of the Monochrome*, Renaissance Society, University of Chicago, Chicago, IL, 1979

— . "The Compleat Smithson", *Art in America*, Jan, 1980

— . "Mostly Monochrome", *Art in America*, 69, 4, Apl, 1981

— . "Robert Ryman Making Distinctions", *Art in America*, June, 1986

A. Raven *et al*, eds. *Feminist Art Criticism*, UMI Research Press, Ann Arbor, MI, 1988

— . *Crossing Over: Feminism and Art of Social Concern*, UMI Research Press, Ann Arbor, MI, 1989

— . *Art in the Public Interest*, UMI Research Press, Ann Arbor, MI, 1989

B. Redhead. *The Inspiration of Landscape: Artists in National Parks*, Phaidon, Oxford, 1989

W. Reh & C. Steenbergen. *Architecture and Landscape,* Prestel Publishing, 1996

K.J. Reiger, ed. *The Spiritual Image in Modern Art,* Theosophical Publishing House, Wheaton, IL, 1987

C. Riley II. *Color Codes: Modern Theories in Color in Philosophy, Painting and Architecture, Literature, Music and Psychology*, University Press of New England, Hanover, NH, 1995

H. Risatti. "The Sculpture of Alice Aycock", *Woman's Art Journal*, Summer, 1985

A.C. Ritchie: *Sculpture in the Twentieth Century*, MOMA, New York, NY, 1952

J. Roberts. *Postmodernism, Politics and Art,* Manchester University Press, Manchester, 1990

C. Robins. "Object, Structure or Sculpture: Where Are We?", *Arts Magazine*, 40, 9, 1966

— . "Empty Paintings", *SoHo Weekly News*, Apl 22, 1976

— . *The Pluralist Era: American Art, 1968-1981*, Harper & Row, New York, NY, 1984

P. Rodaway. *Sensuous Geographies*, Routledge, London, 1994

F. Roh. *German Art in the Twentieth Century: Painting, Sculpture, Architecture*, Thames & Hudson, London, 1968

W. Romey. "The artist as geographer: Richard Long's Earth Art", *Professional Geographer*, 39, 4, 1987

B. Rose. "New York Letter", *Art International*, Feb 15, 1964

—. "Looking at American Sculpture", *Artforum*, 3, Feb, 1965a

—. "ABC Art", *Art in America*, 53, 5, Nov, 1965b

—. *A New Aesthetic*, Washington Gallery of Modern Art, Washington, DC, 1967

—. *American Art Since 1900*, Thames & Hudson, London, 1967

—. *American Painting*, Skira/Rizzoli International, New York, NY, 1986

—. *Robert Morris*, Corcoran Gallery, Washington, DC, 1990

H. Rosenberg. *The De-Definition of Art*, Horizon Press, New York, NY, 1972

—. *Art on the Edge*, Macmillan, London, 1975

—. *Barnett Newman*, Abrams, New York, NY, 1978/1994

—. *The Tradition of the New*, Da Capo Press, New York, NY, 1994

R. Rosenblum. "Frank Stella: Five Years of Variations on an Irreducible Theme", *Artforum*, 3, 6, Mch, 1965

—. *Frank Stella*, Penguin, London, 1971

—. "Notes on Sol LeWitt", in A. Legg, 1978

—. *Modern Painting and the Northern Romantic Tradition*, Thames & Hudson, London, 1978

—. *Jasper Johns' Paintings and Sculptures, 1954-1974*, Ann Arbor, Michigan, MI, 1985

—. "Romanticism and Retrospective: An Interview with Robert Rosenblum", in A. Papadakis, 1988

C. Ross. *Star Axis*, University of New Mexico Press, Albuqerque, NM, 1992

S. Ross. "Gardens, earthworks, and environmental art", in S. Kemal, 1993

—. *What Gardens Mean*, University of Chicago Press, Chicago, IL, 1998

M. Roth. "Robert Smithson on Duchamp", *Artforum*, Oct, 1969

—. ed. *The Amazing Decade: Women and Performance Art in America 1970-80*, Astro Artz, Los Angeles, CA, 1983

L. Rubin. *Frank Stella Paintings: 1958-1965*, New York, NY, 1986

W.S. Rubin. *Frank Stella*, New York Graphic Society, Greenwich, CT., 1970

—. *Frank Stella: 1970-1987*, Museum of Modern Art, New York, NY, 1987

M. Ryan, ed. *Gravity and Grace: The Changing Condition of Sculpture, 1965-1975*, Hayward Gallery, London, 1993

A. Saalfield. *Mary Miss*, Fogg Art Museum, Cambridge, MA, 1980

I. Sandler. "The New Cool-Art", *Art in America*, 53, 1, Feb, 1967

—. *The Triumph of American Painting*, Harper & Row, New York, NY, 1970

—. *American Art of the 1960s*, Harper & Row, New York, NY, 1988

—. *Art of the Postmodern Era: From the 1960s to the Early 1990s*, Harper-Collins, London, 1997

C. Sauer & U. Raussmuller, eds. *Robert Ryman*, Ryman, Zurich, 1992

G. Saunders. *The Nude: a new perspective*, Herbert Press, London, 1989

H. Sayre, ed. *Happening and Fluxus*, Kölnischer Kunstverein, Cologne, 1970

D. Schaff. "British Art Now, at the Guggenheim and Beyond", *Art International*, Mch, 1980

M. Schinz. *Visions of Paradise: Themes and Variations on the Garden*,

Thames & Hudson, 1985

I. Schneider & B. Korot, eds. *Video Art*, Harcourt Brace Jovanovich, New York, NY, 1976

P. Schjeldahl. *Art in Our Time: The Saatchi Collection*, Lund Humphries, London, 1984

P. Schuck. "Interview: Earth, Water, Wind", *Contemporanea*, Apl, 1990

D. Schwartz. *Lawrence Weiner*, König, Cologne, 1989

W. Seitz. *The Art of Assemblage*, MOMA, New York, NY, 1961

P. Selz. *Directions in Kinetic Sculpture*, University of California Press, Berkeley, CA, 1966

—. *German Expressionist Painting*, University of California Press, Berkeley, CA, 1974

—. *Art in Our Times: A Pictorial History 1890-1980*, Thames & Hudson, London, 1982

H. Senie. *Contemporary Public Sculpture*, Oxford University Press, Oxford, 1983

—. & S. Webster, eds. *Critical Issues in Public Art*, Smithsonian Institution Press, Washington DC, 1998

A. Seymour. "Walking in Circles", in R. Long, *Walking in Circles*

—. "Old World New World", in R. Long, *Old World New World*

E. Shanes. *Constantin Brancusi*, Abbeville, New York, NY, 1989

G. Shapiro. *Earthworks: Robert Smithson and After Babel*, University of California Press, Berkeley, CA, 1995

W. Sharp *et al. Earth Art*, Andrew Dickson White Museum of Art, Cornell University, Ithaca, NY, 1969

—. "Structure and Sensibility", *Avalanche*, 5, Summer, 1972

N. Shulman. "Monday at the North Pole", *Arts Review*, June 2, 1989

P. Sims. *From Minimalism to Expressionism*, New York, NY, 1963

N. Sinden. "Interview: Art in Nature: Andy Goldsworthy", *Resurgence*, 129, Aug, 1988

H. Singerman, ed. *Individuals: A Selected History of Contemporary Art, 1945-1986*, Museum of Contemporary Art, Los Angeles, CA, 1986

H.J. Smagula. *Currents: Contemporary Directions in the Visual Arts*, Prentice-Hall, Englewood Cliffs, NJ, 1983

B. Smith. *Fluorescent Light, etc, from Dan Flavin*, National Gallery of Canada, Ottawa, 1969

—. *Donald Judd*, National Gallery of Canada, Ottawa, 1975

D. Smith. *Sculpture and Drawings*, ed. J. Merkert, Prestel-Verlag, Munich, 1986

R. Smith. "Sol LeWitt", *Artforum*, Jan, 1975

—. "Review", *Artforum*, Dec, 1975

—. "De Maria: Elements", *Art in America*, May, 1978

R. Smithson. "Entropy and the New Monuments", *Artforum*, 4, 10, June, 1966

—. "Incidents of Mirror-Travel in the Yucatan", *Artforum*, Sept, 1967

—. The Monuments of Passaic", *Artforum*, Dec, 1967

—. "Toward the Development of an Air Terminal Site", *Artforum*, Summer, 1967

—. "A Museum of Language in the Vicinity of Art", *Art International*, 12, 3, Mch, 1968

—. *The Writings of Robert Smithson*, ed. N. Holt, New York University Press, New York, NY, 1979

—. *Robert Smithson*, ed. J. Flam, University of California Press, Berkeley, CA, 1996

—. *Robert Smithson: A Collection of Writings*, Pierogi Galery New York, NY, 1997

T. Sokolowski *et al. Robert Morris*, New York University Press, New York, NY, 1989

A. Sondheim, ed. *Post-Movement Art in America*, Dutton, New York, NY, 1977

A. Sonfist. *Alan Sonfist*, Neuberger Museum, New York, NY, 1978

—. ed. *Art in the Land: A Critical Anthology of Environmental Art*, Dutton, New York, NY, 1983

W. Spies. *The Running Fence Project, Christo*, Abrams, New York, NY, 1977

A. Staniszewski. *The Power of Display: A History of Exhibitions At the Museum of Modern Art*, MIT Press, Cambridge, MA, 1999

N. Stangos, ed. *Concepts of Modern Art*, Thames & Hudson, London, 1981

J. Stathatos. "Andy Goldsworthy's Evidences", *Creative Camera*, 255, Mch, 1986

F. Stella. *Working Space*, Harvard University Press, Cambridge, MA, 1986

—. *Frank Stella*, Madrid, 1995

N. Stewart. "Richard Long, Lines of Thought: A Conversation with Nick Stewart", *Circa*, Nov, 1984

K. Stiles & P. Selz, eds. *Theories & Documents of Contemporary Art: A Sourcebook of Artists' Writings*, University of California Press, Berkeley, CA, 1996

S.L. Stoops. *Andy Goldsworthy: Breakdown*, Rose Art Museum, 1992

W.J. Strachan. *Towards Sculpture: Maquettes and Sketches from Rodin to Oldenburg*, Thames & Hudson, London, 1976

—. *Open Air Sculpture in Britain*, Zwemmer, London, 1984

E. Suderburg, ed. *Space, Site, Intervention*, University of Minnesota Press, Minneapolis, MN, 2000

T. Sultan. *Inability To Endure or Deny the World: Representation and Text In the Work of Robert Morris*, Corcoran Gallery, Washington, DC, 1990

G. Sutton. "Land art", *Landskab*, Dec, 1989

D. Sylvester. "Interview", *Jasper Johns Drawings*, Museum of Modern Art, Oxford, 1974

—. *About Modern Art*, Chatto & Windus, London, 1996

J. Taylor *et al. Robert Rauschenberg*, Smithsonian Institute, Washington, DC, 1976

C. Thacker. *The History of Gardens,* University of California Press, Berkeley, CA, 1979

G. Tiberghien. *Land Art*, Art Data, London, 1995

S. Tillim. "Earthworks and the New Picturesque", *Artforum*, Dec, 1968

C. Tomkins. *The Scene: Reports on Postmodern Art*, Viking, New York, NY, 1976

— . *Off the Wall: Robert Rauschenberg and the Art World of Our Time*, Doubleday, New York, NY, 1980

— . "Profiles", *New Yorker*, Sept, 1984

— . *Post- to Neo-: The Art World of the 1980s*, Penguin, London, 1989

M. Treib. "Frame, moment and sequence: the photographic book and the designed landscape", *Journal of Garden History*, 15, 2, Summer, 1995

E. Tsai. *Robert Smithson Unearthed*, Columbia University Press, New York, NY, 1991

M. Tuchman. *American Sculpture of the Sixties*, Los Angeles County Museum of Art, CA, 1967

— . *The New York School*, Thames & Hudson, London, 1971

— . *The Spiritual in Art: Abstract Painting 1880-1985*, Los Angeles County Museum of Art/ Abbeville Press, New York, NY, 1986

P. Tuchman. "Minimalism and Critical Response", *Artforum*, 15, 9, May, 1977

— . "Background of a Minimalist: Carl Andre", *Artforum*, Mch, 1978

— . "Minimalism", *Three Decades: The Oliver-Hoffmann Collection*, Museum of Contemporary Art, Chicago, IL, 1988

M. Tucker. *Robert Morris*, New York, NY, 1970

W. Tucker. *The Language of Sculpture*, Thames & Hudson, London, 1974

J. Turrell. *Mapping Spaces*, Peter Blum, New York, NY, 1987.

— . interview, in B. Oakes, 1995

G. de Vries, ed. *On Art: Artists' Writings on the Changed Notion of Art After 1965*, Cologne, 1974

A.M. Wagner. *Three Artists (Three Women): Modernism and the Art of Hesse, Krasner and O'Keeffe*, University of California Press, Berkeley, CA, 1996

D. Waldman. "Samaras", *Art News*, Oct, 1966

— . *Carl Andre*, Guggenheim, New York, NY, 1970a

— . "Holding the Floor", *Art News*, Oct, 1970b

— . *Robert Ryman*, Guggenheim Museum, New York, NY, 1972

— . *Kenneth Noland*, Guggenheim Museum, New York, NY, 1977

J. Walker. *Art and Artists on Screen*, Manchester University Press, Manchester, 1993

— . *Art & Outrage: Provocation, Controversy and the Visual Arts*, Pluto Press, London, 1999

— . *Art and Celebrity*, Pluto Press, London, 2003

J. Watkins. "In the artist's studio: Andy Goldsworthy: touching North", *Art International*, 9 Winter, 1989

—. "Andy Goldsworthy: Touching North", *Art International*, Winter, 1989

M. Webster. "Andy Goldsworthy at San Jose Museum of Art", *ArtWeek*. 26, 4, Apl, 1995

U. Weilacher *et al. Between Landscape Architecture and Land Art*, Birkhauser Verlag AG, 1999

L. Weiner. *Lawrence Weiner, Works*, Anatol AV und Film-produktion Hamburg, 1977

L. Weintraub. *The Maximal Implications of the Minimalist Line*, Edith C. Blum Art Institute, New York, NY, 1985

Welsh Sculpture Trust. *Sculpture in a Country Park*, Welsh Sculpture Trust, 1983

C. West. "From genesis to box", *Modern Painters*, 5, 4, Winter, 1992

D. Wheeler. *Art Since Mid-Century: 1945 to the Present*, Thames & Hudson, London, 1991

J. White. *The Birth and Rebirth of Pictorial Space*, Faber, London, 1981

O. Wick *et al. James Turrell*, Turske & Turske Gallery, Zurich, 1990

A. Wildermuth. *Richard Long*, Galerie Buchmann, Basel, 1985

A. Wilding: *Alison Wilding*, with M. Tooby, Tate Gallery, St Ives, Cornwall, 1994

R. Williams. *After Modern Sculpture: Art in the United States and Europe 1965-70*, Manchester University Press, Manchester, 2000

A. Windsor, ed. *British Sculptors of the 20th Century*, Ashgate, Aldershot, Hants., 2003

C. van Winkel. "The Crooked Path, Patterns of Kinetic Energy", *Parkett*, 33, 1992

M. Winton. "Sculptures That Blow Away", *Ark*, Spring, 1970

R. Wittkower: *Sculpture: Process and Principles*, Harper & Row, New York, NY, 1977

M.R. Witzling, ed. *Voicing Our Visions: Writing by Women Artists*, Women's Press, London, 1992

G. Woods *et al*, eds. *Art Without Boundaries*, Thames & Hudson, London, 1972

M. Wortz. *Light and Space*, Whitney Museum of American Art, New York, NY, 1980

S. Wrede & W. Adams. *Denatured Visions: Landscape and Culture in the 20th Century*, Abrams, New York, NY, 1991

S. Yard. *Christo: Oceanfront*, Princeton University Press, Princeton, NJ, 1975

—. *Sitings*, La Jolla Museum of Contemporary Art, La Jolla, CA, 1986

M. Yorke: *Eric Gill: Man of Flesh and Spirit*, Constable, London, 1981

M. Yule. "Andy Goldsworthy, a Lake District photowork", *National Art-Collections Fund Review*, 88, 1992

L. Zelevansky. "Richard Long", *Art News*, 83, 8, Oct, 1984

Illustrations

SPRING WALK

PRIMROSES AT 3 MILES
FROGSPAWN AT 18 MILES
A CROW NEST-BUILDING AT 29 MILES
A FARMER SOWING AT 34 MILES
LADYBIRDS AT 38 MILES
SQUIRRELS AT 57 MILES
LAMBS AT 62 MILES
STICKY BUDS AT 67 MILES
A TREE PLANTED AT 70 MILES
A BUTTERFLY AT 85 MILES
BLOSSOM AT 104 MILES
DAFFODILS AT 112 MILES

AVON ENGLAND 1991

Richard Long, Spring Walk, 1991

WALKING TO A SOLAR ECLIPSE

STARTING FROM STONEHENGE
A WALK OF 235 MILES
ENDING ON A CORNISH HILLTOP
AT A TOTAL ECLIPSE OF THE SUN

1999

Richard Long, Walking To a Solar Eclipse, 1999

Constantin Brancusi, *Adam and Eve*, 1922, photograph

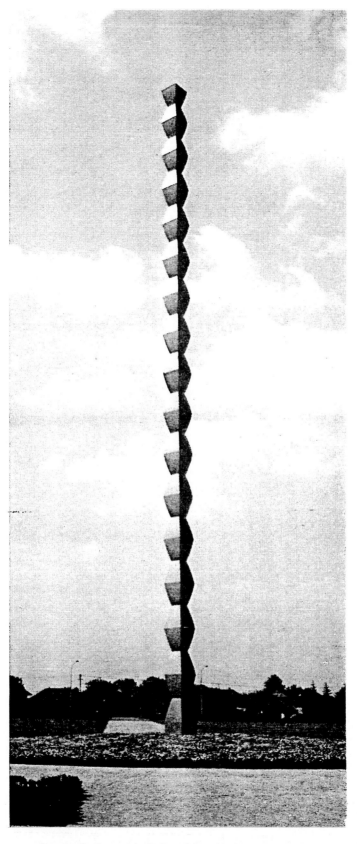

Constantin Brancusi, *Endless Column*, 1937-38, Tirgu-Jiu,

Robert Smithson, *Spiral Hill*, 1971, Emmen, Netherlands

Robert Smithson, *A Nonsite*, 1968, John Weber Gallery, New York

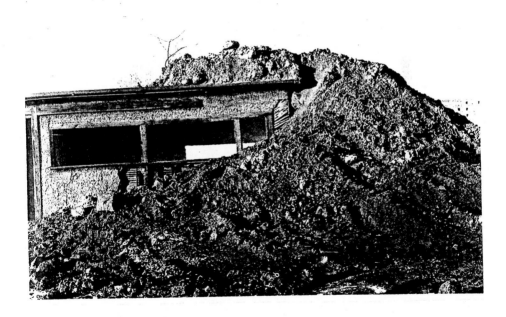

Robert Smithson, *Partially Buried Woodshed*, 1970, Kent State
University, Kent, Ohio

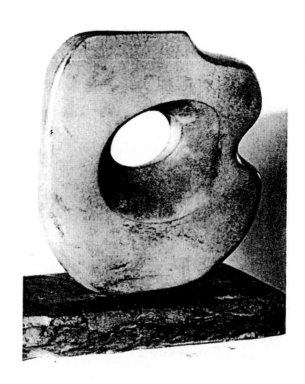

Barbara Hepworth, *Pierced Form (Amulet)*, 1962

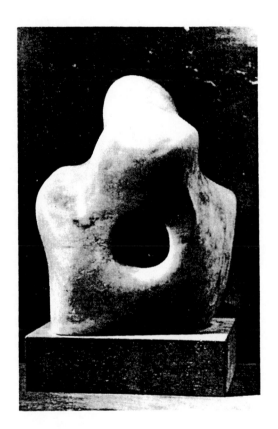

Barbara Hepworth, *Pierced Form*, 1931

Peter Randall-Page, *Wayside Carving*, 1988, Dorset

RINGDOM GOMPA

NORTHERN INDIA JULY 1978

A 14½ DAY WALKING JOURNEY OF APPROXIMATELY 200 MILES TRAVELLING BY WAY OF
RINGDOM GOMPA THE PEN ZI PASS THE ZANSKAR RIVER ATING GOMPA
HUTTRA THE MUNI GLACIER MACHAIL AND THE CHANDER BHAGA RIVER

Hamish Fulton, *Ringdom Gompa*, 1978

Richard Long, *Walking a Line Through Leaves*, 1993, Korea

Richard Long, *Camp Stones*, 1997, Aomori

Chris Drury, *Shelter For the Winds That Blow From Siberia*, 1986,
Lewes, Sussex

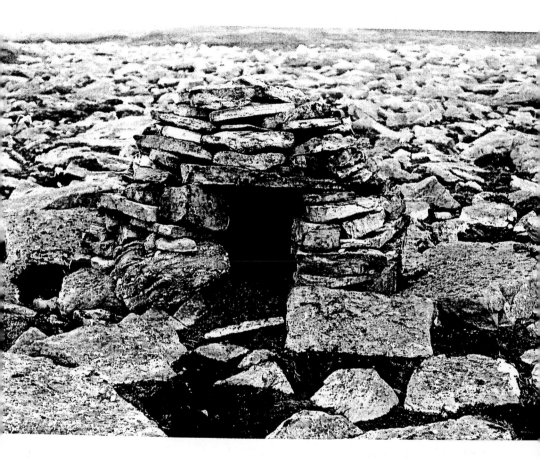

Chris Drury, *Shelter For Mist*, 1985, County Donegal, Ireland

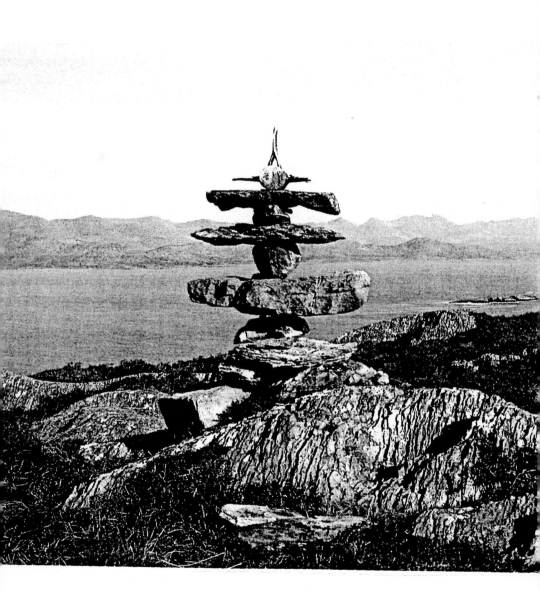

Chris Drury, *Whale Bone Cairn*, 1993, West Cork, Ireland

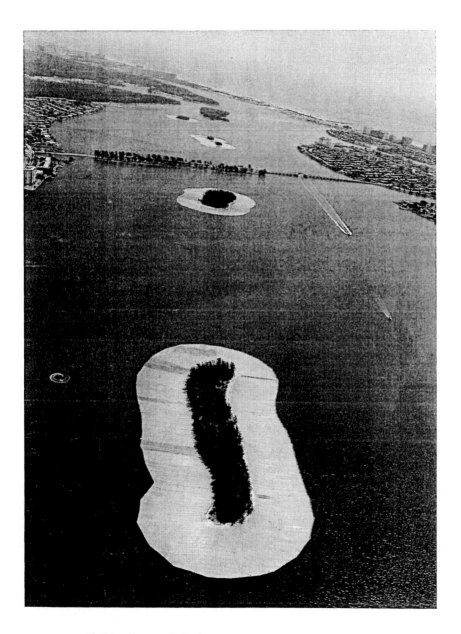

Christo, *Surrounded Islands*, 1980-83, Biscayne Bay, Florida

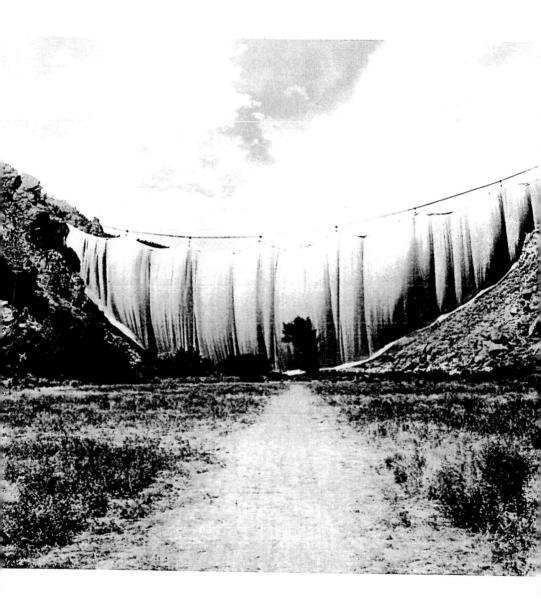

Christo, *Valley Curtain*, 1970-72, Colorado

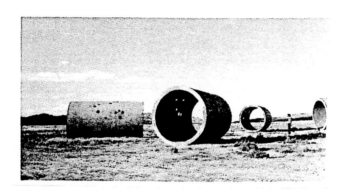

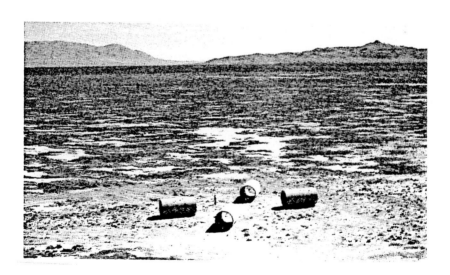

Nancy Holt, *Sun Tunnels*, 1973-76, Utah

Nancy Holt, *Annual Rings*, 1981, Michigan

Nancy Holt, *Annual Rings*, 1981, Michigan

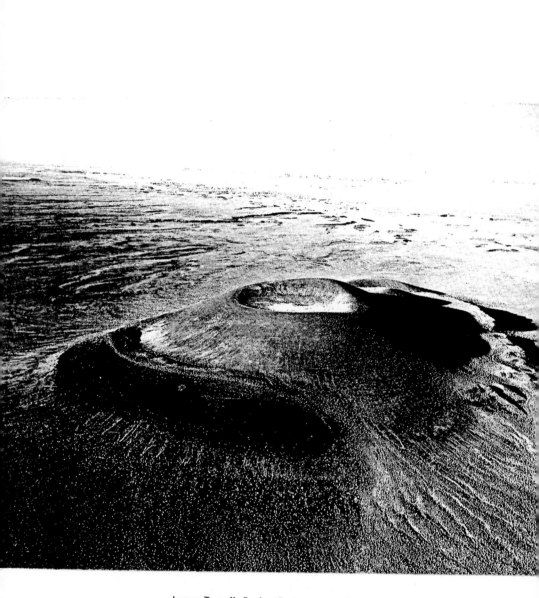

James Turrell, *Roden Crater*, 1977-, Arizona

Donald Judd, *Untitled*, 1968, County Museum of Art, Los Angeles

Donald Judd, *Untitled*, 1966, collection: Howard Lipman,
Connecticut

Robert Morris, *Untitled*, 1979, King County, Washington

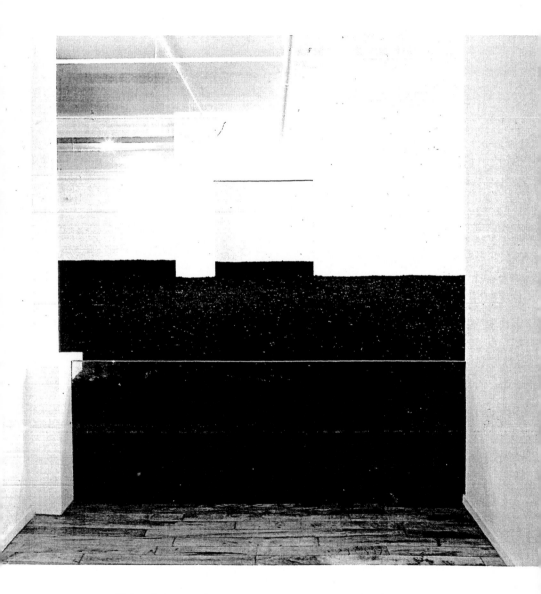

Walter de Maria, *New York Earth Room*, 1977, New York City

Walter de Maria, *Las Vegas Piece*, 1969, Nevada

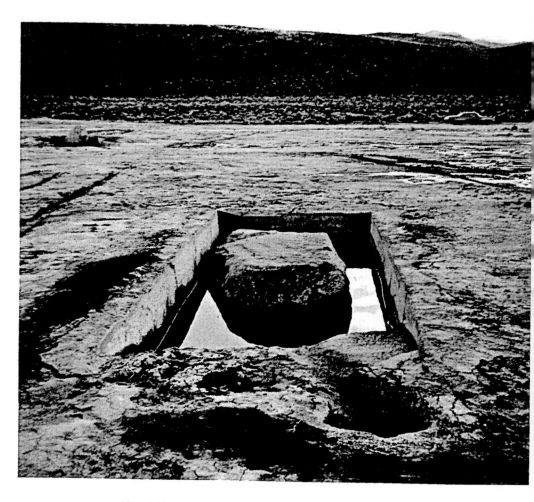

Michael Heizer, *Displaced, Replaced Mass*, 1969, Silver Springs,
Nevada

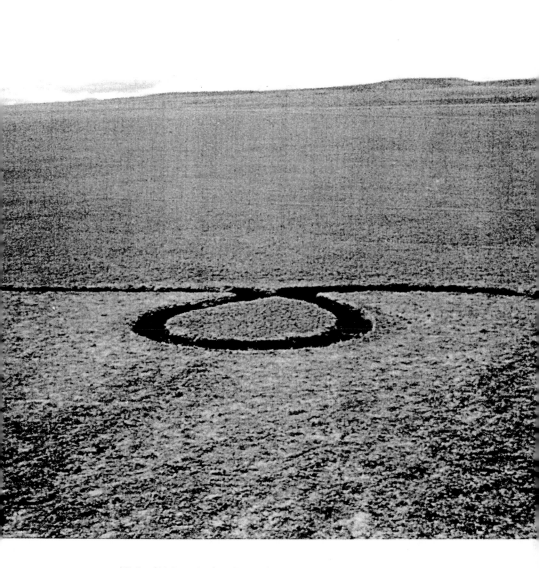

Michael Heizer, *Isolated Mass/ Circumflex*, 1968, Nevada

Alan Sonfist, *Circles of Time*, 1989, Villa Celle Art Spaces, Florence

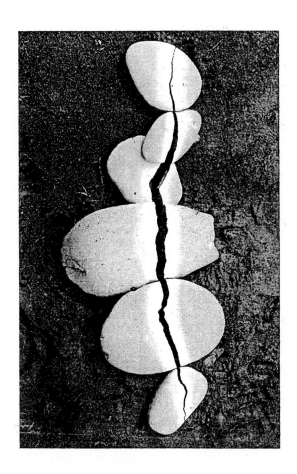

Andy Goldsworthy, *Cleanly Broken Pebbles*, 1987, Scaur Water,
Dumfriesshire

Andy Goldsworthy, *Red Pools*, 1996, Scaur Water, Dumfriesshire

Andy Goldsworthy, *Black Rocks*, 1996, Dumfriesshire